FROZEN LIGHT

THE ETERNAL BEAUTY OF CRYSTALS
LAWRENCE STOLLER

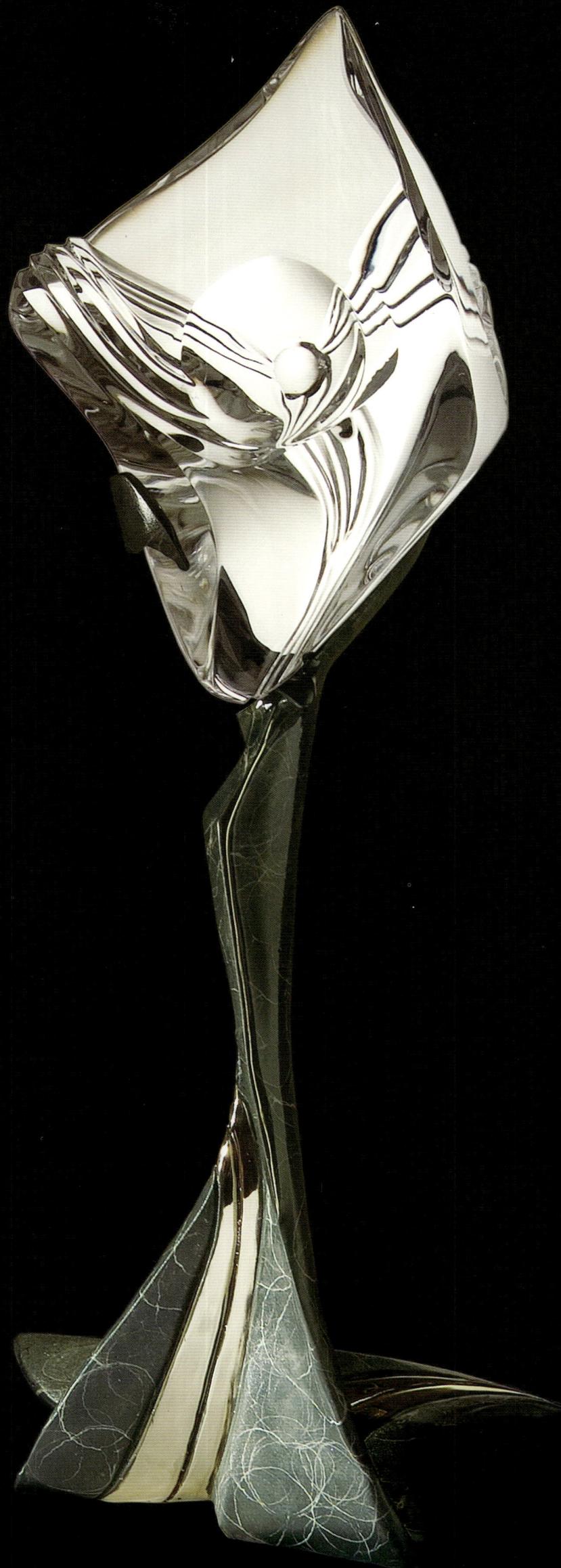

FROZEN LIGHT

THE ETERNAL BEAUTY
OF CRYSTALS

LAWRENCE
STOLLER

EARTH AWARE

Photographs by:
Gary Alvis
Wernher Krutein
Erica and Harold Van Pelt
and others

EARTH AWARE
17 Paul Drive
San Rafael, CA 94903
www.earthawareeditions.com
800.688. 2218

Library of Congress Cataloging-in-Publication Data available.

ISBN-13 978-1-60109-103-1
ISBN-10 1-60109-103-6

americanforests.org
GLOBAL
RELEAF

Palace Press International, in association with Global ReLeaf, will plant two trees for each tree used in the manufacturing of this book. Global ReLeaf is an international campaign by American Forests, the nation's oldest nonprofit conservation organization and a world leader in planting trees for environmental restoration.

REPLANTED PAPER

10 9 8 7 6 5 4 3 2 1

Cover photograph © 2007 Erica and Harold Van Pelt

RIGHT: *Starborn*, STAR RUTILE IN QUARTZ, 12", MADAGASCAR

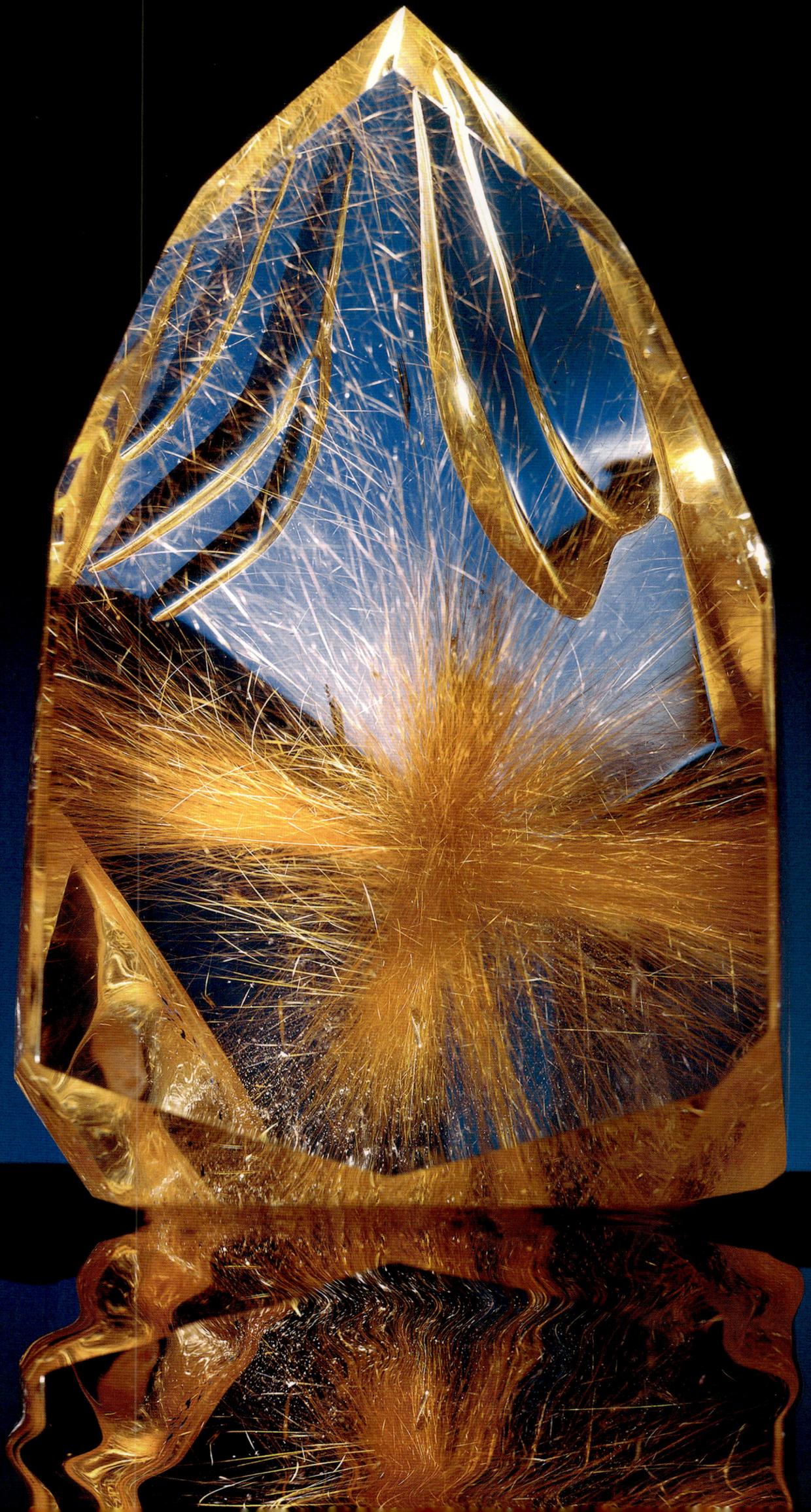

✻

THIS BOOK IS DEDICATED TO:

Sybil and Bob, my parents,

for their many gifts of freedom and love,

allowing me to define myself.

Sunni, my wife and life partner,

who nurtures and sustains me

with a love that ignites the beautiful life we share.

Franc Sloan, my lifetimes-long friend,

whose kindred passion for the roads less traveled

has lead to so much that is fun.

Lazaris,

who lovingly opens doors of possibility,

and then walks me through them

into new realities.

✻

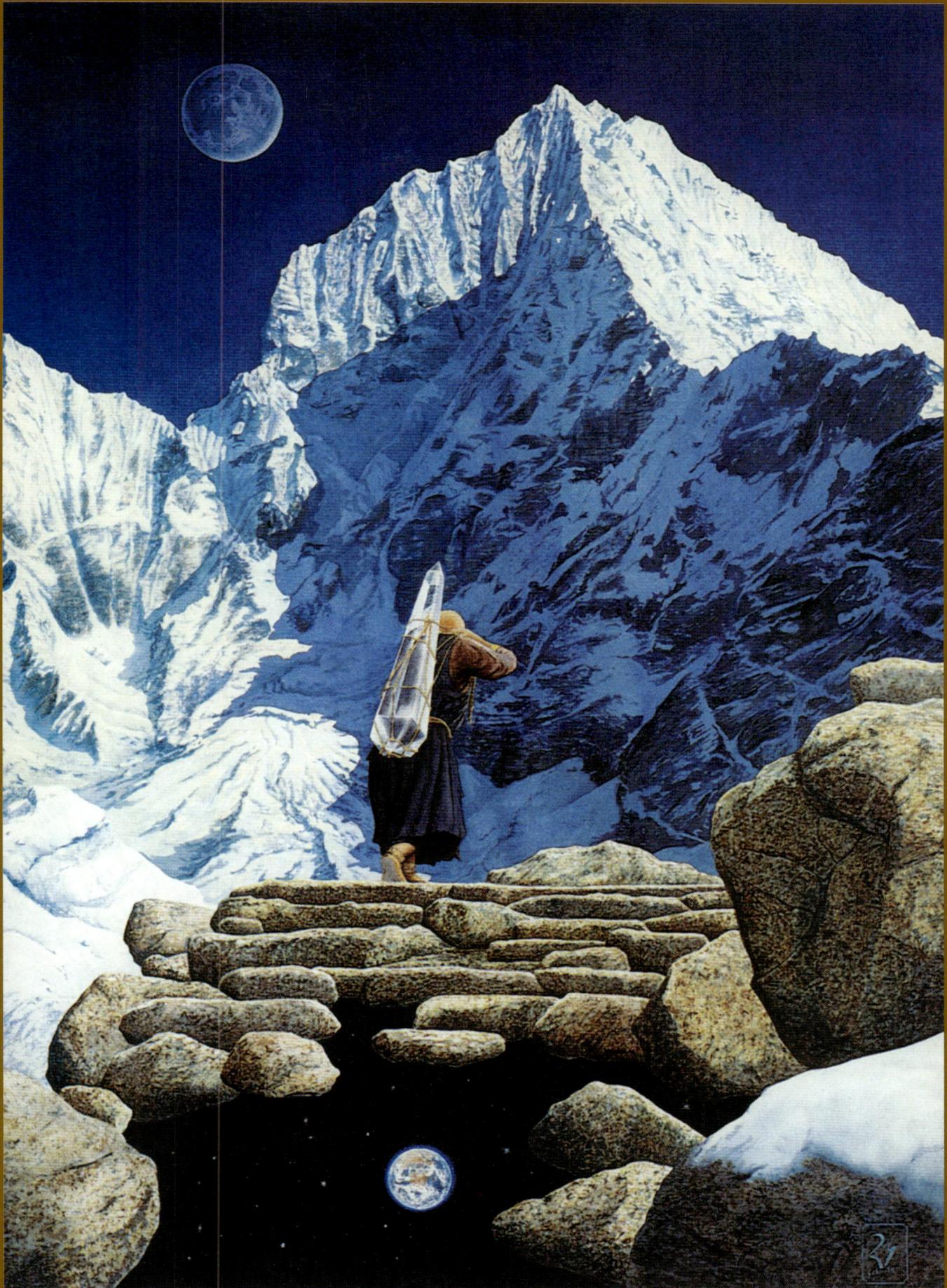

Above: *The Ascent* by Rob Schouten, watercolor, 1989

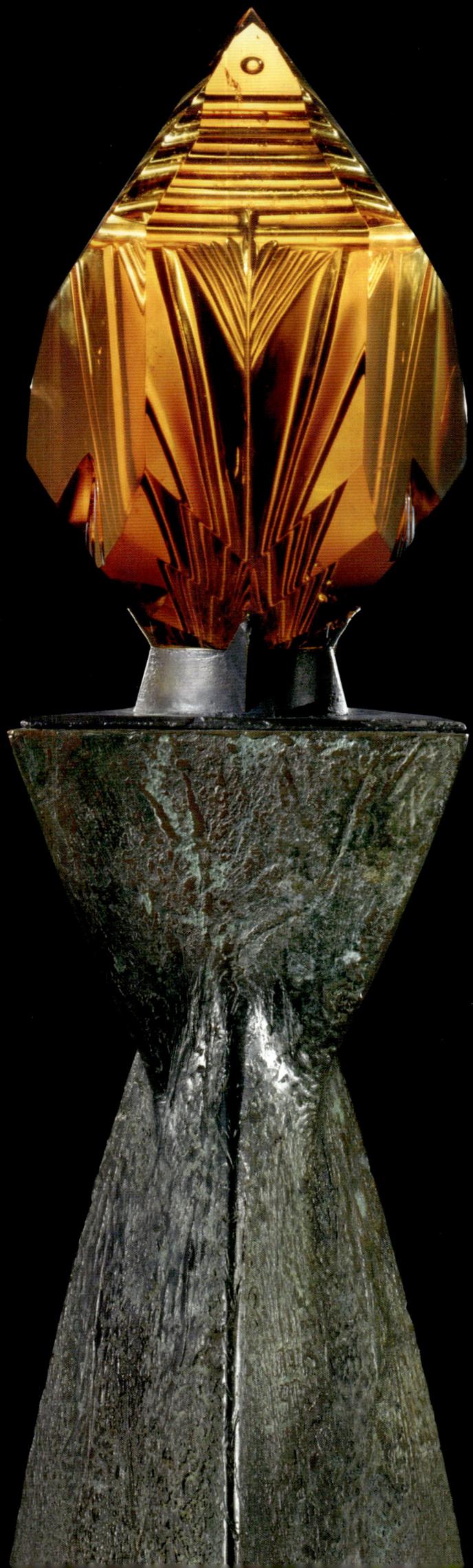

CONTENTS

LEFT: *RA ATUM*, CARVED RED CITRINE QUARTZ,
34″, BRAZIL; BASE BY ROGER STOLLER

"The beauty of nature
inspires the heart to pursue
the nature of beauty."

— LAWRENCE STOLLER

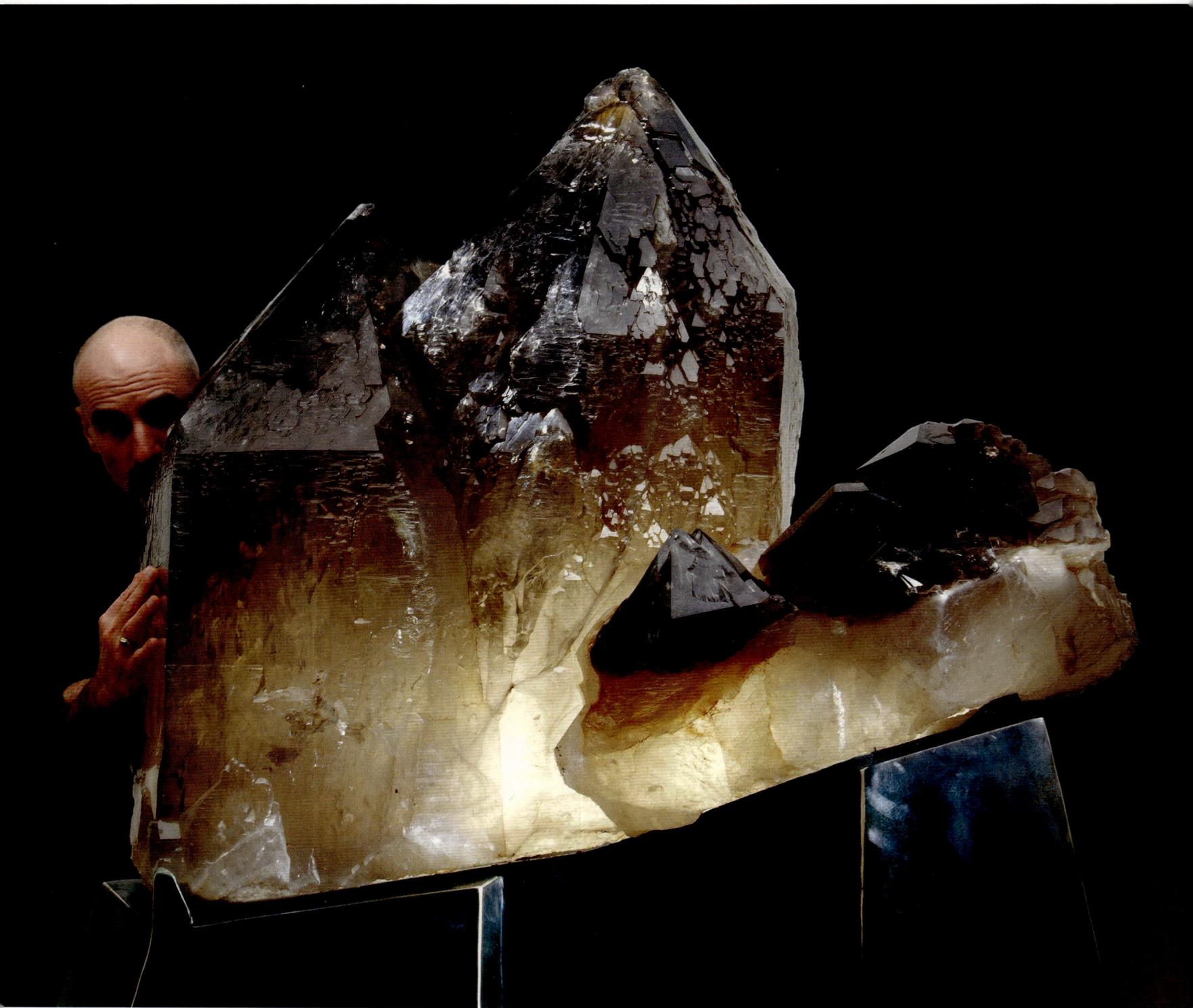

ABOVE: *GATHERING OF THE ELDERS*, NATURAL SMOKY CATHEDRAL QUARTZ, 1800 LBS., BRAZIL

✿

The crystals will be my books,

Reading into them to discover life beyond the margins.

Journeying from primal Earth, past ancient civilizations,

From the timeless technologies, to the inside of matter,

Through the gates of knowledge, and into the terrains of Wonder.

My attempts to translate these experiences into words

Are but record keepers

Of the magnificent remains of Frozen Light.

✿

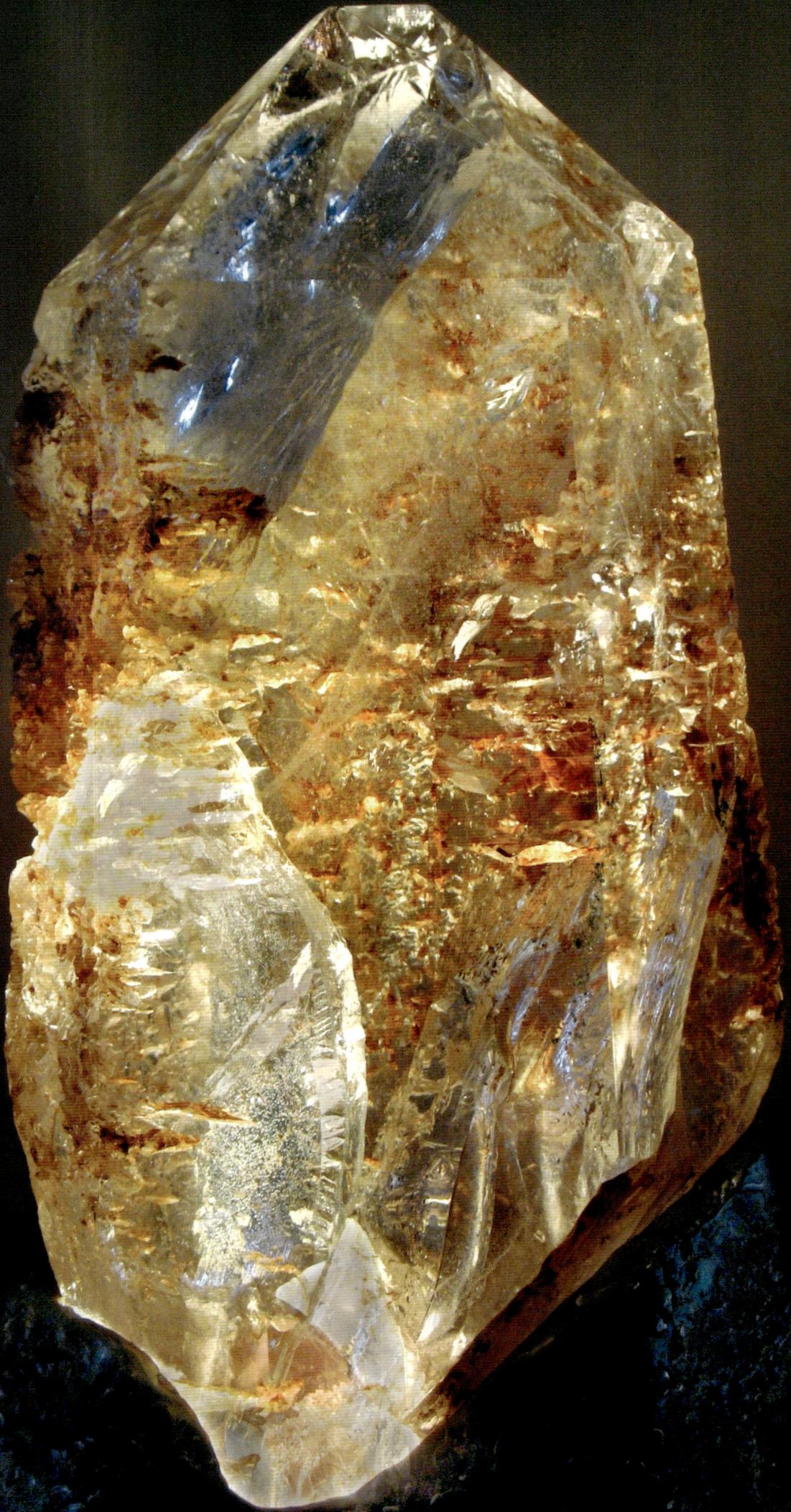

✳

Beauty is eternal,

a quality that transcends human experience:

it exists beyond me,

and inspires within me

a curiosity to travel deeper

down pathways of understanding myself.

So I journey into the radiant

crystal form.

It is as if

a creator god and goddess at play

splashed mercurial colors

across an endless sky,

and then

as a way of recording

their creative prowess of Heaven and Earth,

froze and condensed that sky

as the eternal memory

of crystalline rare earth.

✳

INTRODUCTION

I didn't set out to write a book. Writing a book never occurred to me until one day I found myself writing—a book. We had just finished showing at the Tucson Gem and Mineral Show, an all-consuming two-week mecca in the desert, where mineral lovers from around the world converge to gather a harvest of natural and cut stones, culled from peaks and valleys of remote lands. Following the show, I traditionally am awash in activity, with countless loose ends to tie up, projects to begin, transactions to complete, so on and so forth. But this particular year was different. The show's aftermath felt tranquil, as if we were becalmed on a sailboat, surrounded by ocean and sky, waiting for a wind to set our course.

Meanwhile, the serpent of primal creativity lay still, quietly shedding its skin.

I just felt like writing, and most everything else was a distraction. Memories of my experiences with crystals over the past twenty-some years had been dropping out of my mind, and I was trying to capture them before they scurried away unrecorded. This drive to write made no sense to me at the time, because my day job was being an artist, and the mantra "I need to keep producing" played over and over in my head. My mind was tightly fitted with the logic that I should be working on projects to earn a living, which seemed to be at odds with my desire to memorialize my experiences with crystals. I felt so insecure seeing my thoughts mirrored on paper that I didn't even want to tell my wife Sunni what I was doing. After two months of closeted inner-course hunched over my iMac, I could no longer deny the fact that a book was writing me, sculpting ideas and words instead of hard stones and metal.

In retrospect, it is a logical extension of my work to produce a book, but the motivation came from a place beyond career decisions. I had tapped into something. Ideas were dripping out of my pores within a steamy jungle of insight. When I finally got up the courage to tell Sunni what was happening, her encouragement helped transform my insecurity into commitment.

I don't consider myself a writer. But writing *Frozen Light* is the way to share my fascination with, devotion to, exploration of, and deeply guided relationship to gem crystals, as well as my observations of these exquisite life forms, which Nature herself has fashioned as rare and precious earth.

As an artist and sculptor who works in the densely hard yet versatile medium of gem crystals, I am on intimate terms with this profound matter, in both senses of the word. Holding a crystal in my hands and reforming it, hour after hour, day after day—some works extend for months or even years—we develop a friendship, speak our own language, spanning time. There is no other earthly substance that combines technology, artistry, healing, mineralogy, physics, philosophy, and metaphysics with the deep, wise, transparent beauty that grand crystals possess.

I didn't know any of this to be true when, many years ago, I was blindly swept up in the enthusiasm of working with the stones. There is enigma in crystals; in the beginning, I was compelled to cut and polish their crusty surfaces just to create windows to gaze further into that mystery.

When I was five years old, I went to play at my friend Mitch's house. Finding myself alone in his room, I began looking through his dresser. In the bottom drawer, among plastic army men and dinosaurs, was a fist-sized chunk of quartz. I picked it up and was dazzled, struck by the moment. There was a memory of recognition that transcended my young life's experience, a defining moment of pure awe.

In retrospect, my five-year-old mind was convinced that the euphoric magic of wonder that I was feeling came from rocks.

Some things don't change.

As a young man seeking the Meaning of Life, I was given my first quartz crystal, a small single point, by a Native American wisdom teacher, Brooke Medicine Eagle. She told me that spirit worlds live within the veils. I wanted to believe her.

Growing up, I heard whispers of lore about crystals woven into the fabric of society: crystal-ball gazing, soothsayers and ancient civilizations,

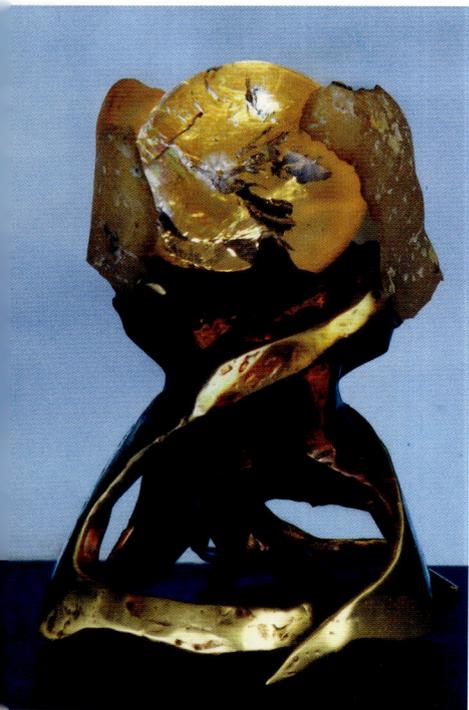

ABOVE: *The Muse*, crystal ball with original river-tumbled crystal rind, 9″, Madagascar
OPPOSITE: Lemurian crystal, 32″, Brazil; base by Roger Stoller

quartz-accurate watches, silicon chips, their "power," their "magic," their mysterious qualities. What information about crystals rings true? What is folklore? What is mineralogically rudimentary, what is scientifically accurate, what are the technological capabilities, what is artistically possible, what is metaphysically attainable, and what has science yet to learn?

I am still looking for answers.

There are those like me who were born rock lovers. Walking down a country road, my eyes are riveted to the ground, ricocheting from stone to stone, like a fox chasing the scent of a rabbit; combing the soil for a glisten, a beckoning color, or an unusual shape. Looking, looking, looking for the magical stone, without ever knowing why.

Somewhere along the way, I learned that from the time of ancient civilizations, crystals and gems have been revered as precious, even sacred artifacts, possessing mystical qualities that compel us to learn more about them, as well as ourselves. And since the beginning of the nineteenth century, humankind learned to harness the hidden physics of the quartz crystal, one of earth's most fascinating geoforms, discovering in it a fundamental building block of our technological age.

When I started working with crystals, I knew very little about them, and even less about the lapidary arts. I was compelled by something, perhaps a memory not rooted in this life, a force that pulled me in a direction that my naïveté, inspiration, and enthusiasm gladly followed. The mineralogical treasures I have encountered along the way demanded that my lapidary skills stretch the dimensions and boundaries of the medium of gem art. Each crystal I work on is a courtship, replete with all the passions, complexities, and commitments of any meaningful relationship. It is a co-creative process. I work on it; it works on me.

This book contains the fruits of these relationships captured in photographic images, which can act as triggers for inspiration. Photographs define surfaces, but they do not contain space. The space within the transparent crystal is where its authenticity, beingness, and primal forces reside. The space between a crystal and someone observing it is where alchemy occurs, making sense—or magic—of the unexplained.

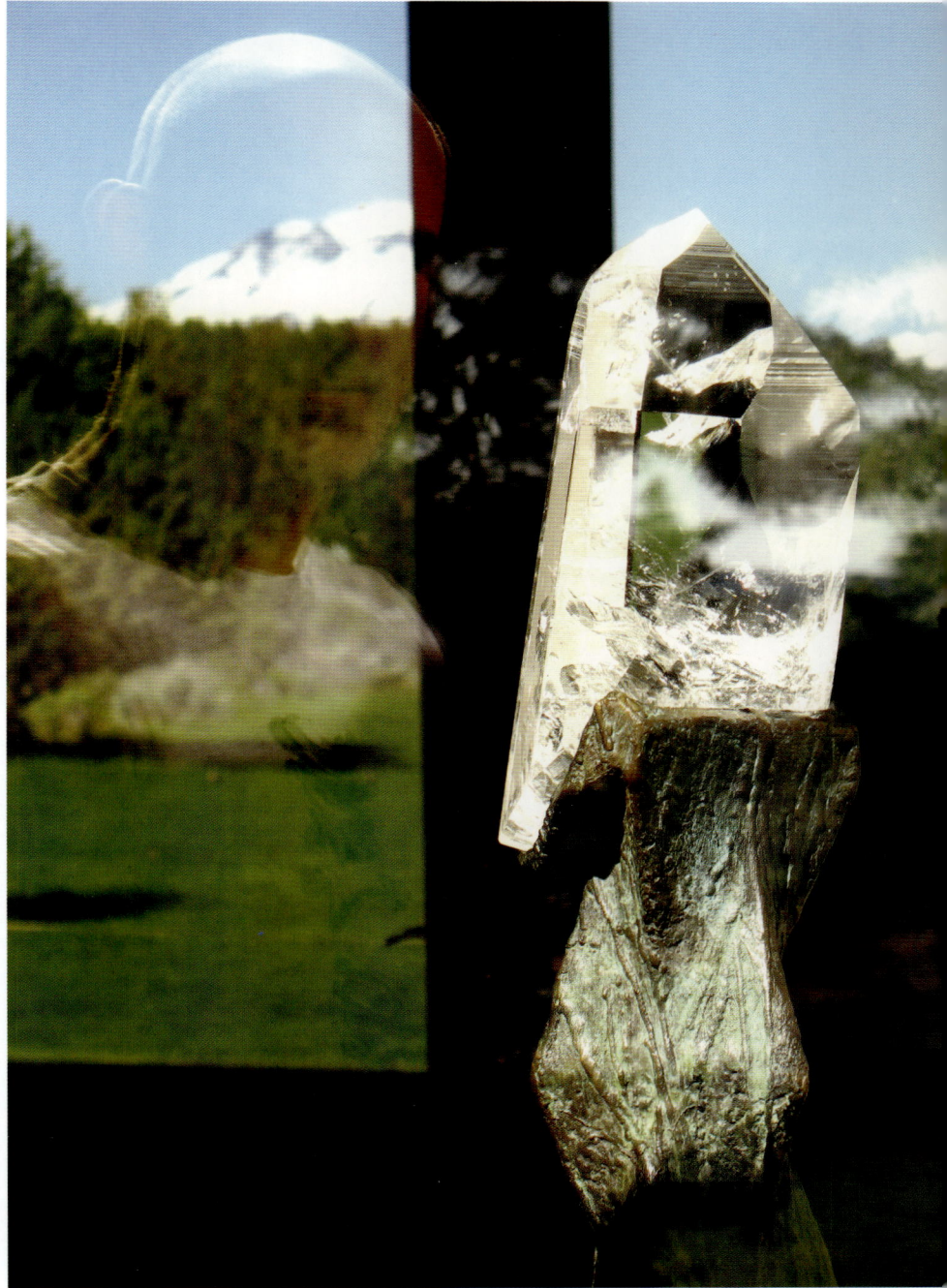

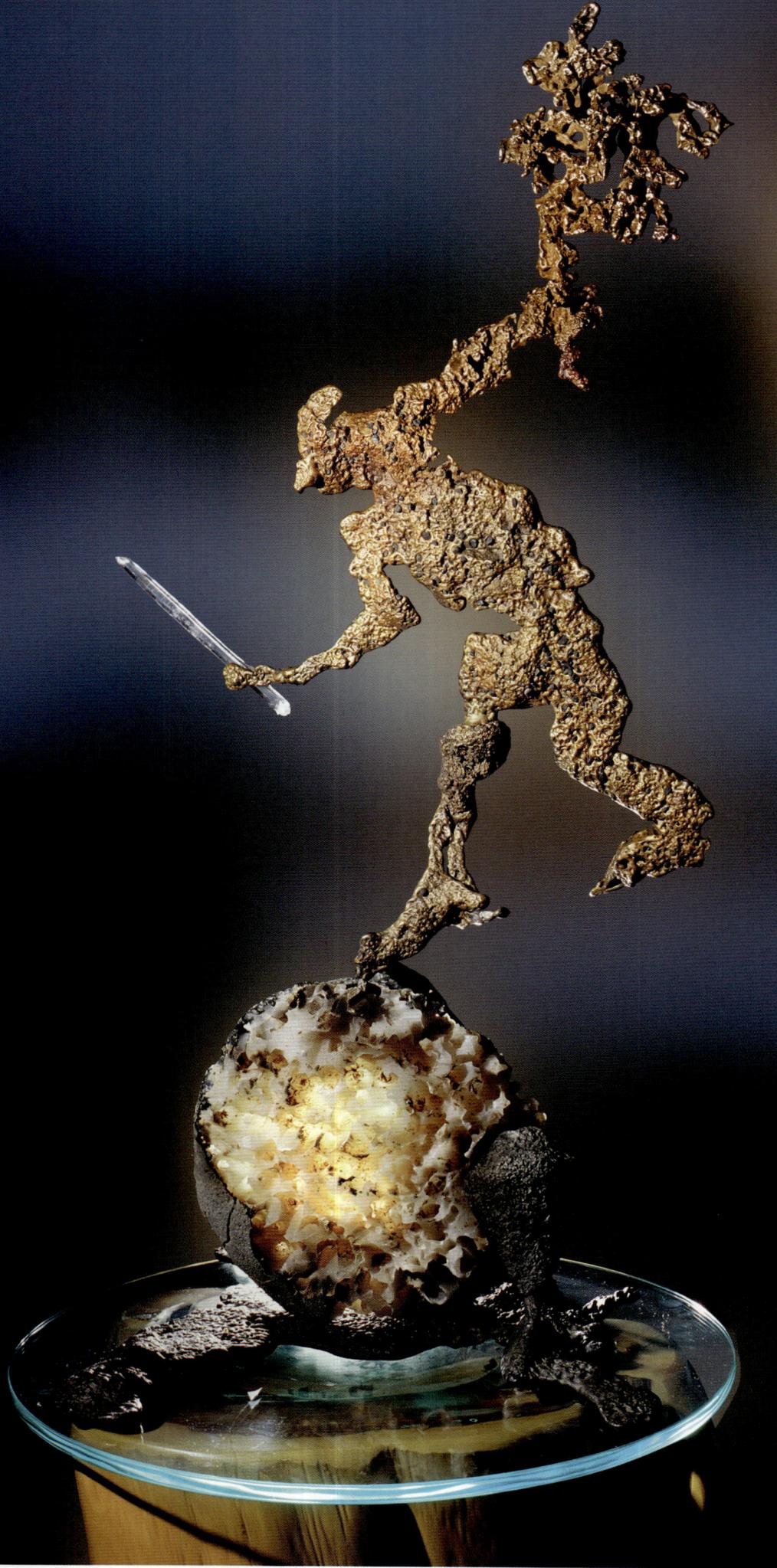

By aligning facts "in-formation," an armature of understanding is built, delivering fascinating and empowering conclusions, although oftentimes I find there are no answers, only questions. Assembling this knowledge transformed an understanding of one of humankind's most significant technological allies into a joyful companionship and a very personal tool for self-discovery.

Crystals contain an authenticity that we human beings seek. In other words, the living art of crystals can nourish the mind's hunger for knowledge, while it feeds the soul's yearning for beauty. Multimillion-carat megagems predate human history by eons, yet as a medium for artistic expression, they are unknown to but a relative handful of people.

Books have been written on art, mineralogy, technology, and metaphysics. All of these subjects are contained within the study of crystals, and I offer *Frozen Light* as a bridge to link these interconnected fields. Like islands, they are joined below the water.

Frozen Light is my attempt to share an authentic experience of the crystals' ineffable beauty. I suggest experiencing it as if you were listening to a song: the pictures are like music, joined to textual lyrics. In this way the two-dimensional medium of a book can transform into a three-dimensional experience of Nature's wonder.

Science has methodically defined the geology, physics, and mineralogical compositions of crystals. Instead of this knowledge being the ends that form our conclusions, let us use these definitions as portals into a parallel world, a new frontier lying just beyond the walls of intellect: a domain of consciousness, where human and mineral share a common language, where investigating with the familiar as well as the unfamiliar senses provides gateways to open ground, and the grand exploration of the nature of Beauty.

I have included facts of science and mineralogy, as well as a few unexplainable experiences that have happened over the years but that don't fit conventional logic, and are thus often dismissed or not noticed. But these experiences, these mysterious aspects of living, can provide a sense of wonder, depth, and fulfillment. In this ever-expanding universe, there is more of the Unknown than we will ever know. And knowing this is freeing.

—Lawrence Stoller, Bend, Oregon

ABOVE: *Thunder & Lightning*, bronze sculpture on agate base holding a "singing crystal," 36″, Diamantina, Brazil
OPPOSITE: *Pegasus*, optical quartz with cut and natural skins, 6″, Brazil

✳

The crystal exists as a multifaceted entity

that humans interact with through four fields of study:

MINERALOGY

TECHNOLOGY

ART

METAPHYSICS

In the same way earth, fire, air, and water are a synergy of fundamental elements,

the crystal exists as more than the separate textbook definitions.

The entirety of the multidimensional crystal is more

than the sum total of the fields through which it is studied.

Beauty is the ingredient that bridges all four disciplines.

✳

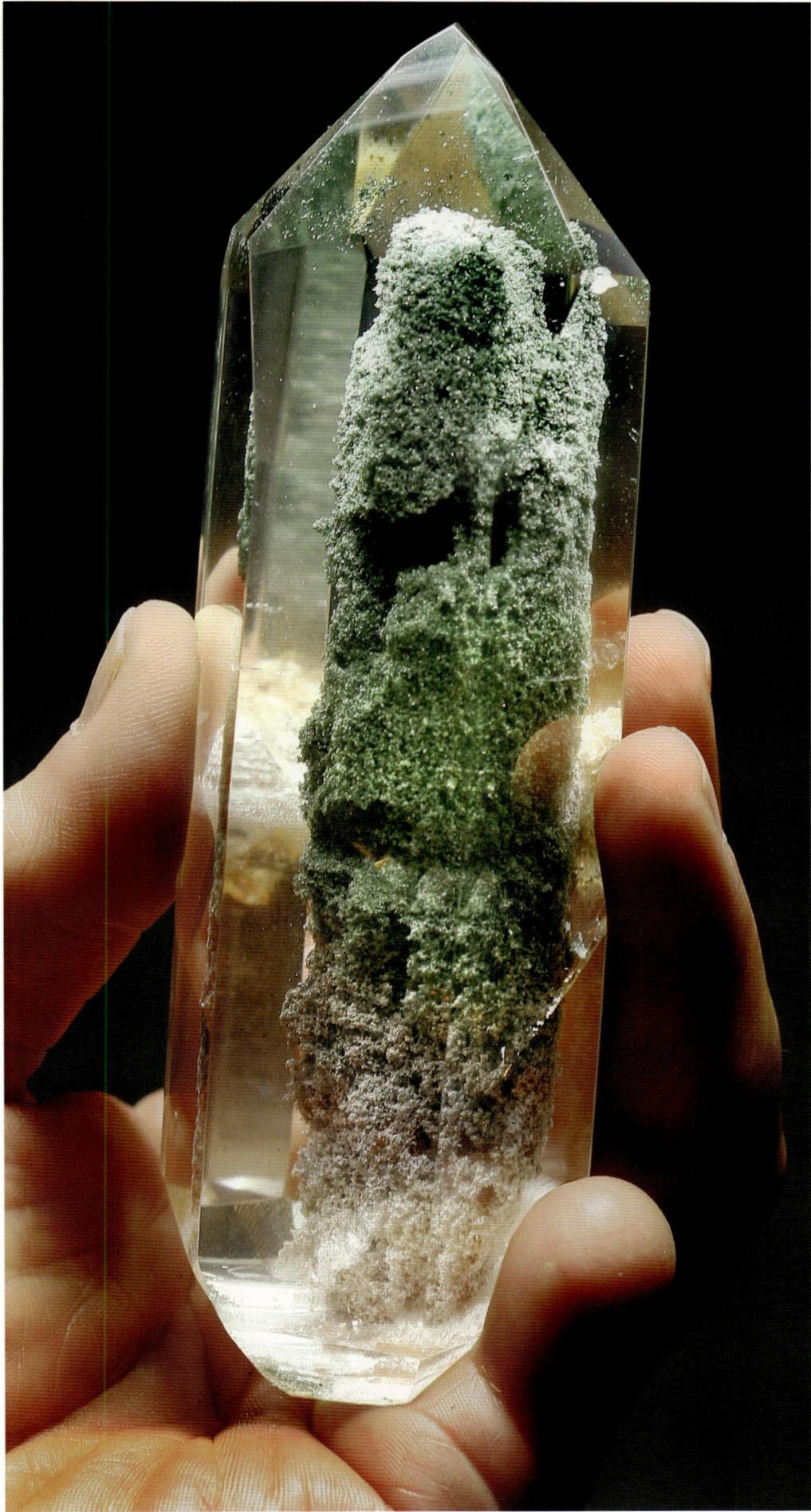

ABOVE: QUARTZ WAND WITH CHLORITE PHANTOM, 6″, BRAZIL

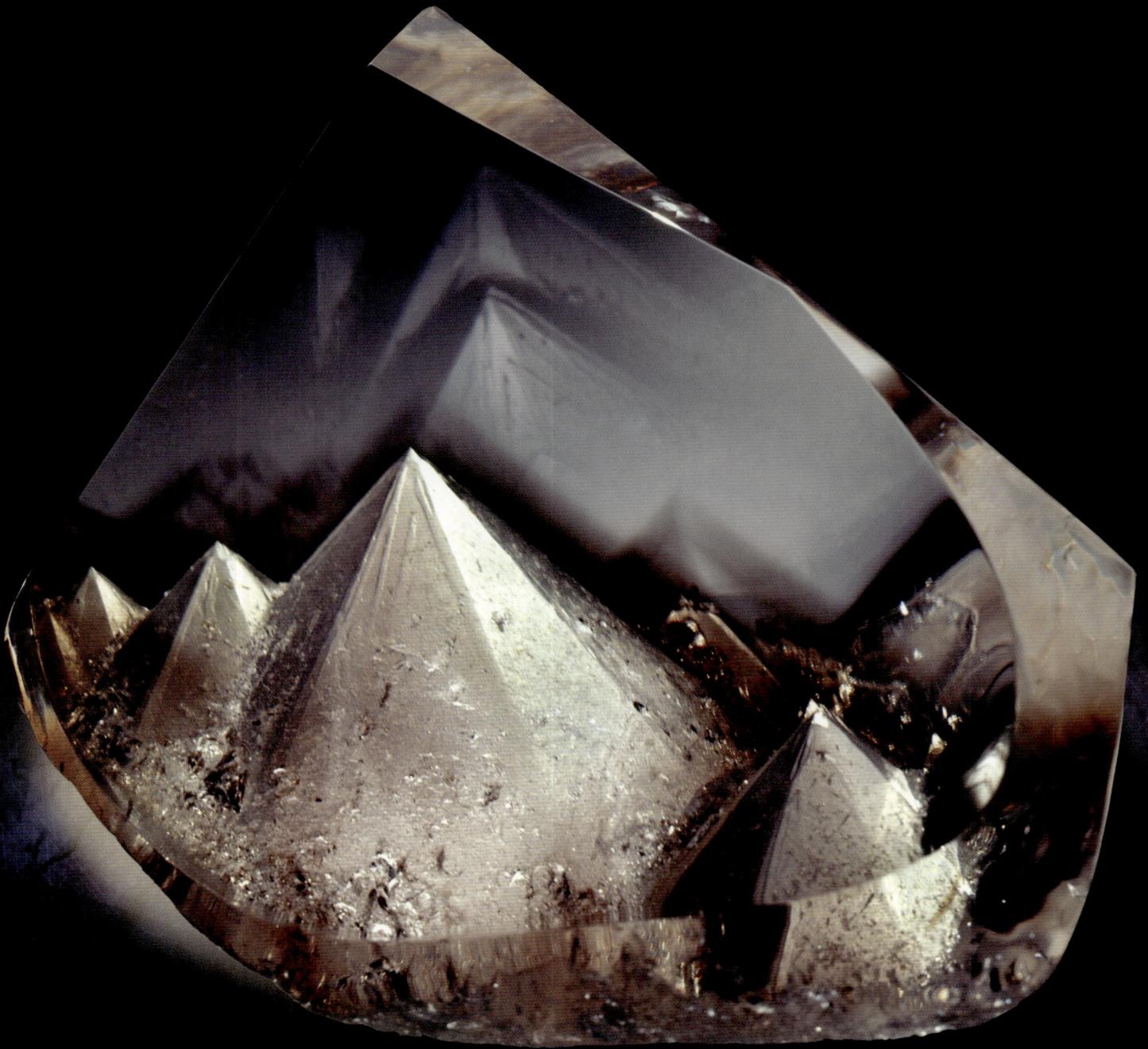

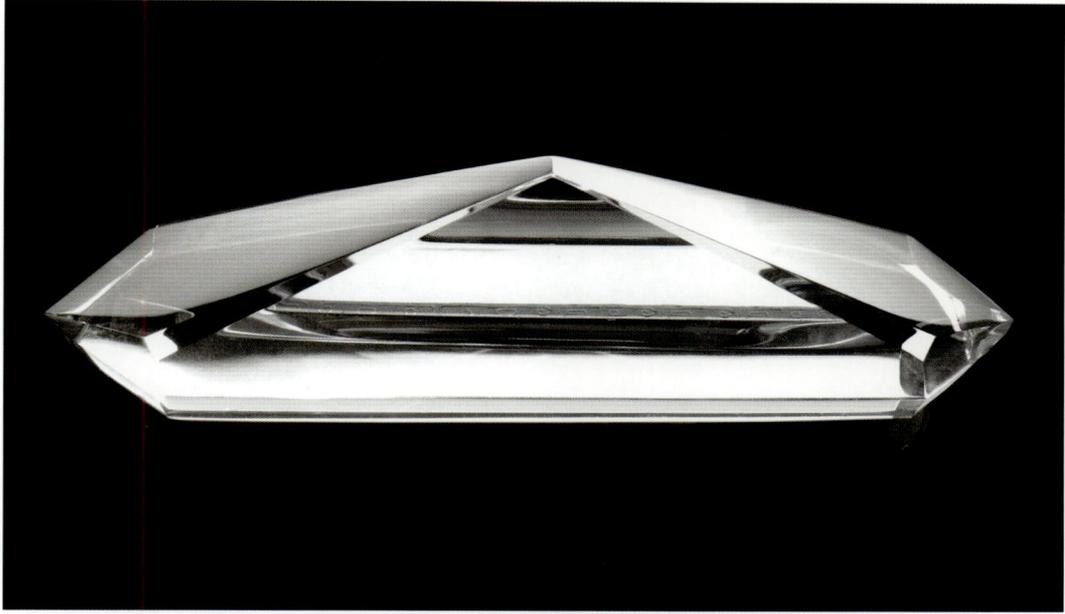

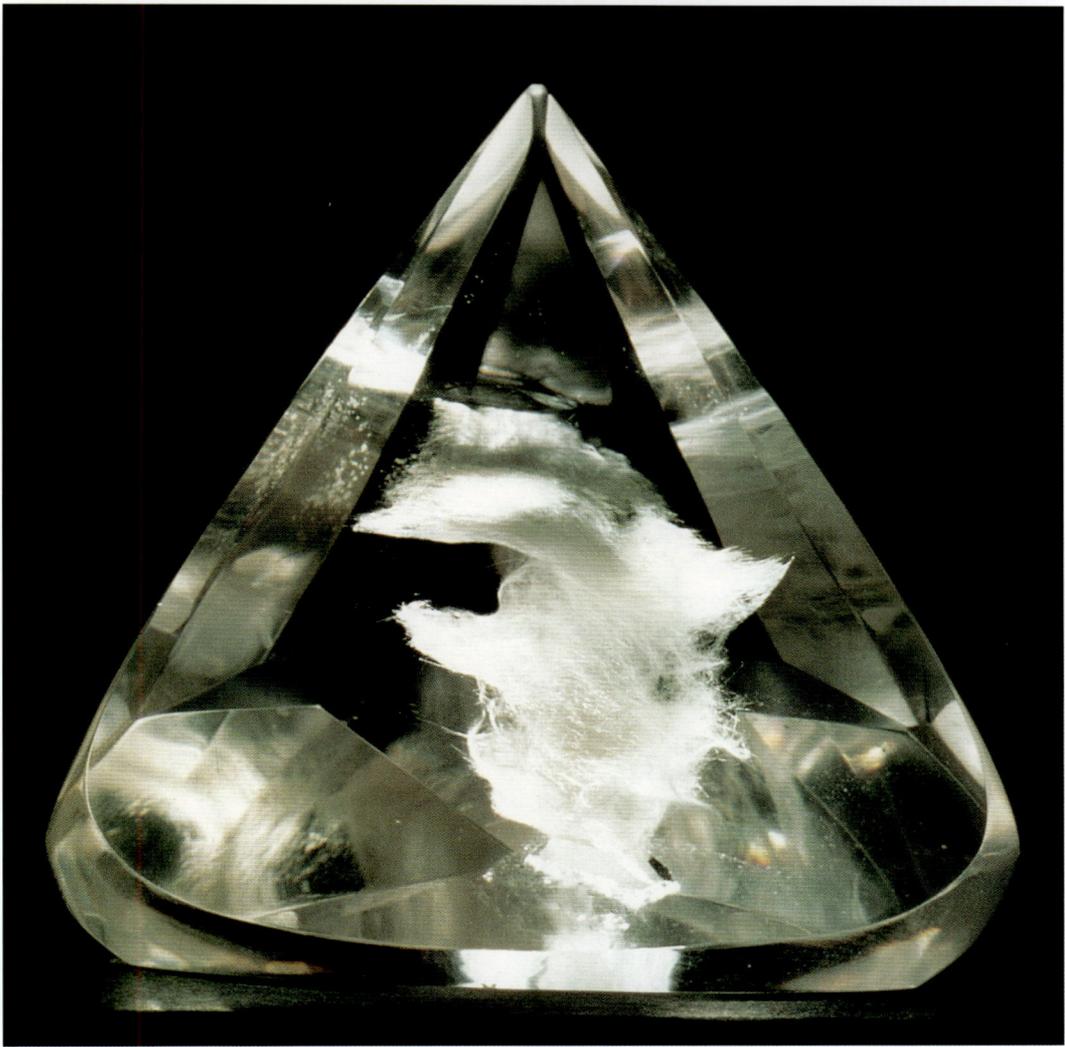

OPPOSITE: *Cheops*, QUARTZ WITH CALCITE PSEUDOMORPH INCLUSION
CAPPED BY SMOKY PHANTOM ZONING, 10 LBS., MADAGASCAR
TOP: *Pyramid*, DOUBLE-TERMINATED QUARTZ, 8″, MADAGASCAR
ABOVE: *Spirit*, QUARTZ WITH UNIDENTIFIED INCLUSION, 4″, MADAGASCAR

THE MINERALOGICAL ART

Si and Ann Frazier

An artist's choice of medium sets parameters. Some are kind to the artist and offer little in the way of technical problems in bringing inspiration to fruition; charcoal sketches are a safer path to artistic fulfillment than the tribulations undergone by a sculptor working in colossal crystals of quartz and other natural minerals. This course has a number of singular challenges that would daunt any but the most stouthearted. Yet this medium is one of the very oldest known to *Homo sapiens*, perhaps even to some of their predecessors.

At most four or five millennia have left us any historical record, although our species is somewhere between, depending on definition, half a million and three million years old. During all of that very long time, humanity was learning to make and use tools, which allowed it to survive in unfriendly or dangerous surroundings. Many anthropologists believe that the making and use of tools actually contributed to the remarkable growth in the size and complexity of protohumans' brains.

The mineral quartz, with its many useful and beautiful varieties, has played an enormously important part in this long, formative process. Finding, choosing, and shaping quartz varieties appropriate for toolmaking was as essential an activity for ancient hunter-gatherer societies as it is for the world of electronics today.

If you were searching through stream gravel looking for a chunk of rock with which to kill your evening meal and cut it up, or to dissuade your neighbor from sharing it, an appropriately sized piece of quartz would become a treasured friend and ally. If it were icy clear and transparent as well, it would catch your attention regardless of dinner plans.

"Primitive man," in many times and places, learned how to shape quartz varieties into the tools that often made the difference between surviving and perishing, and enabled groups of early humans to push into areas and climates that would have otherwise been impossible. Because of its versatility as a raw material and its aesthetic appeal, it is easy to imagine that, from the earliest times, humans developed a keenness for locating, and a sophisticated appreciation for, the various types and varieties of quartz.

A large variety of wonderfully well made quartz tools and ceremonial items can be found in our ancestors' burial sites. These "primitive" societies produced magnificent objects in quartz, most of them utilitarian, such as arrowheads, scrapers, awls, spear points, choppers, and so forth. One has to admire the care and skill used in their making—especially if one has ever tried their hand at pressure flaking, generally referred to as flint knapping by anthropology students and rockhounds who have cultivated this difficult craft. (Moderns who try it should lay in a good supply of Band-Aids.)

Parallel to the utilitarian, the use of rock crystal in artistic works has a long and significant history.

In ancient times, rock crystal was used by various societies around the Mediterranean, the Middle East, and India for decorative purposes. The most important example is seal stones, many of which, now preserved in museums, are pictured and described in an extensive literature, such as Furtwängler's massive, richly illustrated three-volume work from 1900, *Die antiken Gemmen*. One marvels at the high levels of artistry and craftsmanship lavished upon them.

The Greeks and the Romans also utilized rock crystal for many objets d'art. In *Historia naturalis* (79 A.D.)—an encyclopedic compendium of all that the Romans knew about the natural world, and our most extensive and authoritative window into the use of gemstones in the classical world—Pliny the Elder strongly chides the Romans for "excessive extravagance in the use of crystal and agate cups." Among other interesting uses of rock crystal, Pliny describes spheres being used by Roman matrons to cool their hands and doctors cauterizing wounds by using rock crystal, cut as spheres or with strangely convex surfaces, to concentrate the sun's rays.

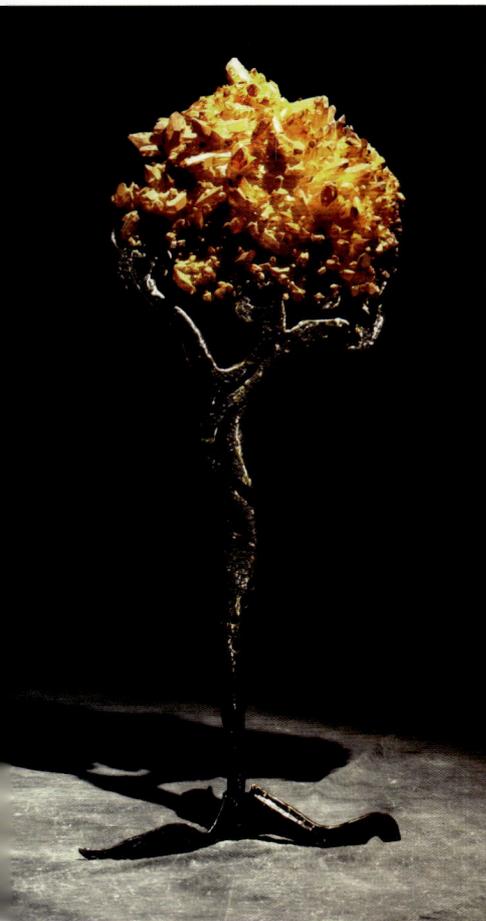

ABOVE: *Tree of Life*, iron-coated quartz cluster, 59", Arkansas
OPPOSITE: *Old Man River*, river-tumbled quartz, 3", Madagascar

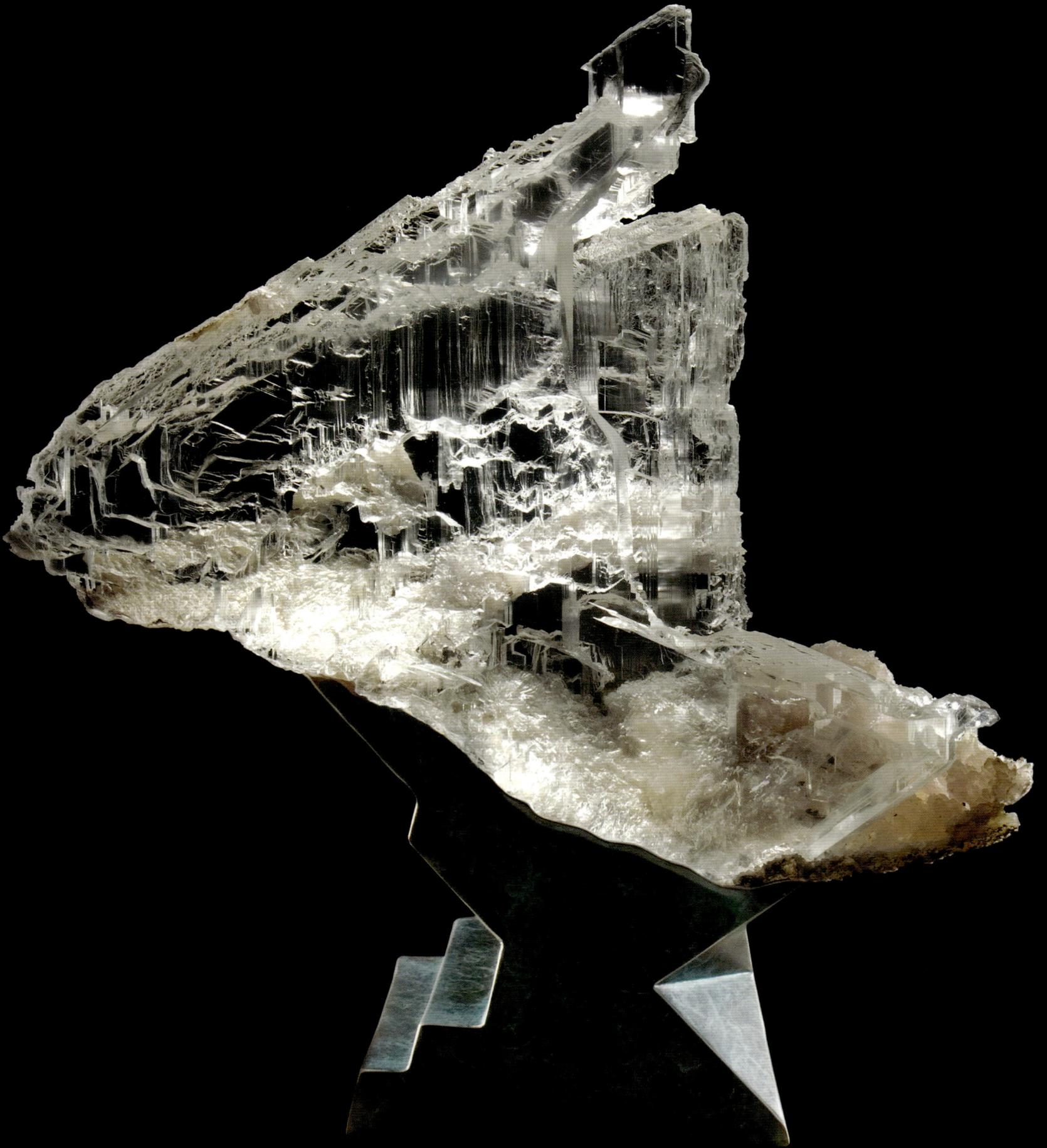

Information about rock crystal art after the fall of the Roman Empire is sparse until the twelfth century. From then through the sixteenth century, many exquisitely carved cups, plaques, reliquaries, and the like were preserved in churches. They are now often found in art museums such as the Prado, Louvre, Reichsmuseum (Amsterdam), Kunsthistorisches Museum (Vienna), and Schatzkammer der Residenz (Munich). Some of the most extraordinary, referred to as *Prunkgefässe*, which might be loosely translated as "splendid containers for display," were elaborate rock crystal carvings designed during the Renaissance as decorative containers for the enhancement of a notable's dinner table, and were usually carved by Italian artists for French, German, English, Dutch, and other northern European princelings and wealthy patrons. Their elaborate carving and detail still inspire awe today.

From the nineteenth century to the present day, the little town of Idar-Oberstein on the western edge of Germany has been the principal gem-carving center of Europe. Documentary evidence establishes that gem cutting, principally of quartz varieties, has been the major occupation of the town's inhabitants for half a millennium. During that time, many special skills were developed; trade secrets were fiercely guarded and passed down from father to son. Pioneer American lapidaries HC Dake and Fred Young, both from Oregon, and John Sinkankas of California have complained in print about the difficulty of ferreting out their lapidary secrets.

Secrecy was a conditioned reflex among Idar-Oberstein lapidaries. This was a commercial advantage because a foreign client could be confident that the firm would not divulge any aspects of the project. Thus, the Fabergé firm, which encountered great success with small but very charming and exquisitely crafted animals carved primarily from rock crystal and agate, was able to work successfully with two Idar-Oberstein firms.

Although Fabergé today is generally associated with the fifty famously elaborate Imperial Easter eggs made for the Czar of Russia, Carl Fabergé and his brother Agathon were the most notable creators of art in rock crystal in modern times. Their delightful animal sculptures brought the art of hard-stone carving to a high point in the late nineteenth and early twentieth centuries.

The Fabergé firm was headquartered in St. Petersburg and had branches catering to the wealthy aristocracy in Moscow, Odessa, Kiev, and London. Chosen by Carl himself, the raw stones were sent with instructions and wax or plaster models to Idar-Oberstein, either to the firm of Elias Wolf or that of Moritz Stern, who in turn chose various subcontractors for various aspects (e.g., blocking, rough grinding, fine detailing, polishing). The finished animals were then returned to St. Petersburg. Fabergé was very demanding and is reported to have kept a large hammer on his desk. Fabergé's business with Idar-Oberstein was unfortunately ended by the guns of August 1914.

More constructively, Fabergé and his creativity, skill, and attention to quality served as an ideal artisans could strive for in Idar-Oberstein. Today, people there are no longer so secretive, and their tools and techniques are proudly displayed and discussed. It is a logical place for any gem sculptor to visit, make friends, and learn. Lawrence has done just that.

Idar-Oberstein is known worldwide for giants in the field of gem carving: Gerd Dreher, Helmut Wolf, Manfred Wild, Bernd Munsteiner, and others have achieved reputations as highly creative masters of the lapidary arts, leaders and innovators in this difficult art form. A new renaissance, preserved and nurtured over the centuries in this small German town, has now spread to North America.

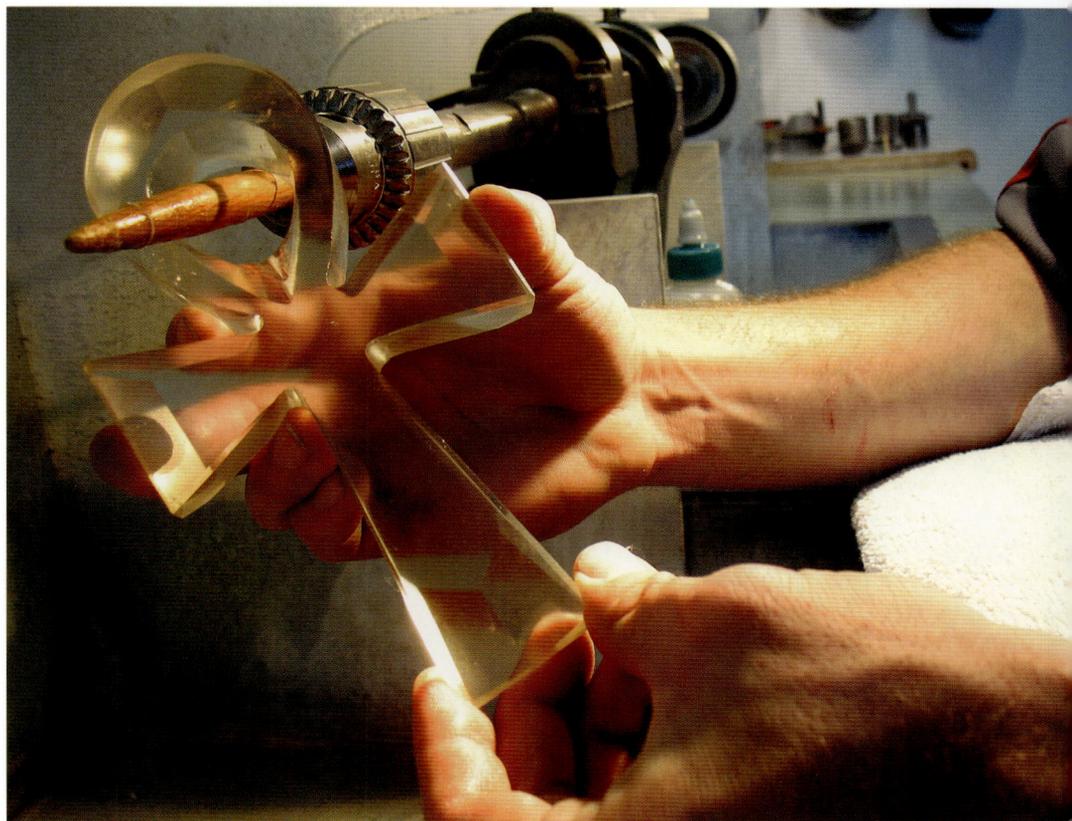

OPPOSITE: *Ibex*, natural selenite crystal, 120 lbs., Brazil
ABOVE: Prepolishing of citrine ankh on carving spindle, 8", Zambia

27

Lawrence has studied German tools and techniques, and his atelier in Bend, Oregon, has various wonderful machines, many of them like the German originals (which are very different from what are normally used for stone carving). Most of the machines are also expanded and improved upon, transformed to meet the exigencies of working with very unusual, very large quartz crystals.

The feldspar group of minerals makes up a large proportion of the Earth's crust, but no single member of this chemically diverse group is as prevalent as quartz, which comprises about 12 percent of the Earth's crust. Of the more than four thousand mineral species, quartz, for a variety of qualities, properties, and characteristics, has proven to be the most useful by far. With its myriad of color and crystal varieties, it is also the most remarkable.

Quartz becomes enormously enriched in surficial deposits because it is hard (7 of 10 on the Mohs scale) and so chemically inert that it is not attacked by ordinary acids and only very slowly by a few alkalis. Although it is exceptionally solid, it can be shaped with marvelous detail, as "primitive man" learned, by striking it with well-aimed blows, or by cleverly causing it to flake by applying pressure with a sharp object such as a deer horn.

Quartz can be divided into two broad groups: the microcrystalline varieties such as agate, flint, chert, and jasper, and the macrocrystalline varieties such as rock crystal, amethyst, smoky quartz, and citrine. The first group is much larger, more common, and generally more useful. The second group is much rarer, also valuable for tools, yet much more attractive and eye-catching. It is these large, transparent macro-quartz crystals that we humans react to most strongly, giving them a special relevance for works of art. (However, Lawrence has indeed produced some extraordinary sculptural works utilizing very unusual, deeply weathered patterns on large, naturally etched agates from Madagascar, which belong to the first group.)

Regardless of why or how it arose, our brains seem hardwired to respond positively to a lovely, clear quartz crystal with sharp angles and planar, highly reflective faces. In a sculptural medium, this characteristic lends crystalline quartz a special artistic cachet. That is the good news. The bad news is that large quartz crystals suitable for even small sculptures are not at all easy for an artist to acquire, and as their

size, clarity, and perfection increase, so does their scarcity.

Large crystals with attractive inclusions such as rutile are orders of magnitude rarer, and present even more complex problems for artistic and aesthetic considerations. This perversity of Nature virtually guarantees that each sculpture is unique and beyond the realistic possibility of duplication. As this book so beautifully illustrates, Lawrence has turned this to his advantage.

His sculptures are literally unique, as rough materials suitable for his works are so extraordinarily scarce. Unlike many artists in other media who create a saleable work and then can go on happily producing variants on the theme, a natural-gem sculptor working in large quartz crystals is faced with a whole new set of creative and physical problems with each new work. The margin for error is minuscule, the process very unforgiving.

The medium clearly requires a great deal of experience, knowledge, and contacts, not to mention luck, to even locate suitable pieces of "rough." Anyone who has been bitten by the mineral-collecting bug quickly learns that it is not difficult to find small quartz crystals at well-known localities such as Hot Springs, Arkansas, or Herkimer, New York (where they are known as "Herkimer diamonds"). However, finding large, well-formed quartz crystals is only possible in a very few places in the world: four especially favored areas where Nature has deigned to produce a very few are the Alps, Brazil, Madagascar, and the northern Ural Mountains in Russia.

Since the human race has been working with quartz not just for a few millennia but for many, one might guess that there is not much new to learn or be developed in the art. *Au contraire.* Painting, sculpture, and music are also very ancient, yet are lively, rapidly changing, and developing media today.

Following in his predecessors' footsteps but greatly enlarging them, Lawrence is constantly expanding and enhancing his medium. Having chosen a particularly demanding one, he has become known worldwide as the leading practitioner of the art of carving beautiful gem sculptures from important and fabulous large crystals. He has brought this ancient art to new heights of imagination, creativity, craftsmanship, and artistry.

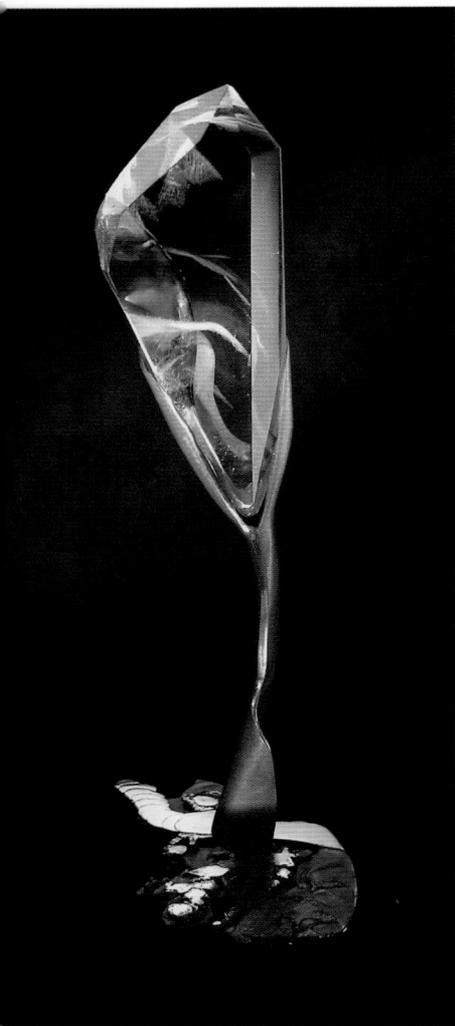

ABOVE: *WATER LILY*, QUARTZ, 15″, RUSSIA
OPPOSITE: *PRINCE OF URALS*, QUARTZ, 33″,
URAL MOUNTAINS OF RUSSIA

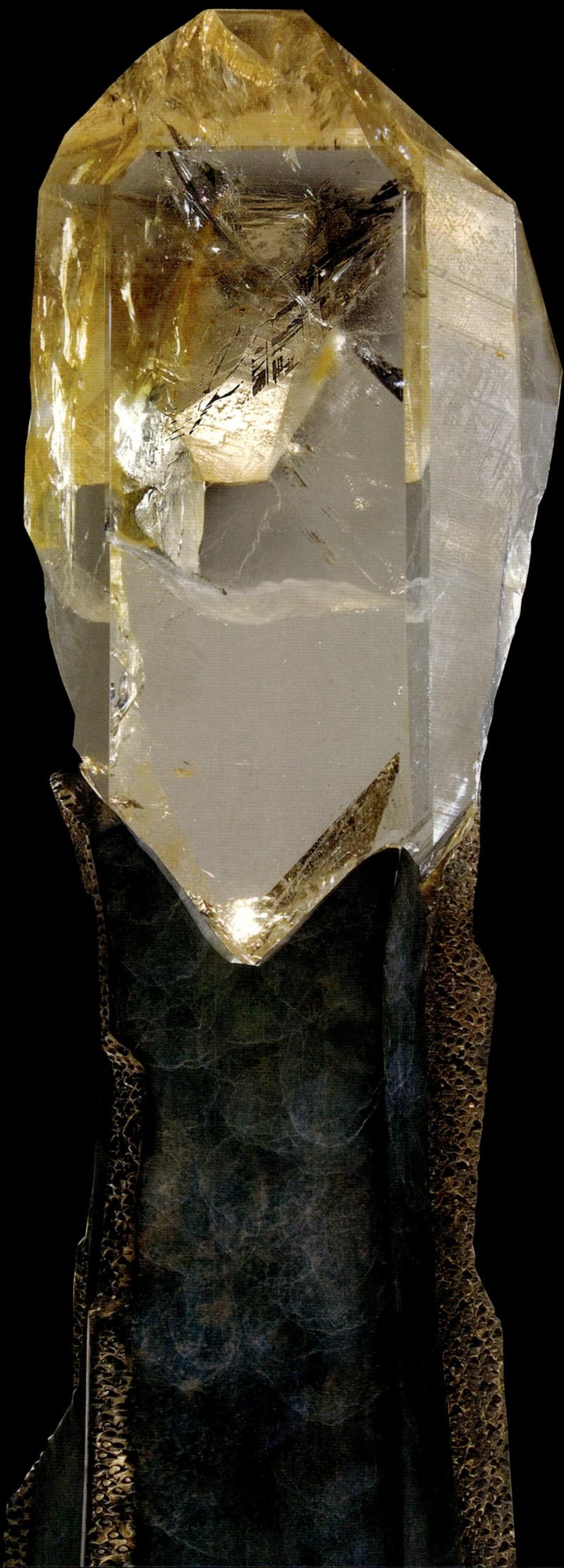

A CRYSTAL'S JOURNEY

1

GOING DIRECT

"Quartz crystals can grow under a variety of circumstances, at very high temperatures in volcanic rocks, and at very low temperatures on or near the Earth's surface. This means that there are innumerable pockets in the Earth's crust where conditions are favorable for the growth of quartz crystals, and they are surely growing. Where? We cannot say. At the very least, one can assume that there are volcanic or fumarolic vents where these creatures are forming even now."

– JOHN S. WHITE

What is it like to be in a dense jungle, hundreds of miles from civilization, in a tight, chiseled cavern 200 feet underground, sweaty, dripping wet, hunting for crystals?

In 1995, I was invited by a miner named Ramiro Rivera to meet him in the Bolivian jungle and there to unearth treasure in his ametrine mine. Ametrine is a recently discovered gem in which amethyst and citrine decided to lie down together, purple and gold united in the same crystal. The Anahi mine may be the only place on earth where Nature concocted this anomaly. It's a long way to Bolivia. Once there, it's a long way to the banks of the Paraguay River. Then it's a long way upriver through hundreds of miles of impenetrably thick jungle, weaving through estuaries, gliding over massive areas of water in an open skiff with an outboard motor. Tropical birds of all colors enliven the skies; alligators sun themselves on the banks. Fall overboard and get eaten: the piranhas are the size of my forearm. Before the sun has set, a desolate road pokes out of the jungle, meeting the banks of a prehistoric lake. At the end of the world's bumpiest road is the mining camp.

The mouth of the mine is a 100-foot vertical shaft. A large bucket lowers to the bottom, to be filled with debris as earth is carved out and brought to the surface. I head down a series of ten woven, vine-wrapped wooden ladders, submerging into the darkness. Gripped with a curious blend of excitement and fear, my boots finally find their footing in the inner earth. Air is being pumped into the hole, but there is appreciably less and less with every step deeper into the mine. Not enough room down here for claustrophobia. I didn't have it going in, but I've got it now. With every step I hunch lower and lower, body scrunched tighter to accommodate the narrowing, descending black tunnel chiseled out of rock.

The fantasy of being in a subterranean crystal mine was exciting a month ago. The reality now is terrifying. My mind asks ugly questions that I don't really want to know the answers to. I was bubbling with optimism until I entered this hole; now the reptilian part of my brain has taken charge, coiled and rattling in this hot, wet subterranean sauna with the air sucked out of it. My adrenaline is spiking, and my heart has moved, up just below my ears. The jarring banging of my hard hat on the low-lying rock ceiling mixes the cocktail of body chemistry into a

froth. Something has to go—either my body or my mind.

But I didn't come all this way to split now; I'm going deeper.

The tunnel is supported by strategically placed hand-hewn hardwood timbers to keep the roof from caving in. My headlamp reveals that some of these rock-hard logs have sprouted bright green leaves in the blackness of the cavern, a testament to Nature's inexhaustible will and the bizarre ecosystem that exists in inner earth. Crawling on my belly through the tightest passageway, my white shirt's become a painting in shades of red clay mixed with sweat. Suddenly, the limestone walls open into a chamber and I stand before a stream gushing through the cave walls at my feet. Affixed to the roof are thousands of crystals hanging like bats. My wide-open eyes pan the room, my headlamp beam sparking reflections off of every facet. In one pocket are different matrices from pegmatites to clay, producing crystals that exhibit a variety of shapes and growth patterns.

The choicest fruit are the floaters on the far wall, delicately packed, pressed into the soft, moist, squishy clay.

My focus has shifted from self-preservation to the wonderment of being entombed in a treasure chest. I take my crowbar and carefully lance the mud, prying out a floating crystal, taking pains not to ding or damage the specimen from its million-year slumber.

I am no longer 200 feet down in the belly of the underworld.

I am in heaven.

MINT CONDITION

When I first began cutting quartz, there were those who protested that cutting compromised the integrity of the crystal. The point is well taken.

There are those crystals that come out of the ground in such pristine condition that cutting them would diminish or disregard their magnificent endowment. These crystals are Nature's wisdom in mint condition. The world of collecting these fine mineral specimens is a passionate pursuit for those seeking the "perfect" in an imperfect world.

However, most crystals come out of the earth in a damaged and eroded state. The millions of years of wear and tumble have scarred and reshaped them from their original (often pristine) formations.

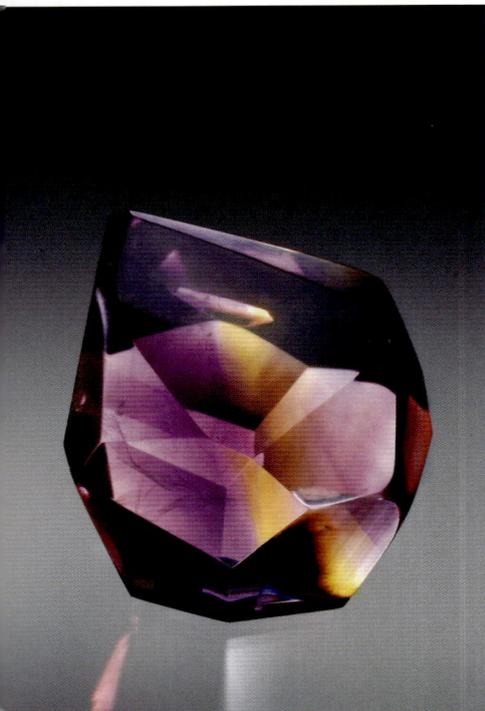

ABOVE: SCULPTED AMETRINE, 323 GRAMS, BOLIVIA

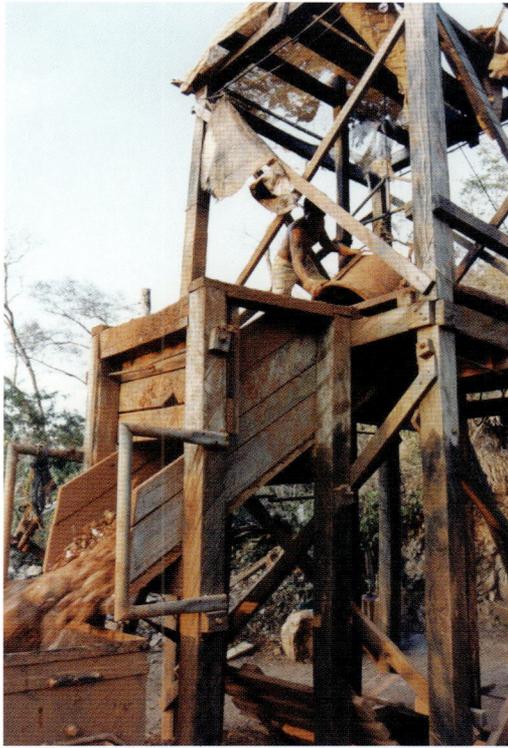

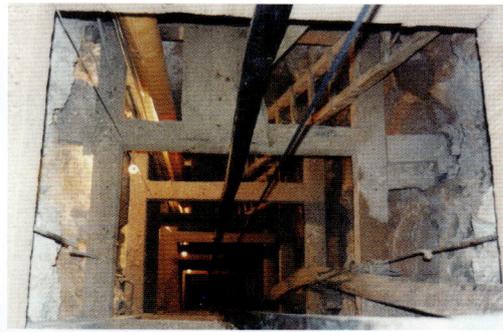

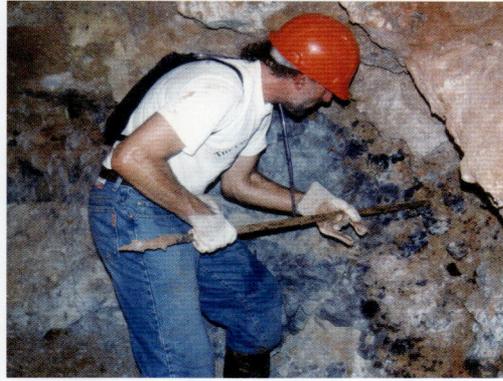

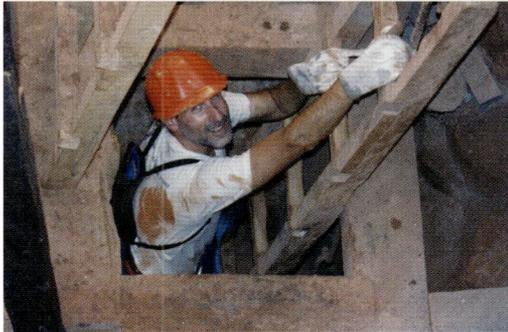

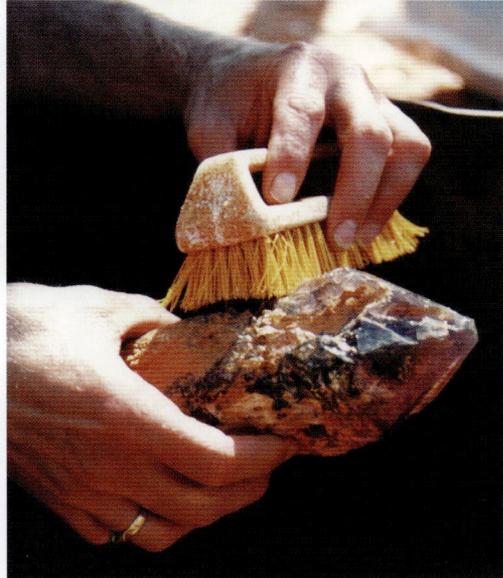

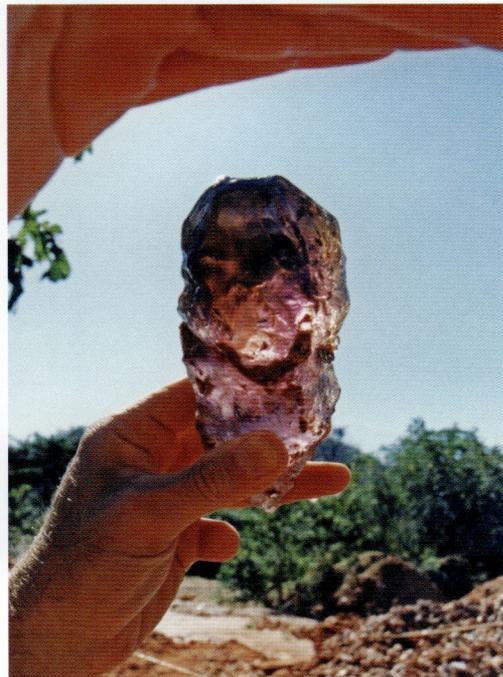

ABOVE SERIES: Lawrence exploring the Anahi ametrine mine

33

By the late 1980s, miners in Brazil, Madagascar, and other countries realized that their harvest of crystals was more valuable when they were extracted and handled with great care. The industry was transitioning from mining quartz exclusively for industrial purposes to finding more collectible, aesthetic, and personal ones.

Chipping and disfiguring crystals was not a concern when crystals were mined for industrial purposes. After all, the crystals would be sliced into wafers for technology, so a few chips and dings were inconsequential. Current mining practices place a priority on preserving crystals as they are carefully plucked, like ripened fruit, from the earth. By and large, they are well cared for when shipped out of country for sale. Economic incentives help to maintain their safety in handling. Very simply, a well-preserved crystal is worth more than a damaged one. But even with the best intentions of the miners, the majority of crystals have incurred corrosively frosted skins and chipped, disfigured faces. Others have been so poorly cut and misshapen by lapidaries that, as when witnessing an abused animal, I feel sad for them.

It is a great feeling to take these crystals and retune them, by reestablishing their angles and faces in the cutting and polishing process, so as to reinvigorate their life force. They appear so happy with their makeovers; their appreciation is undeniable.

Some crystals are best left to the birthright of their natural forms. Others can be enhanced and activated with care in the artistic, reformative process.

ORIGINAL DESIGN

The "ring" growth patterns of trees mimic the aboriginal pattern established by minerals crystallizing. A phantom quartz crystal illustrates the "rings," or layered growth patterns, documenting the crystal's evolution. And dendrites, the fernlike patterns that seeped into and grew in different minerals, prepared the original design sketches for the plant kingdom to follow.

The same dendritic patterns are found in the human brain.

And how fascinating it is that we must have the right mineral mix in order for the human body to function. Minerals in the brain allow the synapses to fire. Calcium and phosphorus form bones. Add in some fluorine, and you have the mineral apatite: smile, and you have teeth, for this is their mineral composition.

Electrolytes are dissolved crystallized minerals that conduct energy throughout the body. Some of us take minerals daily to help balance body chemistry, along with eating plants and animals. We become what we eat, ingesting our evolutionary predecessors.

Crystallized minerals are the original "indigenous peoples." Humans, plants, and animals need them to exist, but do they need us? Maybe they simply need us to appreciate them. As with all consciousness, our understanding, our science continuously evolves.

Philosophers at the beginning of written history proclaimed with scientific conviction how quartz crystals were formed: a quartz crystal was believed to be super-ice, frozen so solid that it would never melt.

In five hundred years, when our descendants are studying our current scientific convictions, what truths seminal to our understanding of modern-day reality will they find equally amusing?

INCLUSIONS

Inclusions are but one of the fascinating phenomena that set quartz crystals apart from other minerals. In mineralogical terms, an inclusion refers to a second mineral that grew inside the quartz while it was forming in a fluid state. An inclusion will not form from an organic substance, such as a leaf or a bug; only secondary minerals are able to form under the suitable geologic conditions. The quartz serves as the host rock within which the other minerals crystallize, the white canvas on which colored layers of exotic minerals are painted. These crystals are often referred to as scenics for their stunning internal gemscapes.

When I first began looking for crystals to cut, I visited warehouses that stockpiled clean, clear quartz imported from Brazil and Madagascar for electronics. I initially believed that the cleanest, visually purest quartz was the "best," because it was the only quartz that had value. Now and then, I would find discarded chunks lying on the warehouse floor containing vibrantly colored minerals floating in the clear quartz: radiant hues of pink, purple, white, mauve, yellow, orange, brown, and red; a starburst of golden rutile or blue tourmalines floating in the quartz; a green chlorite phantom; a dogtooth calcite; or an enhydro water bubble that had been trapped for millions of years. These chips and chunks of quartz with inclusions were usually discarded, oftentimes knocked off with a hammer, because at the time they were perceived to have no value to the electronics industry.

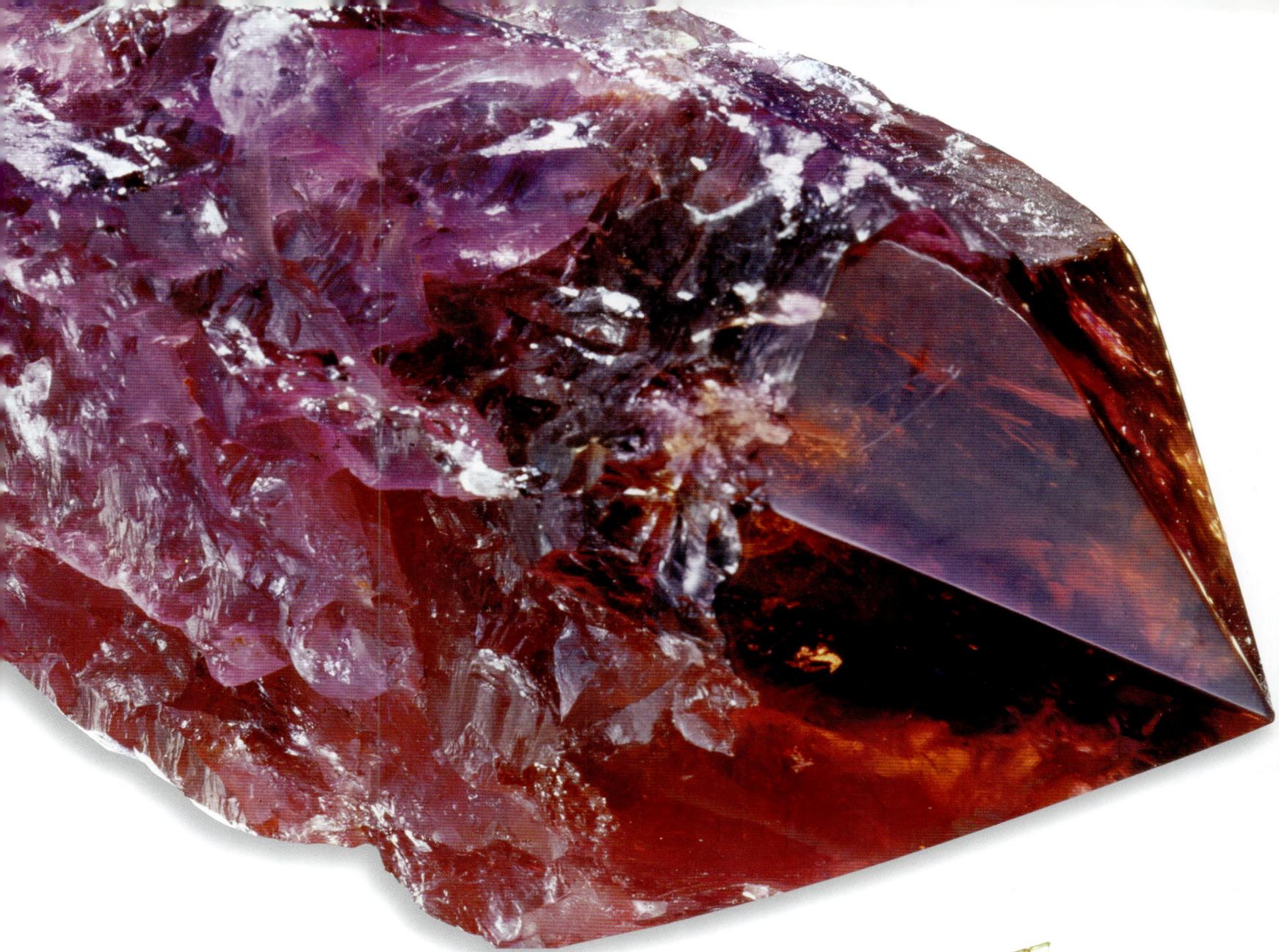

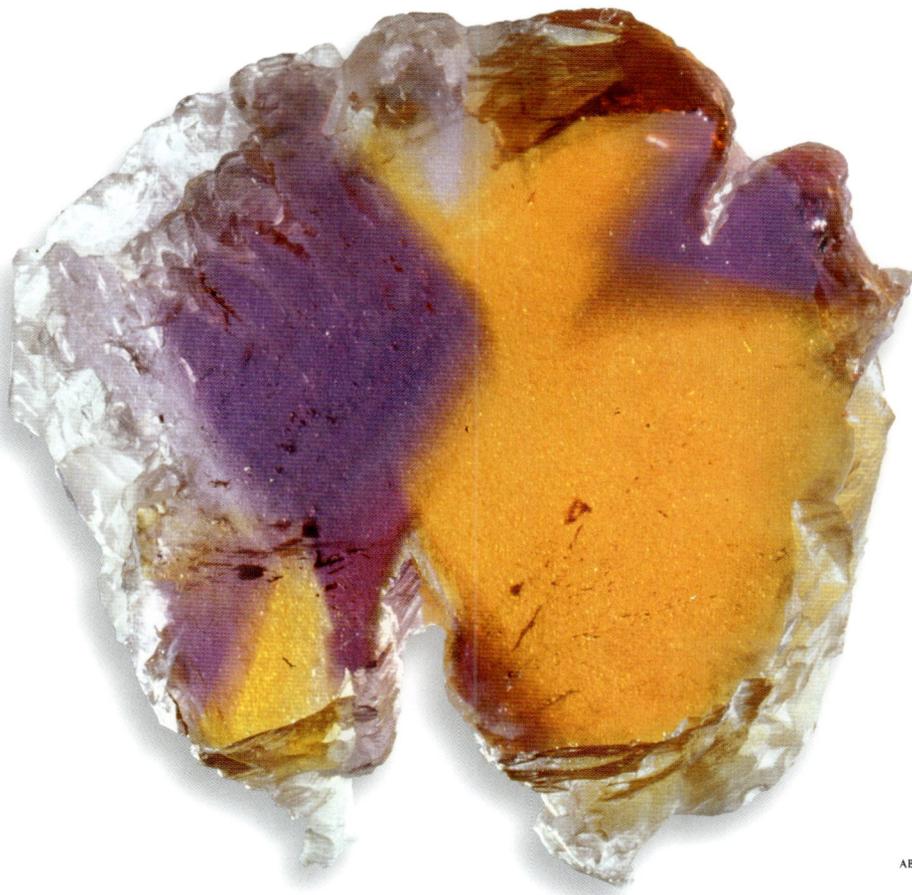

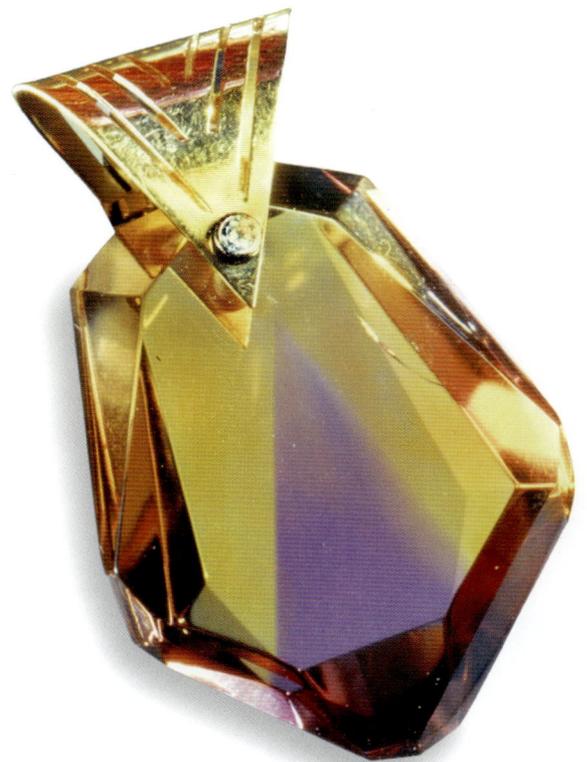

ABOVE: Natural and cut ametrine, natural crystal is 6″, Bolivia

SHARING EARTH

Earth is an organism;

Crystals are the cells of the skeletal system, and humans are cells of the skin.

The cells of the skeletal system are slow growing, dense, structural.

The cells of the skin are fast growing, reproduce quickly,

And exfoliate continuously.

Skin is dynamic, bones are supportive.

Each cell is a constituent of the body of Earth.

We sense the infinitesimal; we perceive the infinite;

We exist in the realms between the infinitesimal and the infinite,

Sharing the body of Earth.

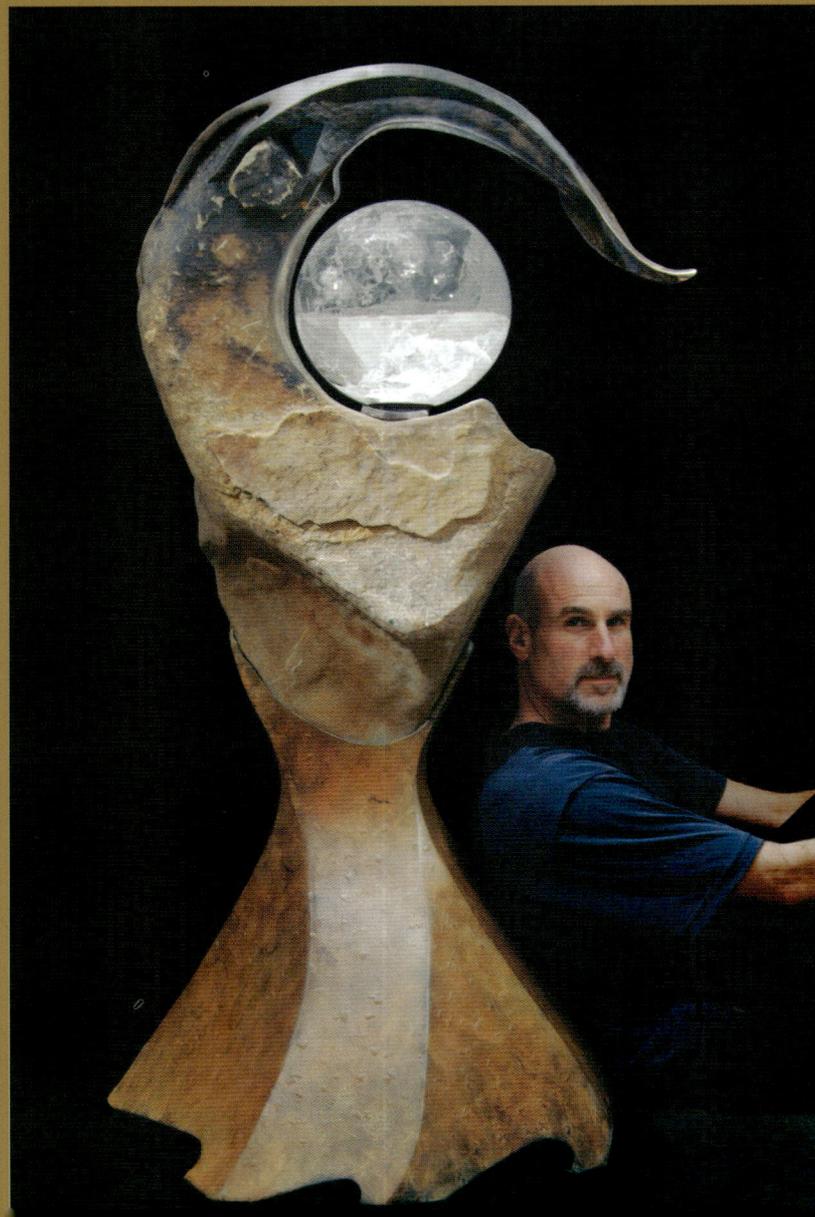

I didn't know what these odd shapes and colors floating in the quartz were, but was more than happy to buy them for almost nothing. I figured that anything this interesting and beautiful could be reshaped, cut, and polished, so that others could enjoy their beauty. Of course, today fine quality "inclusion" quartz is highly sought after and, as a result, quite valuable.

Most quartz crystals have veils floating in their transparent bodies, cloudlike formations that usually consist of tiny trapped air or water bubbles. Floating in the quartz are often highly visible planes that strongly refract light.

Beyond the pure wonder of these formations, the inclusions can be given personal meaning and can suggest ways of working with them in the crafting of one's life. Here is but one example:

In the early 1980s, Edward Swoboda invited me to visit his mining operation located on a sprawling green hilly ranch land in Belo Horizonte, Brazil. Ed, Rock Currier, and Ozario Neto had begun mining in this location, which brought to the world some of the most spectacular phantom crystals ever seen. I had a memorable time extracting a few treasures from their hard rock–encrusted pegmatite cocoon. The crystals lined the walls of an open pit about the size of a large round swimming pool, which had until recently been the top of a domed hill. I leveraged my weight so as to cling (for several hours) to the steep slope as I painstakingly chiseled out crystals. They came out slowly, but each was steeped in the excitement that it might be more exceptional than the last.

Inclusions can take on any metaphorical meaning one gives them. I look at the character of a crystal and the inclusion, and see what it is saying to me. It speaks to the subconscious in pictures contrived by imagination. Some of the images that emerge inside are so obvious that everyone seems to share the same interpretation, while others are more subtle and personal.

One might look like a forest, another like "strawberry fields forever," a waterfall of light, a bright moon in the trees at night, a flock of birds flying free, a world undersea, a mysterious ghost dancer, or the dawn of creation frozen in time. Rainbows abound. Under a very strong light, *blue needles* shooting rays of light may even appear. These are actually voids in the crystal lattice.

One such inclusion may be a gateway to pass through to another realm of consciousness. An etheric gateway is a highly reflective internal structure that is very pronounced when viewed in one direction. When it is turned 45 degrees, however, it becomes invisible. A message plate may hold ancient knowledge, if one is willing to

ask for it to be revealed, and then give it the attention needed to receive an answer.

I am regularly asked by people new to looking at inclusions: "Did you put that in there?" While I am a competent lapidary, only Nature has the prowess to create at this level. And when it comes to inclusions, I am convinced that Nature has tried everything at least once.

In the gem trade, having an inclusion lessens the value of the stone. This is especially true in the diamond and cut-gem industries. I'm happy to say that this is not true when it come to quartz crystals, which can be far more rare and valuable with a special inclusion.

The elusive myth of perfection must be a human invention, existing only in our minds. In Nature, we refer to things being perfect the way they are. There is great beauty in flawless, optical-grade quartz, but with strong enough magnification, an "imperfection" will inevitably show itself. I like to substitute the word "excellence" for "perfection," such as for a beautiful sky that includes clouds containing the colors of a setting sun. When I look inside a quartz crystal, my imagination ignites.

To this day, Sunni and I use one of the phantom crystals I extracted in the mountains of Belo Horizonte as our "abundance generator." The crystal has a thick, green, mossy-looking phantom: we have designated that its function is to emit and attract the energy of prosperity.

GETTING FROM THERE TO HERE

There is a loosely knit network of miners, importers, and dealers who are in the business of flying crystals around the globe. From Brazil to Hong Kong, from Madagascar to Munich, from Arkansas to Singapore, from time to time, from some pocket of the Earth, they make their way to me. The Internet and the instantaneous ability to send photos by e-mail have propelled crystals in all directions. A few years back, I remember an orange sun setting as Sunni and I relaxed, taking our end-of-the-day tub, when the phone rang. My friend Zee was in Hong Kong; he had just seen a crystal mined in Zambia and had first option to buy it. I don't remember his words, but the pitch and decibel level of his voice told me that this was something special. He declared that if I wanted this crystal, I had to commit—it was now or never. A German dealer (whom I knew of) would have this grand crystal carved into a Buddha if I didn't claim it first. The crystal was expensive, and given its 1800-pound mass, the challenge of cutting it was daunting. There was not enough time for me to assess and clarify all

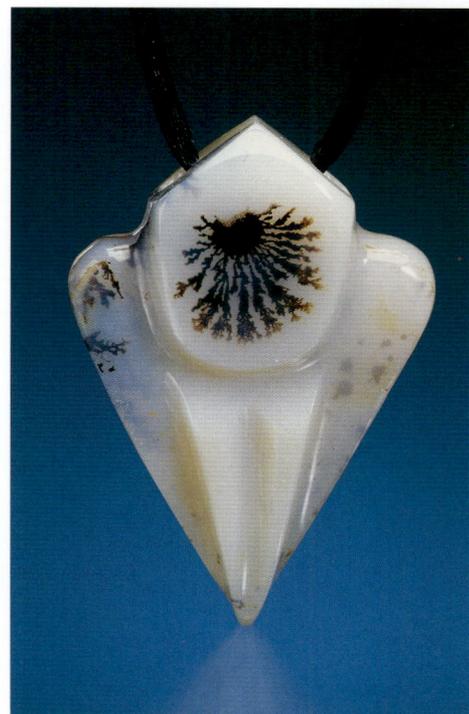

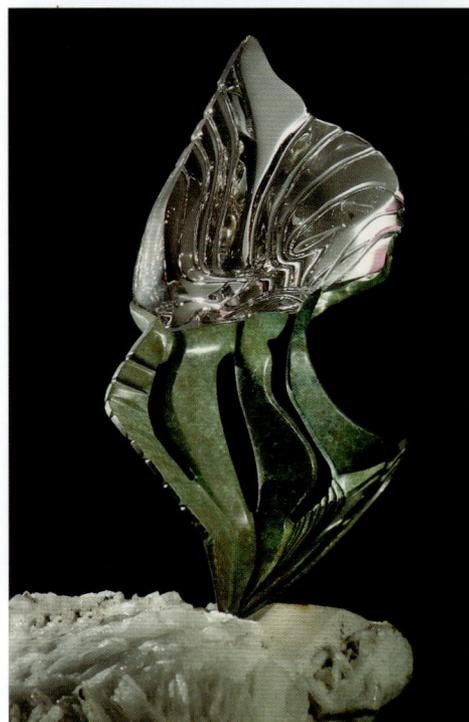

OPPOSITE: *Lunar Tide*, quartz sphere of natural river rock, 58″, Brazil. TOP: Pendant, dendritic agate, 2½″, Brazil. ABOVE: *Bird of Paradise*, electronic-grade quartz set on clevelandite base, 20″, Brazil

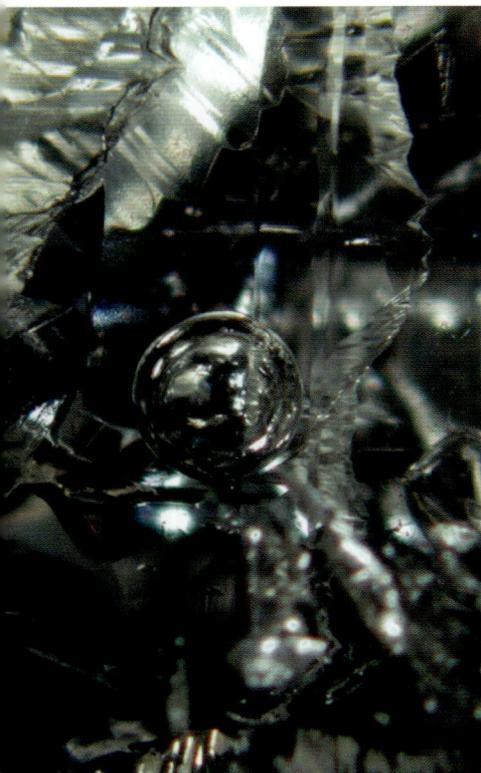

ABOVE: ENHYDRO (WATER BUBBLE) INCLUSION IN QUARTZ, MADAGASCAR. OPPOSITE: IRIS, NATURAL AMETHYST QUARTZ FLOWER, 25˝, BRAZIL

"Mind can see that reality is *evoluting* into weightless metaphysics."

— R. BUCKMINSTER FULLER, *SYNERGETICS*

of the ramifications of this decision.

I never thought a bath could be so invigorating. My head was swimming, my body tingling, not sure if I had just been dipped in ice or was getting into hot water. Sunni and I were soaking up to our necks, the phone was pressed to my ear; our eyes were probing one another with the unavoidable question written on our faces—are we really going to do this? Shouldn't we have a few days to think this through? I need to be grounded, sitting at my desk, feet on the floor, weighing the pros and cons before making such a significant decision. Instead, we were suspended in the moment. Maybe because gravity had less of a hold on us, we each heard the Sirens clearly calling, "Yes, we can do this." And with that, the crystal was ours. We toweled off, and a few days later, a 2200-pound crate showed up at our door.

Another time, my friend Rui Almeida, who regularly e-mails me pictures of crystals freshly unearthed in Brazil, sent me photos of two 900-kilo elestial crystals of the finest quality. Just as it happened, I was working with Roberto Salazar, an interior designer who needed two large, dark, smoky crystals for a home in Las Vegas. Just like that, crystals that had been sleeping for aeons 40 feet below ground in the mountains outside Govenador Valadares, Brazil, were headed to Las Vegas. Now that is a life change.

Every year in early February, people travel from all corners of the earth, bringing hard rocks and hard cash to the Arizona desert for the Tucson Gem and Mineral Show. The city becomes a magnetic convergence, a mineral mecca, an amalgamation of peoples and stones. One hears Mandarin, Hindi, French, "Aussie," German, Swahili, Spanish, Icelandic, and English, just to name a few. People are wearing denim, turbans, robes, suits, saris, high heels, tie-dye, chenille, and Nikes. Their skins run the color spectrum from ivory, beige, pink, and tan to mocha, cinnamon, chocolate, and ebony. They are miners, dealers, spiritual healers, rockhounds, newfounds, penny dolers, and high rollers. What they have in common is that they find minerals irresistible. Rocks are transported in bags, boxes, blankets, barrels, buckets, pockets, packs, tubs, trunks, and trucks. They come with rocks, and they leave with rocks; they come with money, and they leave with rocks, rocks of every shape, size, color, texture, classification, and combination. It all passes through Tucson.

A thousand years in the future, archaeologists might say: "Ancient tribes converged from distant lands (both terra firma and extraterrestrial), mineral merchants, collectors, and worshippers making the pilgrimage to sell, buy, barter, and trade authentic Earth minerals (along with meteorites limited to the local solar system). Evidence suggests that these gatherings were ritualistic celebrations initiated by the mineral kingdom for the purpose of illuminating these ancient humans. It should be noted, however, that at this time, prevailing human beliefs still professed the notion that minerals were inert clods of matter devoid of consciousness. Minerals in those days must have been very tolerant."

Crystals come out of their earthen slumber into the light, seeking those keepers who will care for them. They don't need feet: instead, they enlist us to move them around the planet, as if they are weights placed on a wheel, helping to rebalance the world.

THE SOUL RESIDES IN NATURE

Being in Nature puts me in touch with my soul. However we each describe and define the experience, being in Nature can be peaceful, awe inspiring, calming, joyous, expansive, or transformative.

I believe the soul resides in Nature.

Looking through the transparent window of a quartz crystal immediately transports me into a pristine sanctuary that has been untouched for millions of years. Within the stone is an impeccably preserved artifact of creation, documenting the evolution of our planet, frozen in time. Or is it frozen time itself? Created millions of years ago and virtually unchanged, abstract combinations of crystallized mineral formations conspired to congeal into masterpieces of texture and light.

Traversing the gemscapes of a large transparent crystal requires only your eyes to submerge below the surface. The crystal appears bigger as you go inside. An internal terrain of shapes, textures, and mineralized formations has laid itself down for an eternity; the silence within is palpable. The mind wants to understand what you are looking at, but without accessible answers, the brain downshifts to imagination, as you joyride through shimmering gateways inside of the crystal's transparent majesty. There you witness luminance exposing the interior of solid matter.

It is mind-boggling to think that you are peering into matter so dense that it is harder than steel. And yet because of the crystal's transparency, the eye can grasp a virtual Jurassic Park of prehistory, preserved for all to see. A single moment contains the imprint of all time. Each crystal is its own museum that requires only appreciation as its entrance fee.

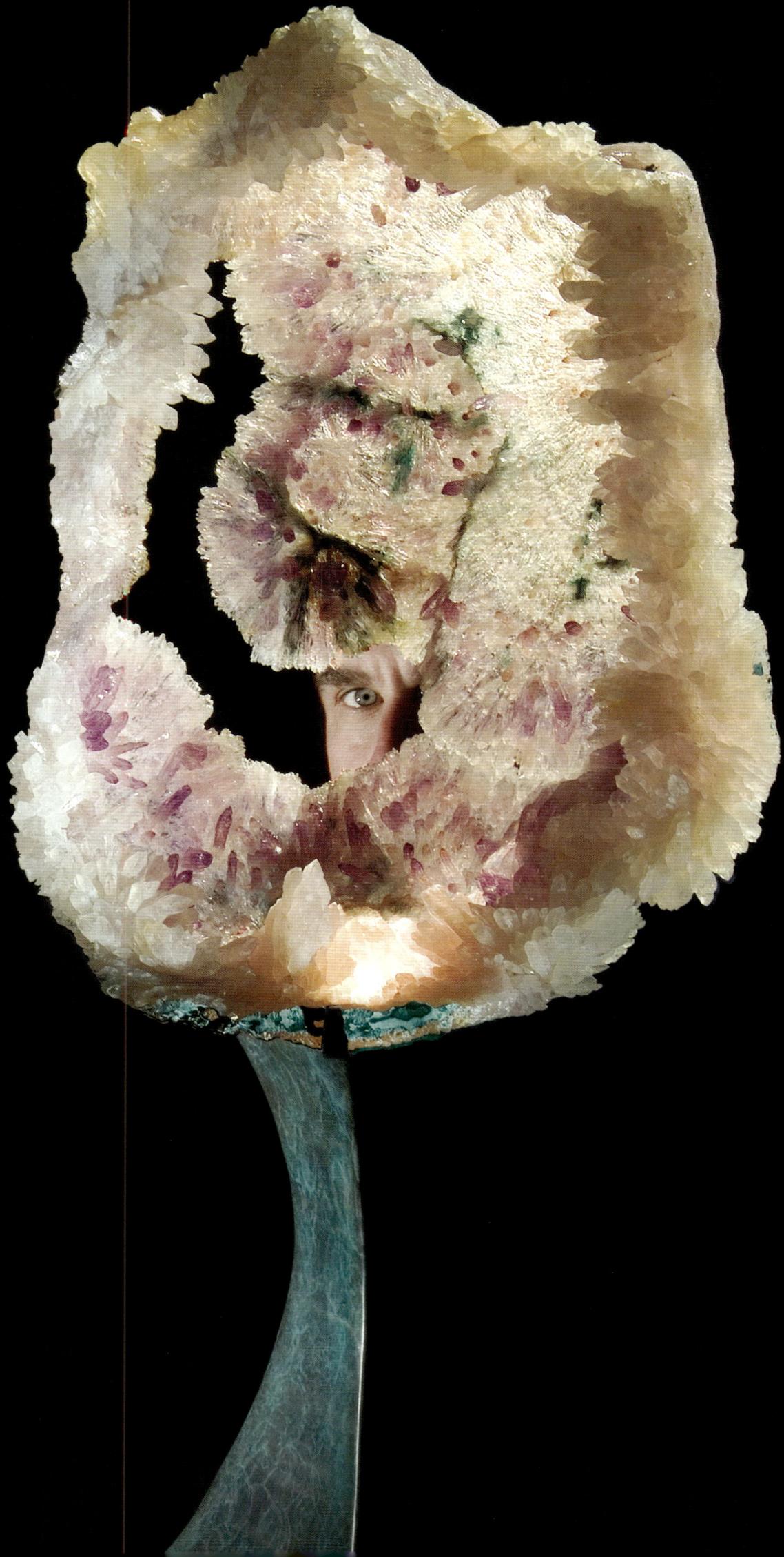

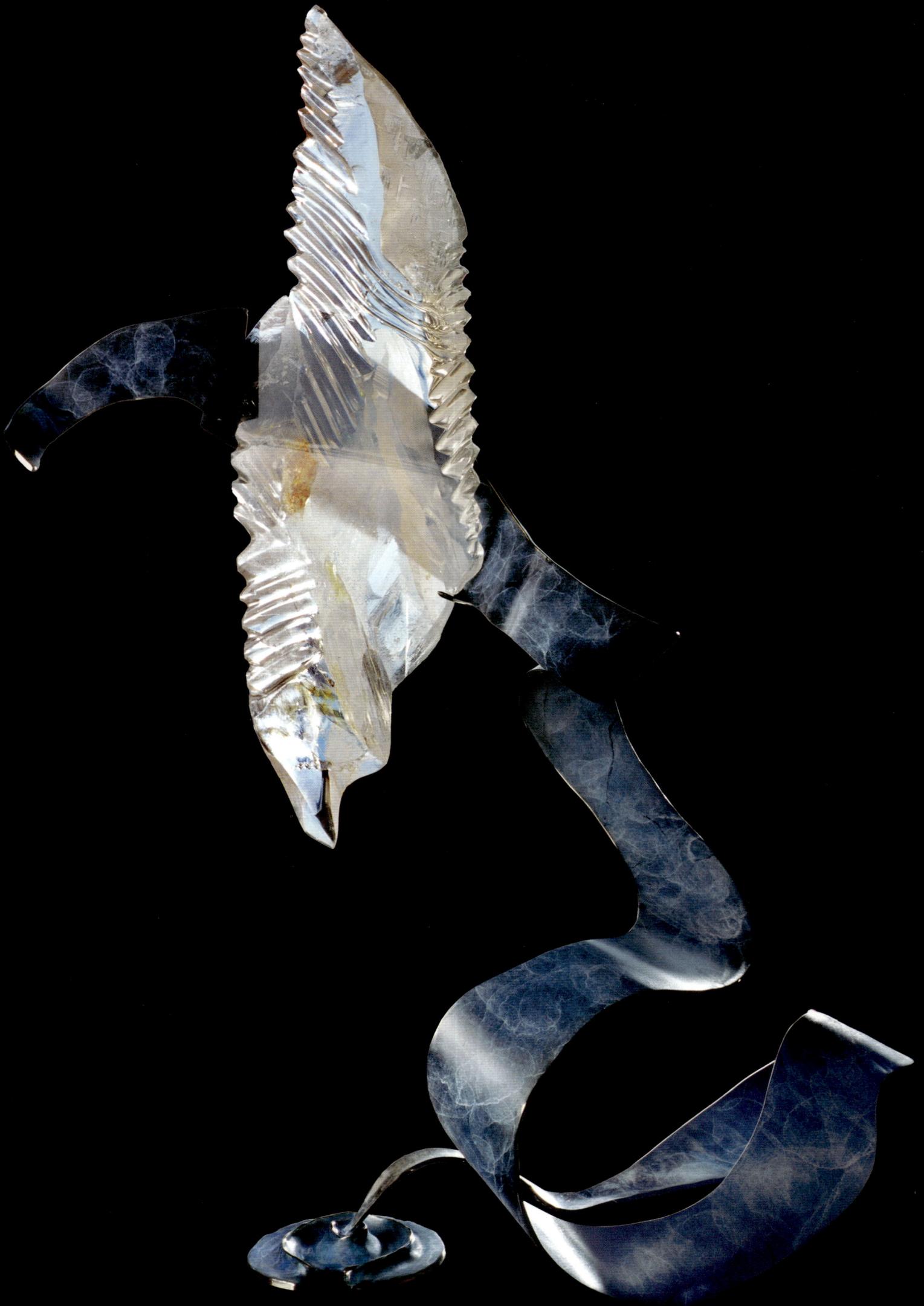

EVOLUTING

To investigate theories of evolution, creation, and the nature of reality is illuminating.

To wonder, challenge, reassess, upgrade, and change my own beliefs is freeing.

Observation: crystals may be the first (silica-based) entities to inhabit Earth —

Inseminated, incubated, gestated, born, and grown.

A concentrated mass of silica, fertilized with a supersaturated sperm

of oxygen and assorted molecules,

tempered in the furnace of a subterranean womb.

Cultivated in a nurturing environment,

they congealed from gravitational forces, and the exotic forces of electrical attraction,

accessing the dimension of time to gestate and grow.

Crystals symbolize the eternal on Earth.

Before the first crystalline structures grew,

Time can only be imagined in the broadest brushstrokes,

using universal and galactic increments.

With the formation of crystals comes the concept of measuring change on Earth

by the growth of this primordial life form.

Why did they manifest in the skin of our freshly formed planet?

An evolutionary quantum leap,

a departure from the random volcanic gurgitations

that the formative planet belched forth during its genesis.

Crystals grow with a sophisticated lattice that bares the DNA of a divine intelligence.

Crystallized minerals are manifest geometric forms,

an organized structure of matter in the paradigm of a fractal universe.

They form from a complex design, both repeatable and predictable,

yet each one possesses individual characteristics.

Before there were eyes to see,

their transparent crystalline bodies became vessels

holding vibrant concentrations of primal, eternal color.

The intelligence that fashioned these minerals used them as starter batter,

blueprints for a continuum of evolution.

And after millions of years of stillness,

these aboriginal crystal inhabitants were joined by evolving plants and trees,

to share terra firma with carbon-based (organic) life forms,

who in turn are composed of organic, mineral-based compounds:

one life form begetting a new cycle of life.

OPPOSITE: *BETWEEN HEAVEN & EARTH*, CARVED QUARTZ, 29", RUSSIA

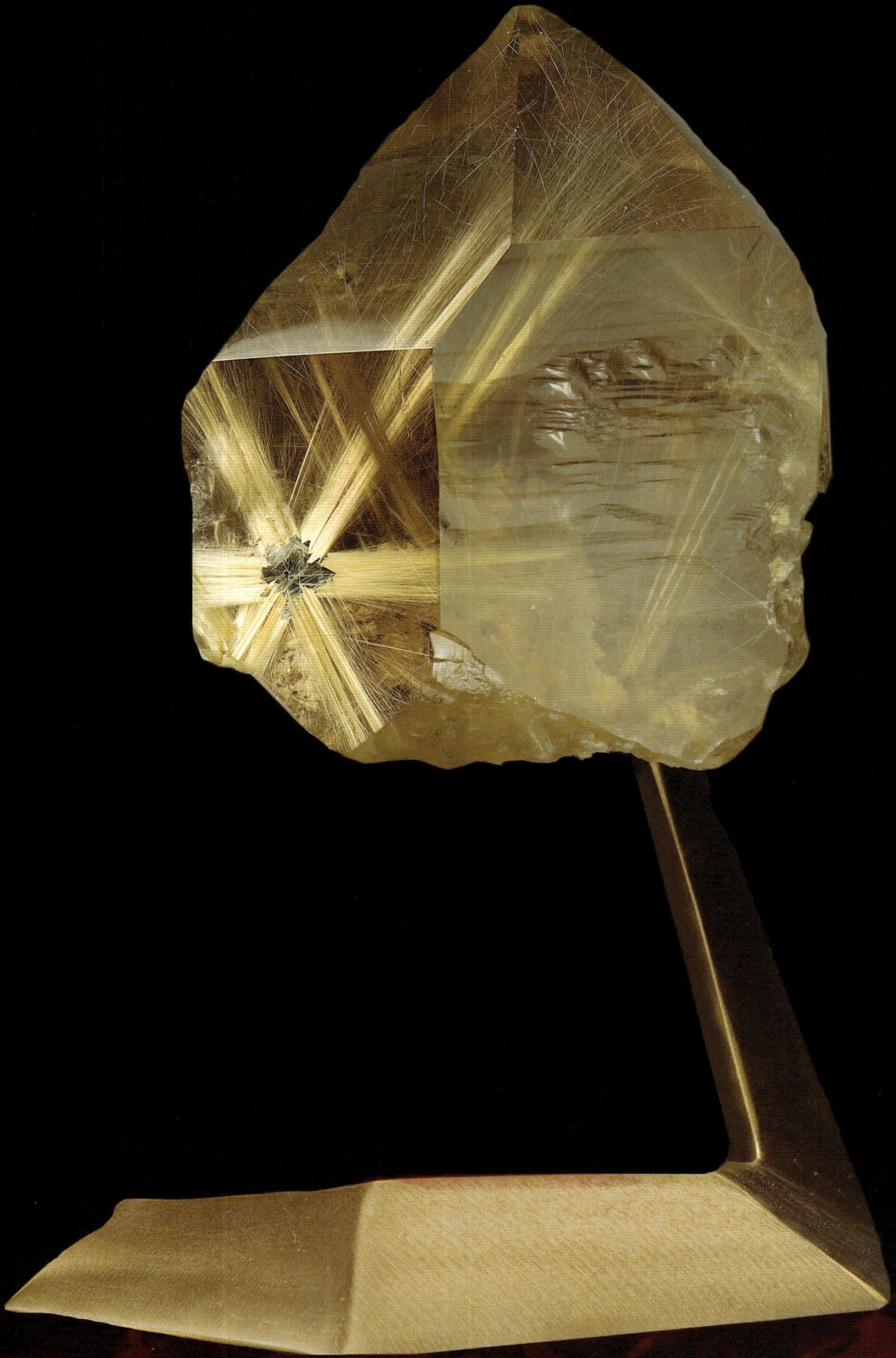

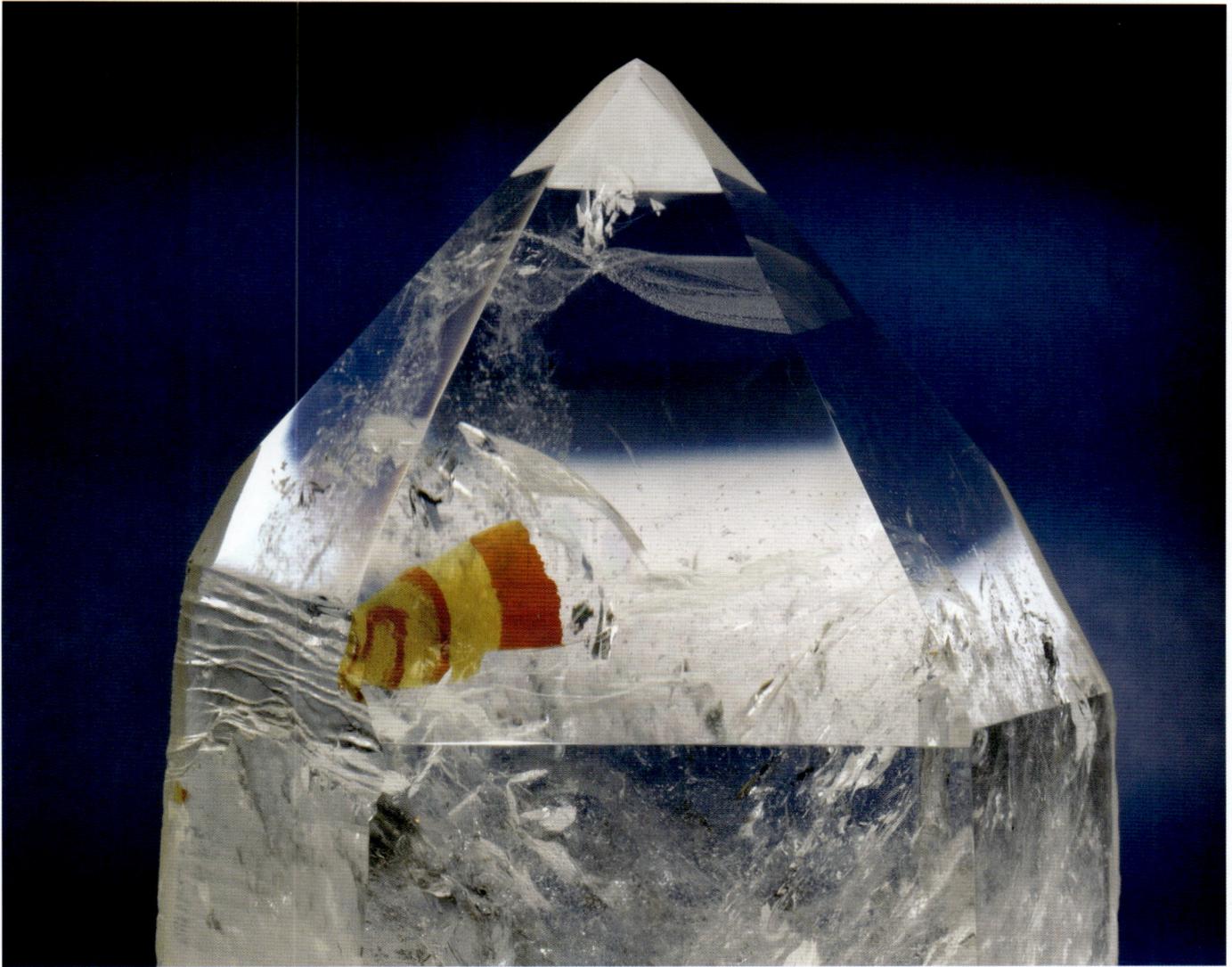

OPPOSITE: *Star Bright*, STAR RUTILE QUARTZ, 10", BRAZIL
ABOVE: *Tropical Fish*, IRON INCLUSION IN QUARTZ, 8", ZAMBIA

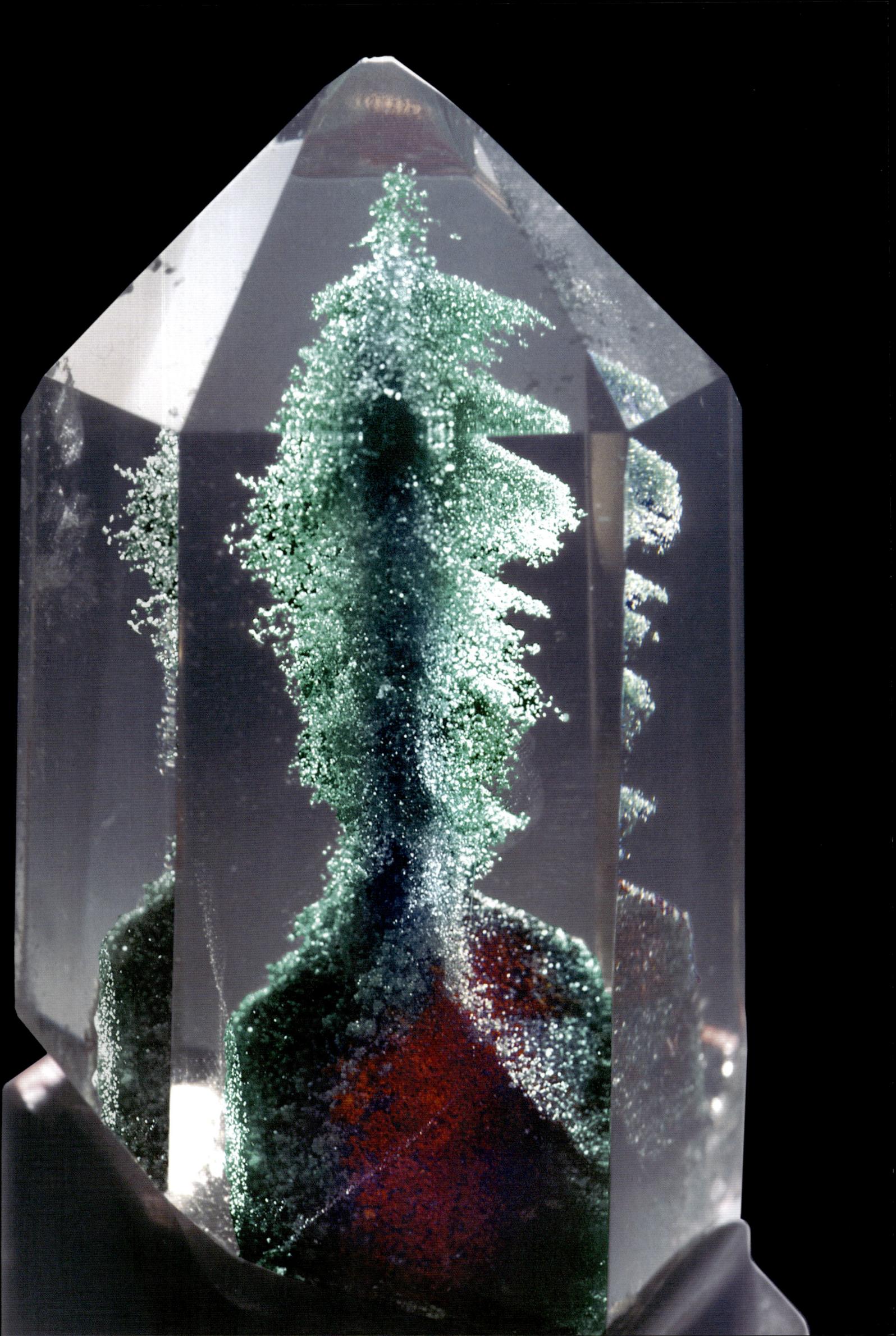

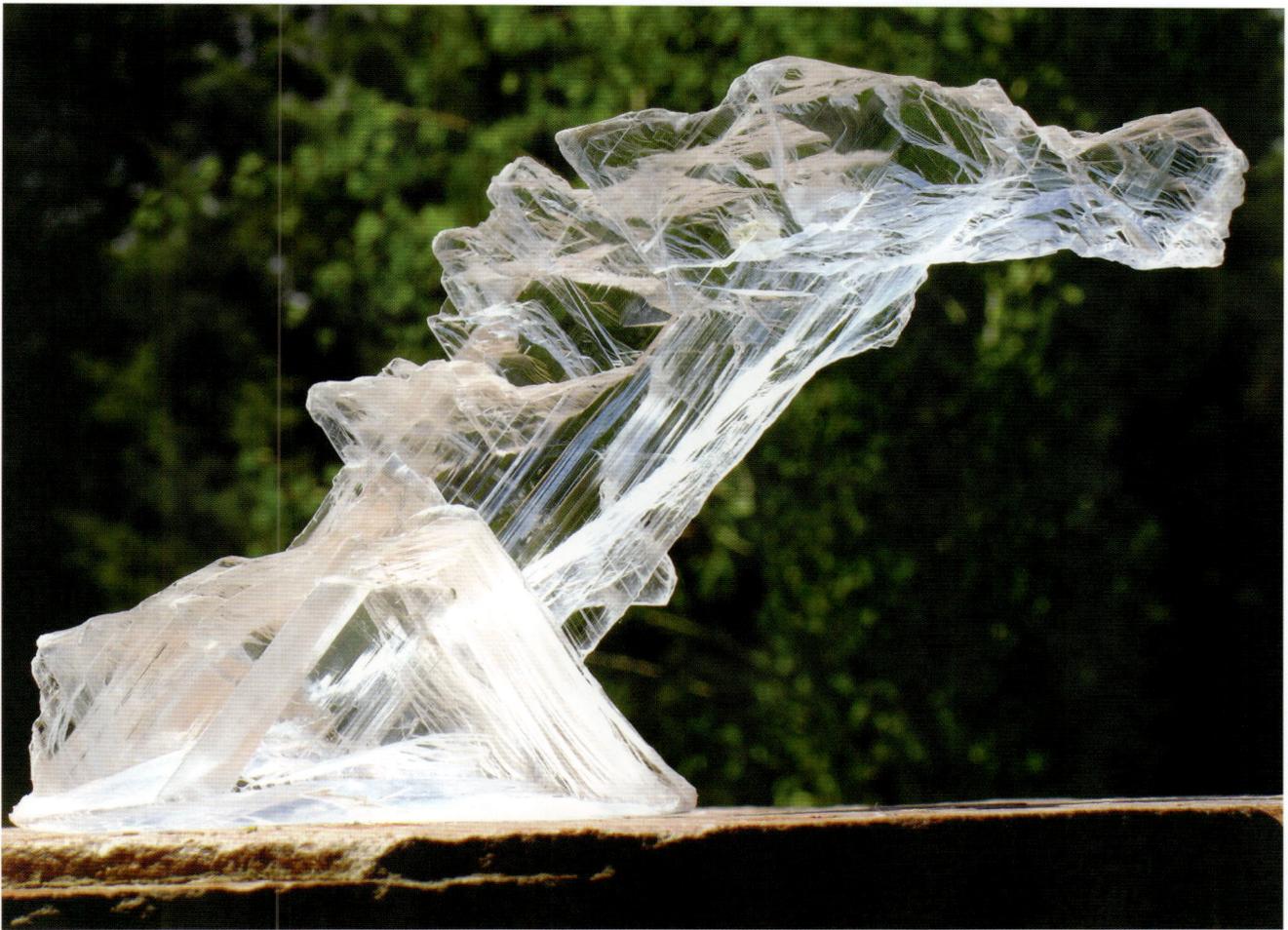

OPPOSITE: *Old Growth*, CHLORITE PHANTOM IN QUARTZ, 4″, BRAZIL
ABOVE: *Calcite Horse*, NATURAL CALCITE CRYSTAL, 5″, BRAZIL

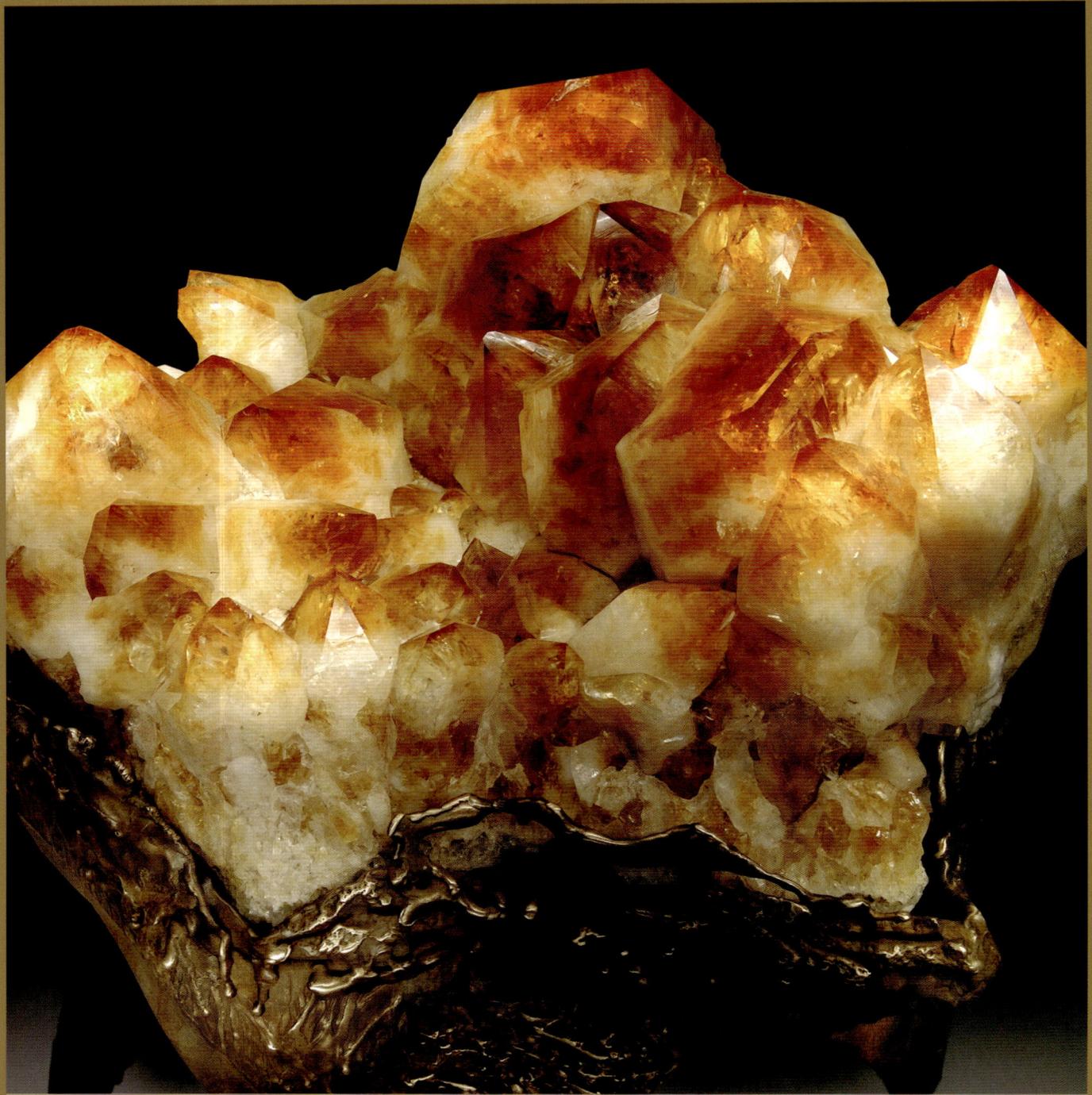

ABOVE: *Cup of Gold*, CITRINE GEODE, 44 LBS., BRAZIL
OPPOSITE: *Lioness*, CITRINE QUARTZ, 24″, BRAZIL

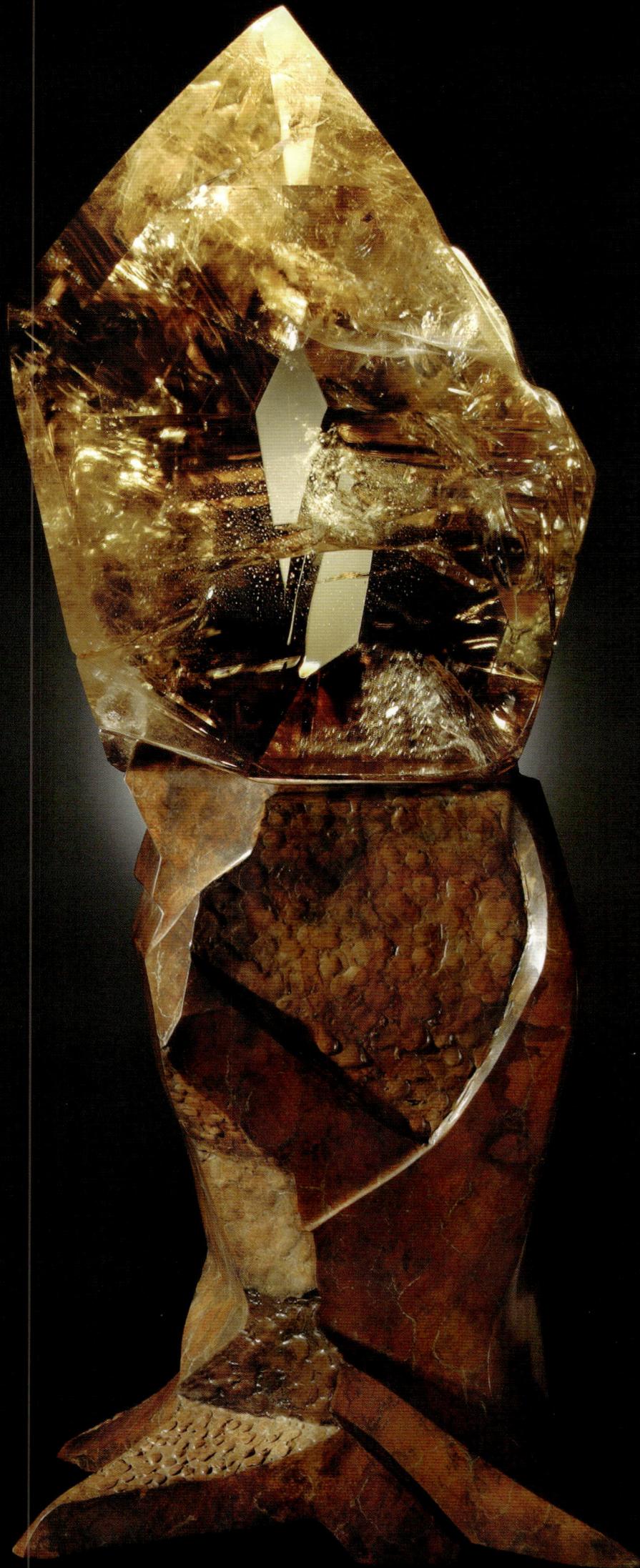

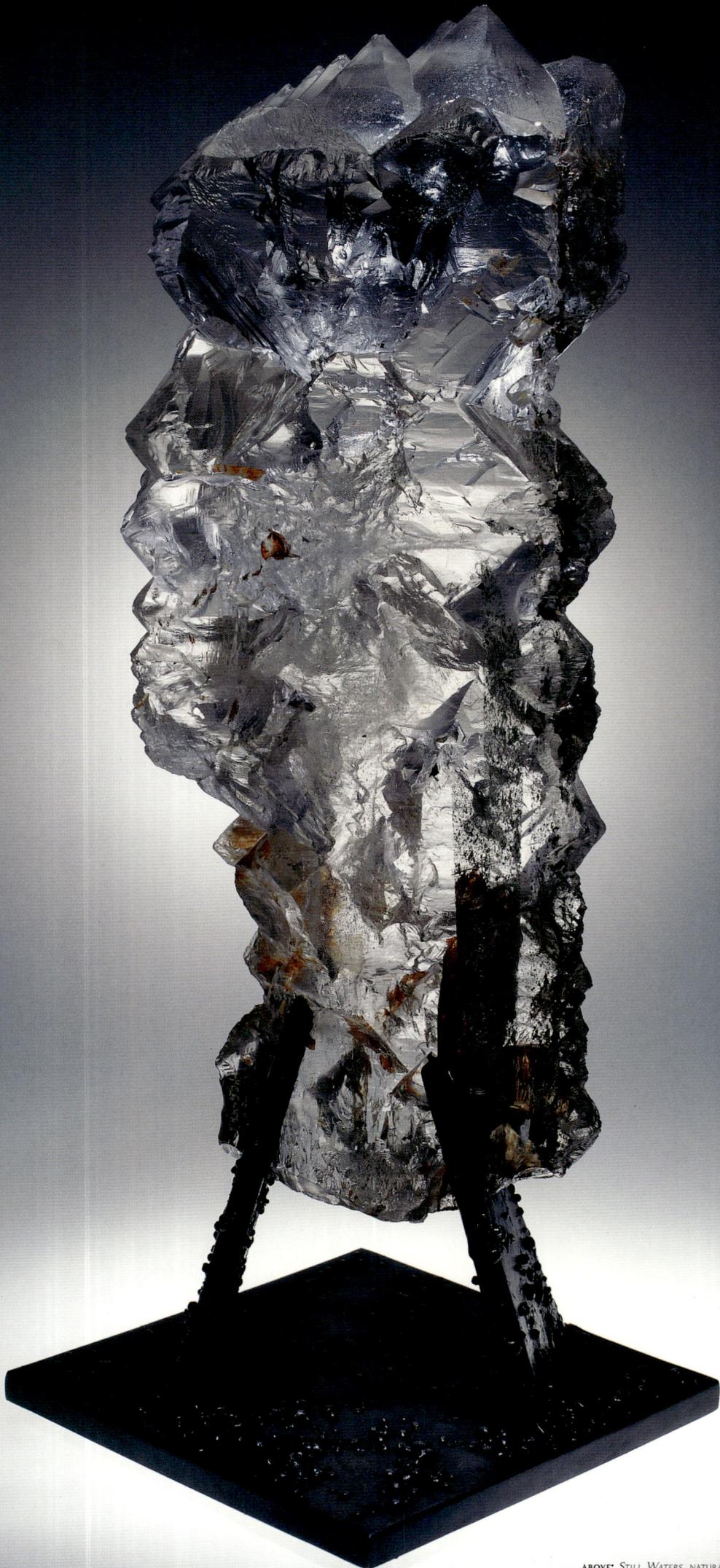

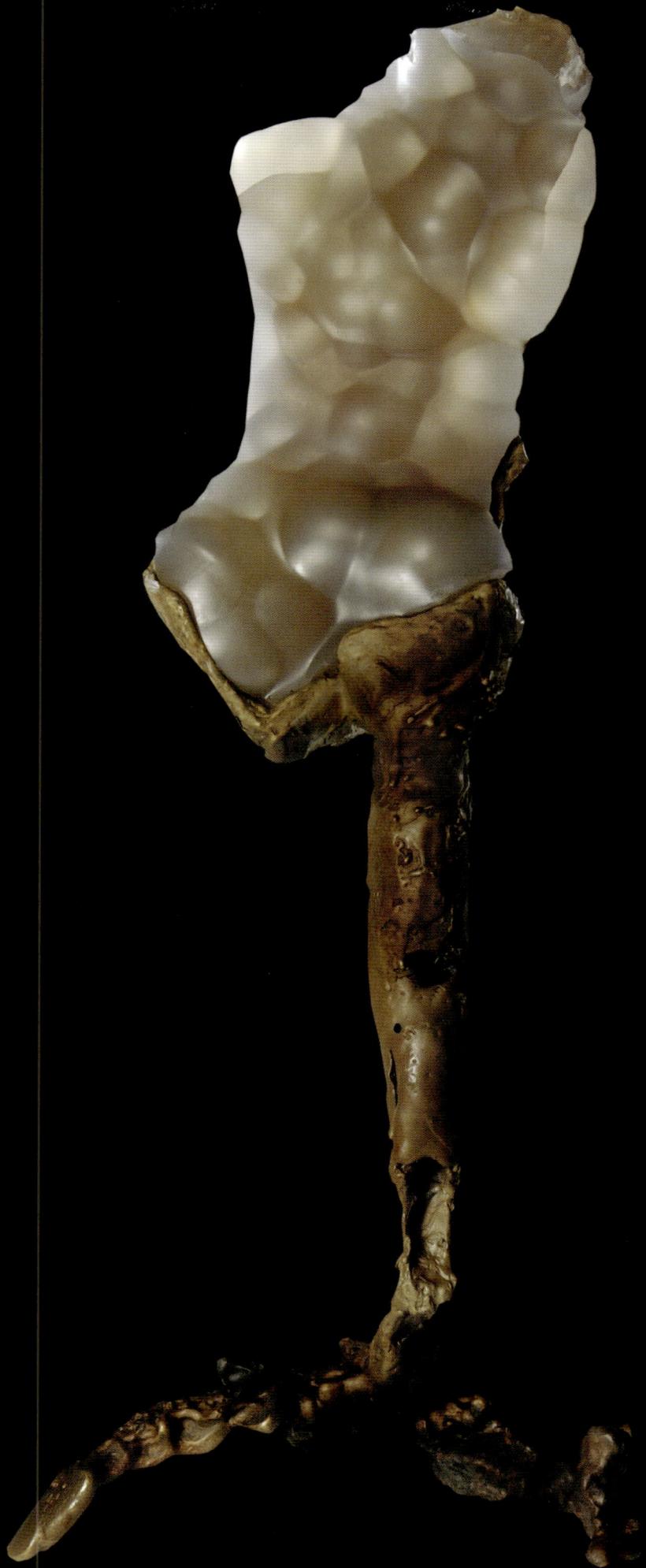

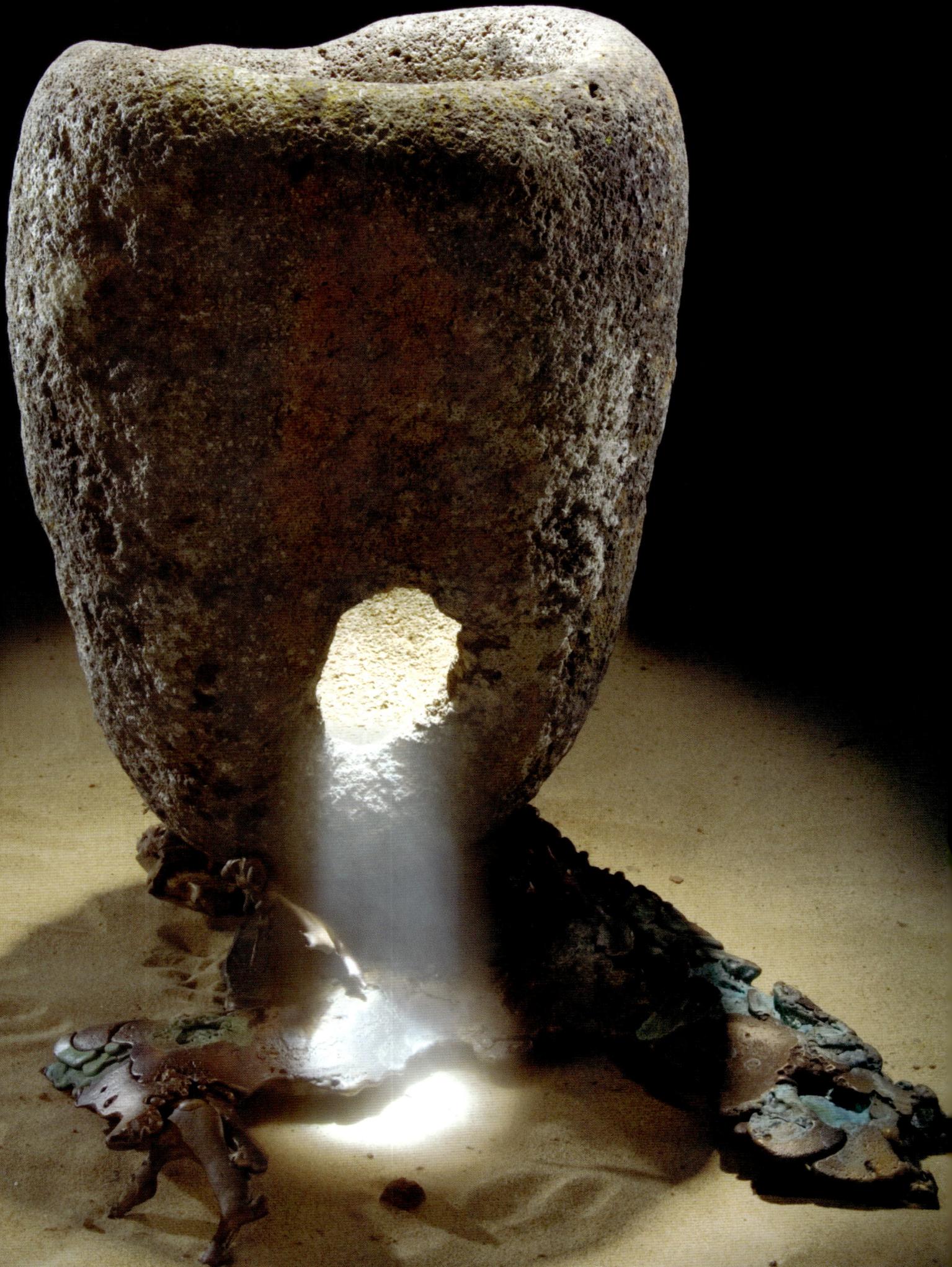

ABOVE: Umpqua Indian hand-carved basalt bowl on bronze, 22″, Oregon
OPPOSITE: *Man and the Moon*, citrine quartz held by
natural copper crystal, 9″ Brazil

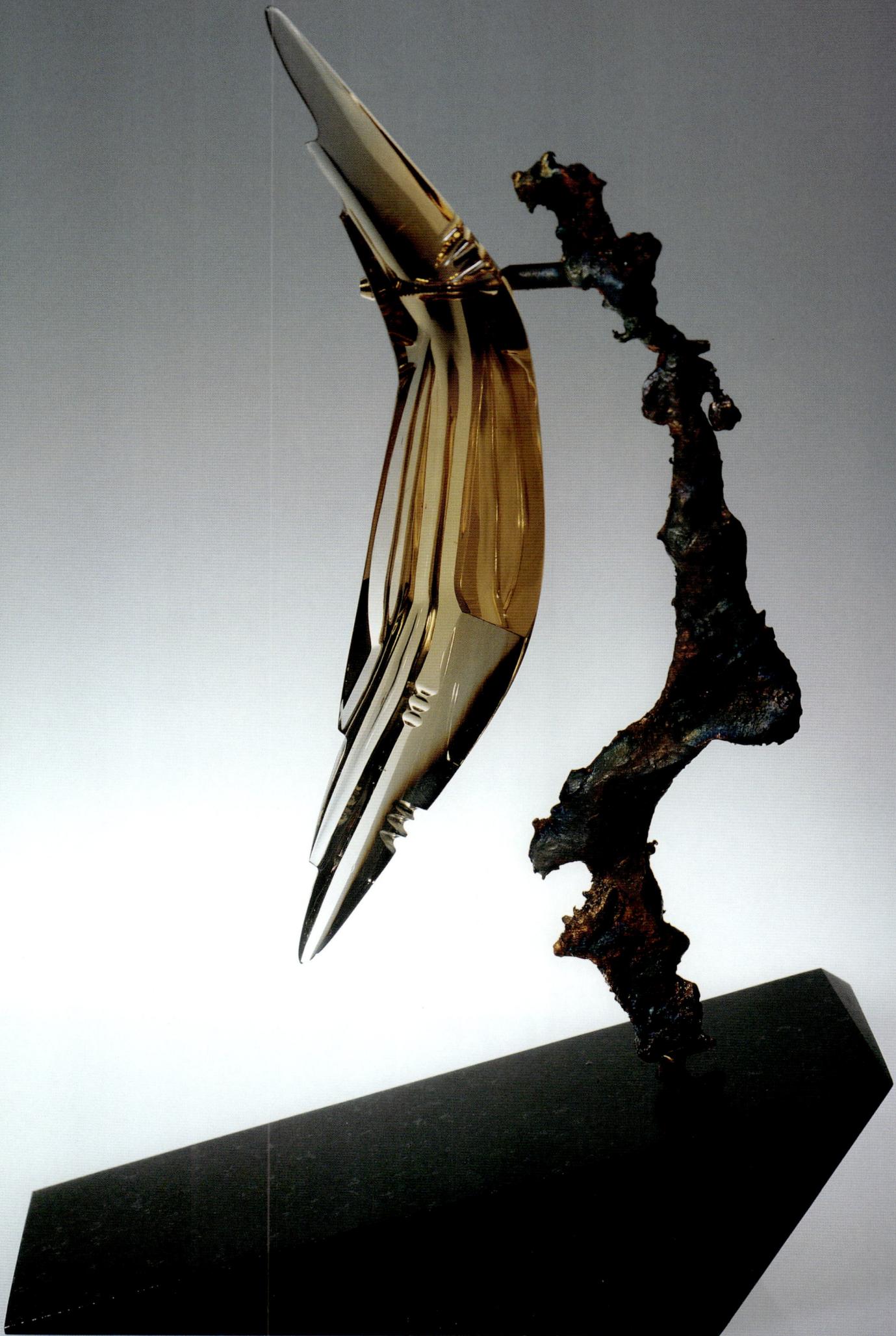

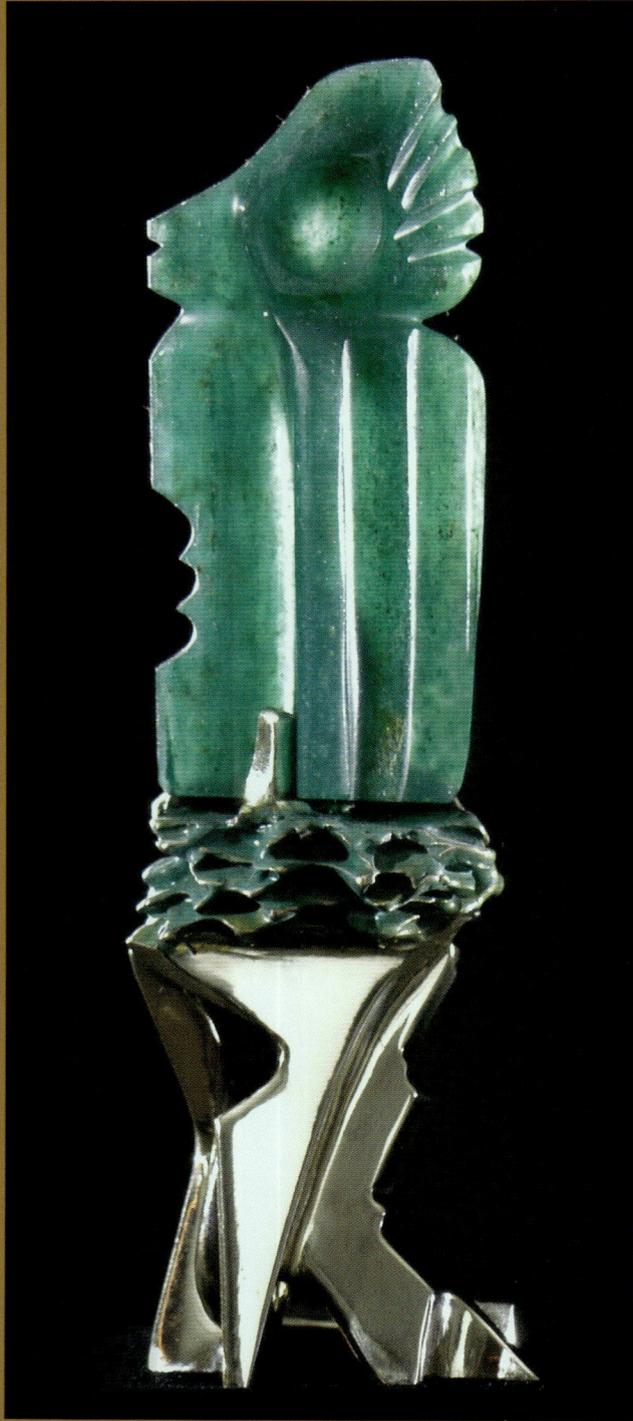

ABOVE: *Forest Spirit*, AVENTURINE, 8″, BRAZIL. OPPOSITE: *Harlequin*, AMETHYST AND CITRINE, BASE OF GOLD-PLATED BRONZE ON OBSIDIAN, 7″, BRAZIL

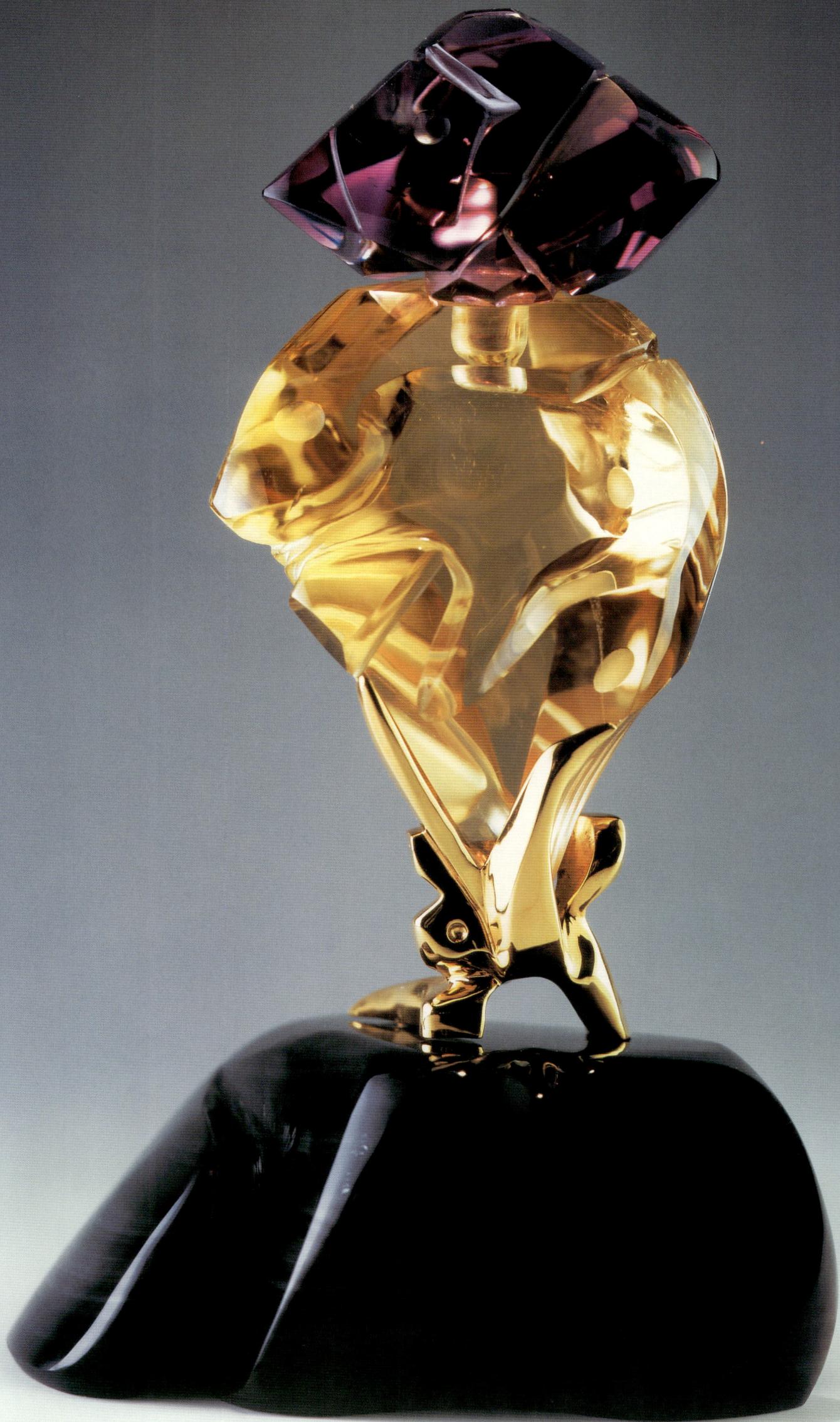

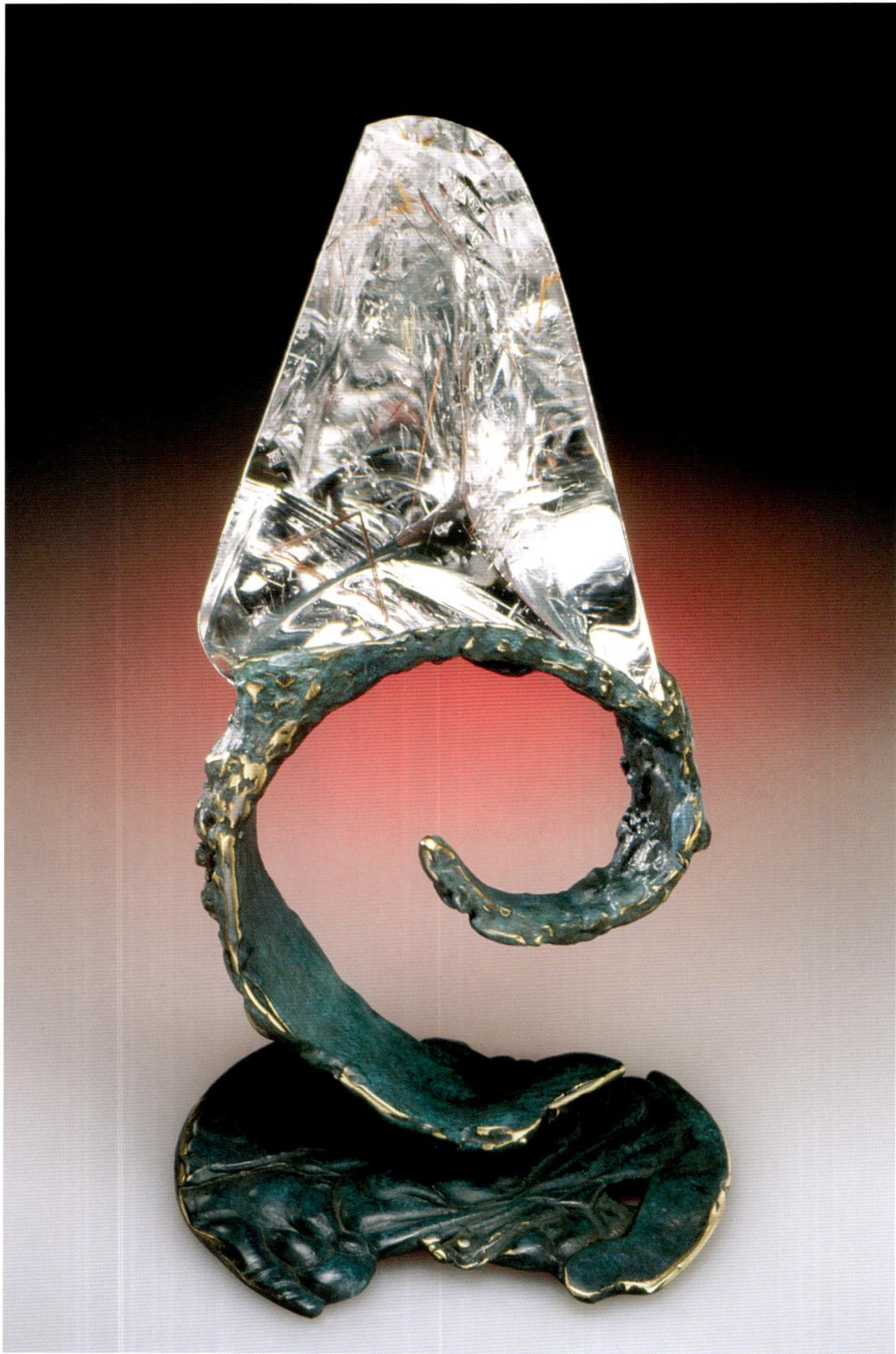

ABOVE: *SAIL-A-WAVE*, RED RUTILE IN QUARTZ, 12″, MADAGASCAR
OPPOSITE: *LADY OF THE LAKE*, AMETHYST GEODE, 22″, BRAZIL

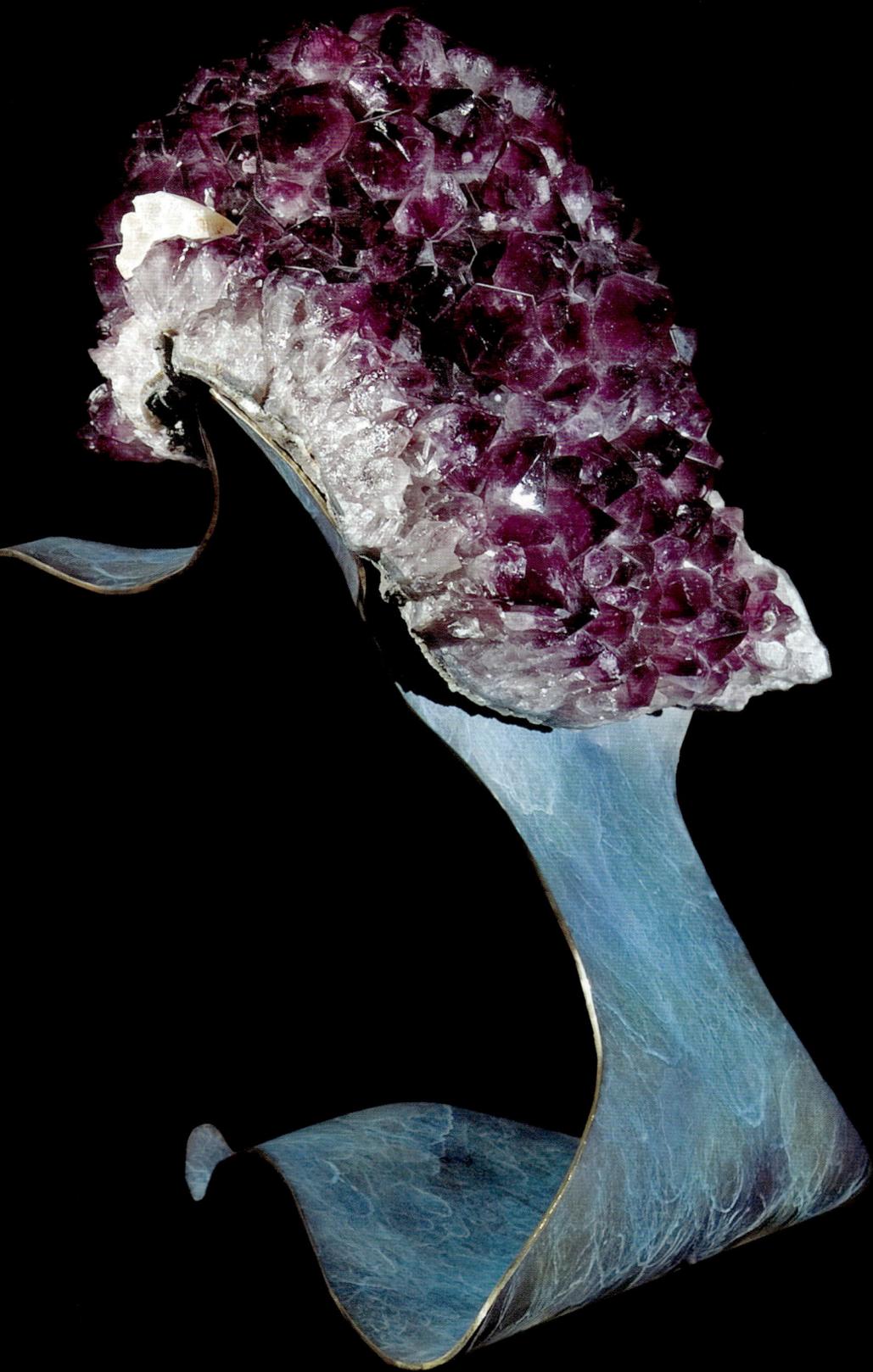

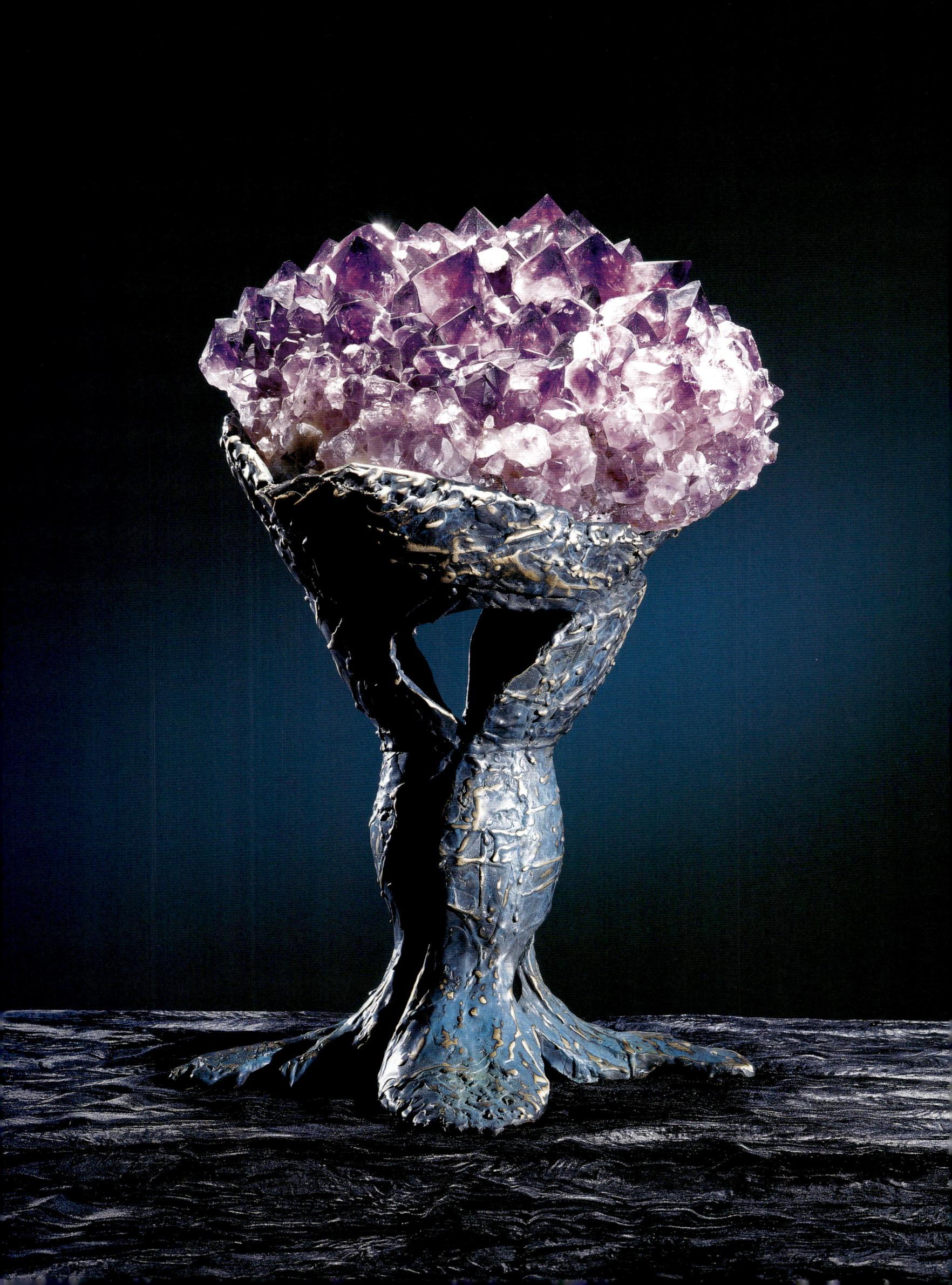

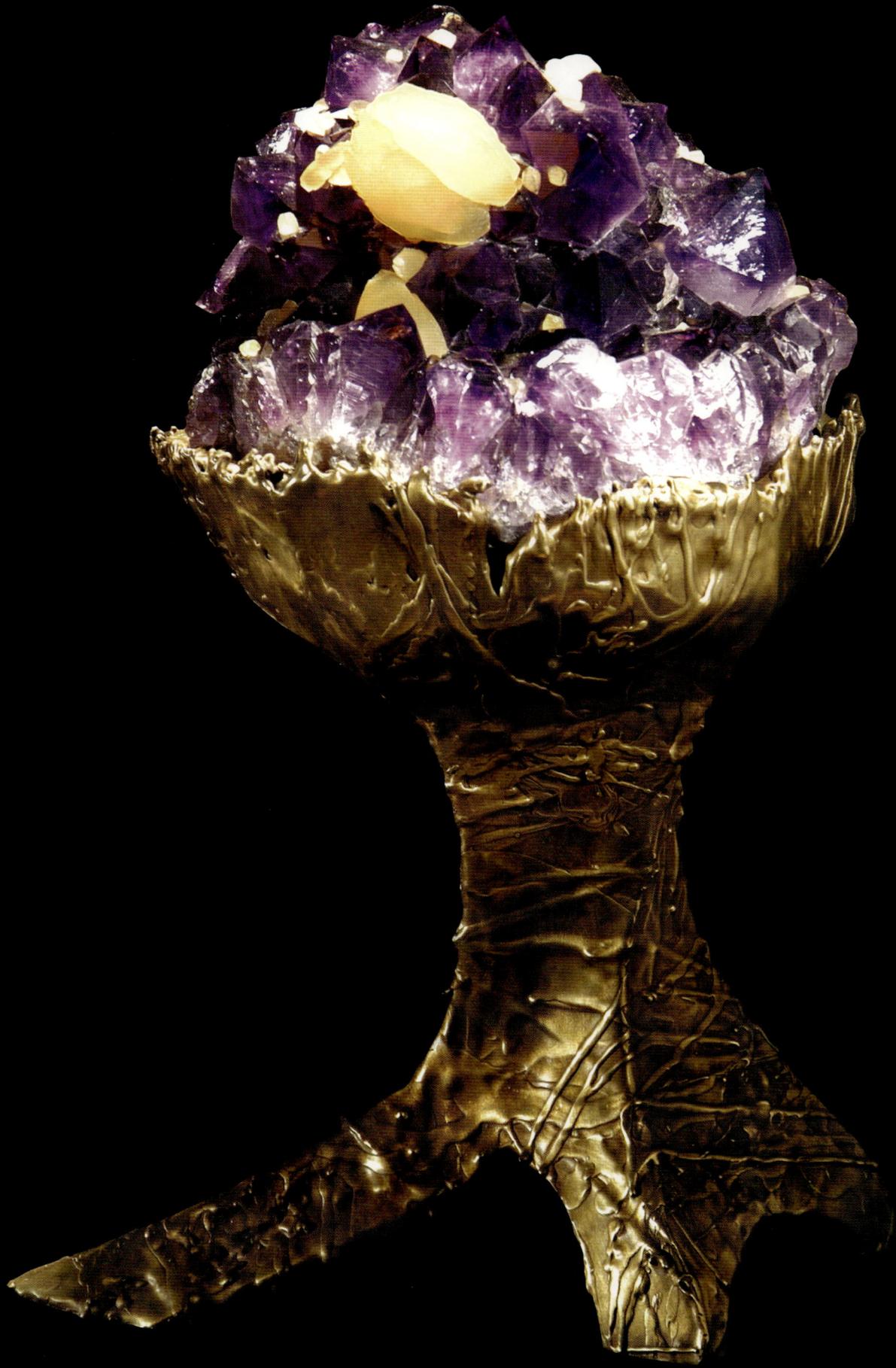

OPPOSITE: *Fruit of the Vine*, AMETHYST CLUSTER, 34 LBS., BRAZIL
ABOVE: *Nectar of the Gods*, AMETHYST CLUSTER WITH CALCITE, 19″, URUGUAY

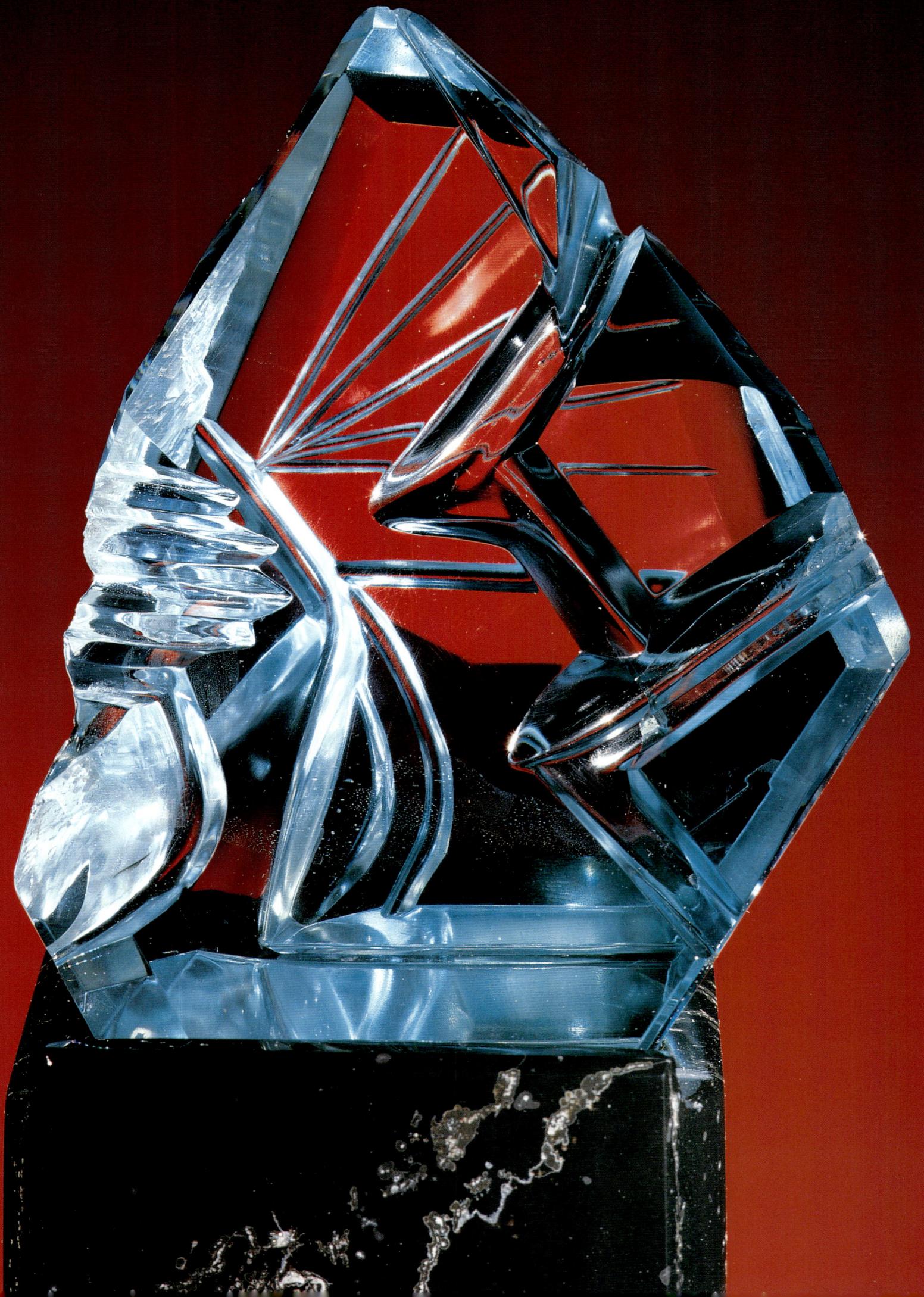

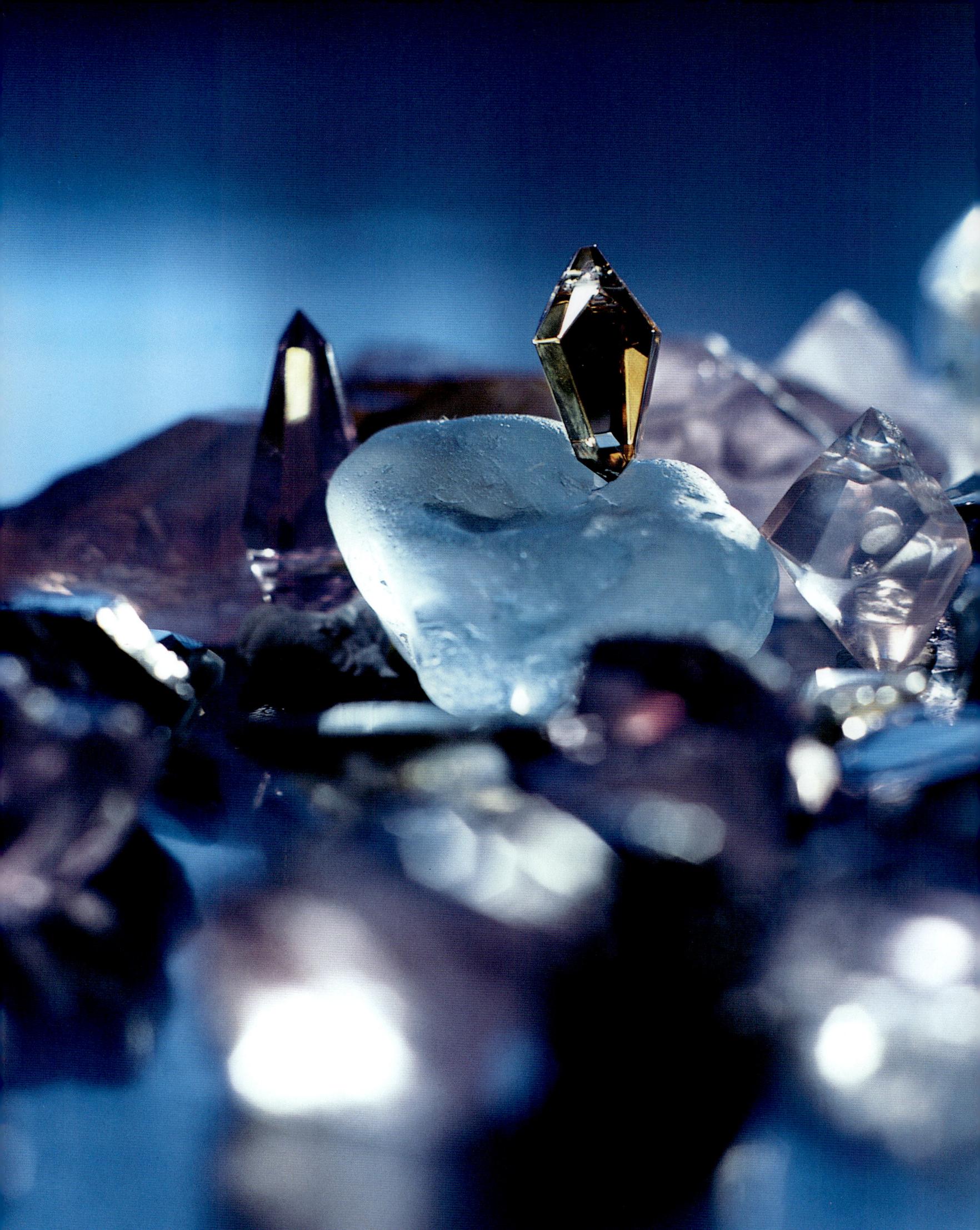

OPPOSITE: *Rhythm In Blues*, TOPAZ ON BASALT, 525 GRAMS, BRAZIL
ABOVE: NATURAL AND CUT GEMS, 1" TO 3"

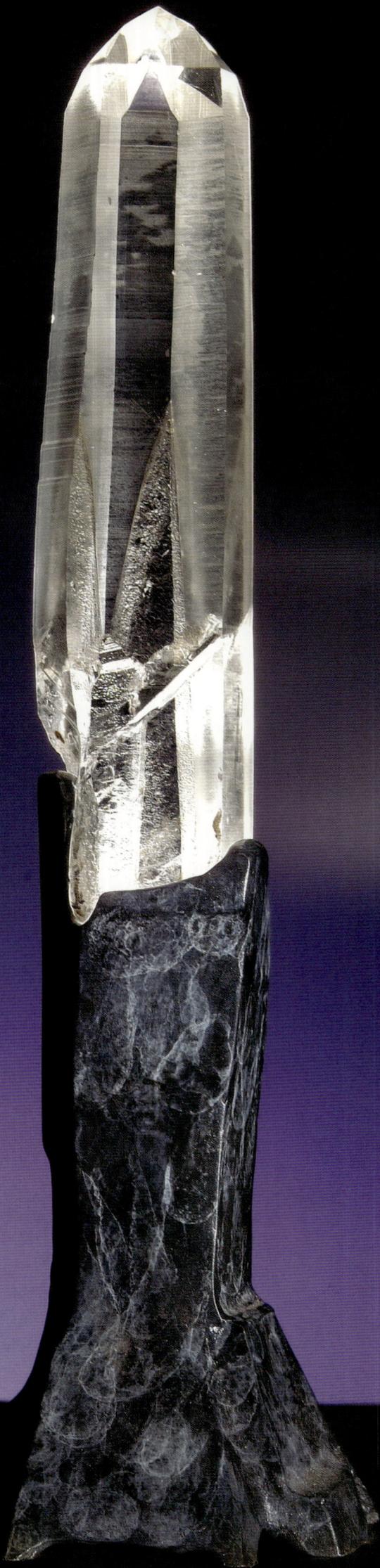

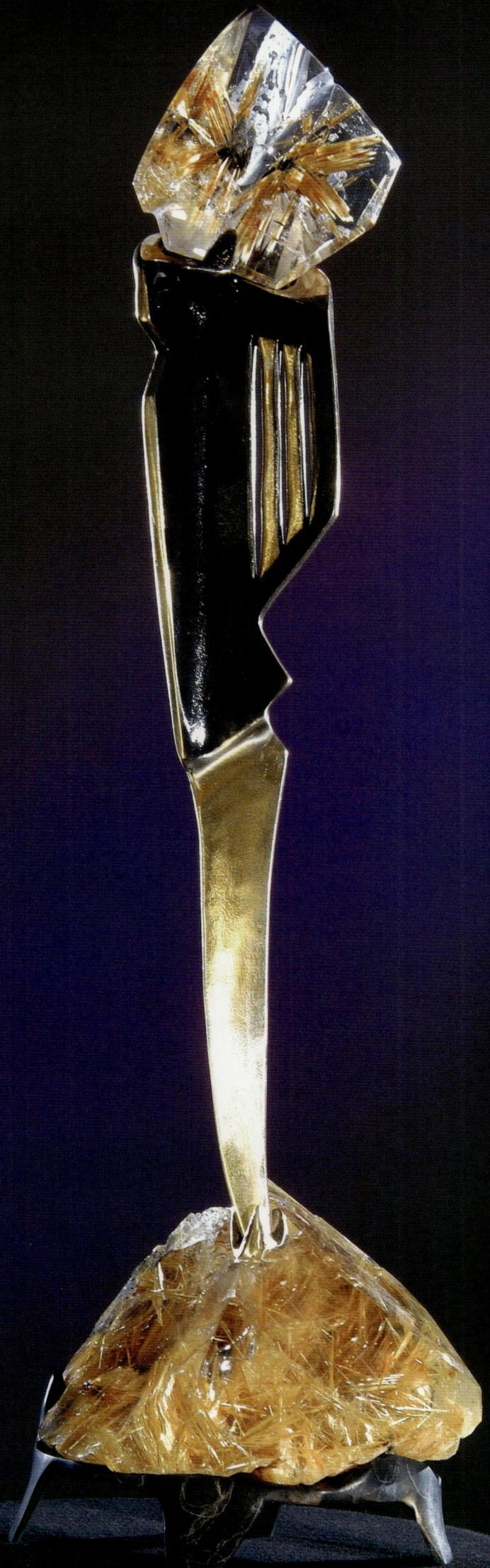

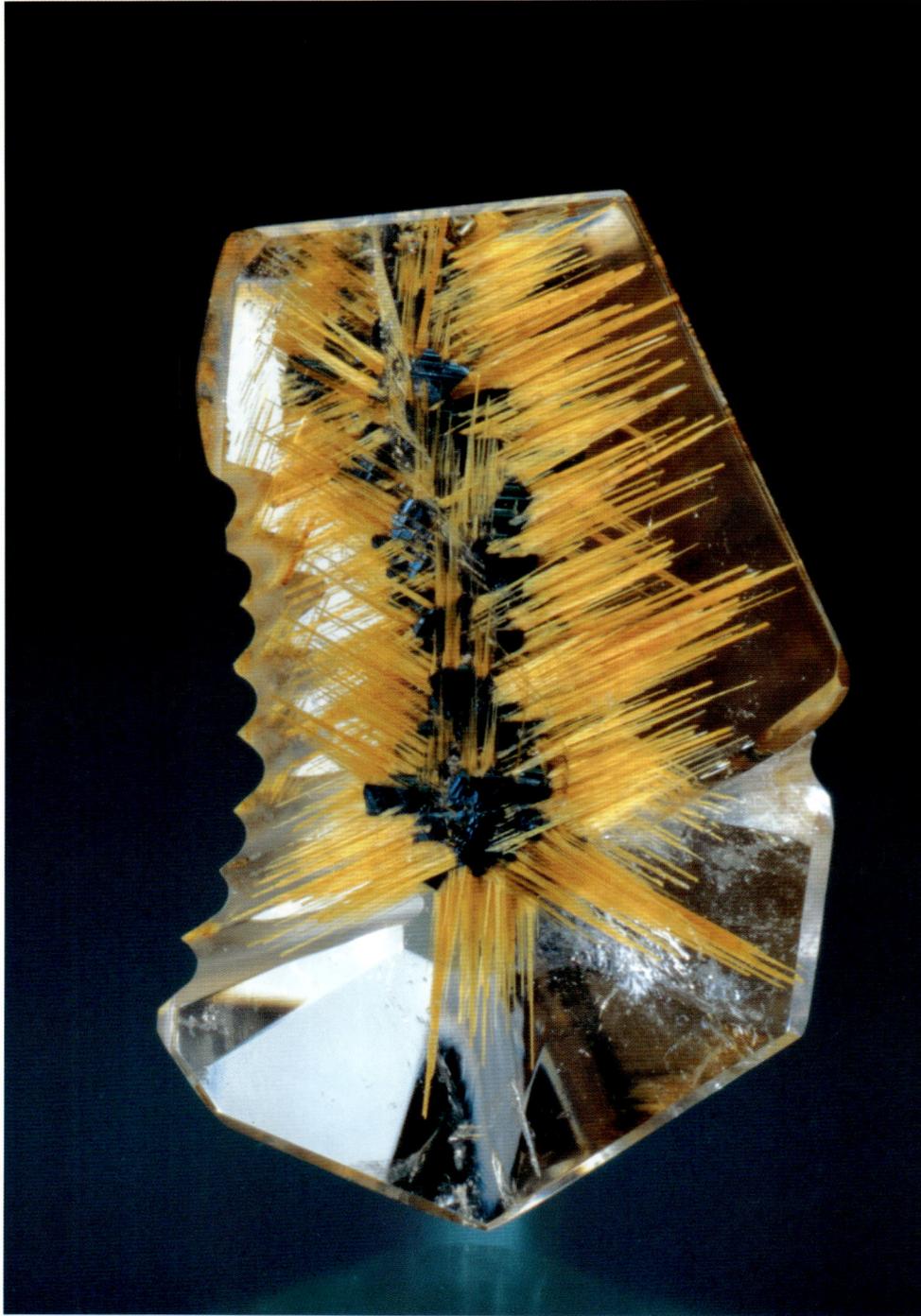

ABOVE: *SHOOTING STAR*, RUTILE STARS FORMED FROM HEMATITE IN QUARTZ, 3″, BRAZIL
OPPOSITE: *FLAME OF HOPE*, QUARTZ WITH RED RUTILE ON BLACK MARBLE BASE, 20″, MADAGASCAR

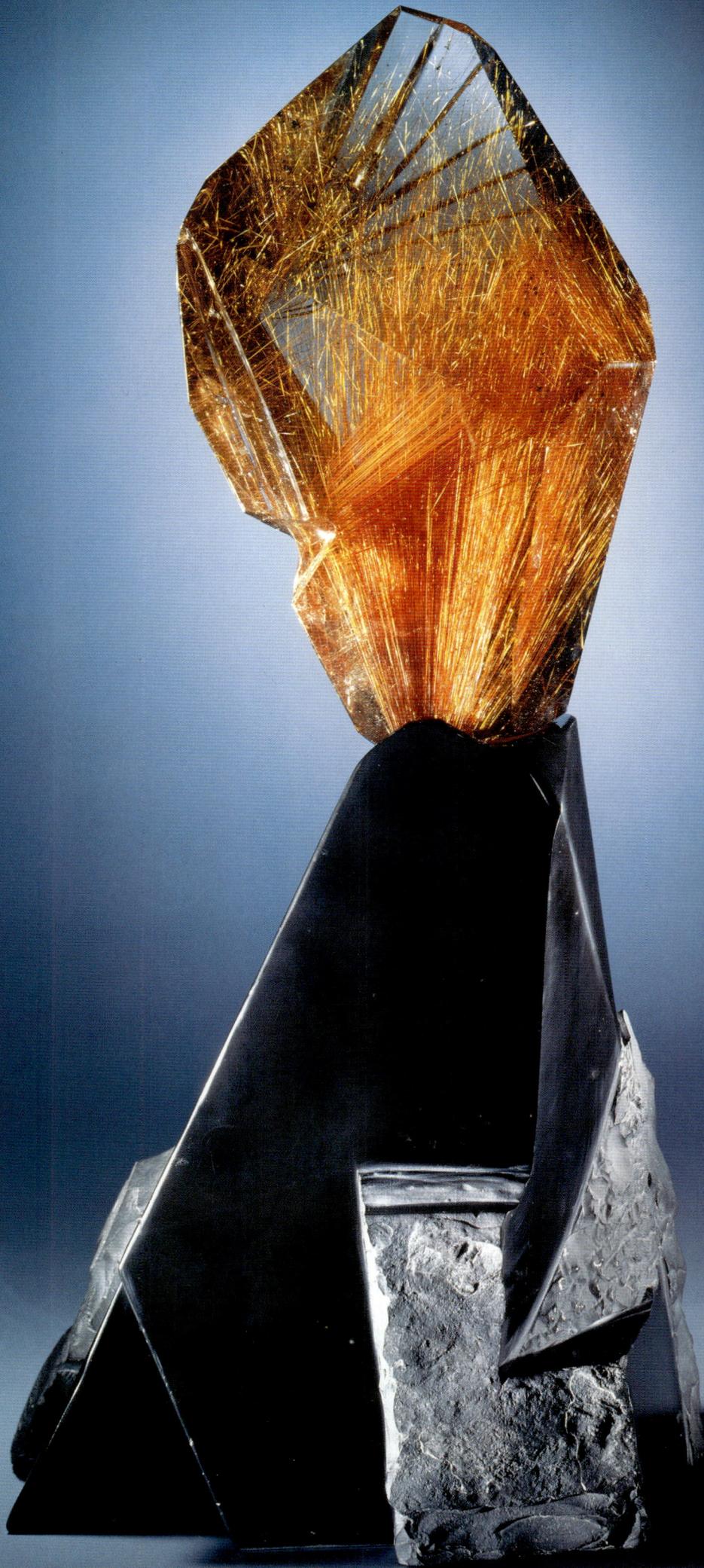

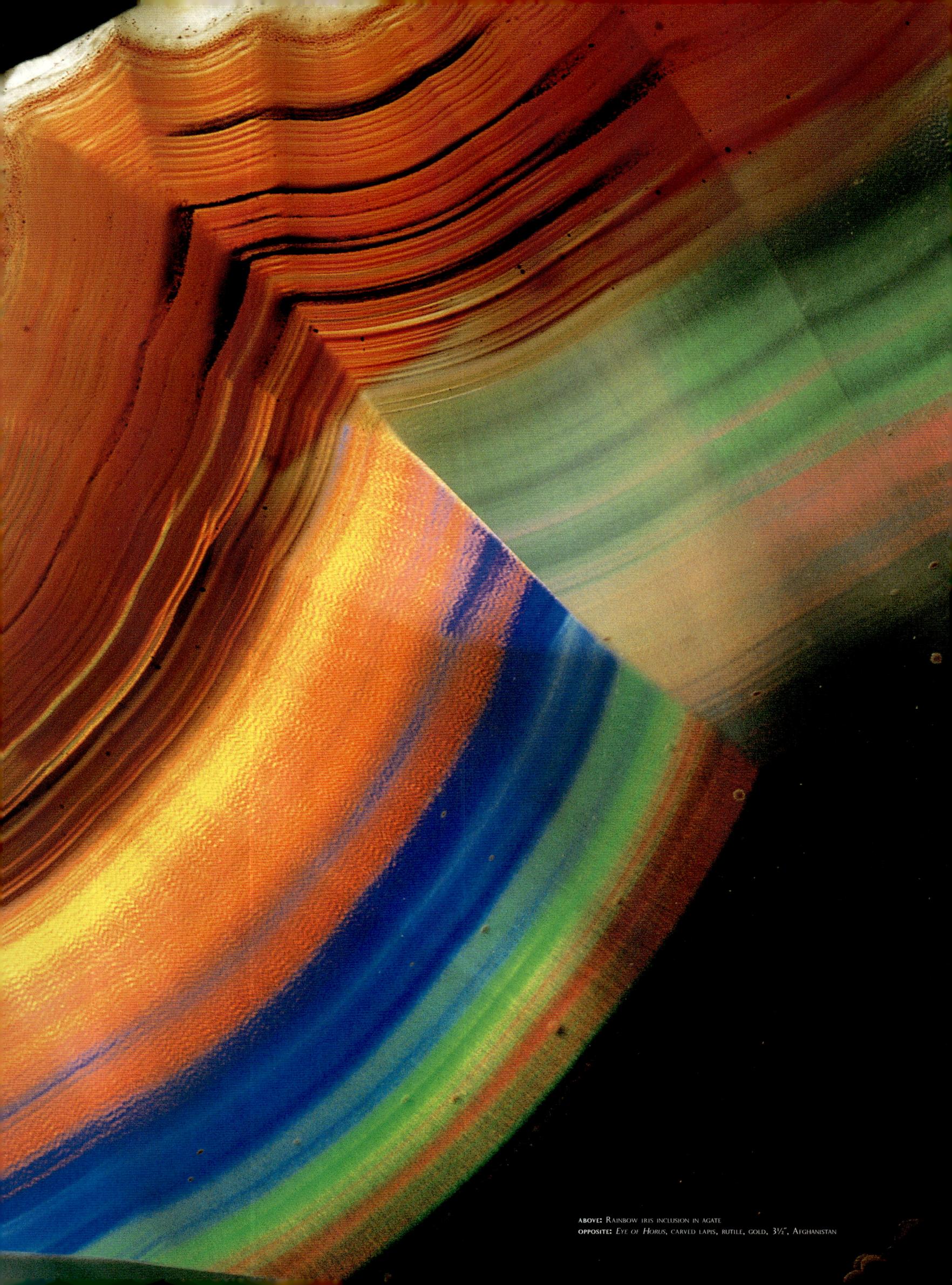

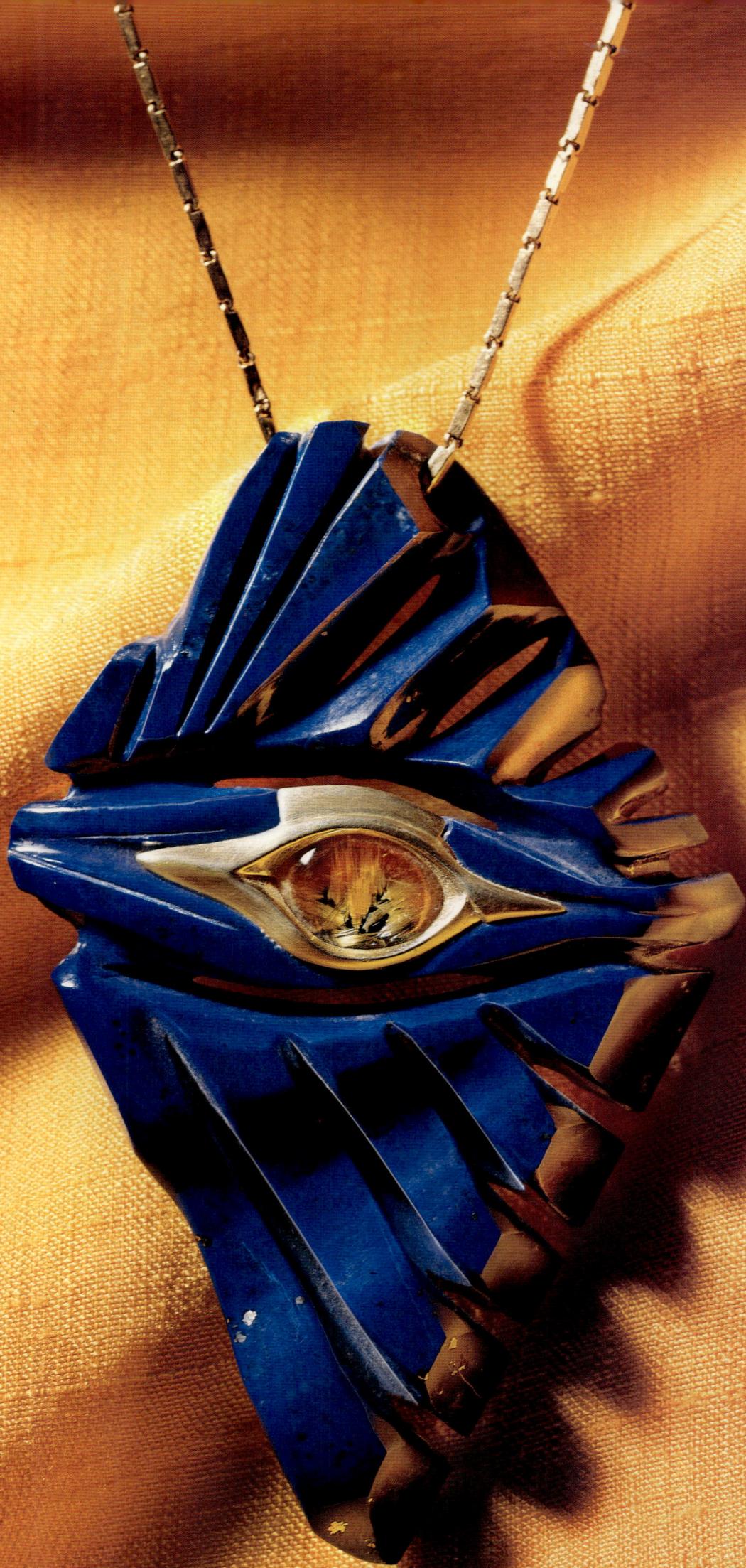

CRYSTAL WORKS

2

CRYSTAL ARTISAN

We begin a relationship, the crystal and I, committing to the work of finding its highest expression. Before we begin working, I connect by touching and exploring, examining the history of its worn and broken surfaces, peeking inside, where its beauty lies still. I admire it. The inspiration is combustible. We agree about the work to be done, and I envision a blueprint of its potential form. I won't make a cut until I feel a "yes" fill my body, clearing me to proceed. To change the state a stone has been in for millions of years can be daunting, yet also serious fun.

It is my task to elicit beauty from matter. The crystal trusts me.

To assume the crystal is an inert clod of earth with which I can have my way feels like artistic chauvinism. The diamond-cutting tools I use can disfigure in seconds what took aeons to create. Working a crystal demands full immersion, concentration, and commitment to the task. It requires that I surrender, with a clear mind and spirit, to the art. The crystal knows if I have other agendas and will apply any means necessary to get my attention. I respect it as consciousness, alive. While there are specific angles and geometries that will enhance the energy flow through a crystal, there is no fixed, predetermined geometry that can be applied as an absolute in the cutting process. There are rules I follow, until the disposition of a crystal dictates changing them. To believe that all crystals should be cut according to a predetermined formula (like a faceted gem) disregards the fact that they each have their own character and individual identity. While it is simpler to cut homogeneous shapes and sizes, I seek the individual's personality and singular beauty.

There are, however, very exacting angle configurations that Nature has instituted with unbending consistency. I have great respect for this sacred geometry. Augmenting the geometry of the crystal can maximize the movement of energy.

Beauty is a primal force, emanating from, and amplified by, the crystal. I focus on activating the flow and force of beauty.

Imagine a dusty, rolled-up canvas painted by a Renaissance master has just been found in a hidden alcove of a castle basement in Italy. Before it was found, as far as our world is concerned, it never existed. But after it is discovered and the dust of centuries wiped free, its authenticity is validated; it is restored and preserved, framed by experts, and then presented to the world for humanity to treasure. Similarly, the work of presenting a crystal frames, activates, and preserves a masterpiece of Nature to be enjoyed by those who have the opportunity to experience it.

GEM ART

Art is but a short chapter in the Book of Creativity. And an artist is one who inspires him- or herself and others to perceive and conceive anew.

Where is the line drawn between what is nature and what is art? *Webster's* defines "nature" as the external world in its entirety, a creative and controlling force in the universe, and "art" as human effort to imitate, supplement, alter, or counteract the work of nature. How does a mineral go from being perceived as a rock to being appreciated as art? Is Michelangelo's *David* a piece of marble or a man?

The painter puts a brush to flat canvas, raising an illusion from paint. The sculptor forms an object using the movement and dimensions of its opaque surfaces to define its image. Nature's divine intelligence spent aeons in the formative engineering of the atomically brilliant rare-earth gemstone. The stone's transparency offers an added visual dimension of vibrancy and depth found only in gem art. Not only are the outer surfaces of the piece defining space, but the interior of the transparent crystal opens a portal to a magical "otherworld." At its essence, the art is the shaping of light.

Art is a transaction—something given, something received. I want art to transport me somewhere, to flip on an emotional circuit, connecting me to a place I have never been. The art and I, face-to-face, locked in an encounter that changes the *from now on*, even if but for a moment.

The most powerful art combines beauty with meaning, transforming the observer into a participant.

I often come across a crystal that has been badly broken, hammered by time and circumstance, reconfigured from its millions-of-years-old, hexagonal crystal shape. I allow its cleaved body to guide me in the grinding transformation from fractured chunk of stone into an object designed to capture, transport, and release the engines of imagination.

The impact of my work hinges on the size of the stone. A gemstone measured in millimeters and carats is too small for my eye to explore and get lost in. A small gem will dazzle and sparkle light. But if I cannot gain entry without a

"When I am working on a problem I never think about beauty. I only think about how to solve the problem. But when I have finished, if the solution is not beautiful, I know it is wrong."

— R. BUCKMINSTER FULLER

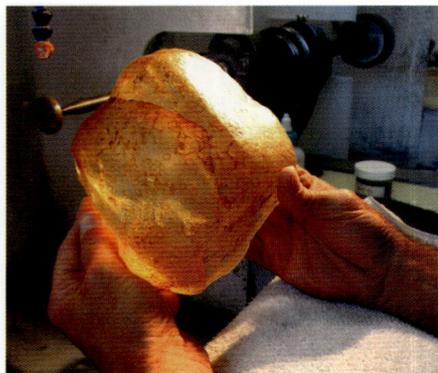

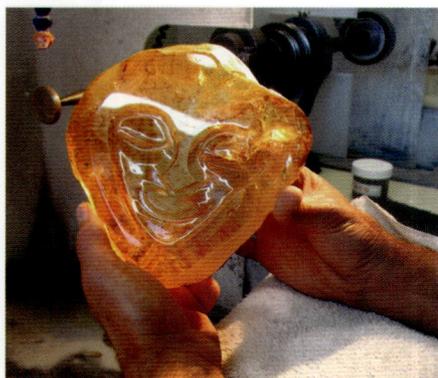

ABOVE: *River Face* at carving bench, river-tumbled quartz, 7˝, Madagascar

✳

BEAUTY IS ETERNAL

Born but never ending,

It lives within and without me.

Beauty exists beyond my interpretation of it,

And doesn't need my approval.

It inhabits a dimension governed by its own rules of attraction.

It transcends limitation,

An endless sea beckoning me to get lost inside;

I stand on the shore spellbound before the horizon.

When struck by Beauty, there is impact

Crashing over me.

Caught in its currents and tides,

I surrender and float where it takes me.

I agree and disagree with Beauty.

I admire it, seek it, and savor it.

I am its slave, yet attempt to master it.

Sometimes I avoid it altogether:

This is when I am blind to myself.

The moment I perceive Beauty

It enters me,

Filling up my insides,

Healing me beyond my body.

The function of Beauty is to feel

Wonder and majesty,

Inspiration and enchantment,

Joy and peace,

All at the same time.

So I design forms for Beauty to live in,

Building homes,

Hoping it will take up residence

So that I can come visit

And sit quietly in Its living room.

Crystals embody, amplify, focus, and direct

Beauty's undeniable force.

They magnetically attract Beauty

And magnify its force field.

Beauty is encoded in the molecular lattice of crystals,

Existing in the liminal space

Between matter which appears solid

And the heart of what matters.

Beauty is always present

Somewhere between what I see

And who I am.

✳

magnifying device, I am unable to know who really lives in there. I prefer to work with crystals that have volume, whose interiors tell a story of a world I have never known.

The crystal directs the design. I follow its edges, breaks, and contours, grinding free the least amount of gem material possible to create an outer shape of balanced harmony. The journey is an adventure, and an adventure has spontaneous moments of excitement, sandwiched between hours of anticipation and concentration. While moving edges on the flat diamond lap wheel, I search the horizon for an outline to emerge that shouts *land ho!* I'm looking for a shape that inspires the commitment to set sail, navigating for countless hours of focused, detailed attention, rubbing back frosted surfaces, beckoning the internal light to escape. But the outer profile is only the vessel that carries the inner cargo of the work. There is buried treasure to be found. The light within the crystal has a quality that is ancient, authentic, penetrating, pure. By faceting the exact degree of angle, an exterior face bends the internal light to reflect and refract in vibrant ways. It projects the art into the eye, beyond the brain, to the heart and emotional homeland. Emotion creates dimensionality. Without emotion, I can sail right off the edge of the sculpture. Without emotion, the world really is flat.

Art is my way of imitating Nature's godly presence, a way for me to put my fingers in the socket, to be jolted by the primal current of perpetually flowing creativity. As an artist, I don't need to accept any conclusions; I don't need to convince anybody of anything.

CUTTING THE CRYSTAL

Like the woman in Paul Simon's song, I often have diamonds on the soles of my shoes.

Quartz crystals are hard, some of the hardest matter on this planet, harder than steel, designed to last. Only diamonds, corundum (ruby and sapphire), and topaz are harder, as defined by the Mohs scale.

Crystal cutting is a primitive endeavor first attempted by cavemen abrading rocks. In essence, this is what I do as well: grinding and reshaping one rock with a harder one—diamonds grinding quartz. My heritage is caveman. This is the only explanation I have for choosing to spend untold hours grinding one rock against the surface of another.

Until quite recently, the tradition of gem carving evolved slowly over thousands of years. Before the advent of precision electrical

diamond cutting tools, I can imagine a mason in Mesopotamia hand rubbing, back and forth, back and forth (now repeat the words *back and forth* a million times for effect). First, a coarse stone is used for shaping, back and forth, followed by rubbing a finer one to smooth the shape, back and forth, followed by a more refined one, back and forth. I assumed that in ancient times, this work was mandated by a supreme ruler, because only the enslaved or the spiritually impassioned would have the perseverance to see the process through. It might take a few generations to complete a work because quartz crystals are so hard.

While gem cutting has taken a quantum leap with the advent of electrical tools and high-tech diamond tool technology, the process is still arduous, consuming large expanses of time. These very recent innovations, many in the past thirty years, have allowed the caveman to become a gem artist, transforming slave labor into a labor of love.

The diamond tools I use are saws, grinding lap wheels, diamond-impregnated wood wheels, dowels, cylinders, cores, cones, burrs, bits, belts, points, pads, and anything else I can imagine, invent, or buy to skin these cats.

With a small to medium-sized crystal in grip, I handhold, using no calibrated faceting machine. It is an eye-to-hand process—optic-nerve-to-brain, brain-to-hand, mental calibration of the angle of incidence—resulting in the precise wrist position and finger pressure. Sometimes, muscles are tensed hard; at other times, with a sensitivity as light as thought. Larger crystals must be cut with rotating circular saws held in position by wedges and clamps, though the alignment is still a process of eyeballing, measuring, and lining up with a variety of tools. I often measure using three independent methods to insure that the cut will be accurate. Aesthetic judgment is the final criterion.

Gem cutting is a feel deal, using instinct, touch, and finesse. It involves looking, measuring, aligning, re-looking, re-measuring, and re-aligning; cleaning, examining the scratch patterns and pits in the surface with just the correct angle of light refraction to see, as the coarse and pitted surfaces become more and more refined. The lights are bright, the sounds are hard, the focus is constant, the medium is unforgiving; with the final polishing comes the fleeting yet boundless sense of satisfaction and joy.

As in any sport, there is a zone, and when I am in it, the crystal becomes malleable, soft, and smooth; it feels as if I can bend it, effortlessly changing as I direct it. As I lay delicate facets, crisp and symmetrical, the crystal graciously responds, working with me, embracing its new form.

Or am I following its command, simply an instrument of its redefining itself for the next million years?

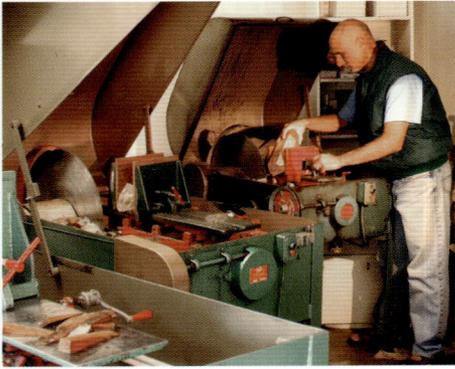

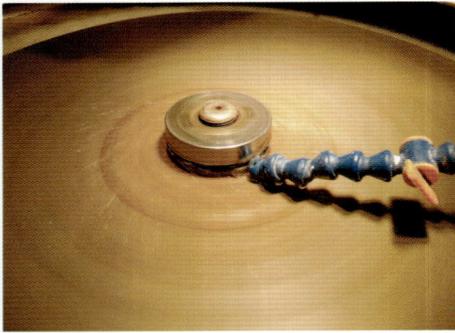

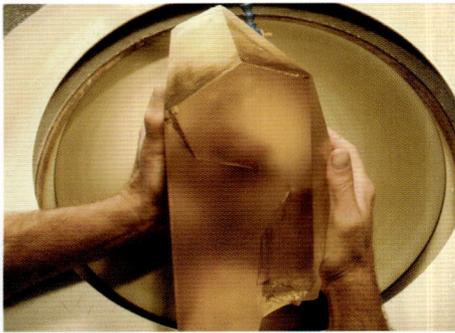

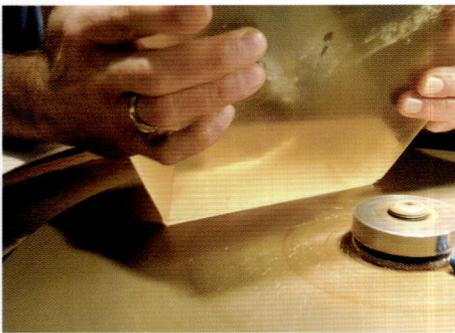

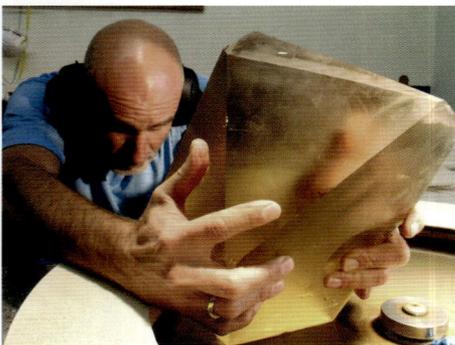

ABOVE: The cutting process, shaping citrine sculpture *Wizard of Oz*. Diamond-blade saws, followed by shaping on diamond lap wheel. OPPOSITE: *Wizard of Oz*, citrine quartz, 22", Brazil

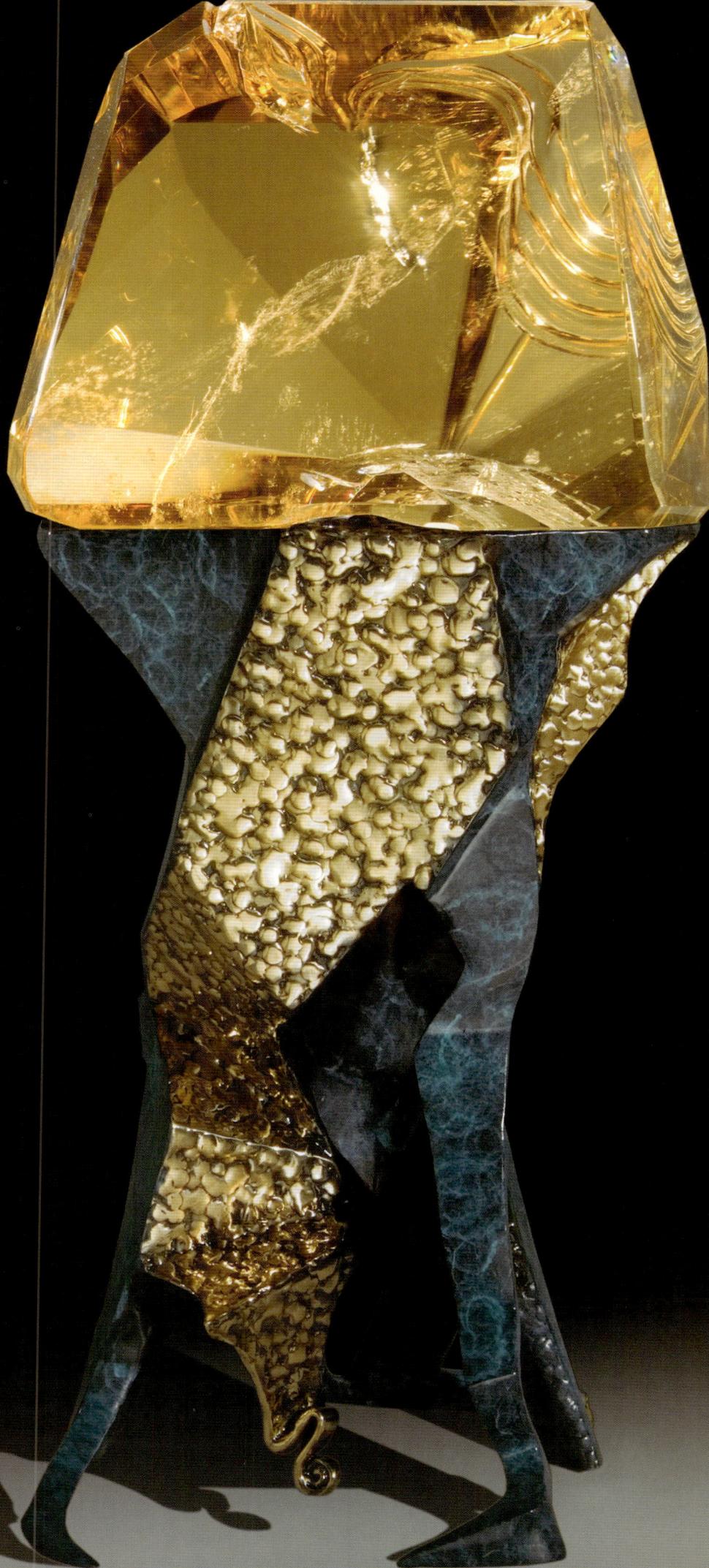

SEARCH & DEVELOPMENT

A while back, over a period of two years, I cut a collection of crystals for a Native American group who used them for what they termed the extraction of negativity from the body. We powwowed, pondered, and discussed. We perused, squeezed, and rolled many raw six-siders in our hands, looking for volunteers whose destinies called them to this service. We designed different configurations of angles and geometries that we concluded would vacuum dissonant energies from the body. They tested each newly designed and cut crystal to determine how it worked, and then asked me to change the design slightly, according to their desired specifications. It was your standard research-and-development project. After we agreed upon each new design alteration, I would disappear on a vision quest. Closing myself in my grinding room, with ears plugged and cooling water flowing, I pressed the crystal faces to the 18-inch diamond-impregnated lap wheel, forging the new geometric. I would emerge transcendent after indeterminate chunks of time, as if having spent days on a high desert plateau in the blazing sun, seeking divine deliverance.

Cutting and polishing a crystal can leave me feeling like I've performed feats of magic, changing the illusion into something more real. By my becoming all-consumed in this ritual, the rules of time and space get broken, and I have no desire to fix them. At the end of the process, I have a glistening, transparent, precisely shaped, glowing object in my hand: the mystery of changing substance into frozen light. And I wonder, "Did I have anything to do with this?"

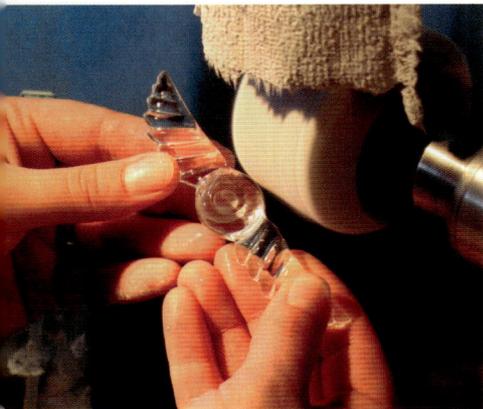

ABOVE: FINAL POLISHING OF *SUN DISC*, AN EGYPTIAN DESIGN IN CLEAR QUARTZ. OPPOSITE: *ORACLE*, QUARTZ SPHERE, 85 LBS., BRAZIL

CRYSTAL EYES

A s a kid I was a treasure hunter, ever scanning the ground for fortune: an Indian Head nickel, a multihued rock, a gnarled twig with a face twisted into it. The anticipation of finding something special and claiming it as mine was instinctual, like galloping is to wild horses. Magical was not yet a concept but a pure state of being, and I liked being in that magical state. The first time I polished the face of a quartz crystal and looked inside, I was back in the realm of magic.

Often there is a vibrancy and richness lying dormant just below the weathered exterior of a crystal. Each saw cut is its own treasure hunt as the diamond blade slices off the weathered outer skin, or rind, revealing delicious visual fruits within. Sometimes the same stone may

appear to be entirely different when cut from one direction and then rotated 90 degrees and cut on another axis. Different patterns and light refractions present entirely new scenic experiences.

In the course of my career, I've witnessed a significant improvement in lapidary tools and techniques that far exceeds the advances of previous centuries. This has allowed for a vibrancy of polish that by and large was unattainable thirty years ago. Achieving the highest polish on a gem or crystal allows the eye to penetrate the stone with optical precision, while absorbing the maximum light *in-formation* available. A well-prepared surface diminishes distortion, which in turn provides a "looking glass" view into a wonderland: a true and authentic experience of the crystal. This is where the sparkle and the life reside. The vibrancy, the beauty that penetrates the eye, stimulates the neuropeptides in the brain, releasing a chemical reaction, triggering an experience that must have been what Alice found down the rabbit hole—pure magic.

When we talk about the polish on a crystal, we are actually referring to a seven-step, laboriously painstaking process. It begins with grinding away the surface. The facet must be sheer to retain the flattest possible plane, so as to eliminate any distortion that will interfere with viewing the interior. This is followed by the prepolish, a repeating sequence of refining and diminishing the scratched and pitted surfaces, the final step of which is the actual "polish." If an impeccable job is not done on each step of the prepolish, the final polish will be lifeless, dull, and scratchy. And while the untrained eye may not even be aware of it, it may result in missing the majesty of the crystal, like looking into murky waters instead of seeing the rounded rock bottom of a pristine aqua blue mountain lake.

GAZING INTO A CRYSTAL BALL

C rystal balls have been round since before recorded history. Why is it that (throughout the ages) sages, mystics, entertainers, politicians, and (more recently) Federal Reserve chairmen wished they had one? "If I only had a crystal ball," the colloquialism goes, "I could foresee the future," a catchphrase for "I wish I knew then what I know now." Is there a grain of truth about crystals and crystal-ball gazing that can reveal aspects of the future to those willing to look? And wouldn't it be nice for those of us who have them if they did help us reveal more about ourselves? Scrying is a term for crystal-ball gazing, an activity that

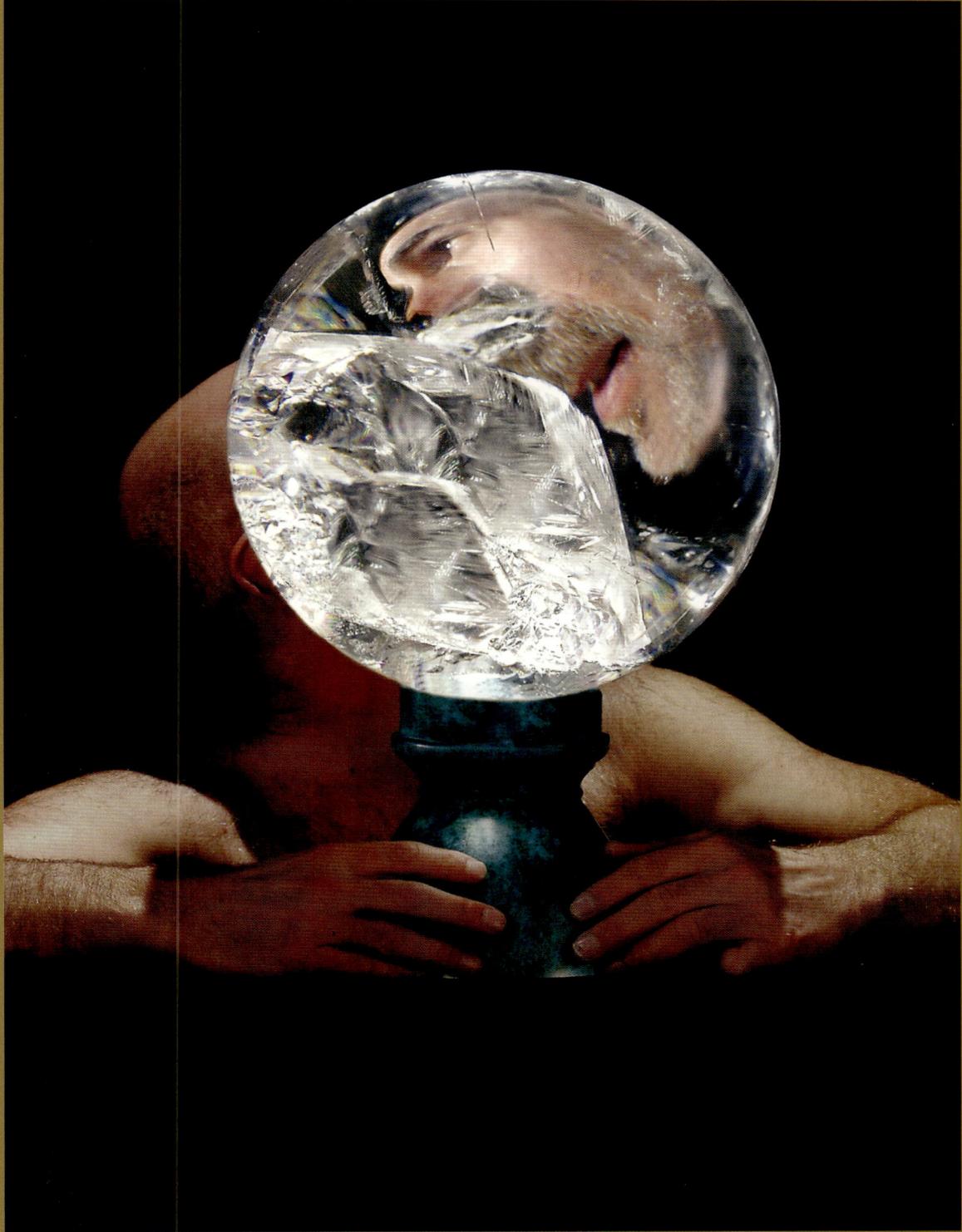

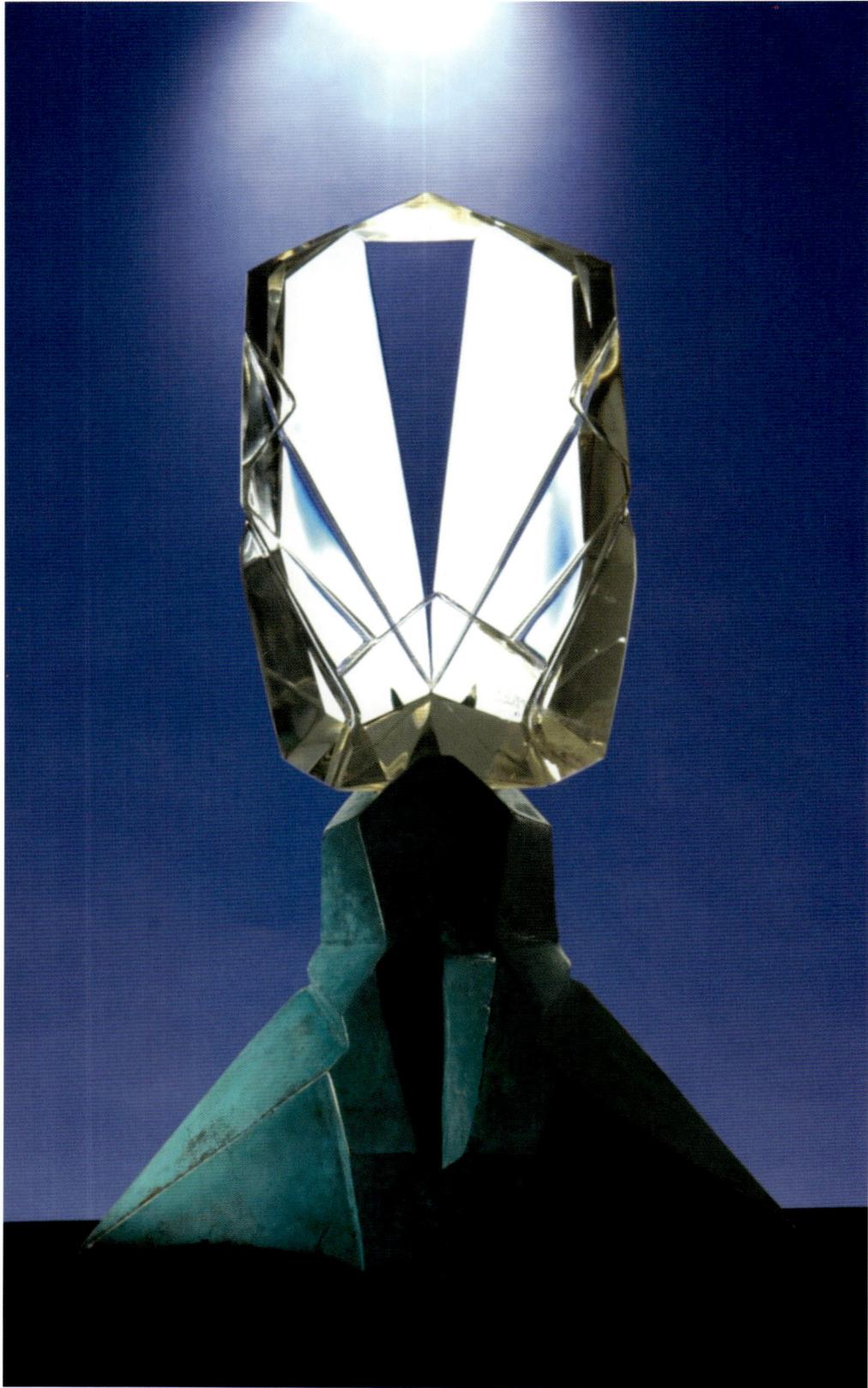

ABOVE: *Harbinger*, electronic-grade quartz, 28″, Russia
OPPOSITE: *Amethesula*, carved amethyst and quartz
on obsidian, 9″, Brazil

appears to have been going on for thousands of years. So why do it?

Scrying occurs when you gaze into a crystal ball, allowing the logical mind to detach from the world of straight lines and logic, letting your imagination swirl in consort with the frozen movement of the crystal's internal veils and textured patterns of light suspended in its transparency. The "normal-ady" of life is barred from entering the sphere's surface. There is nothing predictable inside, and one gets the free-floating feeling of being lost—and found. The experience moves you in the way that a great work of art can.

Detaching one's mind from the rush-hour traffic of thoughts can allow intuition to emerge. Looking into a crystal or crystal ball can focus, tune, and open one's mind to intuition. And what is intuition but the ability to perceive what is going to happen—*in the future?*

So, when I look into a crystal ball, what future do I see?

All I know for sure is that it is luminous.

WAKING UP

The first time I experienced a crystal "waking up," I was unable to incorporate the phenomenon within the limitations of my logic. A rock coming to life just didn't fit in with what little I knew about minerals. I had been cutting crystals for a relatively short time, still discovering the proper technique and angle configurations to best energetically enhance a crystal. While I had cut a number of pieces successfully, there was one piece that still sat motionless on the shelf after cutting. Over the next few months, this crystal became more and more conspicuous to me for its lack of luster and its subdued, dormant nature. A wallflower that was more wall than flower, a shy stone, standing alone, silent, the preverbal, proverbial rock. It just wasn't as attractive as the other points I had. When customers came to look for crystals, this one was invisible, never seen, let alone considered. I wasn't used to talking to crystals, but eventually I picked this one up to see if I could decipher what was going on. It didn't appear unhappy; it just wasn't happy. I examined the gradient of its tip angles and decided to re-cut them with a slightly sharper termination, hoping this would get to the point. After re-cutting the crystal, it was singing like a songbird at daybreak. I placed it back inside the dusty outline on the shelf, exactly where it had been for so many months.

The very next day, I was visited by a woman determined to find "her" crystal. She looked carefully over my brood. It took a matter of minutes to determine that there was only one piece for her: it was as if the lone, freshly re-cut crystal were the only one in the room. It was calling for our attention like a cat that hadn't been fed, and it purred in our hands as we passed it back and forth, admiring it. I had never seen anything like it. The crystal couldn't have been more animated if it had a tail to wag and could bark.

Another time, several Buddhist monks came to my studio for a visit. Upon their arrival, they politely took a cursory look around the studio. One went immediately to a collection of fist-sized natural amethyst points sitting on an out-of-the-way shelf. He cradled one between his hands and examined it briefly. He asked me if I had seen the *Om* symbol perfectly inscribed just below the surface of the front face. It was etched, clear as scripture, on a message plate floating inside the crystal. I instantly recognized it, which startled me. "No" was all that came out of my flabbergasted mouth. Before I had time to think about keeping it myself, he said, "I'll take it." I figured that it must have been destined for him. The monks thanked me in unison, politely bowed, and left.

Crystals "wake up." They go through a process of awakening. It is as if one day they are quiet and dormant in their rock-ensconced slumber, and then suddenly they become animated and excited, almost demanding attention. When they meet the person who is to be their keeper, contact occurs—you can feel it—and the crystal's consciousness is activated. This phenomenon of activation also happens regularly in my studio after a crystal is cut. When the work is conducted with respect and care, it will often inspire a quality of awakening, a brilliance, a life force, a beckoning attitude of *I'm here, let's get to know each other.* Like Rip van Winkle emerging from a long slumber, the crystal rouses, absent the burden of time.

Awakening can occur with any crystal, whether it is cut or not. I have watched others who have the gift of activating and awakening crystals, bridging the great divide that separates the human and mineral kingdoms. There is great affection involved, like a parent touching forehead to forehead with an infant. But make no mistake, the infant in this case would be the human as opposed to the 40-million-year-old crystal.

If a crystal is cut without respecting its angles and nature, it will often appear listless, flat, uninterested, hibernating. I have seen crystals

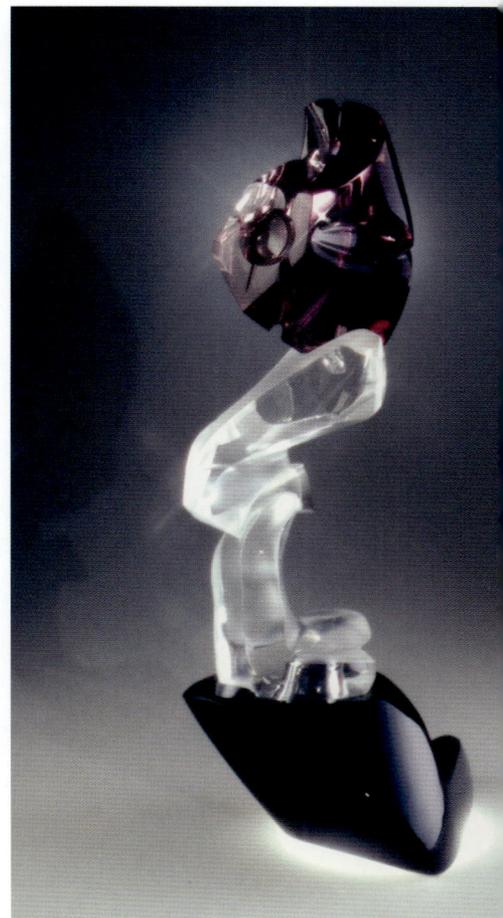

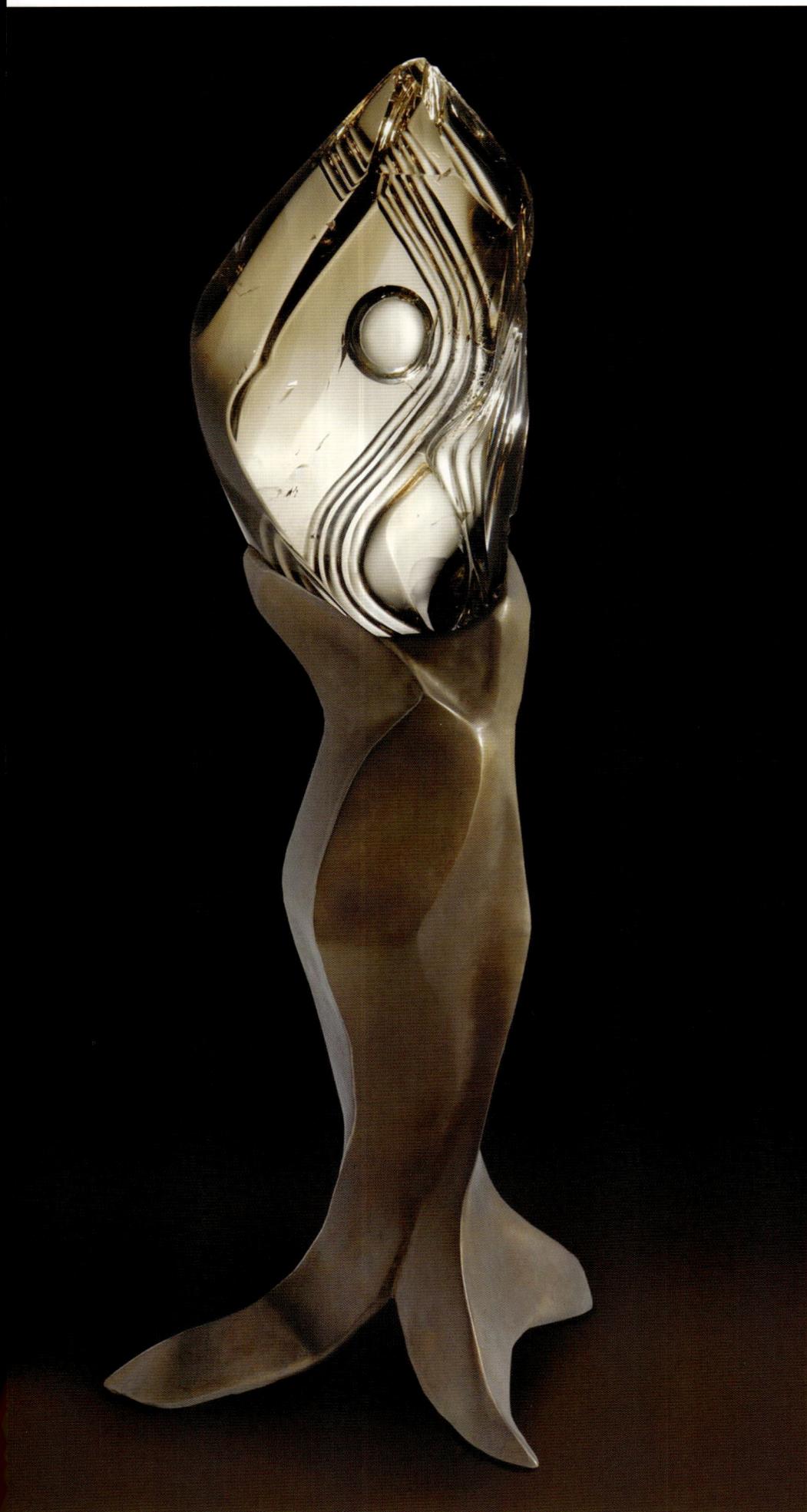

awaken and then go back to sleep. Rub ego all over them, pay them no attention, or treat them like a rock, and they will return inward, like a bear in deep winter. After all, what is another few thousand years of slumber to a rock?

A great awakening crystal can take me where I want to go, lead me to what I need to know, wake me up to who I am becoming.

Dylan famously sang that he not busy being born is busy dying.

THE BRONZE AGE

Crystals love light. They respond to light like the night sky yearns for the sunrise. Interesting to think that crystals, for most of their existence, have been buried in absolute darkness. Perhaps this is why they radiate a type of joy when illuminated.

Around 3500 B.C., civilizations in western Asia, Egypt, and Europe transitioned from the Stone Age to the Bronze Age by developing the ability to forge bronze into useful shapes, tools, and, eventually, sculpture, some of which endure to this day. My art has experienced a progression from stone into bronze as well.

Many of the crystals lying on my desk, a table, or shelves are greatly enhanced when mounted on a complementary base. In my early days as a crystal cutter, I had no interest in doing bases, though whenever I put a crystal to light, the full majesty of its interior ignited. It may have something to do with the polarity of the two media: minerals are among the densest matter on earth, and visible light among the "lightest" waveforms in the universe. When light enters the dense but transparent gemstone, substance and illumination collide, oscillate, and integrate all at once. By beaming a halogen light into the crystal, it appears bigger, more articulated, more alive. Directing light into a crystal or gem is comparable to when we humans feel joy. Looking into the illuminated crystal is like getting to know who someone really is, as opposed to having only a first impression. The light reveals who lives inside.

And so, getting light into the crystal has become an important feature of my work. Initially, I bought generic light boxes for this purpose. These bases were not very attractive, but they functioned well enough. I felt that the finer crystals were begging for their own lighted pedes-

LEFT: *Pisces*, CITRINE QUARTZ, 27˝, BRAZIL
OPPOSITE: *Deco Mecca*, CITRINE QUARTZ, 24˝, MADAGASCAR

tals, so I set about making bases of fine wood.

Eventually, I started working with bronze and enlisted the talents of my brother Roger in creating my first bronze light-bases. By creating a form in wax and then casting it in bronze (the lost-wax method), I can accomplish shapes and forms that fit the size, contours, character, and textures of a particular crystal. Some sculptures are fabricated, welded together with sheet bronze. Bronze is a regal and bold metal that carries a patina of antiquity. Whether casting or fabricating, I work closely with foundry artists Peter W. Small and Roy Swan, who craft and forge the metal around the personality of the sculpture.

I've surrendered to the idea that most of the significant crystals I work with require high-quality basing to light and enhance their forms. Compelled to attain greater articulation and integration between the stone and the base, I found myself setting crystals in sculpture.

And as I embraced the process, magic began to happen.

A jeweler sets a stone in gold or silver, thus creating jewelry. I set my gems in bronze as sculpture, a kind of unwearable jewelry. And thus the transition from being a lapidary to being an artist, a gem artist, truly began.

With some crystals, the metalwork and the addition of light "complete" the stone; the sculpture becomes a synergy, visually and energetically more powerful than the individual components.

Not only do crystals look good set on a fitted bronze base glowing from an internal light, but they also seem to have an intangible quality of being more animated, as if they are reaching out to touch, to make contact.

Bronze is an alloy, mostly composed of copper, a highly conductive metal used as an electrical conduit. Energetically, the conductive bronze and the piezoelectric (lighted) quartz stimulate one another to create a vibrational vortex, or standing wave of resonance. Some may call it beauty.

I call them Harmonic Resonating Sculptures.

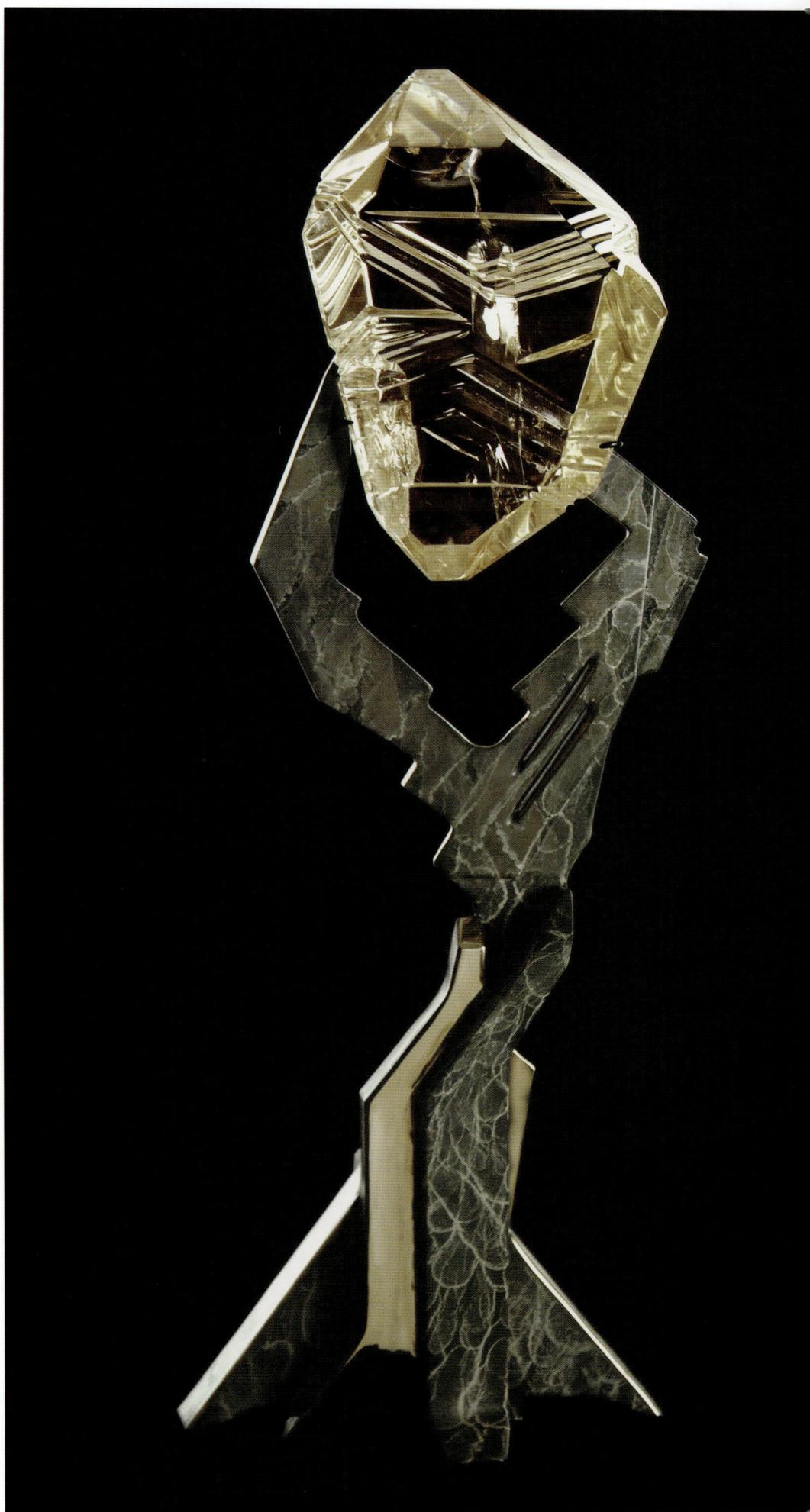

✳

HARMONIC RESONATING SCULPTURES

A Harmonic Resonating Sculpture is art with a specific purpose,

alive with an interactive dynamism that can be felt from across a room.

The art penetrates the skin as you enter its resonant field.

The sculpture's function is to uplift the life of an environment

by boosting its vibrational ambiance.

In the same way that a rheostat controls the temperature of a room,

the resonating properties of a dynamic crystal,

set on a lighted, electronically conductive bronze base,

create a palpable luminance

that buoys the psyche of those within its domain.

Tuning the frequency of a room with a sculpture

composed of electromagnetically charged elements

creates its own vortex, ambiance,

and field of balance and harmony,

which invites a feeling of well-being.

Sunni and I have a crystal that governs

the vibrational well being of our home,

a large, captivating, beautifully clear crystal

with wispy veils, message plates, and a waterfall of light.

It began talking to me the moment I saw it and has never stopped.

Although it originated in the Ural Mountains in Russia,

we speak the same language.

Currently residing in the living room,

its mission is to energetically tune our home.

And, like a conductor, it interacts

with the other crystals throughout the house.

Together they link to create a vortex

that embraces all who enter our home.

✳

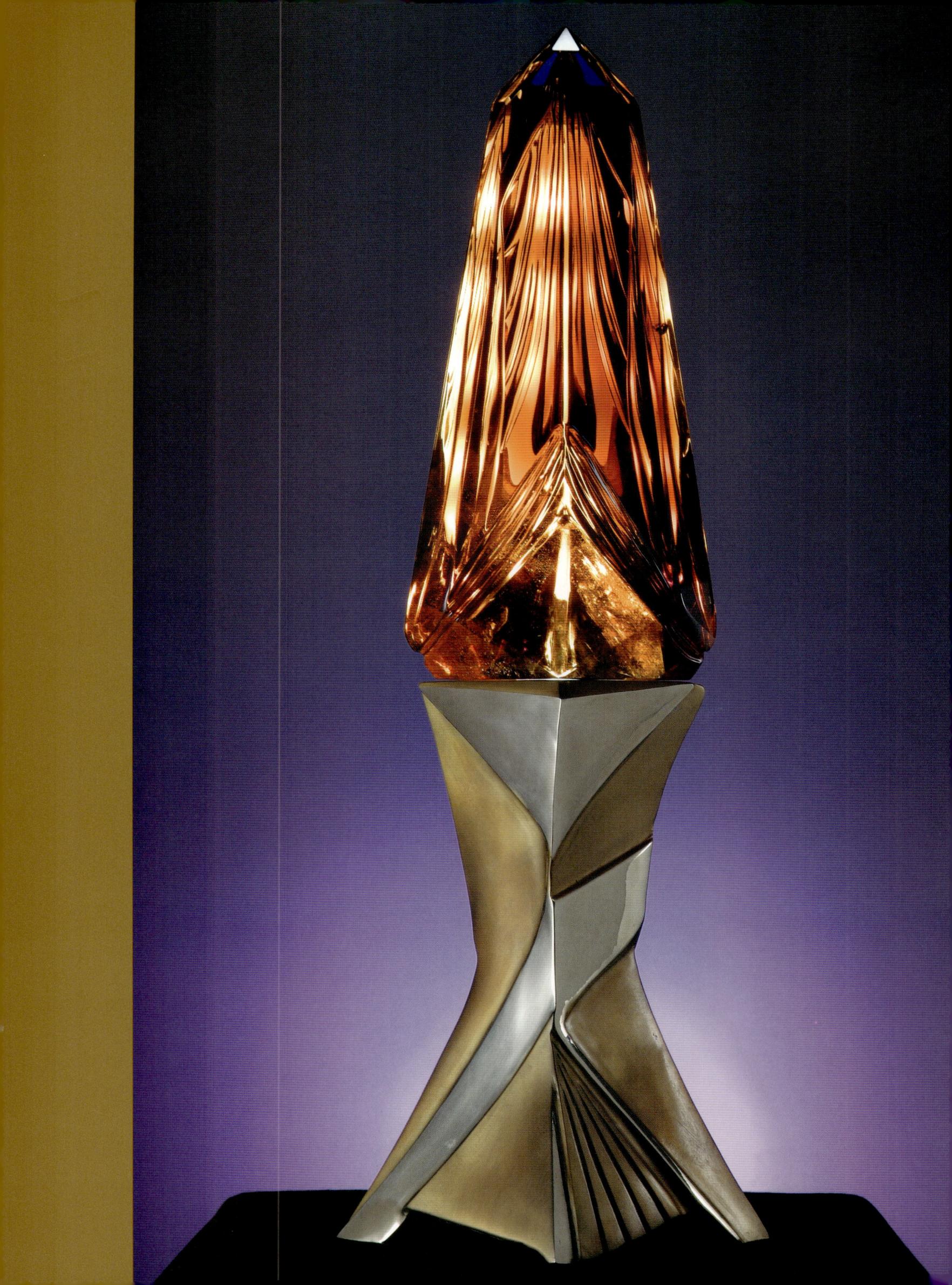

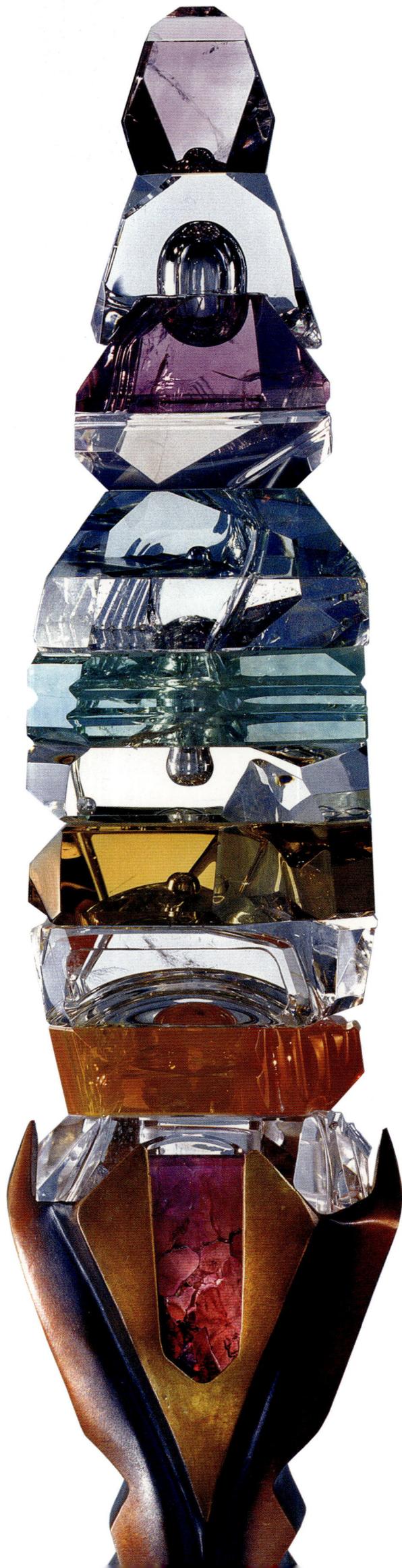

LEFT: *Odyssey*, a carving of Zambian tourmaline, Brazilian opal,
Madagascar citrine, Brazilian morganite, Pakistan topaz,
Bolivian amethyst, and Brazilian rose d'France, 22″
RIGHT: *Endless Horizon*, natural blue topaz (35,000 carats, 28″)
ring in jade boulder, Brazil; cut with Glenn Lehrer

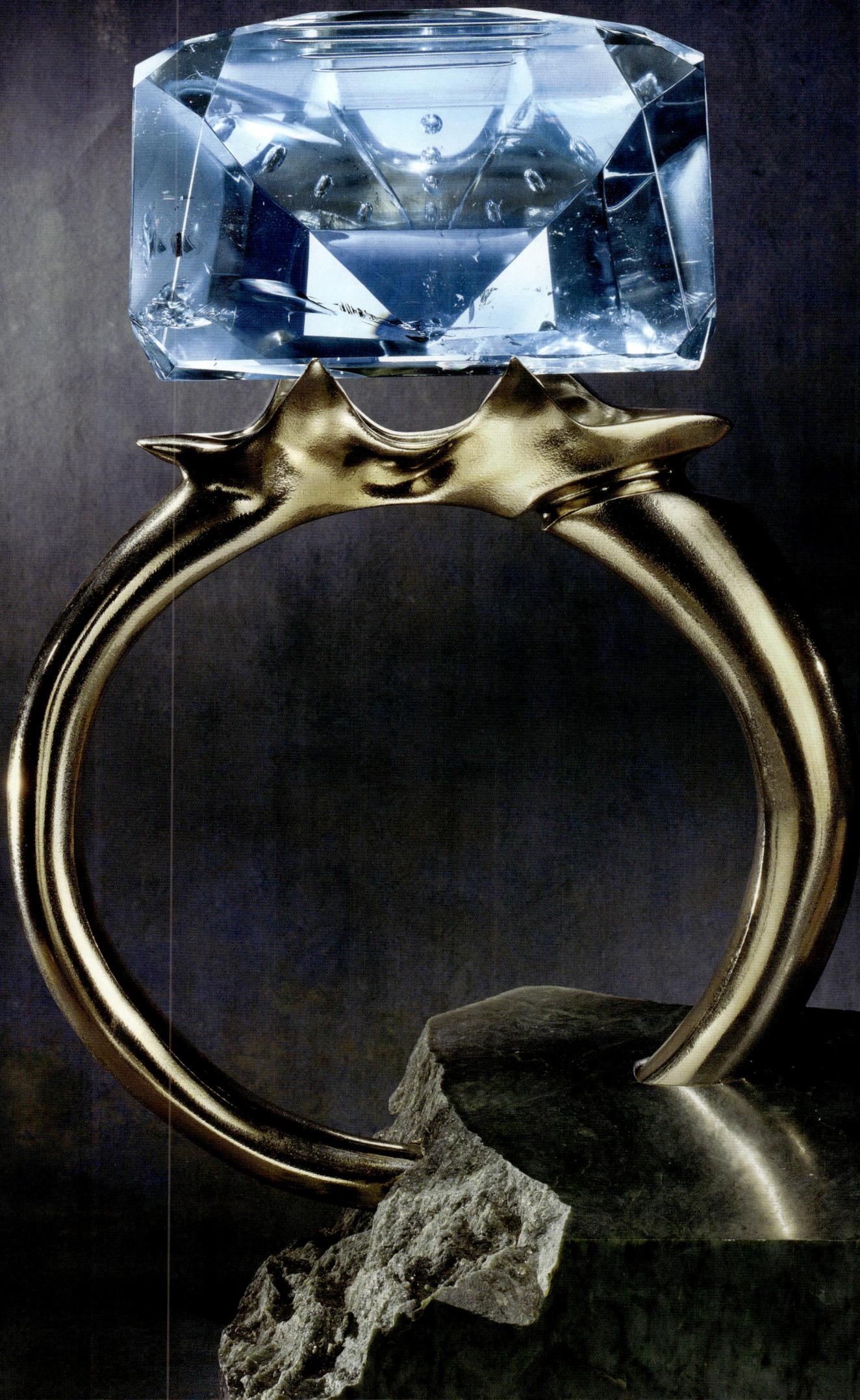

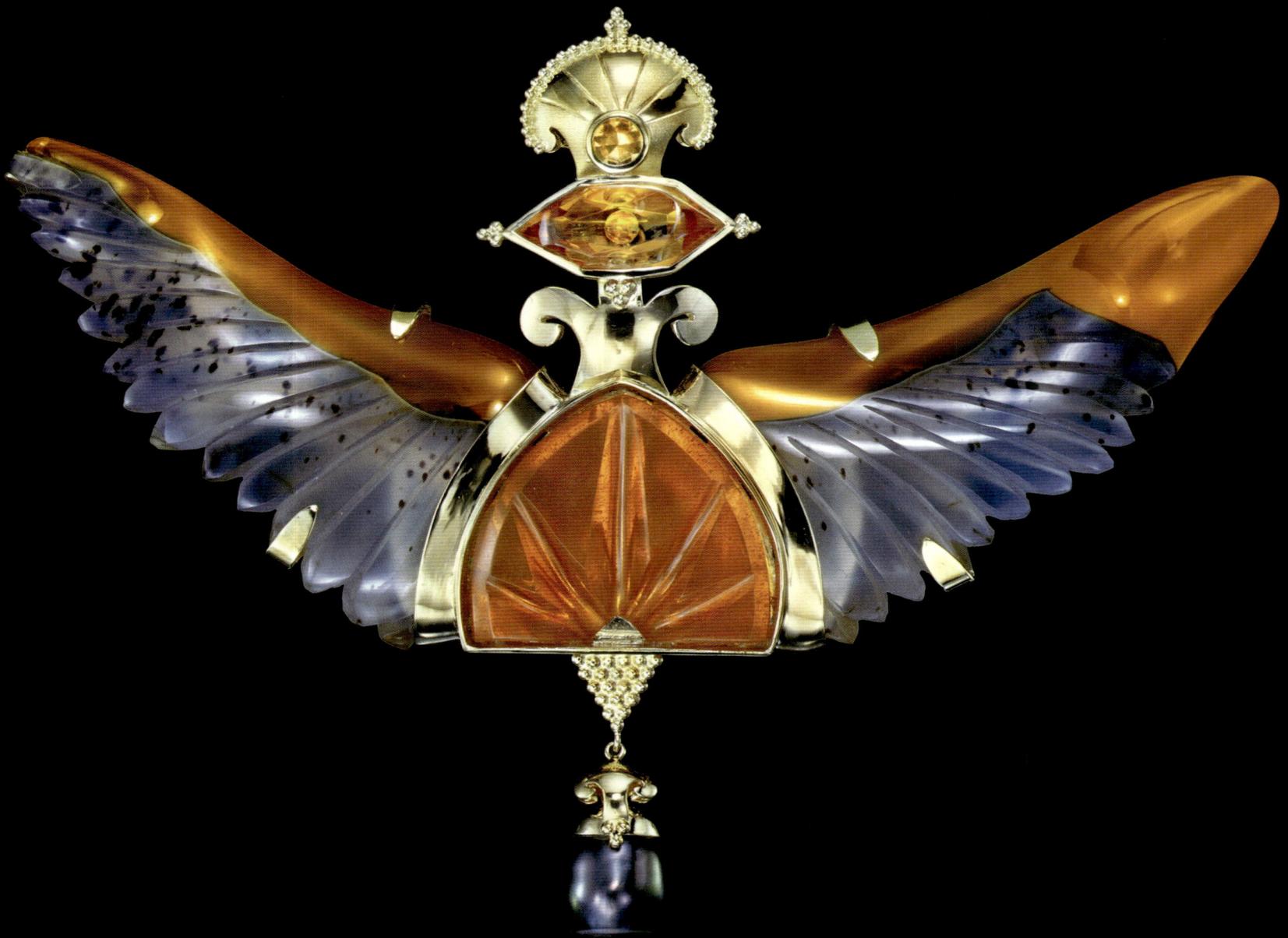

ABOVE AND OPPOSITE: *FREEDOM'S FLIGHT*, MONTANA AGATE, TOPAZ, ZIRCON,
OPAL, PEARL, 18K GOLD; WING SPAN 6˝; CREATED WITH
JEWELRY DESIGNER PAULA CREVOSHAY

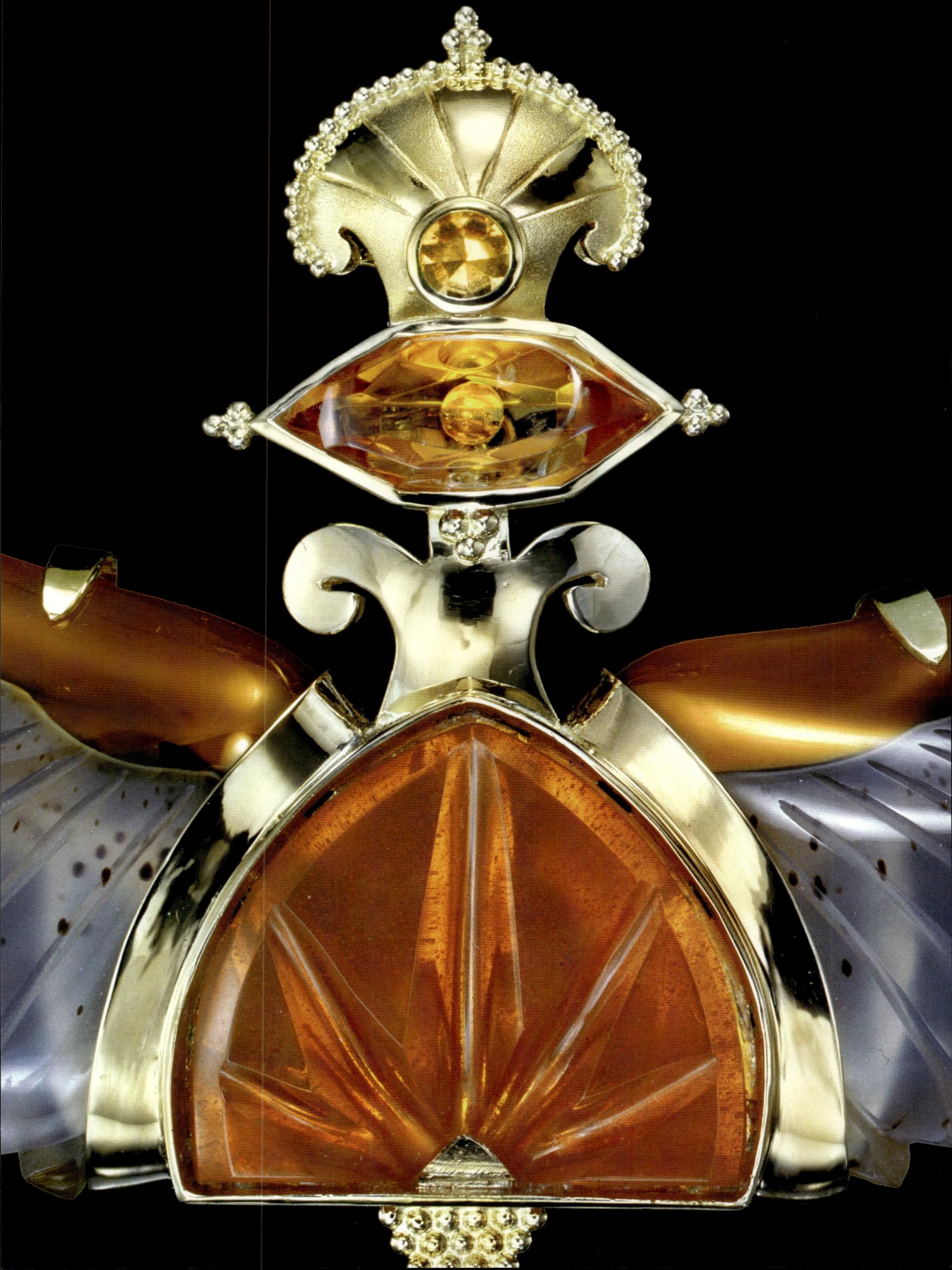

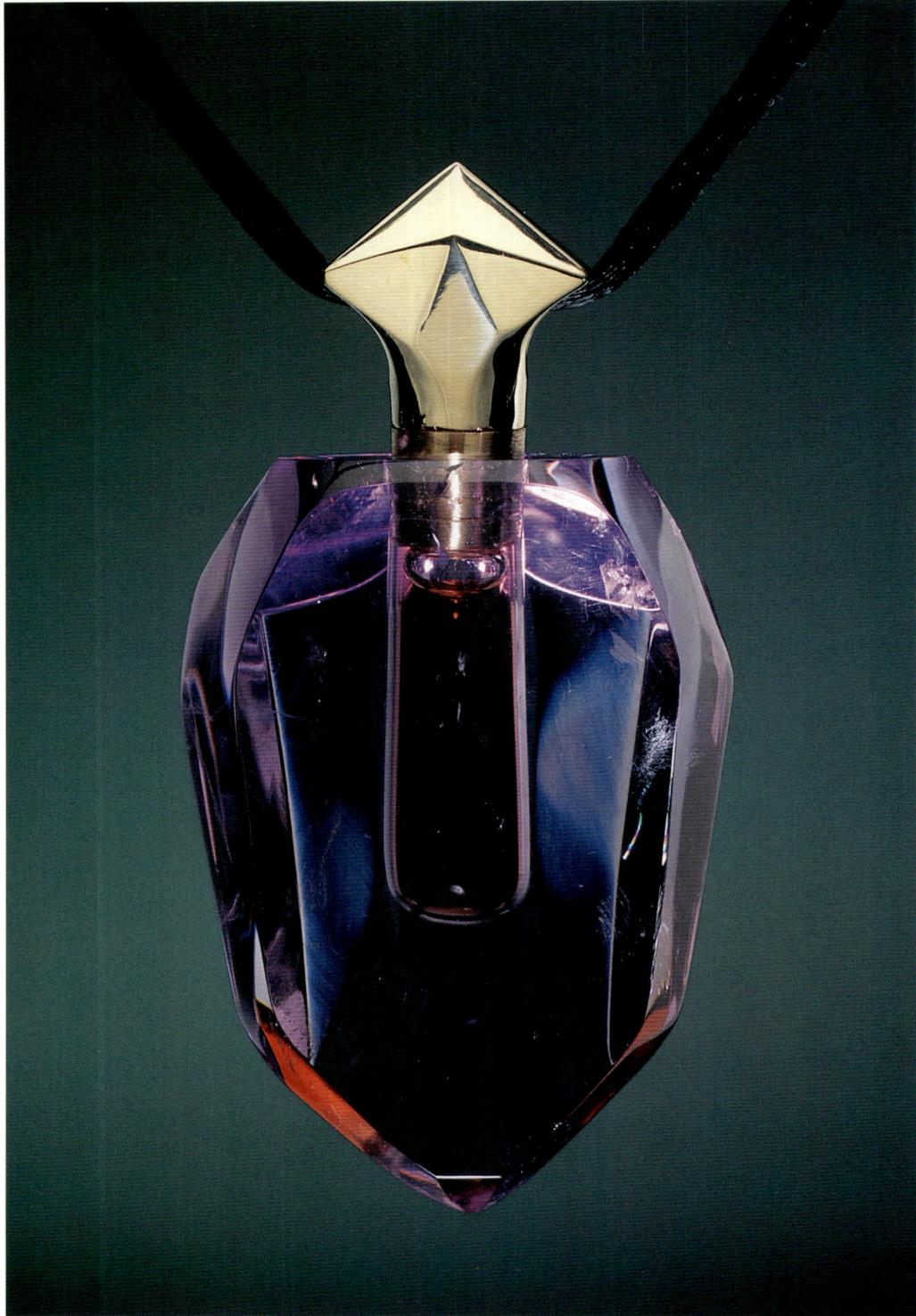

ABOVE: ESSENCE VESSEL PENDANT, AMETHYST WITH 18-CARAT GOLD, 2″
OPPOSITE: *Buddha Bottle*, ESSENCE BOTTLE, AMETHYST, 6″, BRAZIL

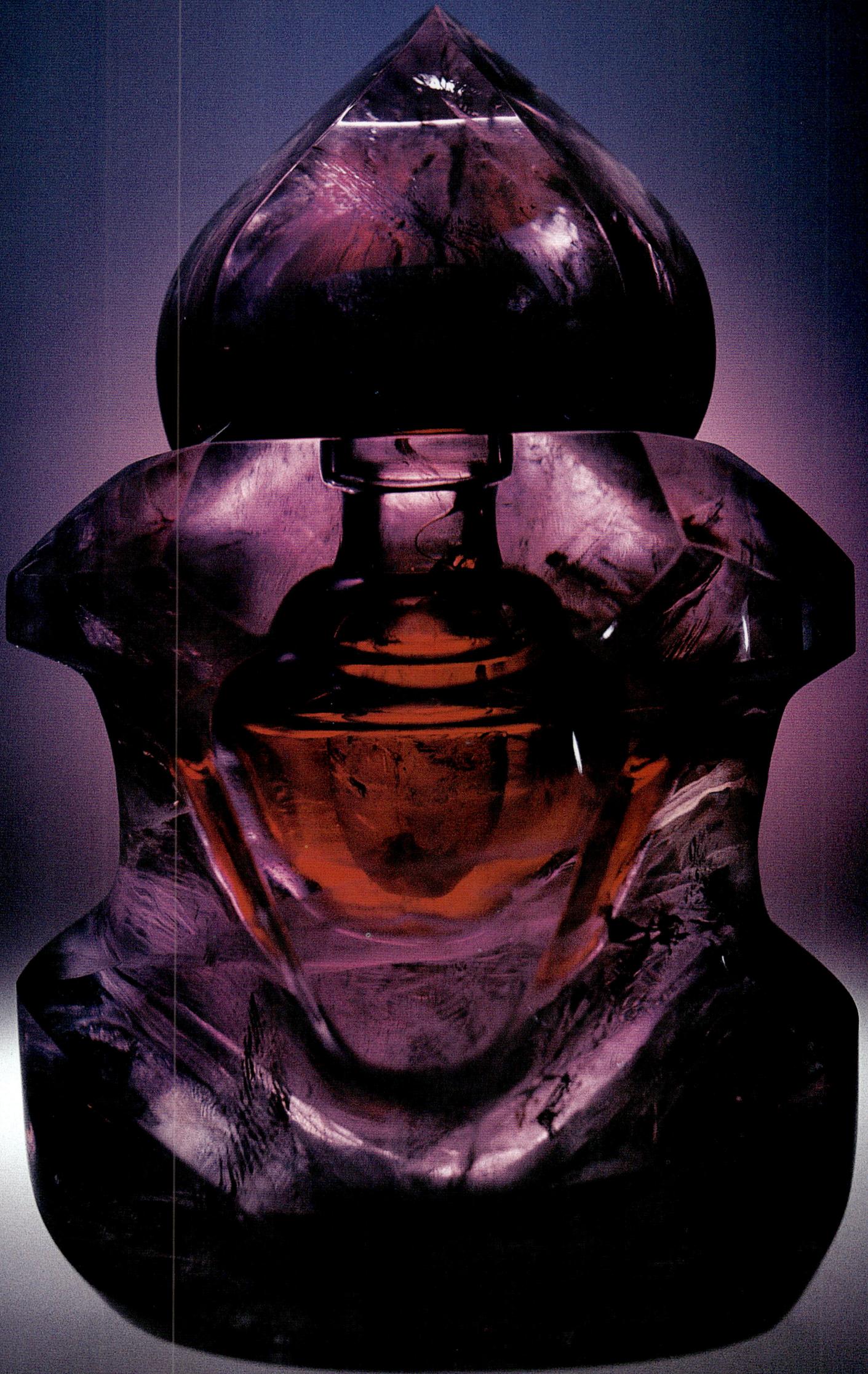

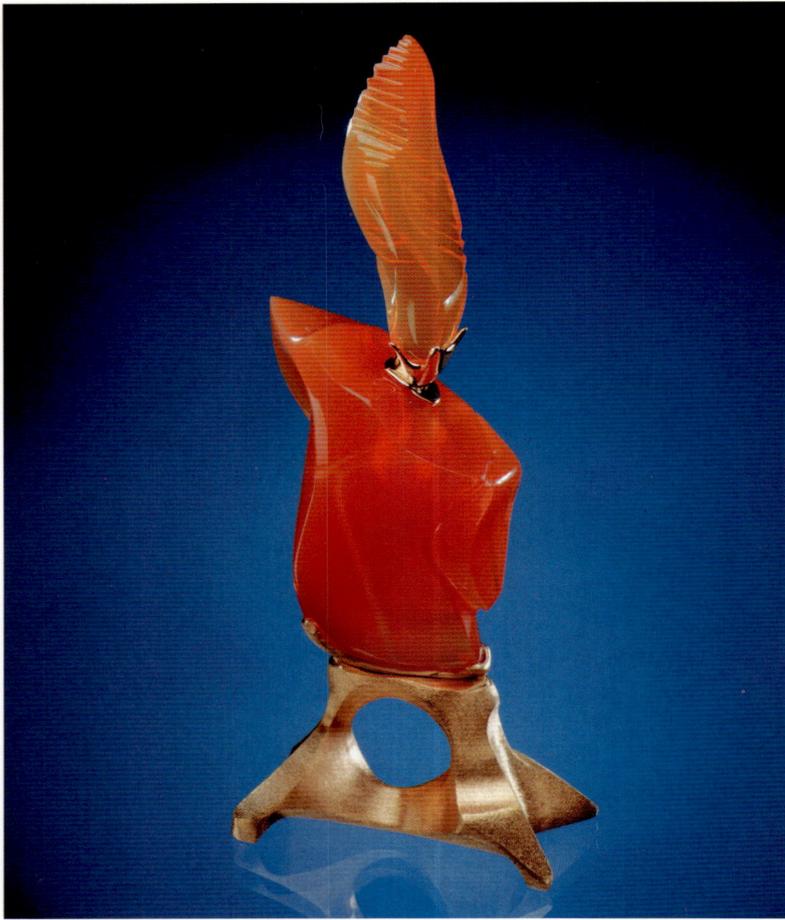

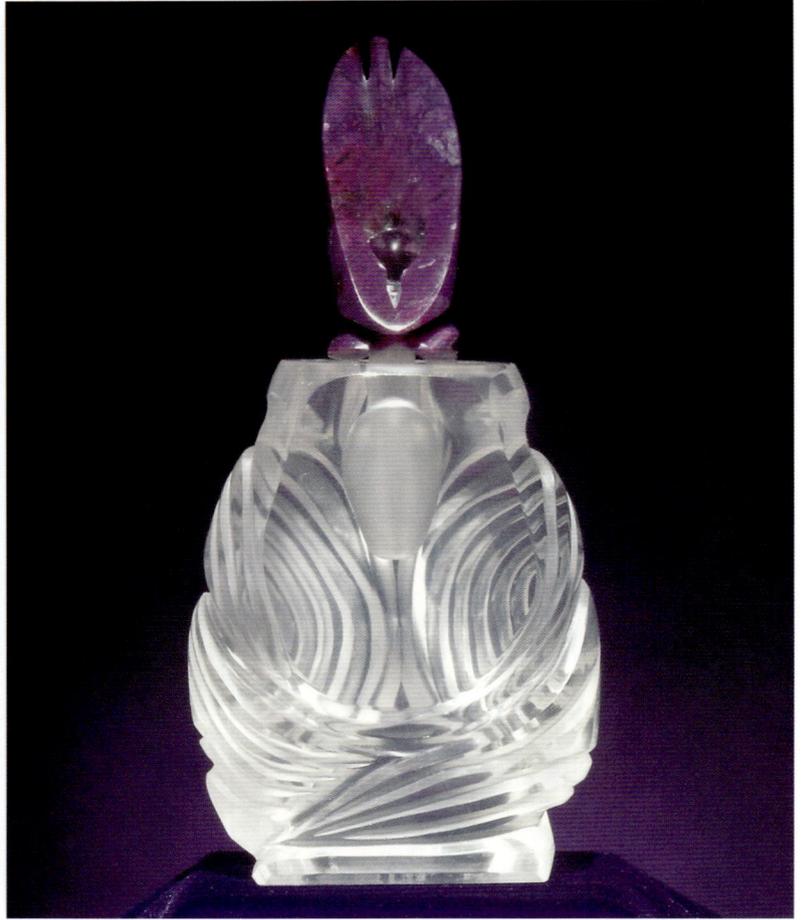

LEFT: *Chariot of Fire*, fire opal (247 grams) with 18-carat gold stopper on gold-plated bronze, 6″, Brazil
ABOVE: *White Nile*, essence bottle, smoky quartz with Sugulite stopper and gold, 5″
OPPOSITE LEFT: Essence bottle, citrine quartz with apatite stopper, Madagascar
OPPOSITE RIGHT: *Fantasia*, essence bottle, amethyst, 5″, Brazil

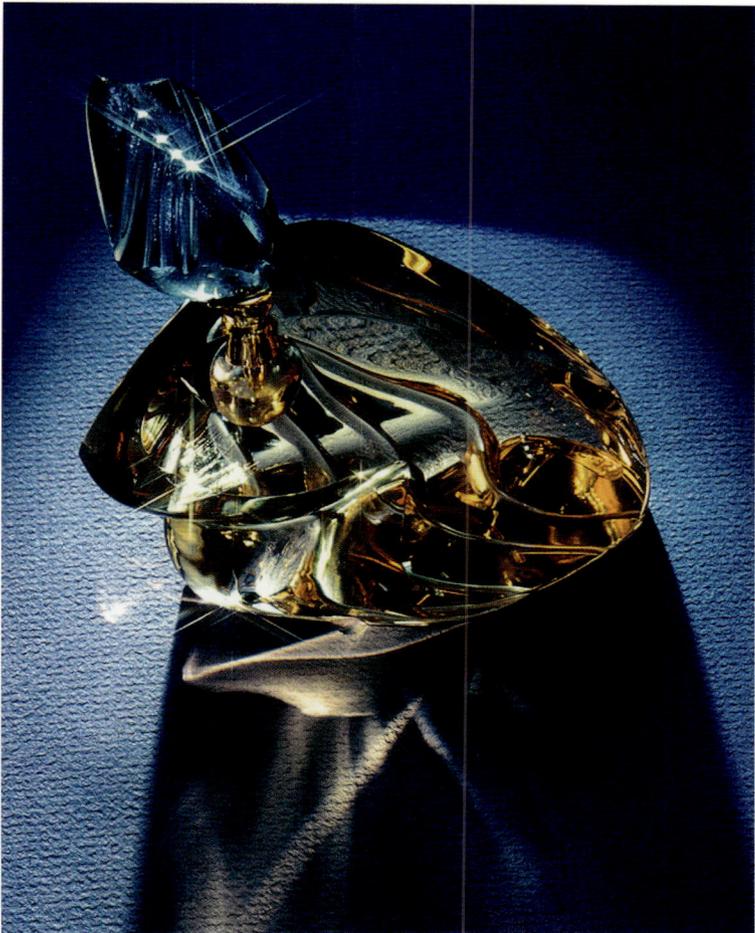
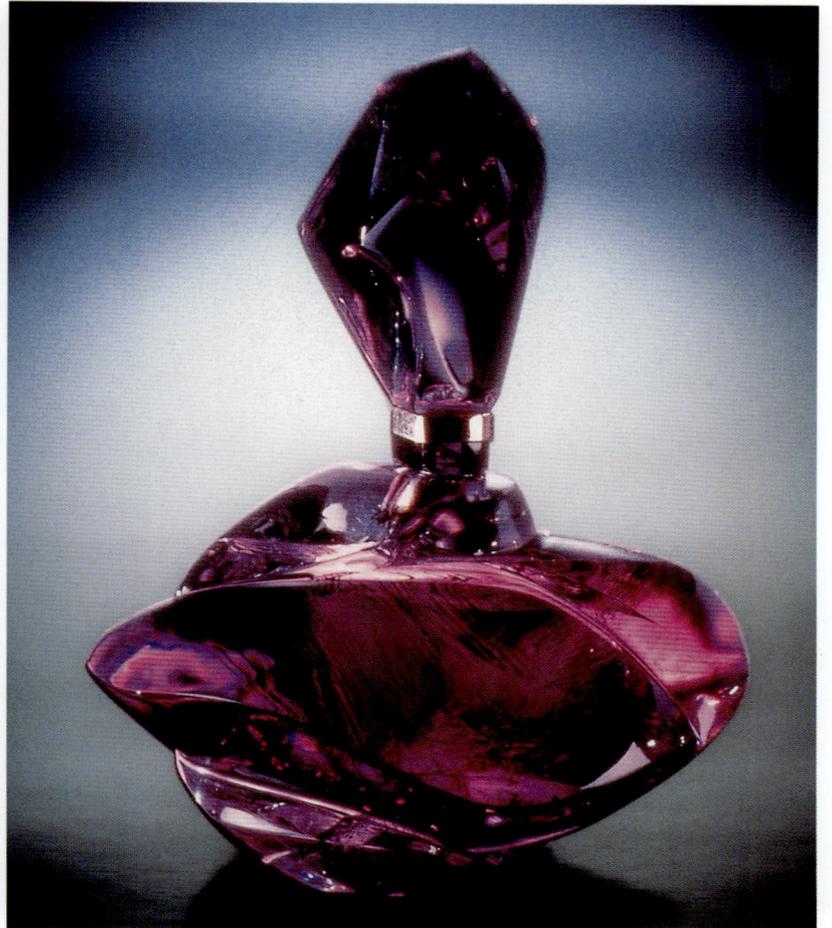

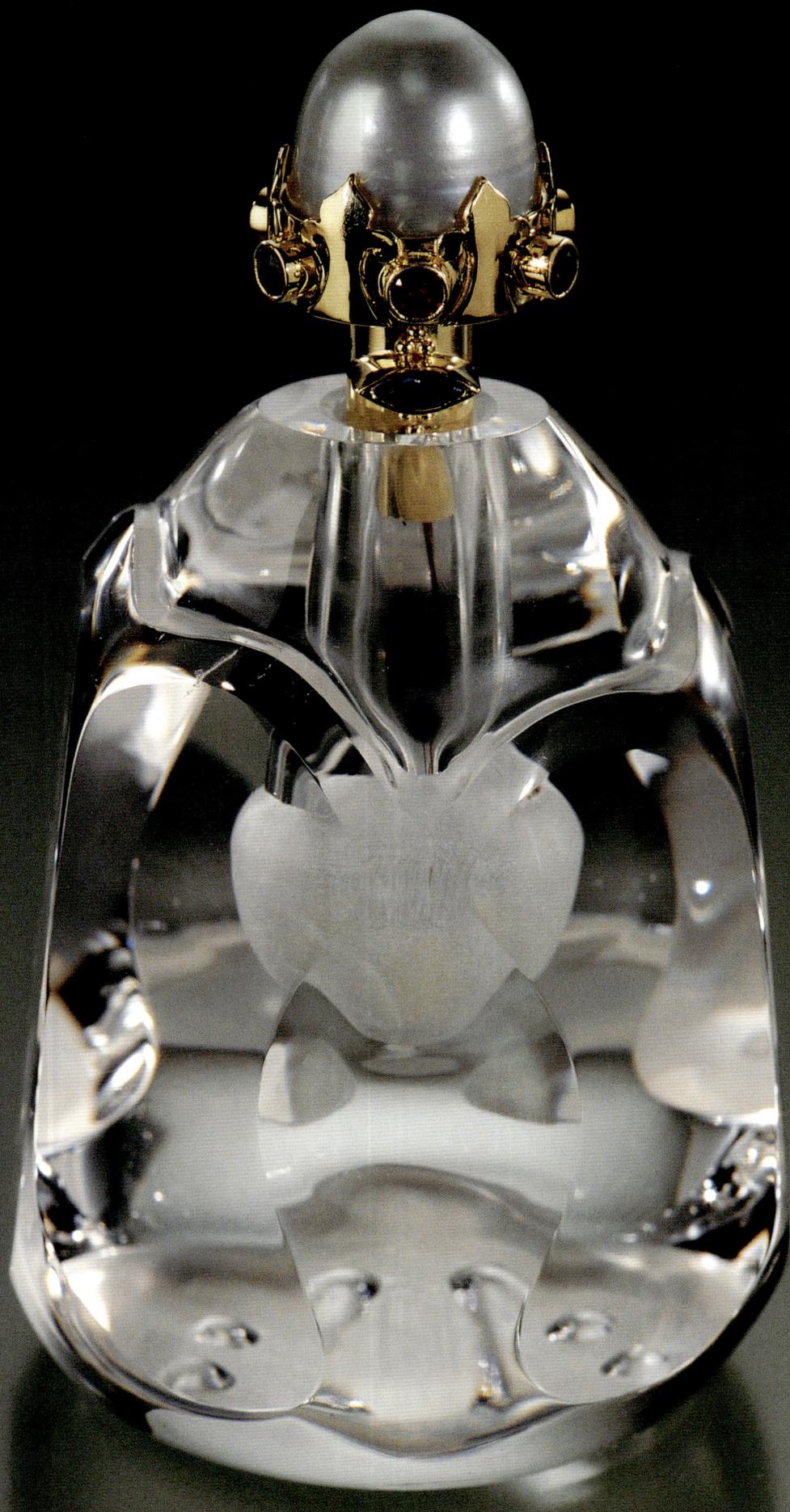

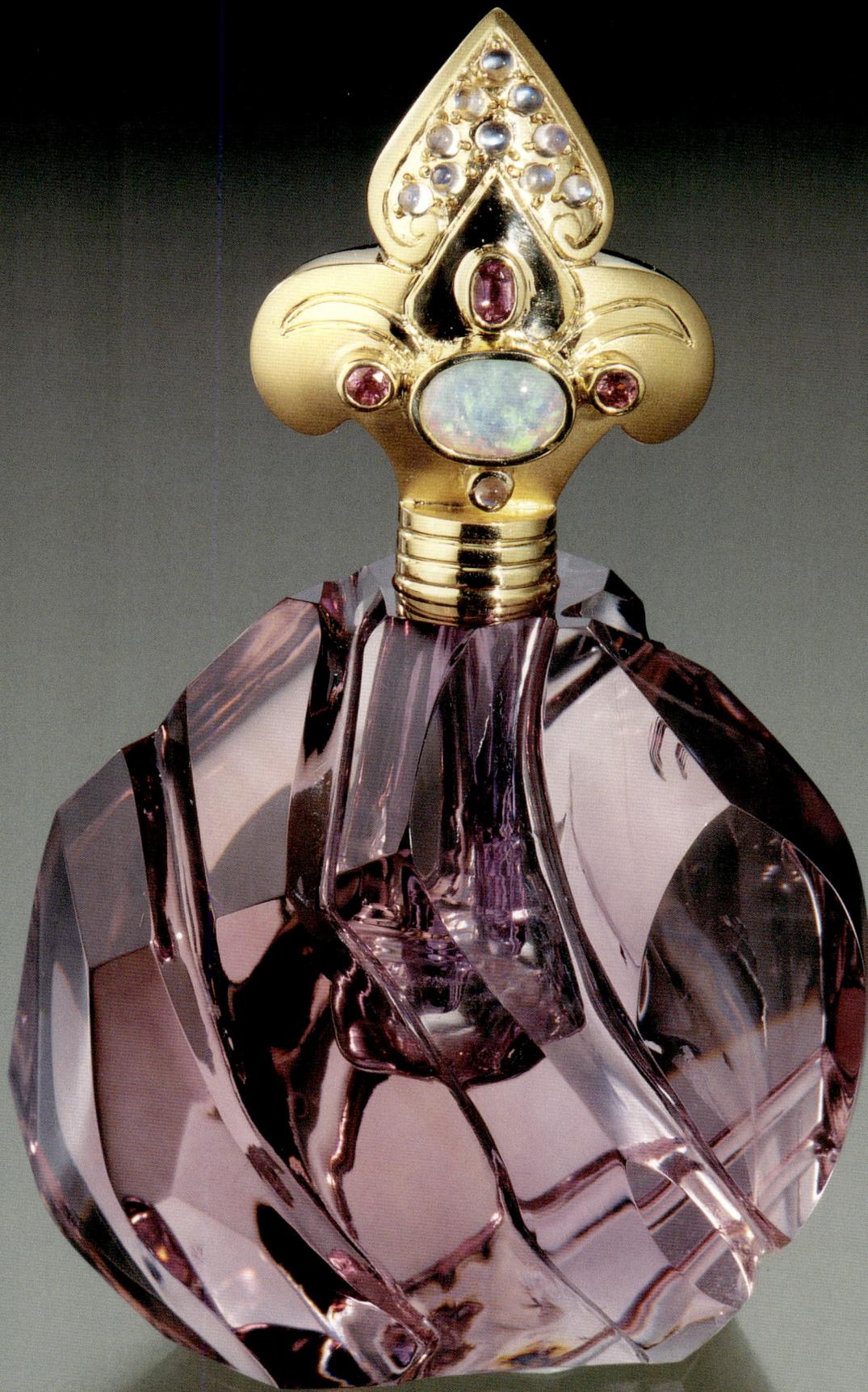

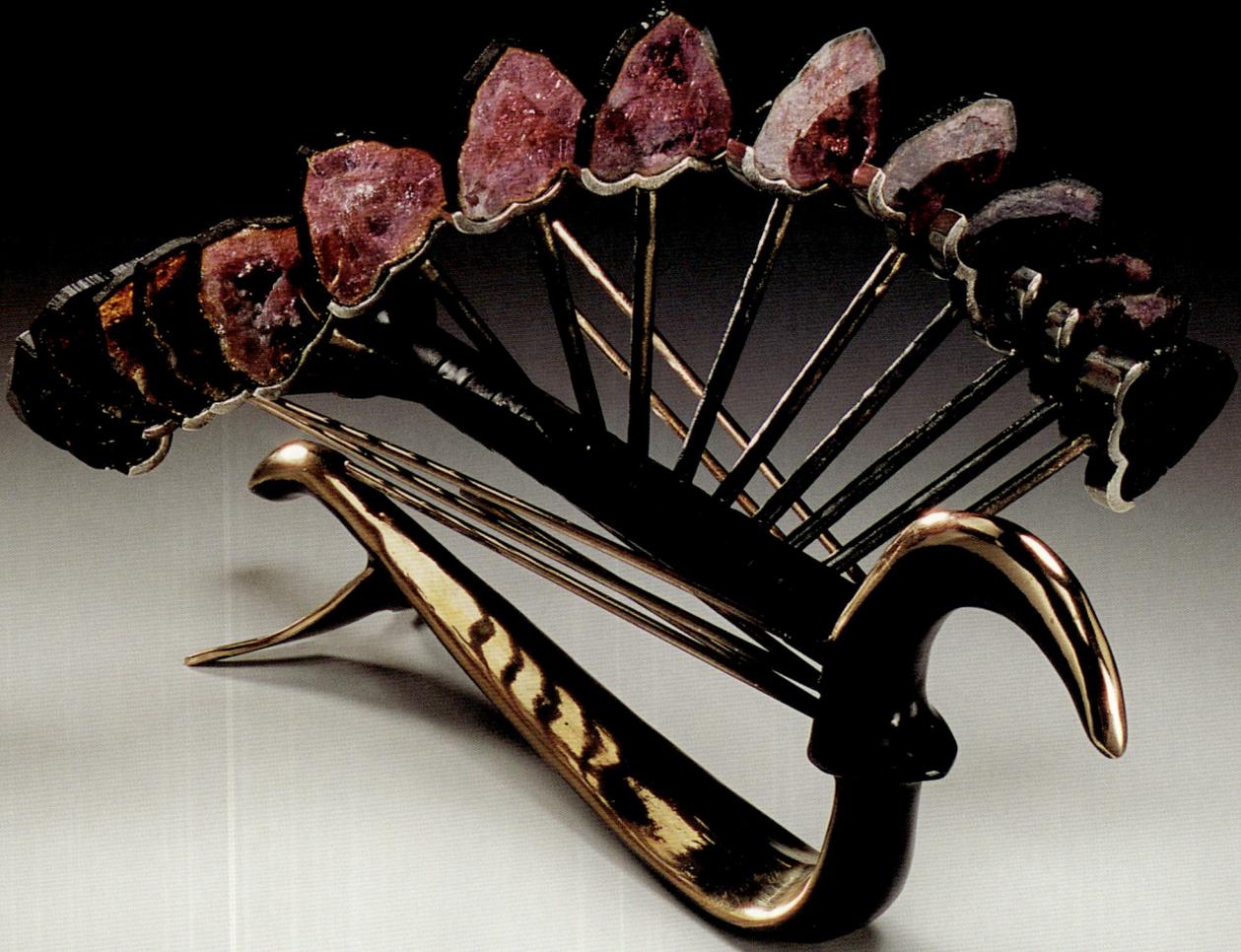

ABOVE: *Viking Ship*, pink tourmaline and bronze, 14″, Zambia
OPPOSITE: *Box of Rose*, rose quartz, 6″ x 4¾″ x 3¼″, Madagascar

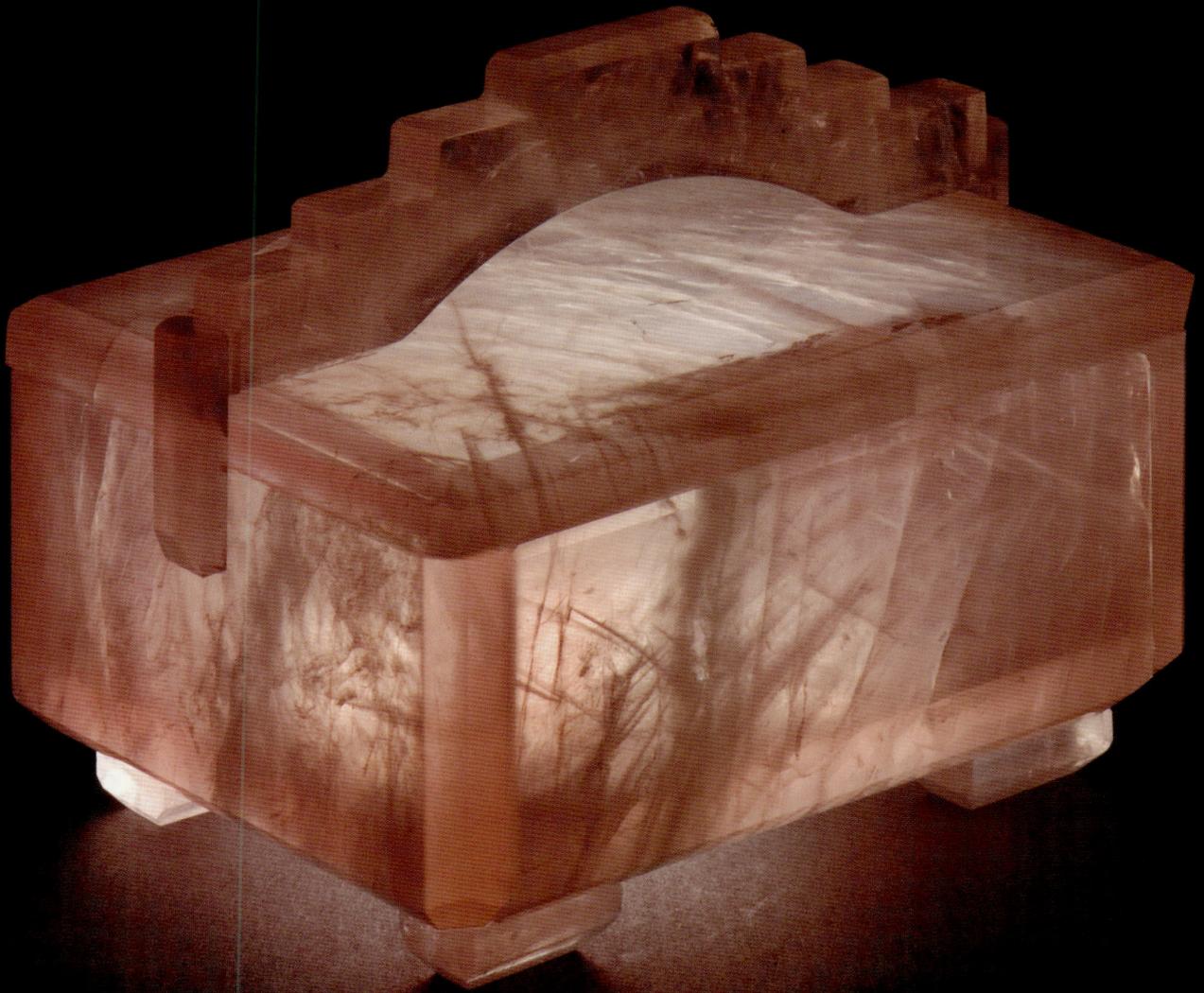

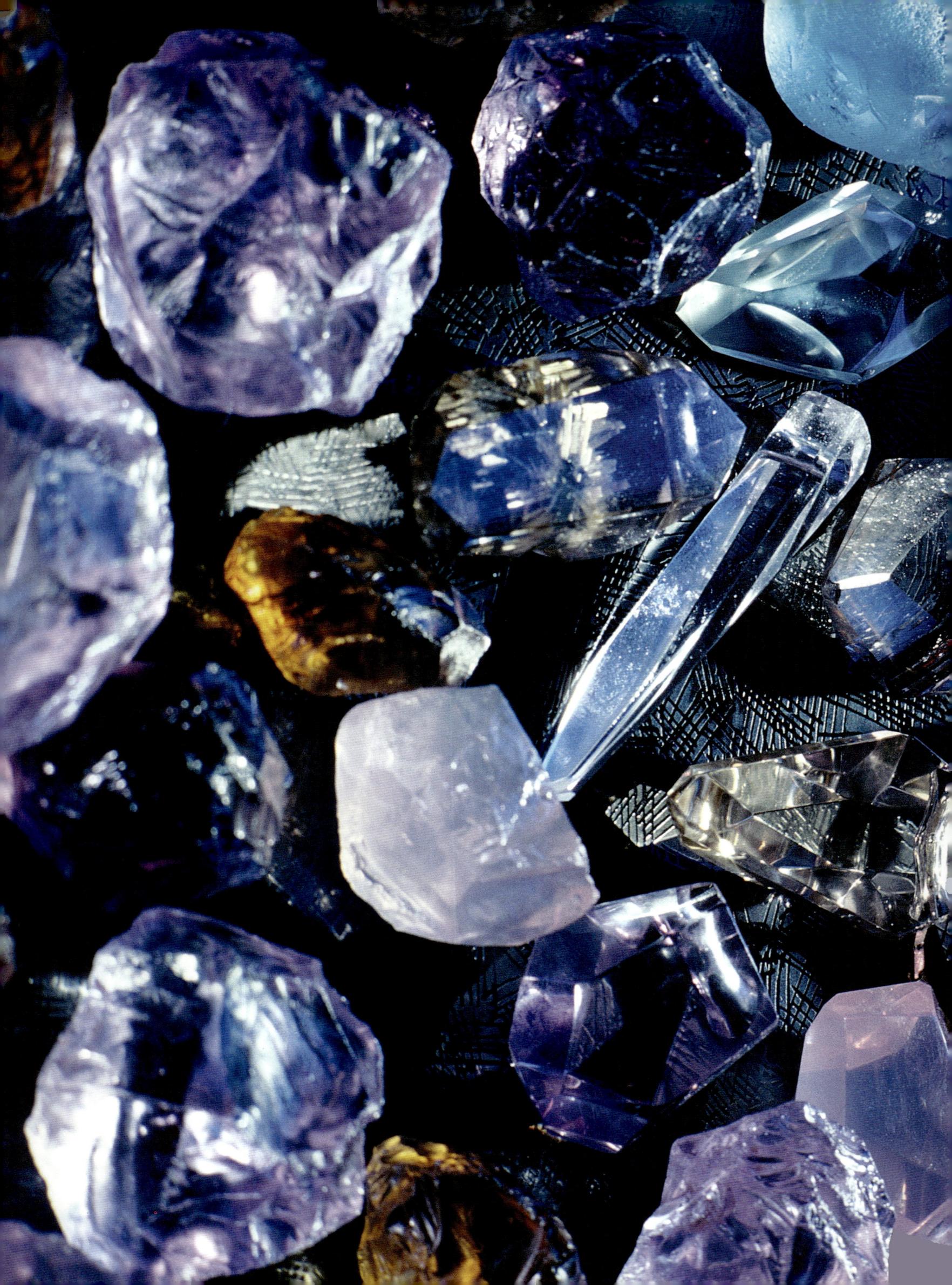

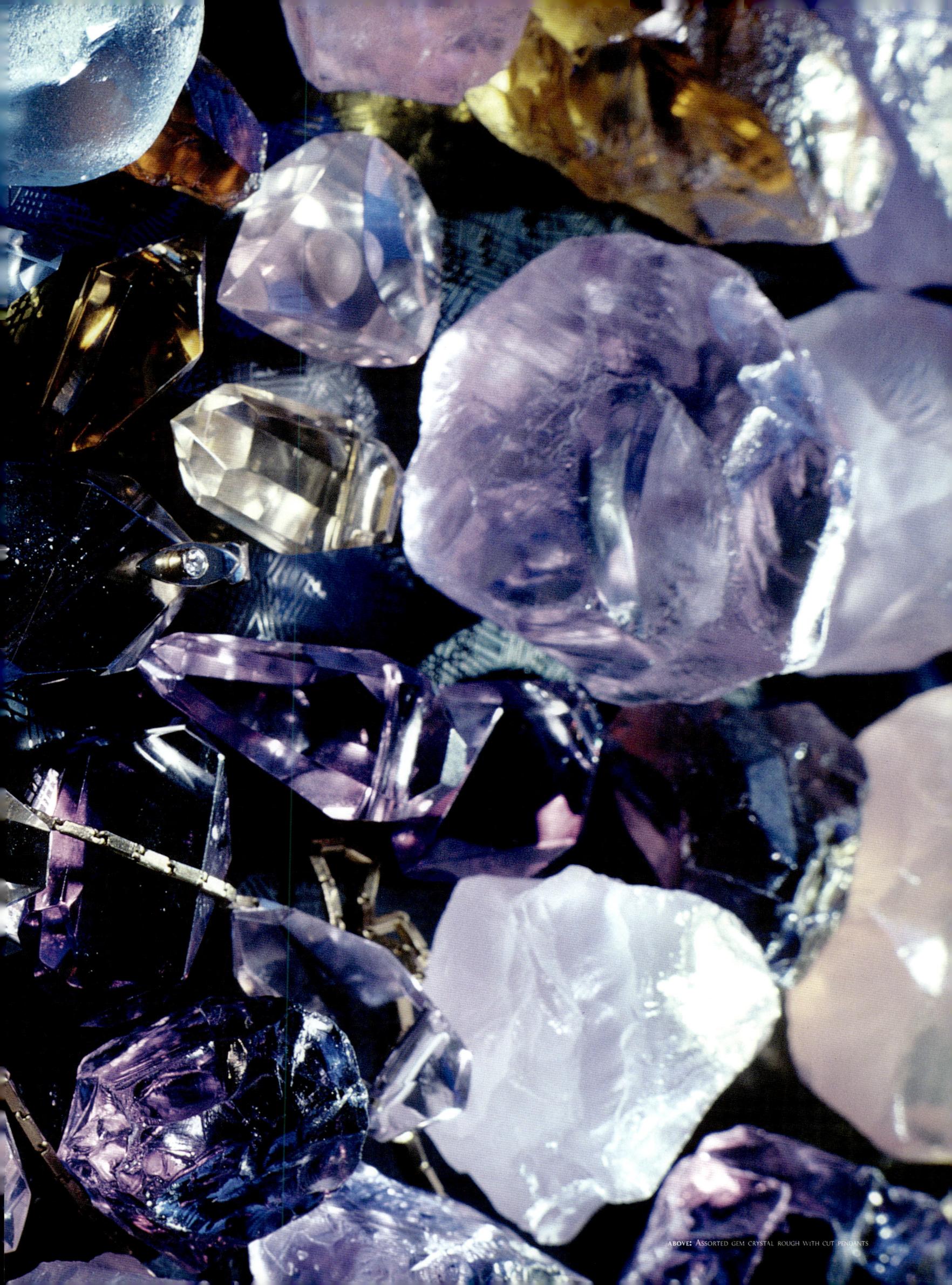

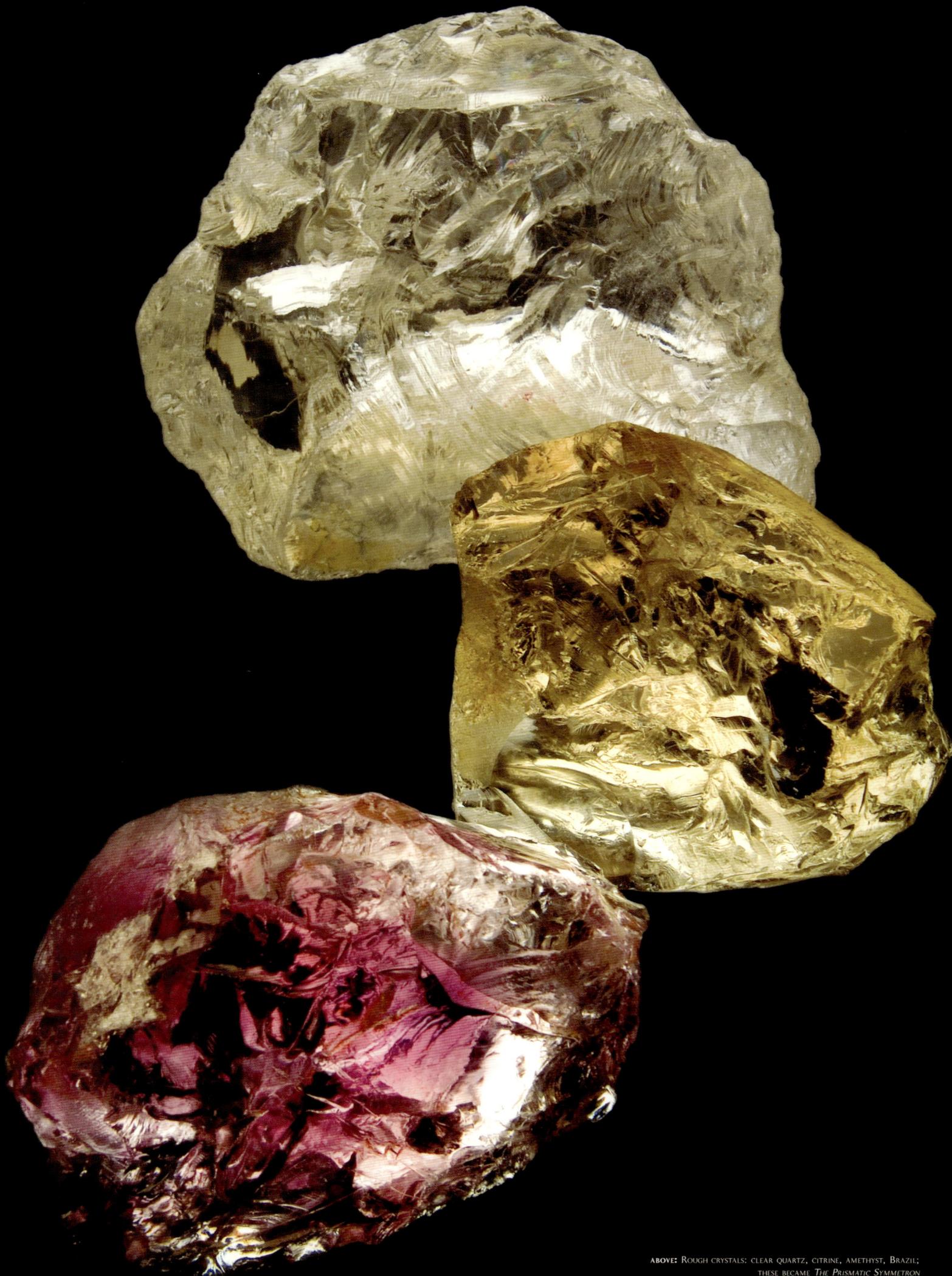

ABOVE: Rough crystals: clear quartz, citrine, amethyst, Brazil; these became *The Prismatic Symmetron*

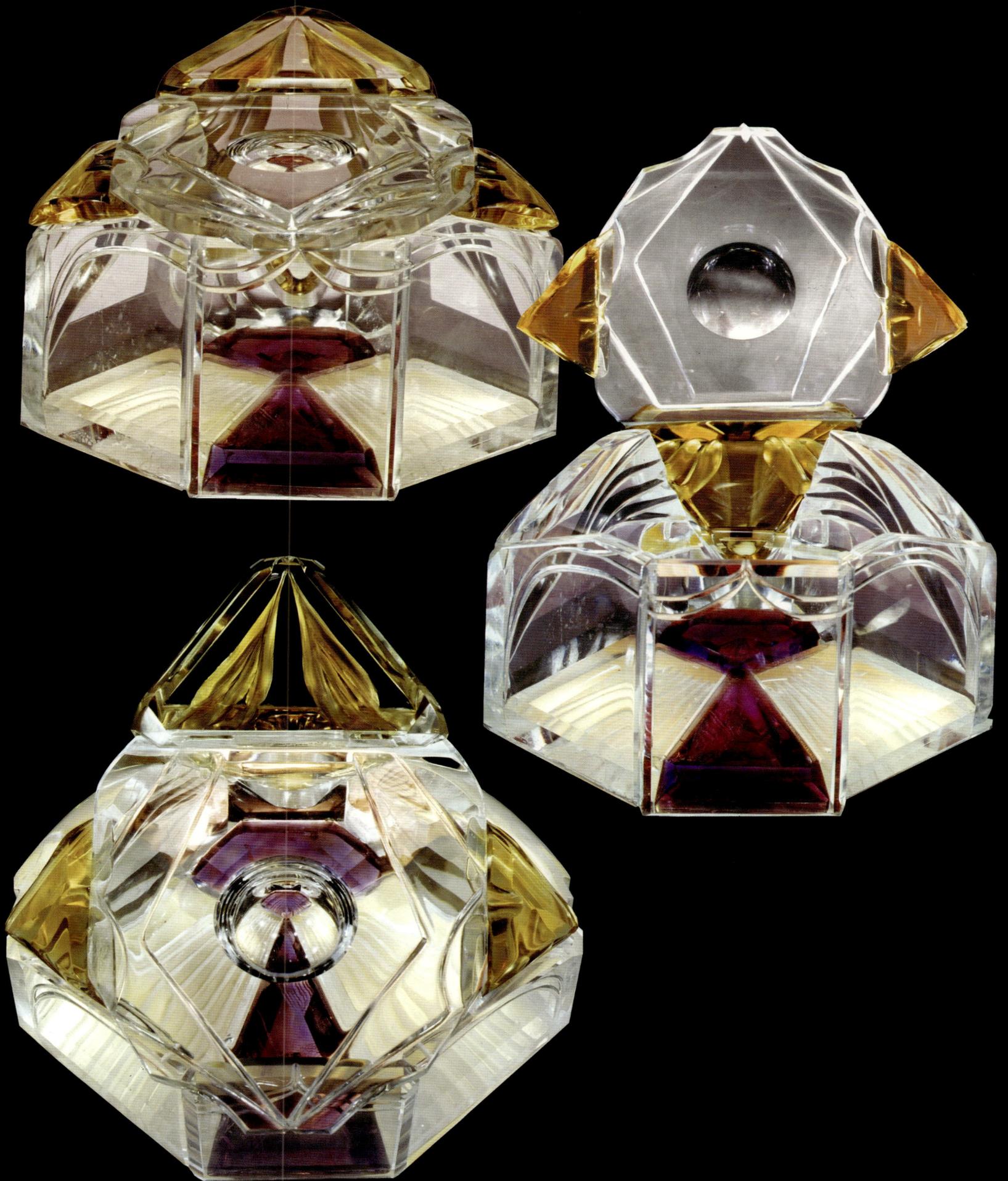

ABOVE: *The Prismatic Symmetron*, a transparent gemstone container of clear quartz, citrine, and amethyst, with a hinging system made from translucent agate (assisted by Gene Morgan), 7" x 7" x 5"

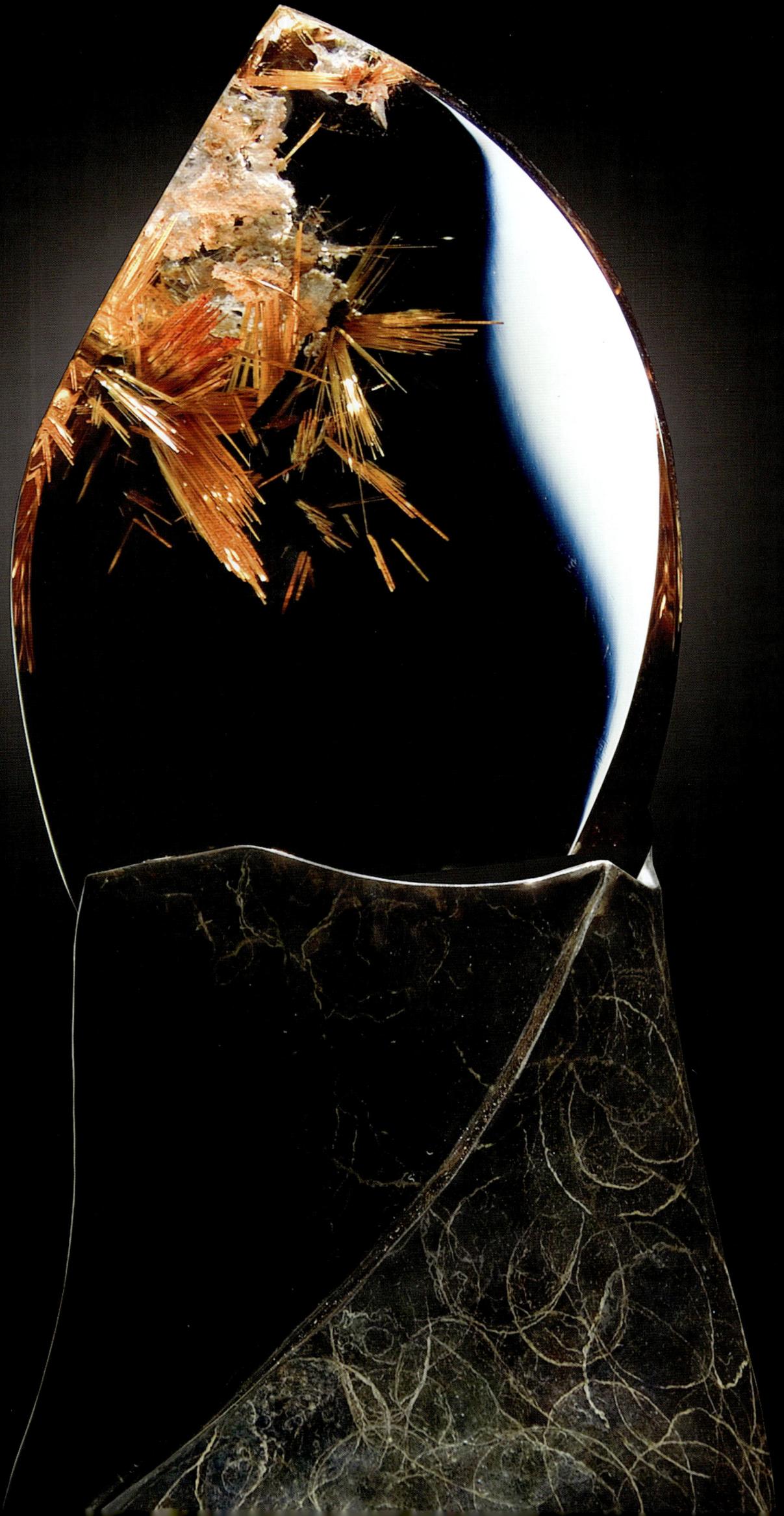

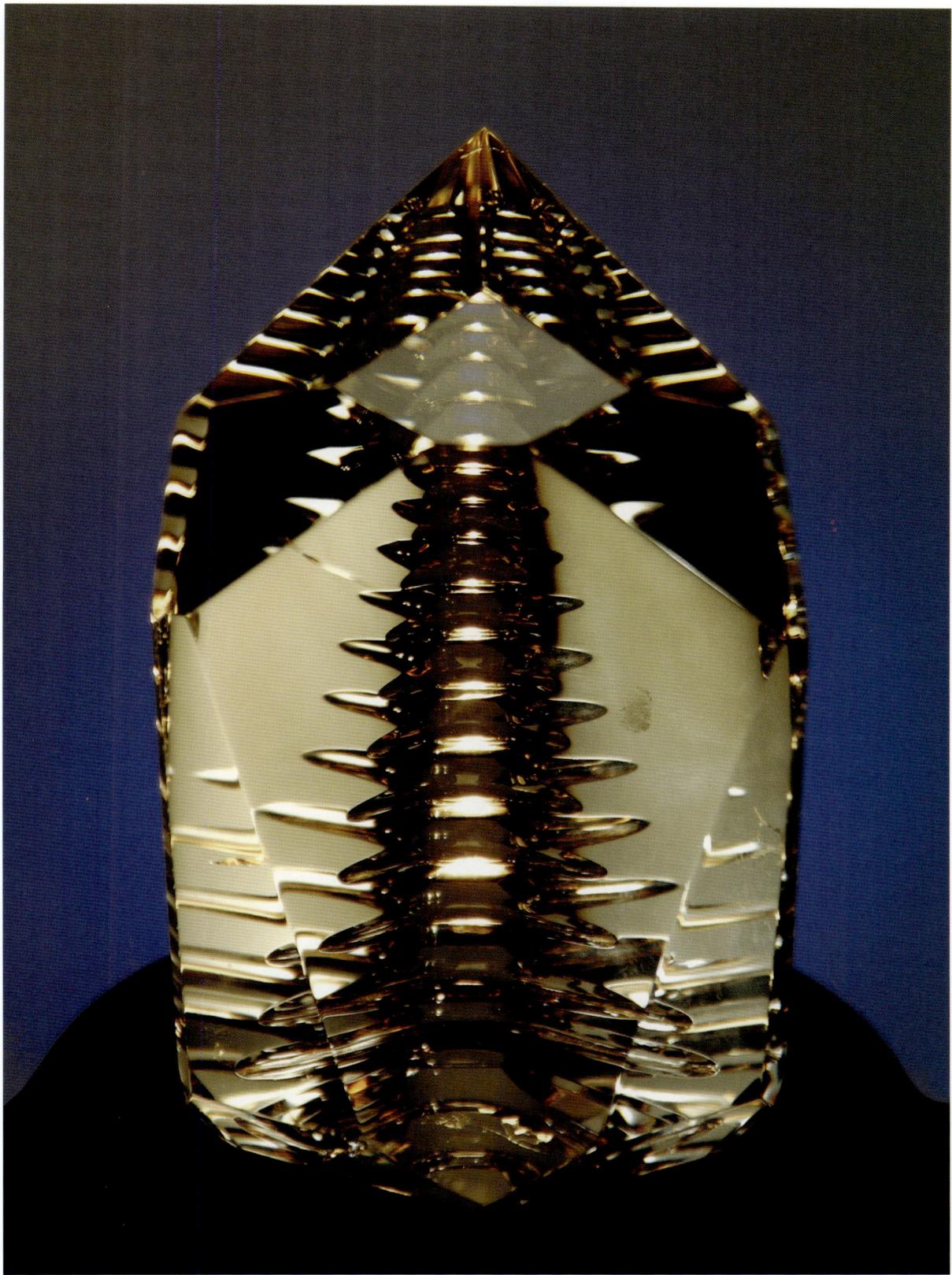

OPPOSITE: *Star Power*, star rutile in quartz, 9″, Brazil
ABOVE: *Inner Space Station*, *Citrine* quartz, 6″, Brazil

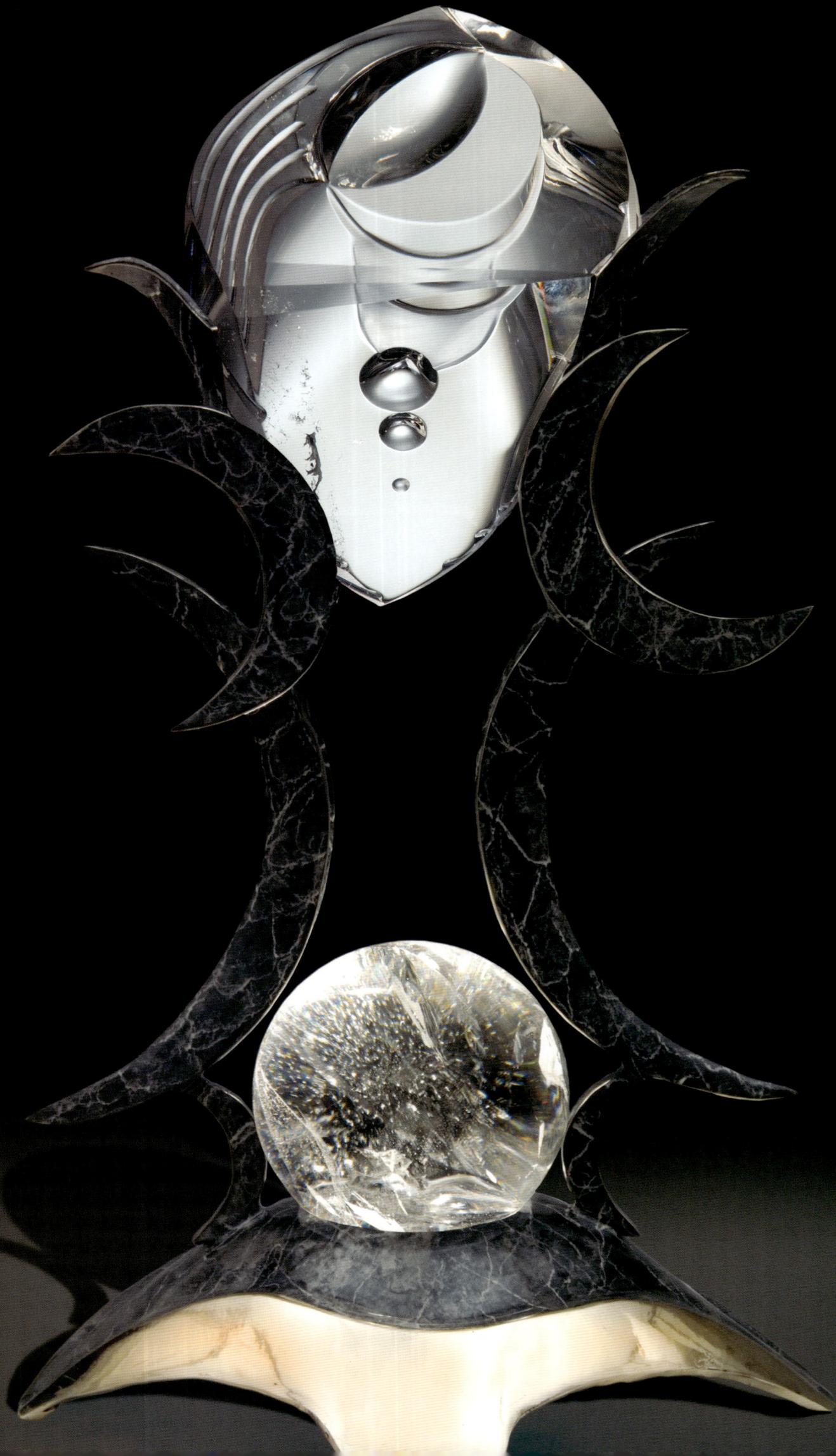

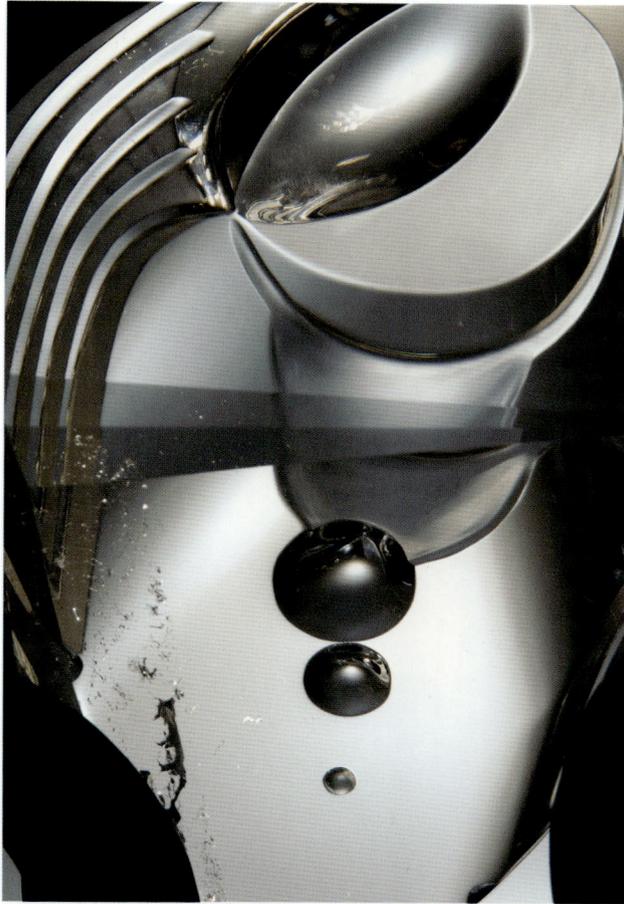

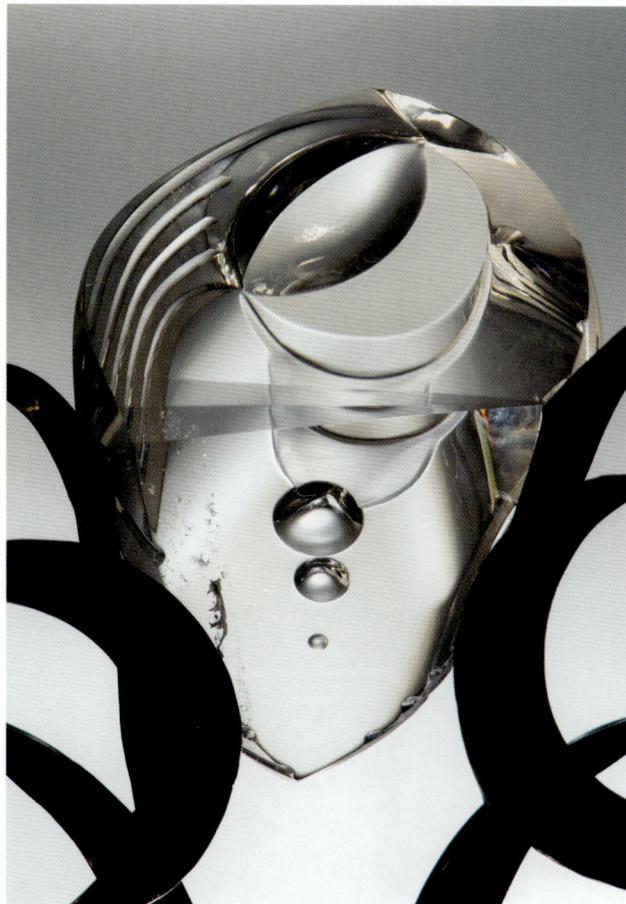

OPPOSITE AND ABOVE: *CHAIN OF MOONS*, ELECTRONIC-GRADE QUARTZ, 16″, BRAZIL

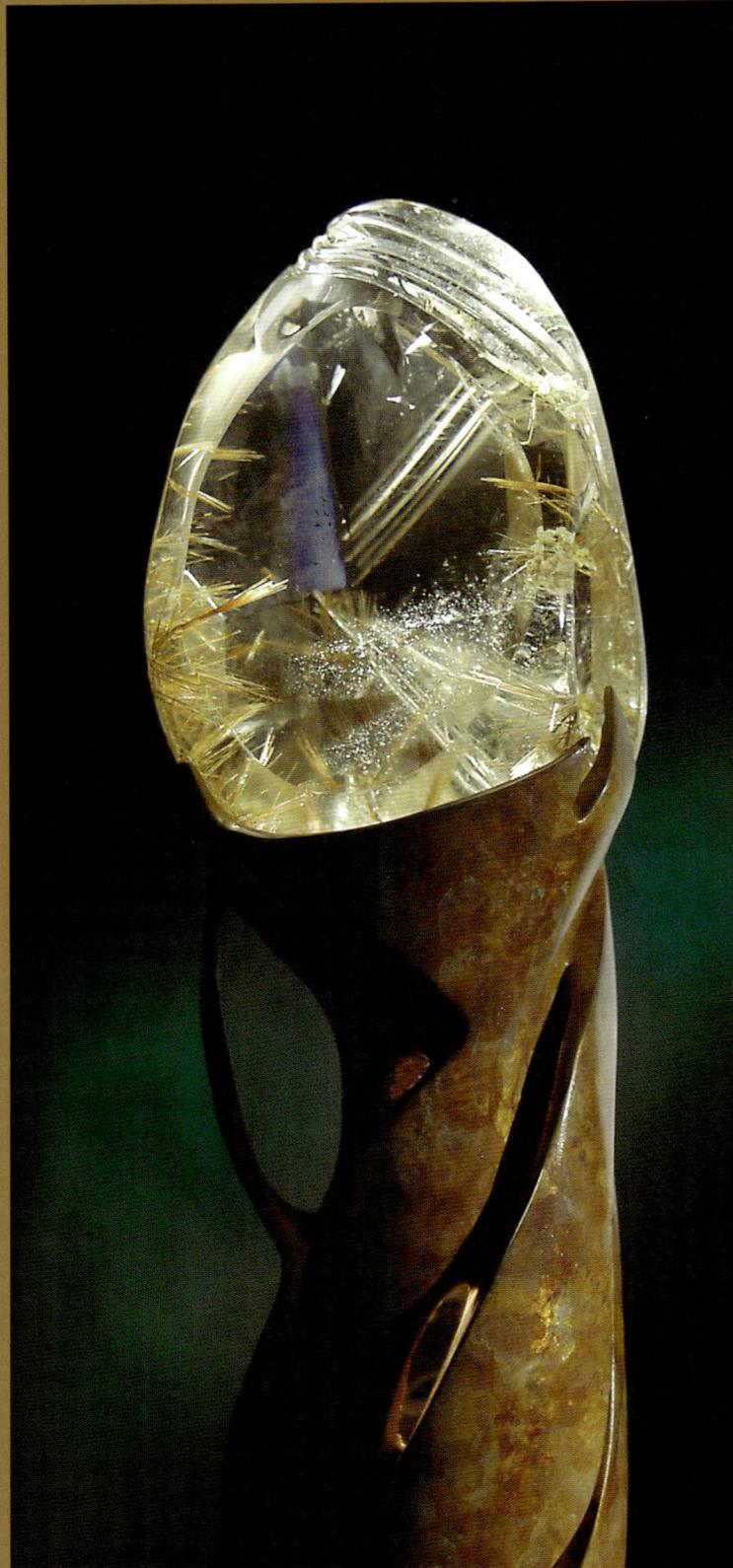

ABOVE: *Spark of Life*, rutile in quartz, 15", Brazil
OPPOSITE: *Sunrise in the Mind*, citrine quartz, 22", Madagascar

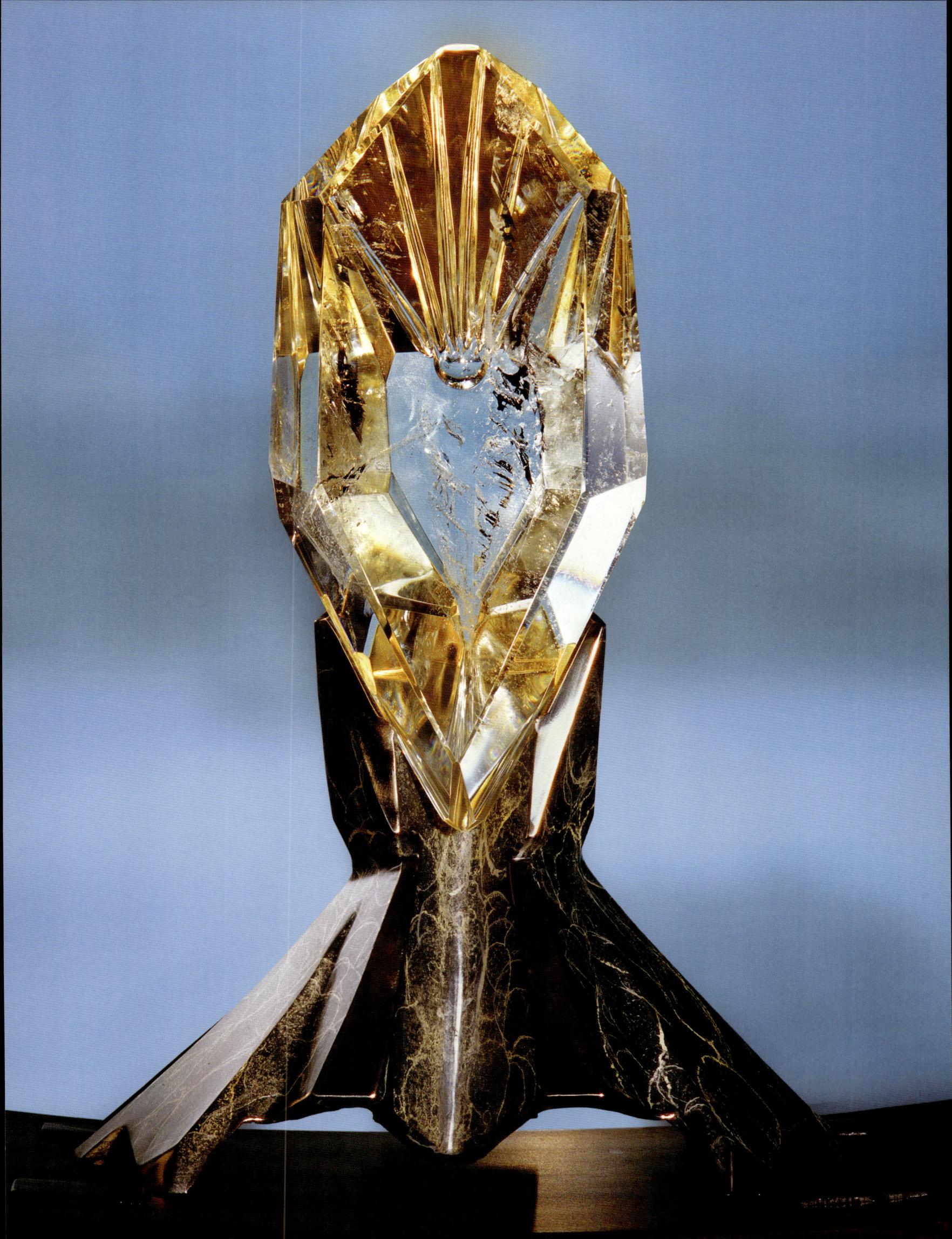

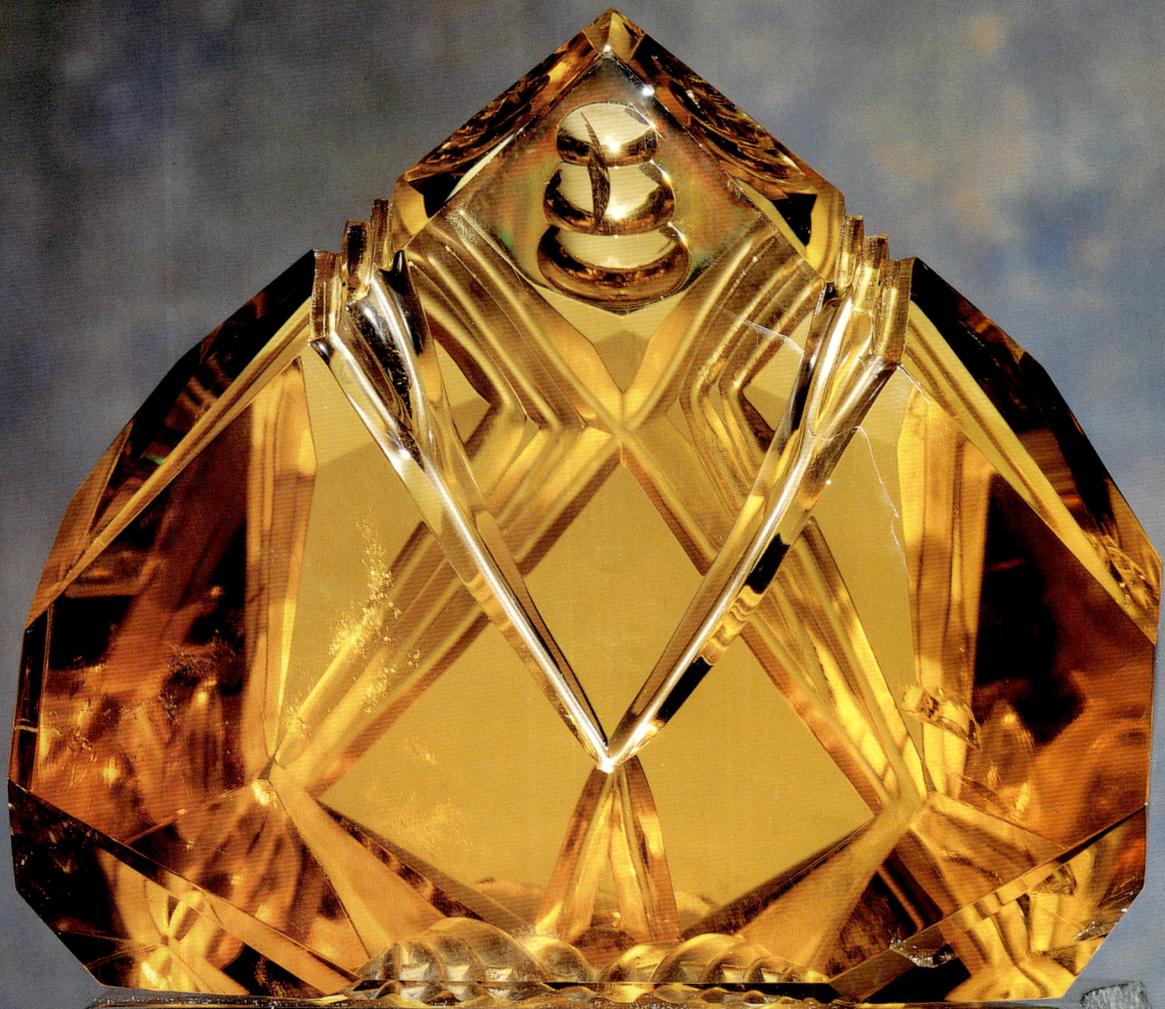

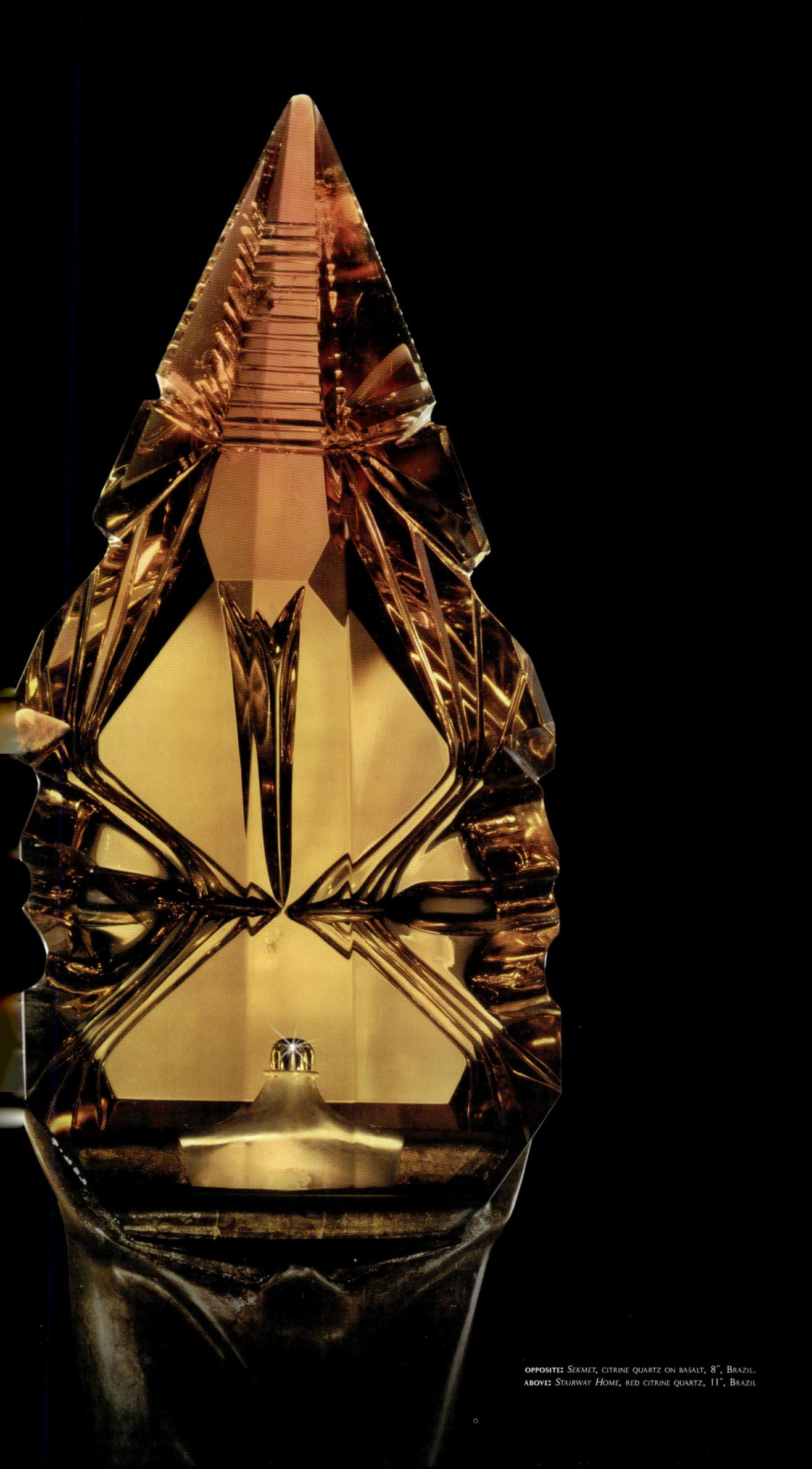

OPPOSITE: *SEKMET*, CITRINE QUARTZ ON BASALT, 8″, BRAZIL.
ABOVE: *STAIRWAY HOME*, RED CITRINE QUARTZ, 11″, BRAZIL.

3
WRITTEN IN STONE

CRYSTAL CONSERVANCY

In 1985, I encountered the largest crystal I had ever seen, weighing 67 pounds. I could feel my molecules rearranging themselves the moment I saw this crystal, because in it, I saw my destiny. After Glenn Lehrer and I cut and polished it, the crystal became known as the *Empress of Lemuria*. Every crystal I had worked with prior to the *Empress* had fit in the palm of my hand. We carried the weight of this crystal in our arms like a loved one.

In those days, the bigger the crystal, the more excited I got. The logic was simple: I love small crystals, so I will love large ones that much more. It wasn't long before larger and larger crystals came to me. These giants were unearthed from time to time in the crystal-rich countries of Brazil, Madagascar, and Russia, as well as parts of Africa, but no one seemed to know what to do with them. They had undetermined commercial value because there was no marketplace.

While Glenn and I were pioneering the tools and technology of cutting these megagems, we couldn't afford to continually muster the money and time that these giants required. With no market to establish their value, we wondered how to create awareness and appreciation of these natural treasures.

In 1985, there was no one else doing lapidary to enhance the large crystals' natural beauty. Within five short years, however, the interest in crystals had grown in our culture to such a degree that cutting factories began operating in Brazil and Madagascar. The most immediate market for giant crystals has been for cutting them into smaller, more manageable and saleable shapes and sizes. This is a regular practice now in Brazil, where the majority of large crystals are unearthed. For example, a 1500-pound crystal might be cut into hundreds of small crystal shapes, or several crystal balls. The economic need to do this is understandable.

"Crystal Conservancy," a concept I developed with my dear friend Franc Sloan, is a term for an awareness of and commitment to preserve the grandeur of the finest giant crystals, so as to display their majesty to the world.

THINKING BIG

The lapidary tools and techniques that existed in America when I began cutting crystals in 1983 were engineered either for the diminutive world of the gem trade or the wafer-thin world of electronics. There was no way to cut and polish large chunks with tools designed to facet small chips. At that time, a "large" cut crystal was two inches long and weighed a few ounces (still bigger than all but the largest diamond in the world). Traditional lapidary was geared toward sparkle-sized faceted stones, fragments that could get lost if you dropped them on the floor. I wanted to cut stones that were too heavy to lift off the floor.

So, how to get from the facet-oriented tooling to cutting megagems? Think big. In our quest to cut crystals of increasing size and complexity, Glenn and I did what trailblazers do: we identified our destination and then set out step-by-step through the bush. A lot of trailblazing involves finding oneself at a dead end, or standing at the foot of obstacles that seem insurmountable and then finding ways around them. In retrospect, the answers were a combination of small, relatively simple resolutions that needed to be strung together in the right sequence. But the key ingredients were imagining the outcome we wanted and having the unbending desire and perseverance to achieve it, coupled with an unwavering belief it could be done. And we also did the obvious: designed tools that were bigger and could accommodate larger work. We also unabashedly borrowed and adapted machines from other professions, including dentistry, automobile manufacture and repair, monument fabrication, and masonry.

Glenn and I were evolving our own techniques and technology in a virtual Darwinian Galápagos Islands of invention. Concurrently, a handful of other North American gem artists were figuring out their own garage-band lapidary styles, inventing very innovative carving and faceting techniques. And on the other side of the world was the city of Idar-Oberstein, Germany, the gem-carving capital of the world, with centuries of tradition, technique, and technology.

Initially, Glenn and I had no awareness that such a tradition existed: we had had no contact with the mainland of lapidary, instead existing on our own little islands. We had to forge through the unknown, having neither the advantages of generations of craft nor mentors to point us in the right direction when we were facing backward. But what we lacked in experience we made up for with fresh eyes and ideas we might have missed had we been confined to the prevailing beliefs and traditions of lapidary. (As our careers later developed and diverged, Glenn and I eventually did incorporate carving technologies originating in Idar-Oberstein.)

Because we never had the limitation of someone telling us how it was supposed to be done, the sky was our limit. The disadvantage

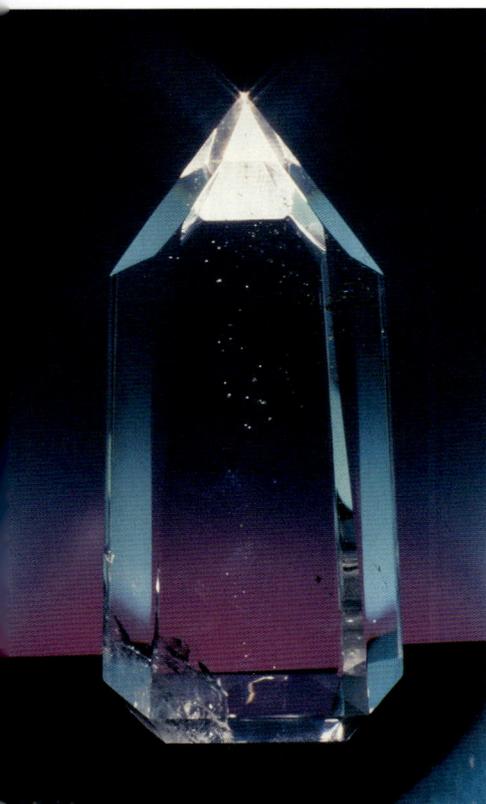

ABOVE: *EMPRESS OF LEMURIA*, QUARTZ, 16″, BRAZIL; CUT WITH GLENN LEHRER

was that there had to be a lot of trial and error: one has to be willing to be wrong in the pursuit of what's right. The advantage was that there was no one assuring us that we could not accomplish what we set out to do. Occasionally, I would meet someone quite knowledgeable and convincing about the impossibility of cutting huge crystals; my response would simply be "Then I'll just have to figure out how to do it." Naïveté can be a marvelous ally.

PRESERVATION

For more than a century, industry has cut quartz in exact, repeatable configurations, providing enormous benefit to humanity through technology. At the same time, the slicing and dicing done for industry strips the "soul" from the crystal. It is like an old-growth redwood tree, thousands of years old, cut into so many board feet of lumber, essential for building: the essence and majesty of these ancient trees are lost in the process. The same is true for the ancient ones, the crystals.

While in Brazil sometime in the 1980s, I visited a warehouse that processed quartz mined for electronics. A worker walked by, and in his arms was one of the most pristine crystals I had ever seen, about 16 inches long, weighing about 45 pounds, perfectly shaped and crystal clear. As it whizzed past, it called out to me like an abducted child. I asked my host, "Where is he taking that crystal?" "He is taking it to the saw to be sliced into thin wafers" was the response. I will never forget the impact of that moment and the sorrow I felt. That crystal, possibly more than 40 million years old, is now probably so many faceted chips performing clockwork in quartz-accurate watches.

I have found that the best way to preserve a magnificent crystal is to make its beauty available for all to see. Something happens when I cut, shape, smooth, and polish the faces of a crystal. I am using grinding and polishing tools, but applying the tools of precision, care, and respect are equally important. Refining the crystal's outer shape, thus opening windows of transparency, allows you to be gripped by the world of its internal majesty. Once it has a hold on you, all that remains are the indisputable facts of its magnificence and the story of its existence. Its beauty is a treasure, and it feels good to share this bounty, preserving it for future generations.

The more respect a crystal is given, the more respect it will generate.

Billions of marketing dollars over the last two centuries have institutionalized the value of diamonds, which are not inherently valuable. Although they've been associated with European royalty since the thirteenth century and India since the sixth, their beauty and relative abundance, combined with sophisticated marketing, have made them universally desirable and accessible. Although an enormous diamond weighs as much as 100 carats, some megagem crystals are well over three million carats. Giant quartz crystals are equally rare and more challenging to cut, and yet are virtually unknown to the world. When a giant crystal is preserved and restored in its full majesty, it becomes more valued, insuring its preservation.

It has taken the last half century for our culture to gain an awareness of preserving the giant old-growth trees and forests. Because there are so few giant crystals, there is currently little awareness of preserving them. They are some of the most ancient, durable, and spectacular naturally occurring life forms of our planet, and yet in our world, there is only a sliver of awareness that they even exist. Having lain dormant for millions of years, they are being unearthed across the globe at an increasing rate and are regularly at risk of being cut into smaller pieces for commercial applications. With an awareness of Crystal Conservancy, this will change.

The process of restoration for these giants can last a year, sometimes more. Through this process, the crystal transforms, becoming a synergy of rarified earth, advanced lapidary technology, and articulate craftsmanship, culminating in a lasting expression of the splendor of life on earth, which future generations may behold and, perhaps, become enriched by.

BAHIA

In 1983, Glenn and I embarked on an adventure together, exploring the mystical qualities of crystals and the arcane process of cutting and shaping them. The culmination of our ten-year journey was the creation of the megagem sculpture *Bahia*.

Glenn and I frequented the same circle of friends. I knew him as a talented gem cutter, but had no interest in stones or jewelry myself until one day when I saw Glenn wearing a crystal pendant he had fashioned. It so captivated me that I told him, "You have to show me how you did that." Fortunately, he was gracious enough to accommodate my demand. Glenn and I spent the next seven years almost inseparable, figuring out through trial and error the tools and techniques that would allow us to cut larger and larger crystals. Our obsession powered us through the difficulties and challenges of

ABOVE: *Bahia* with Lawrence and Glenn.

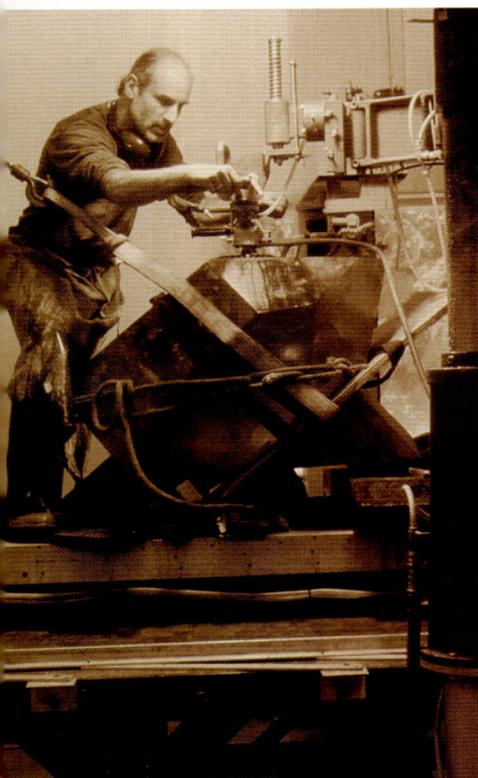

TOP: LAWRENCE, TIM TURCO, AND PETER W. SMALL HOISTING 1000-POUND CRYSTAL INTO SAW. MIDDLE: PREPOLISHING CRYSTAL TIP ABOVE: LAWRENCE WORKING ON *THE GOLDEN ONE*

uncharted territory. We were the Lewis and Clark of crystal cutting, mapping a frontier of the great Unknown. And like most explorers, we had to learn to survive while we figured out where we were going.

We were passionate and doggedly determined to succeed. Had we been smarter, we might have gotten day jobs to support our families. But we were just naïve enough to plow into our shared passion, taking on each new challenge that presented itself with a "we can figure this out" attitude. *Bahia* was the culminating project that not only extended us artistically, but was formative in shaping who we were each to become.

The grinding that Glenn and I did over the years was not simply for the crystals we fashioned. The intense process of working together to pioneer a new art form forced us to continually shed the skins of our "lesser" selves to grow into new people. We had no choice; it was either work through our problems or never see one another again. With the help of our loving wives, Shanon and Sunni, we continually chose the less comfortable path of working it out. The result of our willingness to evolve our friendship and place it ahead of hardships was ultimately rewarded by the creation of *Bahia*. *Bahia* was birthed from our commitment to maintain the integrity of our friendship, knowing if we did this, we could work through any other problems physical matter might throw at us—such as sculpting a spectacular 800-pound rutilated crystal. We were joined in our endeavor by the brilliant efforts of metal sculptor Pepe Ozán.

When admiring a work of art, the observer sees only the art. But beyond the curves and facets, the artist sees reflections, the agonies and joys comprising the process that changes one's life forever.

For Glenn and me, *Bahia* was this kind of art.

THE GOLDEN ONE

The Golden One is the name given to a massive citrine quartz crystal unearthed in Zambia, equatorial Africa, remarkable because of its size, internal clarity, majestic golden color, and presence. At 900 kilos (almost 2000 pounds), the crystal's outer skin wore the weathering of millions of years, while retaining the beautiful symmetry of the hexagonal crystal shape. The tip, however, had been sheared off. Restoring the original crystal shape inspired my approach to reinstate the majesty of this ancient stone.

Gemstones, even the largest ones, are measured in carats. The approximate finished weight of *The Golden One* is 3,178,000 carats (over 1400 pounds). It stands approximately 3 feet tall, 2 feet wide, and 18 inches deep, and appears much larger in person because the mind's eye is able to fully experience the volume of transparent three-dimensionality.

Work on *The Golden One* began in 1997 in the CrystalWorks Studio in central Oregon. New tools and techniques were developed to accommodate the cutting of such a massive crystal. As the crystal became more internally clear from the polishing process, those of us witnessing it became spellbound with the plays of light and the numerous dancing rainbows that floated in the vast sea of transparent golden quartz. Because of this gem's transparent depth, the eye can descend into it. Never before have we been able to look so deeply into such a vast terrain of some of the earth's densest matter.

I needed to build a second studio to accomplish the cutting and finishing of *The Golden One*. I also needed to invent a system to move the massive stone around. I solicited the help of engineer (and all-around problem solver) Peter W. Small to help me design and fabricate a cutting technology that would work. My research led me to monument carving, whose tools could cut giant blocks of granite and marble. I purchased a small (by industry standards) wire saw, which was 12 feet tall. Peter built a huge concrete table/runway. We then designed, and Peter built, a carriage to carry the stone. Under the carriage we placed pontoons, one on each corner. Attached to each pontoon was a garden hose fed by well water. When the hose was turned on, the pontoons lifted the more than 2500 pounds of crystal and steel. I could then maneuver the crystal with the touch of a finger to any location on the table. Peter also rigged up a pulley system with a cable from his old hang glider. With a few pounds of weight from some discarded barbells placed in a bucket on one end and the carriage on the other, the crystal was drawn through, being cut with a diamond-beaded wire blade. This system, while inventive and functional, was wrought with challenge after challenge, day in and day out; the process of rough shaping the crystal took more than a year.

Two years after I finished the three-year process of working *The Golden One* I had the opportunity to meet the miner who had unearthed the giant crystal in Zambia. I was brimming with questions, the answers to which might fill in some of the life story of this magnificent creature, and give me an idea of what occurred in the millions of years leading up to our being introduced.

Nassim Doost and his family had been mining for aquamarines in a northeastern tropical region. He told me that this crystal had been found in a sandy pit uncharacteristic of the geological environment that would produce such a specimen. He went on to say that as several men burrowed into the earth looking for very small aqua crystals, the thud of their shovels began to define the outline of something massive. As the entombing loam was scraped clear, they uncovered three crystals in the sandy soil. Instead of the earthen bed that was mineralogically expected, displaying the geological conditions to produce such specimens, the three crystals were stacked one on top of another.

Nassim's excitement exceeded mine as we puzzled over how this could have occurred. Were they shifted and transported by the geological forces of millions of years? Were they part of a pegmatite pocket that collapsed in an earthquake? Why had these crystals not shown the typical geological characteristics consistent with the mineralogical evidence of their growth, which presumably occurred in this location millions of years ago? How were they placed one on top of another? Upon excavation, it was discovered that the tip of the giant citrine was entirely sheared off. Yet Nassim was quick to point out that no chipped pieces or remnants of any kind were found in the pit. He looked at me and said with bemusement, "It appeared as if someone placed them there."

ELEVEN TEARS

The tragedy of September 11, 2001, left us all in pain and confusion. At that time, my wife Sunni and I envisioned a giant crystal placed at Ground Zero—a monument that would bring light and healing to our nation's collective wound. Nearly a year after the attack, I was humbled by the profound honor of participating in such an undertaking, facilitated by my friend Harvey Siegel.

Landscape architect Ken Smith won the jury-selected commission for a memorial at the headquarters of American Express. His vision was to create an intimate tribute to the victims and a powerful architectural vortex in the spacious lobby of the building, which had been badly damaged when the World Trade Center collapsed directly across the street.

The memorial consists of a pool of water mirrored by a canopy in the 35-foot ceiling. Uniting the space between this heaven and earth, a 600-pound, 11-sided sculpted quartz crystal suspended by 11 cables hovers two inches above the water. Drops of water intermittently fall from small holes in the ceiling, symbolizing tears for those lost, hence the name *Eleven Tears* for the eleven American Express employees killed.

The memorial crystal resonates with the determination, love, and care of each of the nearly one hundred craftspeople and many others who had combined their energies in this common goal of healing.

I was consumed for seven months. The fever-pitched work of sculpting the giant crystal seemed as if it were one endless day. At the final moment of installation, I stood quietly with architects and engineers around the memorial as the first drops of water began falling from the ceiling, rippling below the crystal in the pool at our feet. My eyes filled with tears as memories of the forceful events that compelled this monument broke over the space like a giant wave.

The next day, a tightly packed gathering of more than a thousand people attended the ceremony. In the afterglow, I stood next to one of the principals on the project. We both seemed to be in an altered state, reflecting the power of the moment. He turned to me and said, "When this tragedy first happened, we were left in shock, hollow and empty. We knew that we had to do something as we picked up the pieces of our lives, but we knew nothing could fill the void that was left. Yet we believed we had to build something to honor those we lost. Since the attack, and during the rebuilding, this lobby has felt so cold and empty," he continued, "but now it has a heart."

TOP: *Ki & Kitty*, QUARTZ, 98 LBS., BRAZIL; CUT WITH GLENN LEHRER. ABOVE: *Eleven Tears Memorial* CRYSTAL, SCULPTED ELEVEN-SIDED QUARTZ HENDECAHEDRON, STAINLESS STEEL FRAME, CRYSTAL WEIGHT 600 LBS., BRAZIL, REFLECTED IN BLACK GRANITE POOL

BAHIA

SI AND ANN FRAZIER

Although one of the most durable substances known to man—which is why so many archaeological treasures are made of it—quartz also has unique peculiarities. Would-be sculptors wanting to work in this difficult medium must learn about and invent ways to cope with them.

One that is not generally known to the public, even to the "experts" who write introductory textbooks, is that quartz crystals have several directions of cleavage which are usually so difficult to produce, which most elementary textbooks state flatly that quartz has no cleavage. That is just simply not so—as many lapidaries discover afresh, to their dismay, every year. Either thermal shock or a strategically placed blow can produce fine, perfect cleavages in certain directions.

In 1987, Lawrence and his good friend Glenn Lehrer were able to obtain, with the help of importers Charles Cosac and Michael Naify, a very fine, unusually large citrine quartz crystal from Bahia, Brazil, that had sharp, well-defined crystal faces and beautiful rutile needle inclusions. Because of its unique size and internal beauty, they had originally planned only to clean up and polish the faces, itself no small task: polishing large quartz crystal faces takes special

techniques, equipment, and knowledge, which are beyond the scope of all but a few lapidary artists.

Unfortunately, the crate in which it was being shipped must have been in an unheated cargo space, and the thermal shock at 30,000 feet—in contrast to the warm climate of its birthplace—caused the development of two large cleavages parallel to the positive rhombohedron faces. It seemed at first that their plans to produce a magnificent, polished rutilated citrine quartz crystal—now in three pieces—would come to naught. However, they did not give up. After more than seven years of thinking, planning, and working hard, they produced one of the most breathtaking sculptures to be seen anywhere in the world. Today, *Bahia*, as they christened it, is the pièce de résistance of the Gemological Institute of America's public display at its Carlsbad, California, campus.

Although we have visited many of the world's most famous stone sculptures, we have never been so moved as when viewing *Bahia*, now hung in a special atrium-like space where it is struck by the morning sun. The effect is overwhelming. It is, however, marvelous even when the sun has passed the meridian, or when it is lit by artificial light.

"When admiring a work of art, the observer sees only the art. But beyond the curves and facets, the artist sees reflections, the agonies and joys comprising the process that changes one's life forever."

-LAWRENCE STOLLER

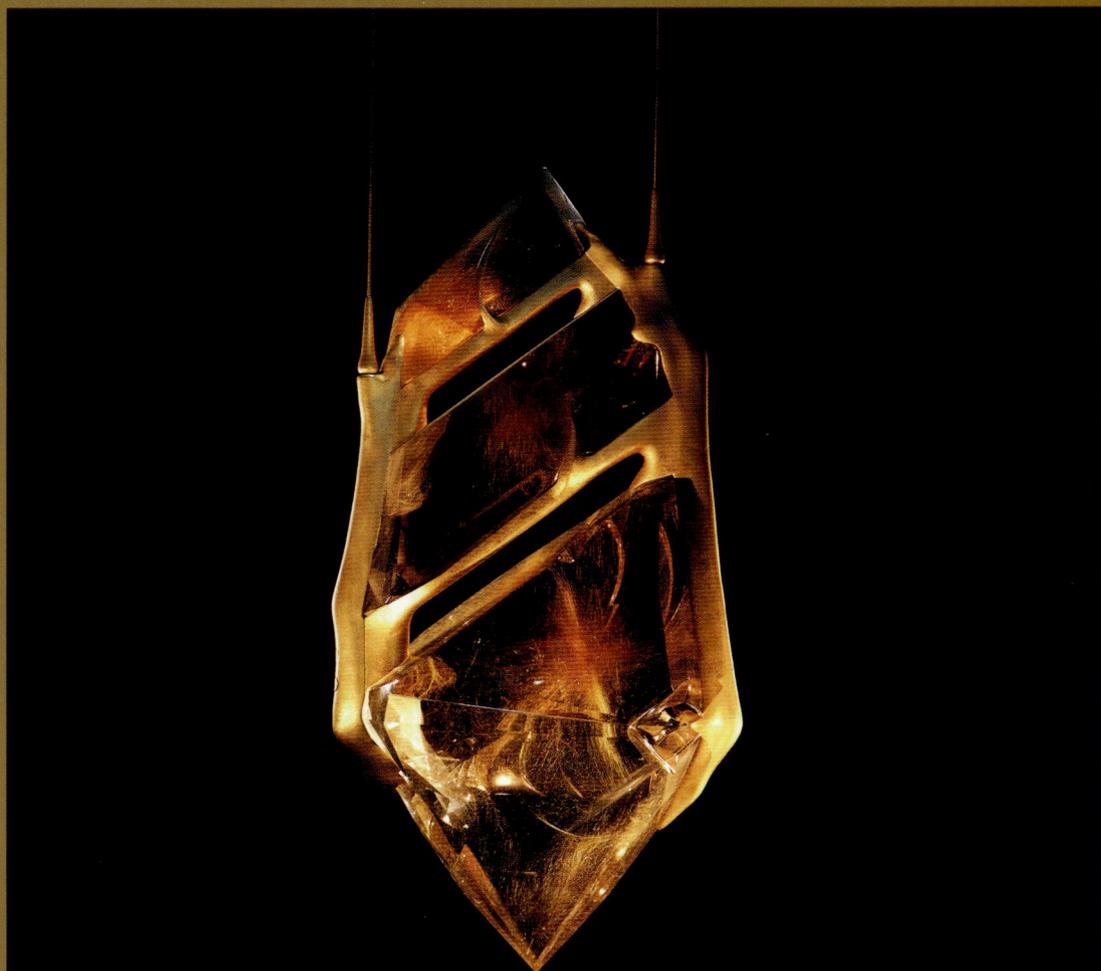

RIGHT AND OPPOSITE: *BAHIA*, RUTILATED QUARTZ SCULPTURE ON GOLD-PLATED STEEL FRAME (BY PEPE OZÁN); CRYSTAL WEIGHT 450 LBS., OVERALL HEIGHT 5′, BAHIA, BRAZIL

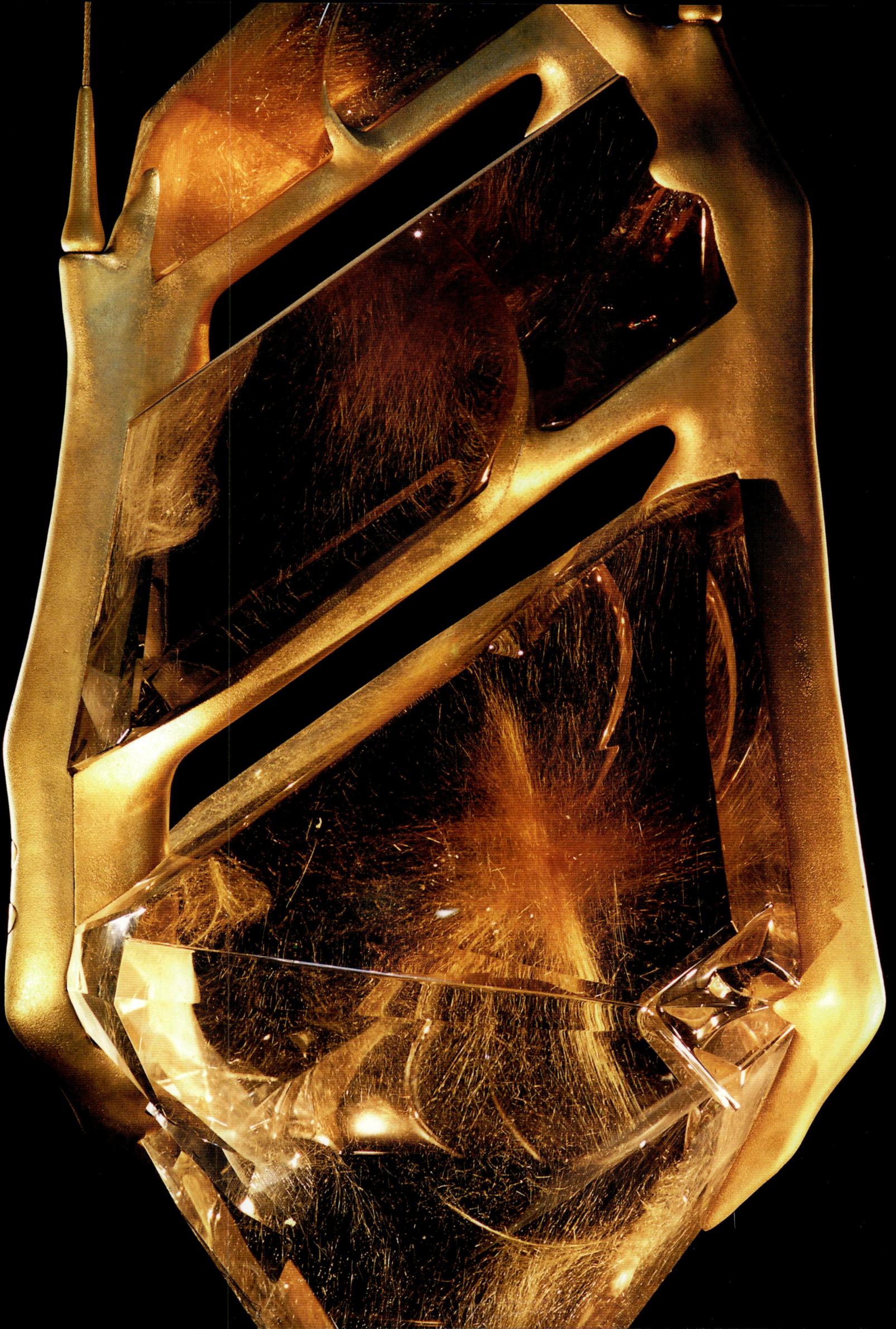

ABOVE: *THE GOLDEN ONE*, CITRINE QUARTZ,
CRYSTAL WEIGHT 1400 LBS., ZAMBIA

THE GOLDEN ONE

The years of working with *The Golden One* have awakened something very ancient in me.

Something that came from beyond me,

something that came from some part of me that is beyond my capacity to know:

from a level of consciousness that comes from within me and without me,

but is beyond words.

And though it is an expression of mastery,

and though it is an expression of artistry,

I would be hard-pressed to say it's "my mastery" and "my artistry" that are expressed here.

It is a combination of the artistry of the consciousness

and the mastery of the consciousness

that is indeed held within this grand and glorious crystal.

And it is something more.

It has challenged me, physically, yes,

but it has challenged me emotionally, it has challenged me mentally.

I have sought its counsel and it has given me its counsel.

I have sought its magic, and through its counsel it has shown me that magic,

and has awakened so much more within me in terms of what truly matters.

And has awakened so much more within me of matters of the heart,

and matters of the mind,

matters of beauty and matters of enchantment.

Some stones are to be crafted by my mastery and artistry,

some to be crafted by a mastery and artistry that are beyond me.

Standing before *The Golden One* and looking into its vast innerscape

renders me nowhere to be found,

expanded to a state of observation

I disappear in its enormous transparency.

The eye has never looked through so much dense matter:

harder than steel, and yet I travel effortlessly, passing right through it.

It is a living paradox.

Creation was frozen within its formation,

and this crystal body is spanning time

between "the beginning" and the future.

Like an astronaut looking back at Earth from space,

I am witnessing a world inside the space of matter.

It has altered my brain, and changed me.

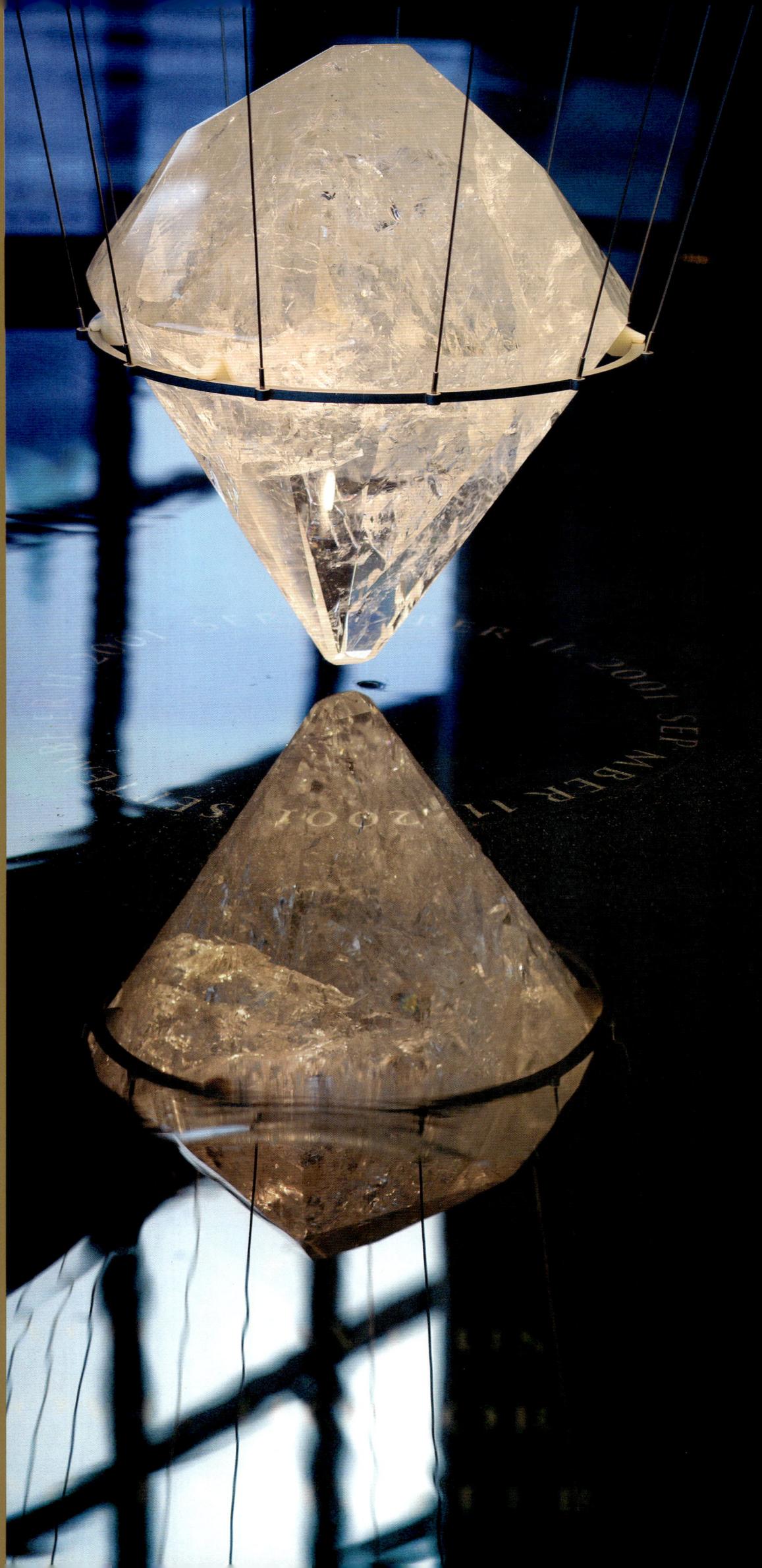

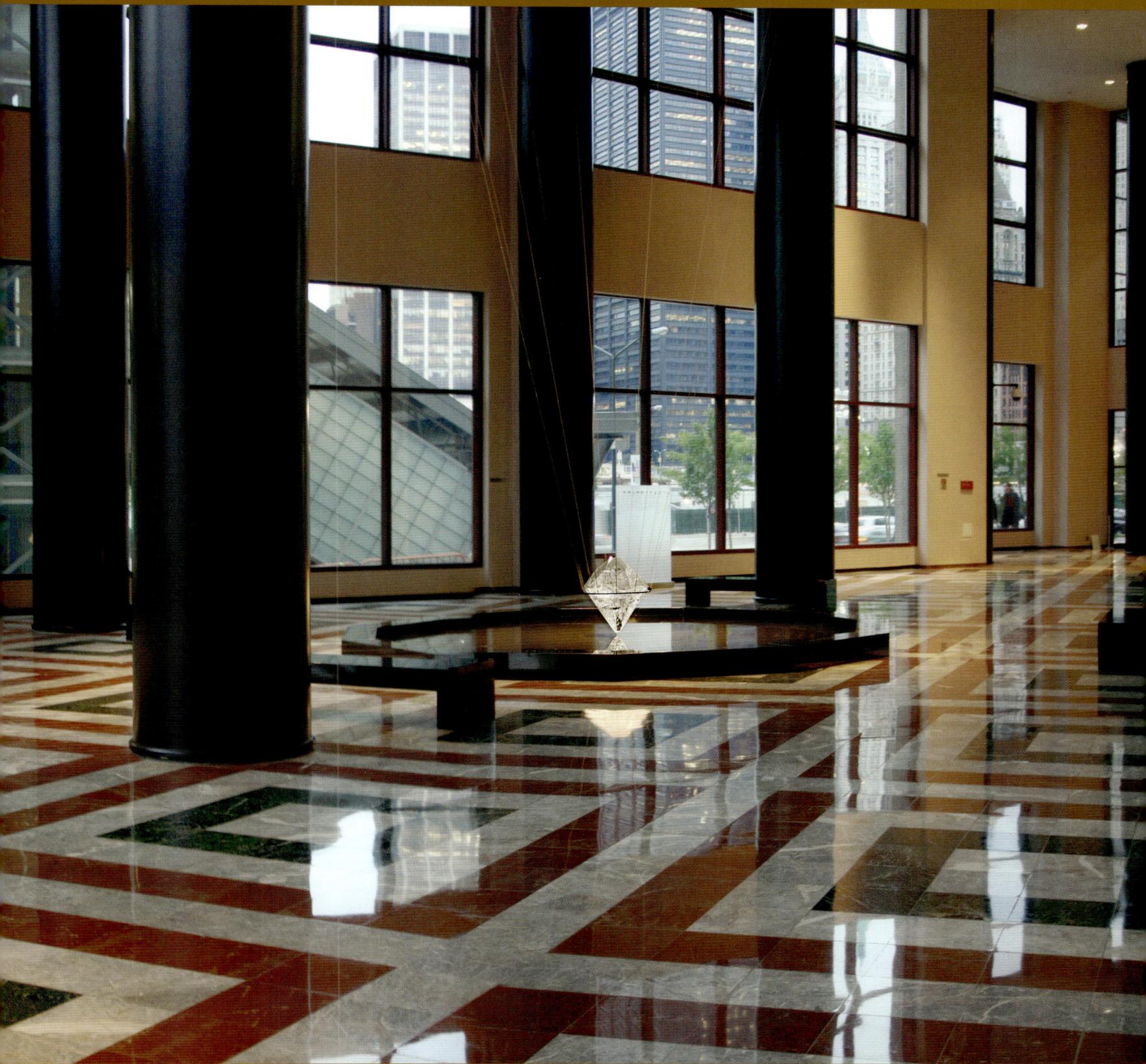

OPPOSITE AND ABOVE: *ELEVEN TEARS MEMORIAL*, DESIGNED BY
KEN SMITH, AMERICAN EXPRESS BUILDING LOBBY, NEW YORK CITY

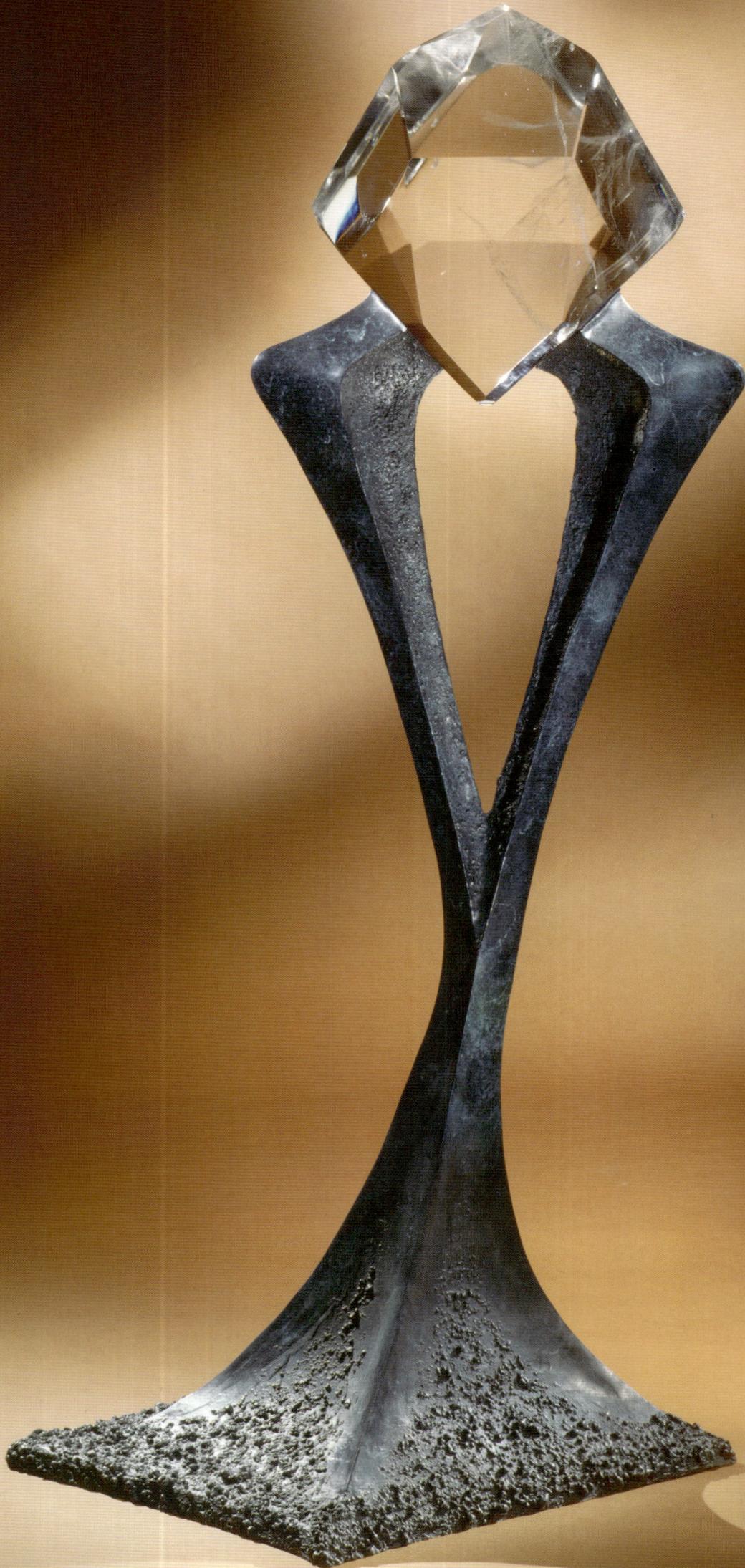

ABOVE AND OPPOSITE: *Ancestor*, QUARTZ, 98 LBS., 56″, RUSSIA

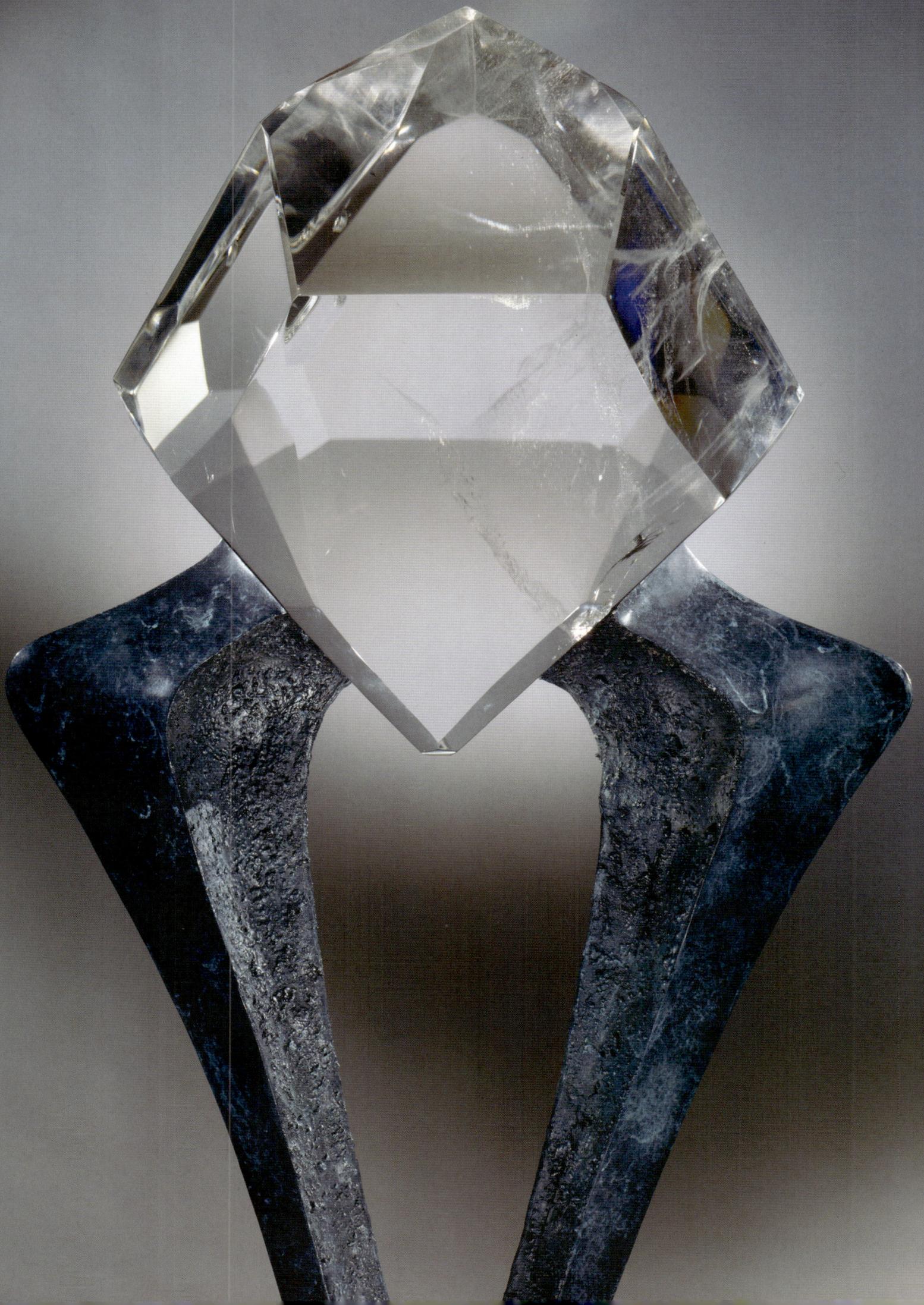

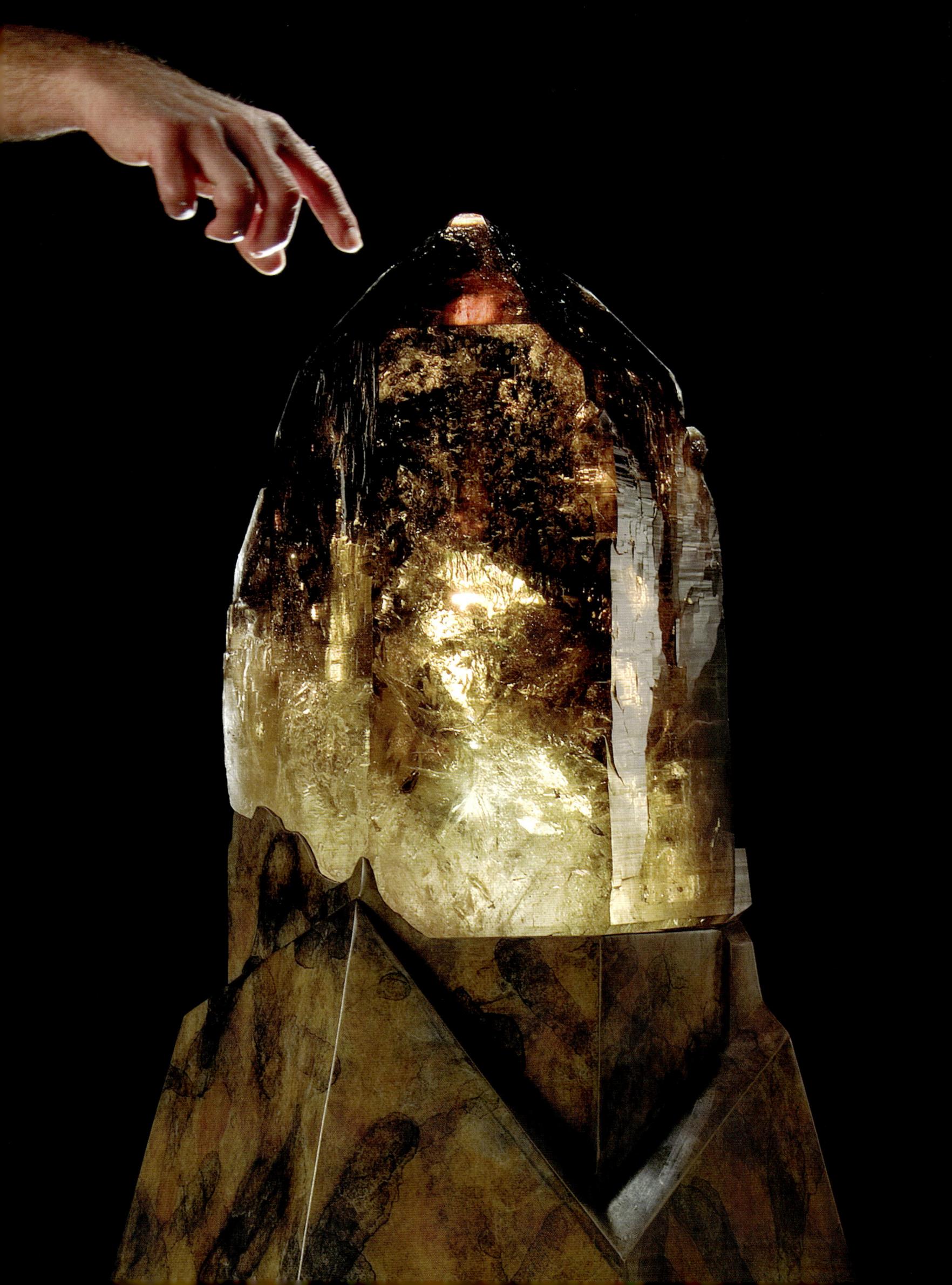

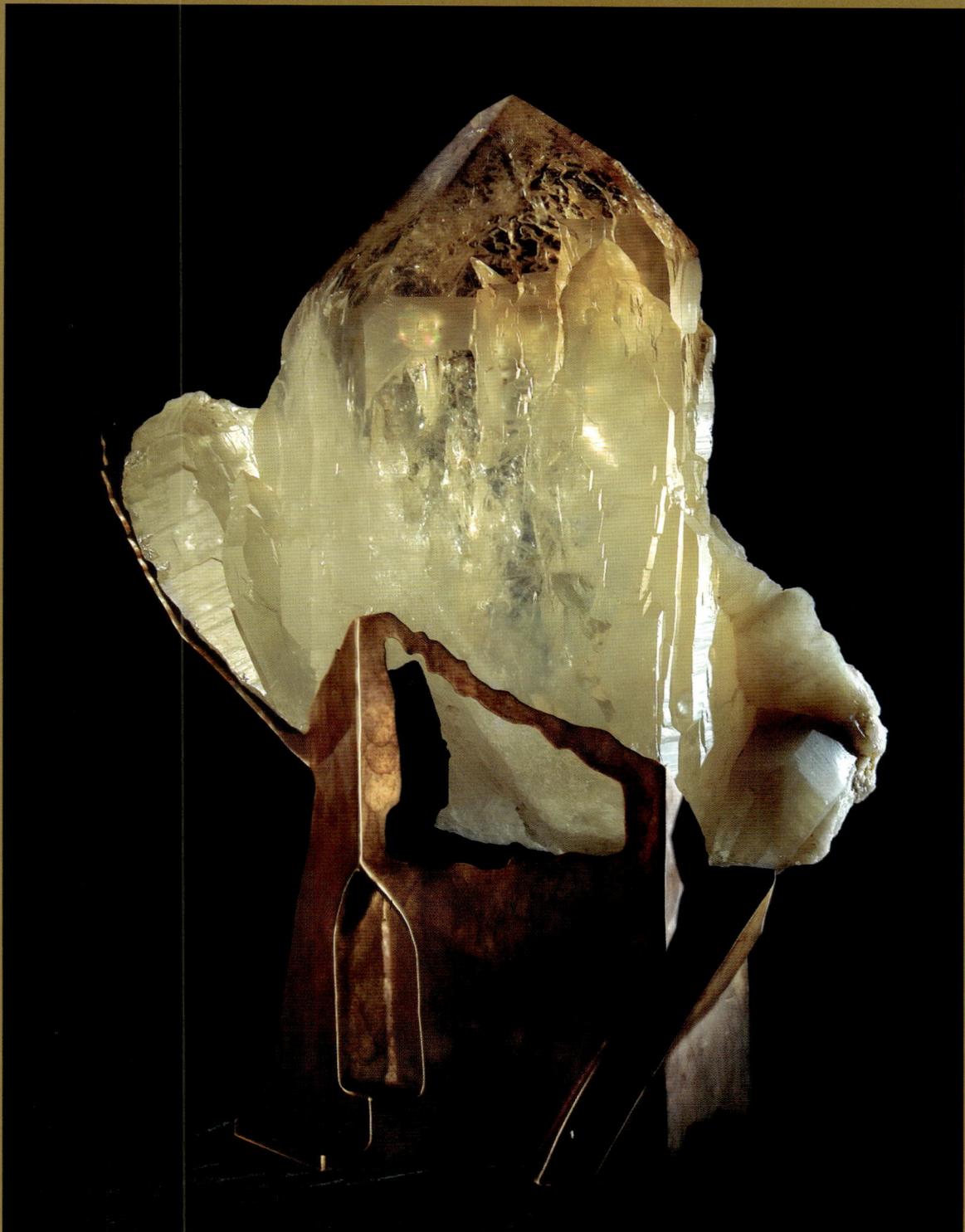

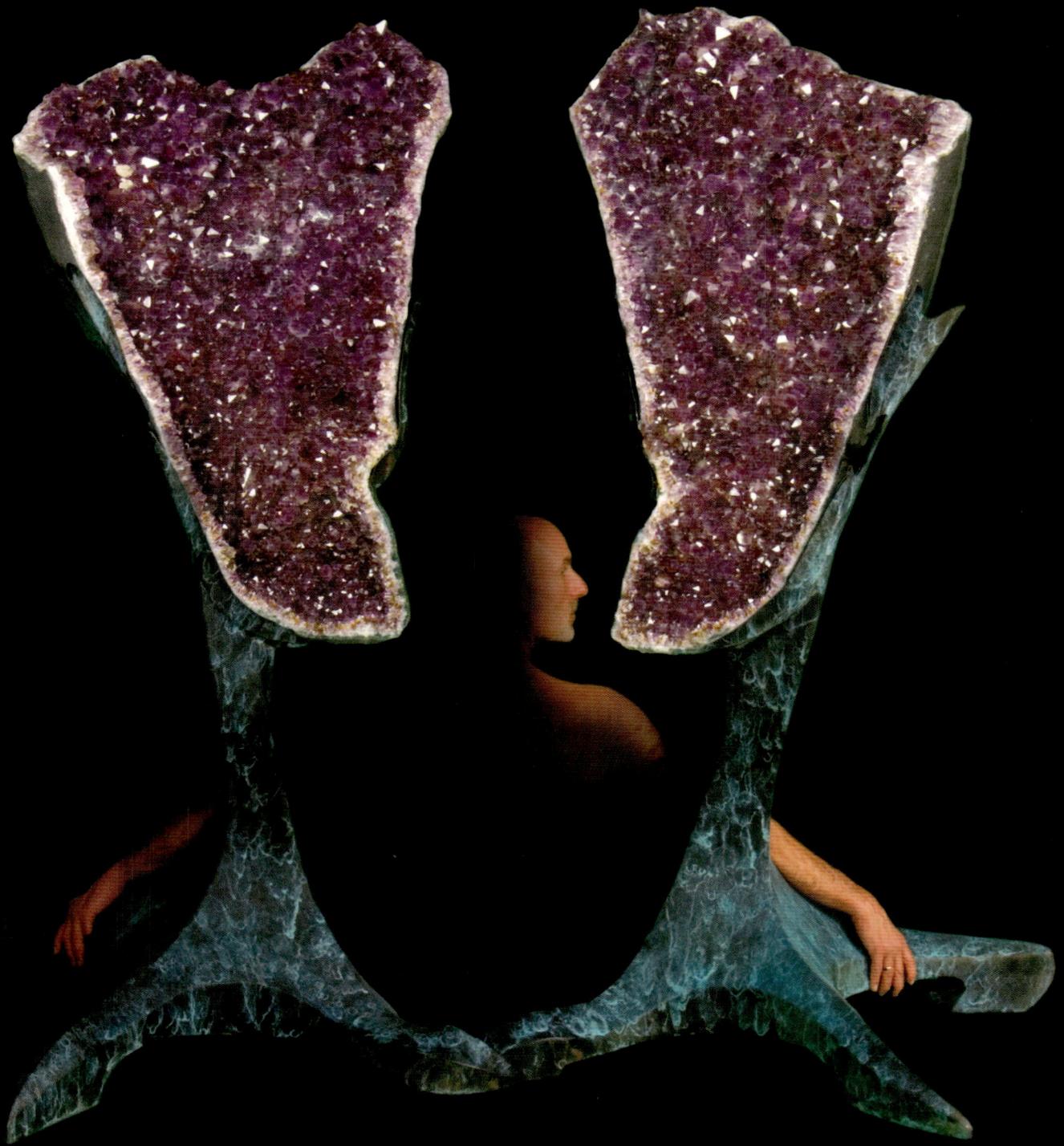

ABOVE: *Tu-Lips*, matching amethyst geodes
from split single geode, 61″, Brazil
OPPOSITE: *Twin Peaks*, twin quartz crystals, 62″, Brazil

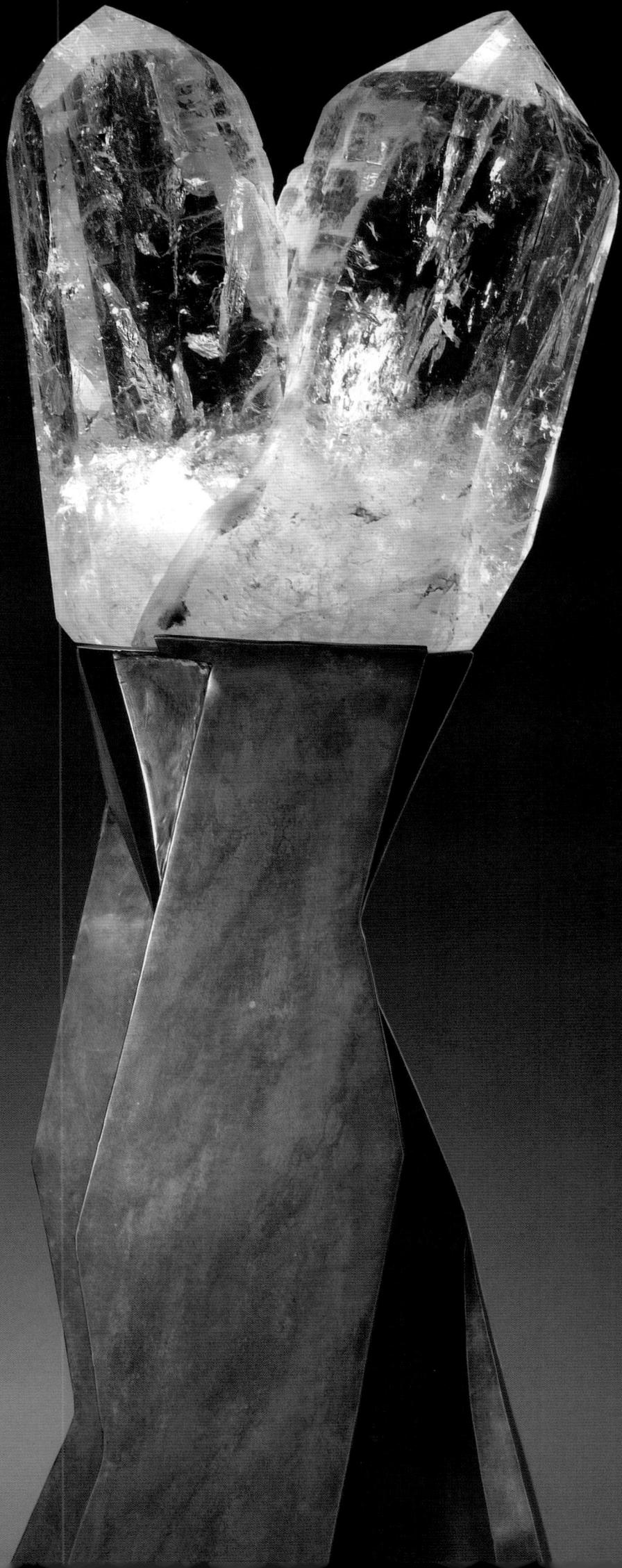

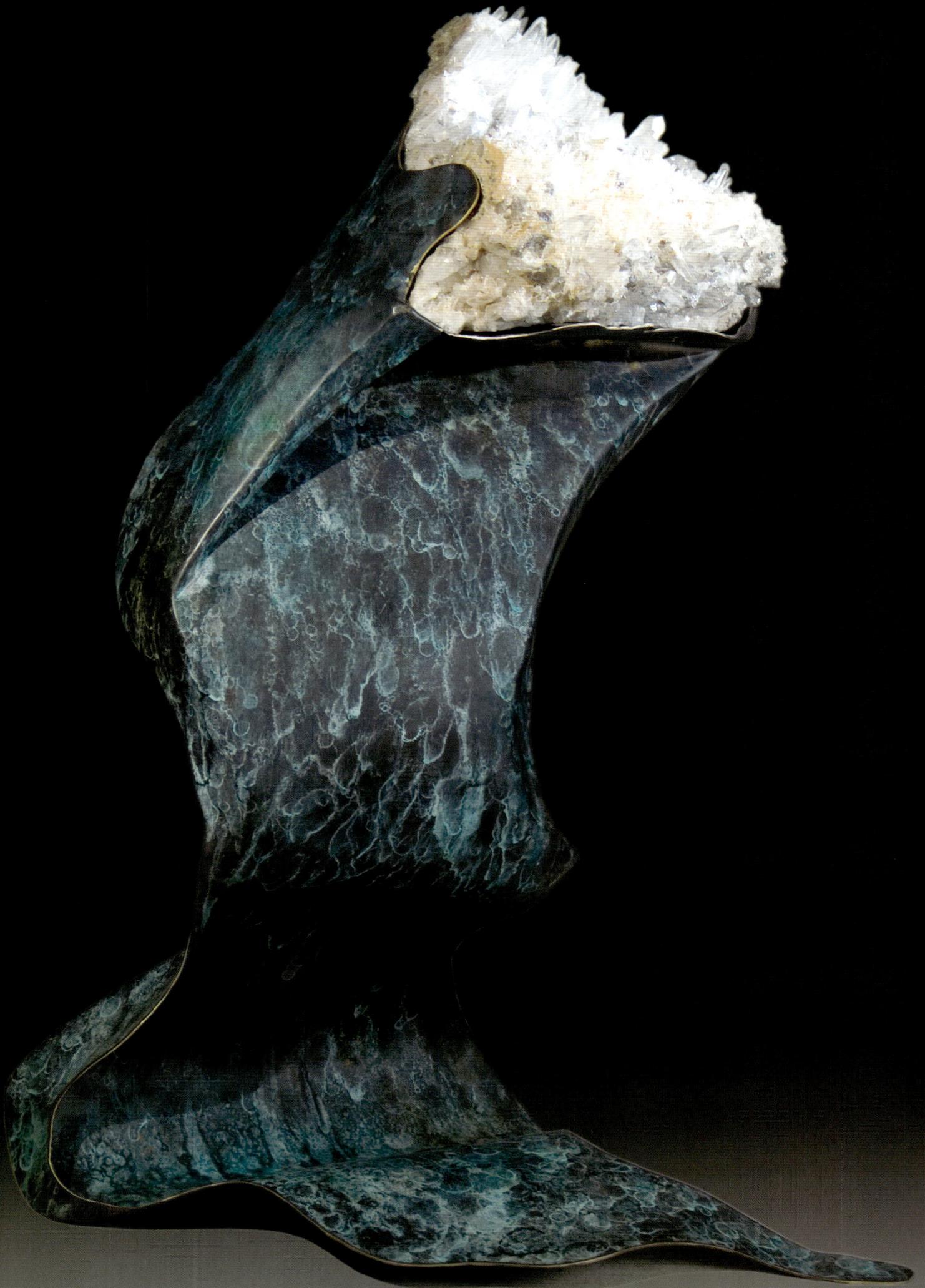

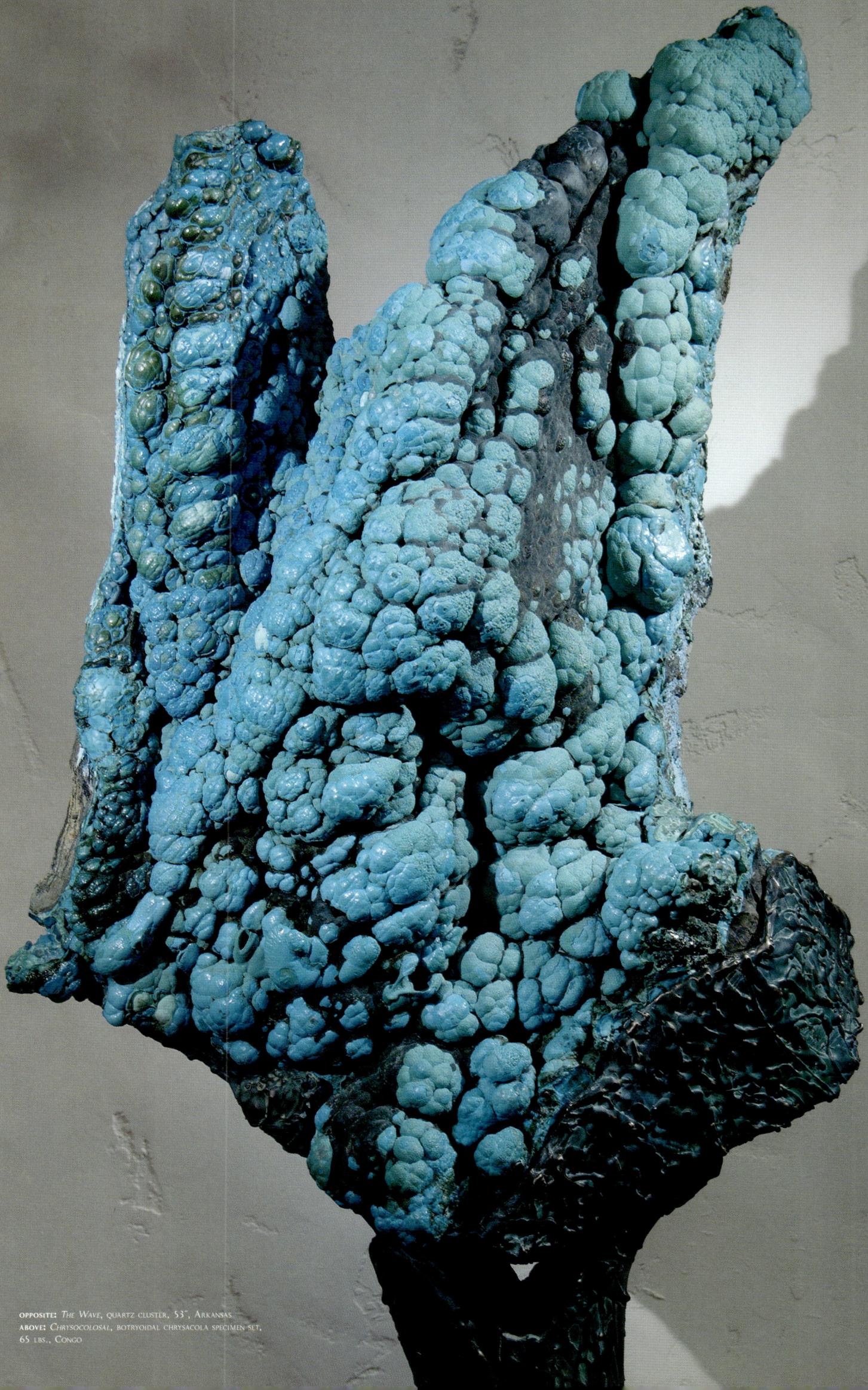

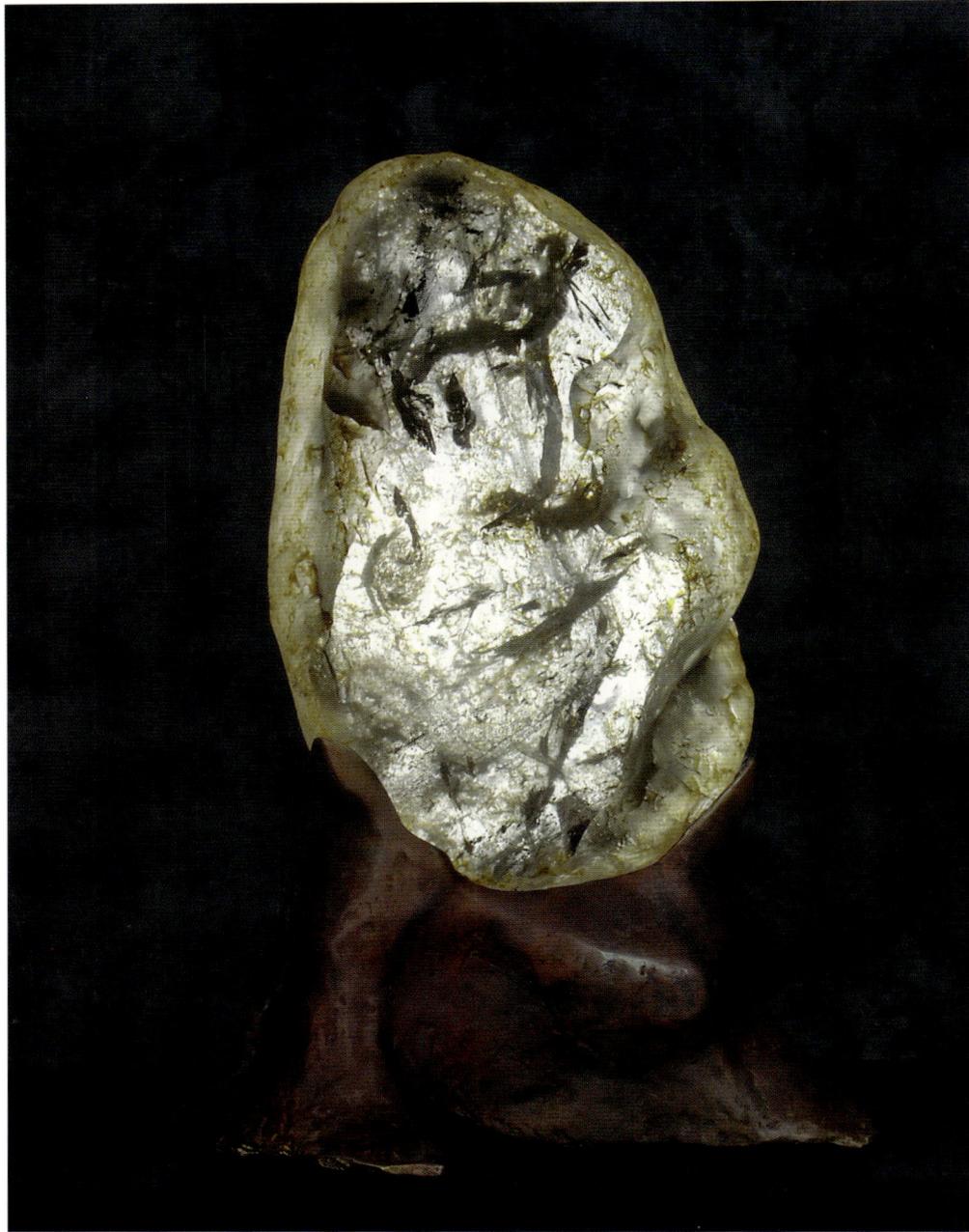

ABOVE: *Rolling Stone*, RIVER-TUMBLED QUARTZ, 146 LBS., MADAGASCAR
OPPOSITE: *Mount In-Formation*, ELESTIAL QUARTZ, 58″, BRAZIL

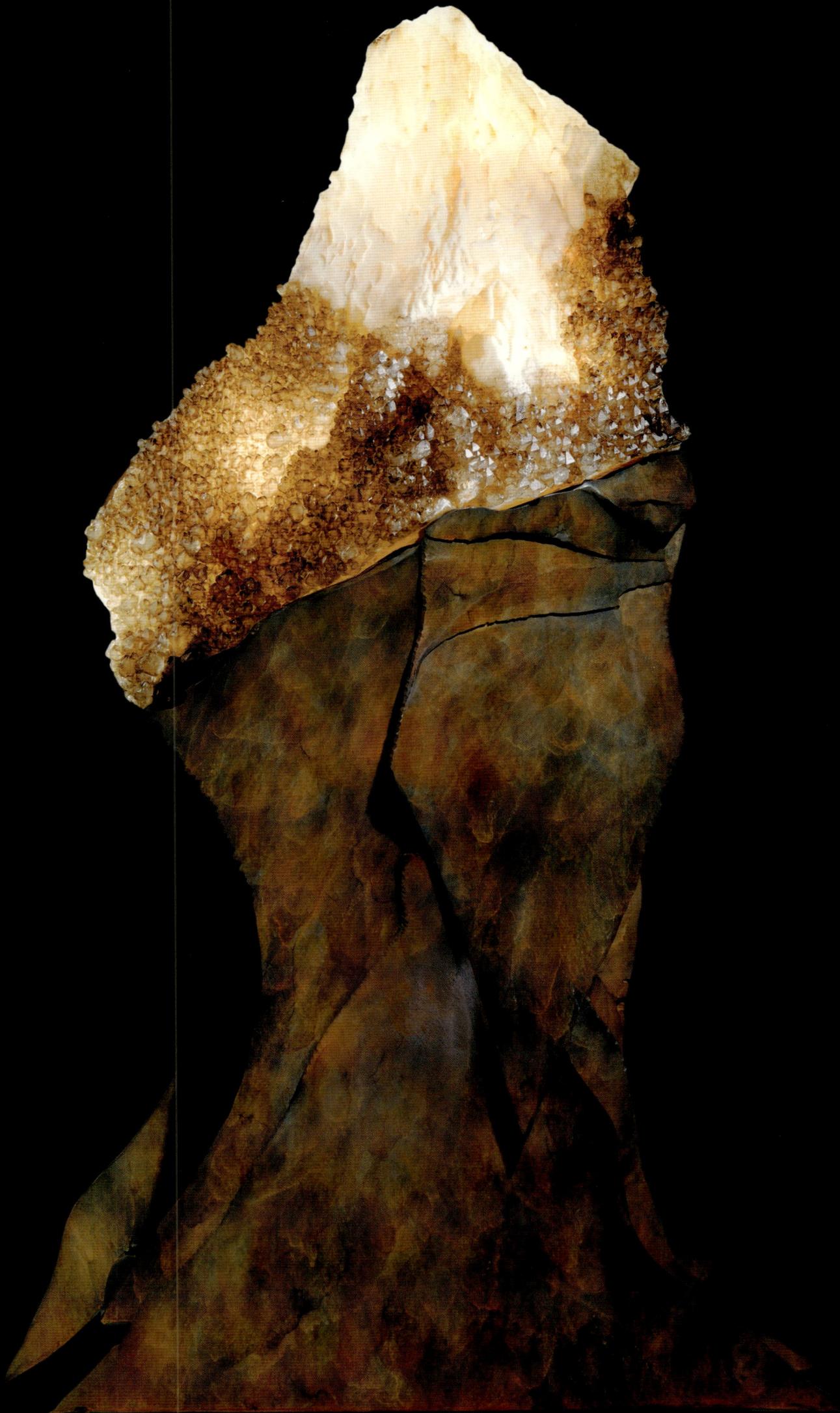

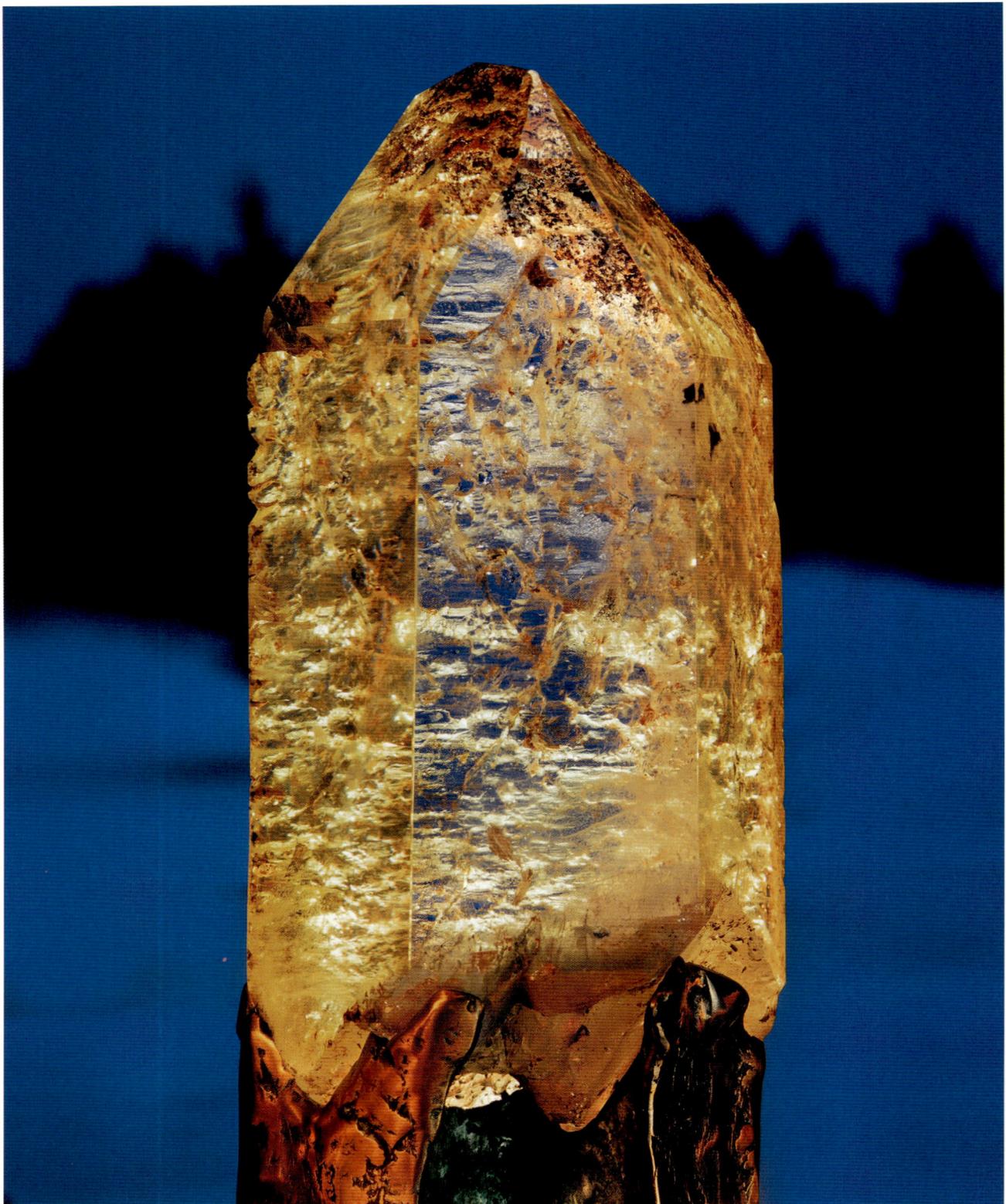

ABOVE: *MIDDLE EARTH*, TRANSPARENT QUARTZ EXHIBITING CUT
AND NATURAL TEXTURED SKINS, 95 LBS., MADAGASCAR
OPPOSITE: *THE PERFECT STORM*, CARVED QUARTZ BOULDER WITH GOLDEN
RUTILE, PHANTOMS, AND CHLORITE INCLUSIONS, 35˝, BRAZIL

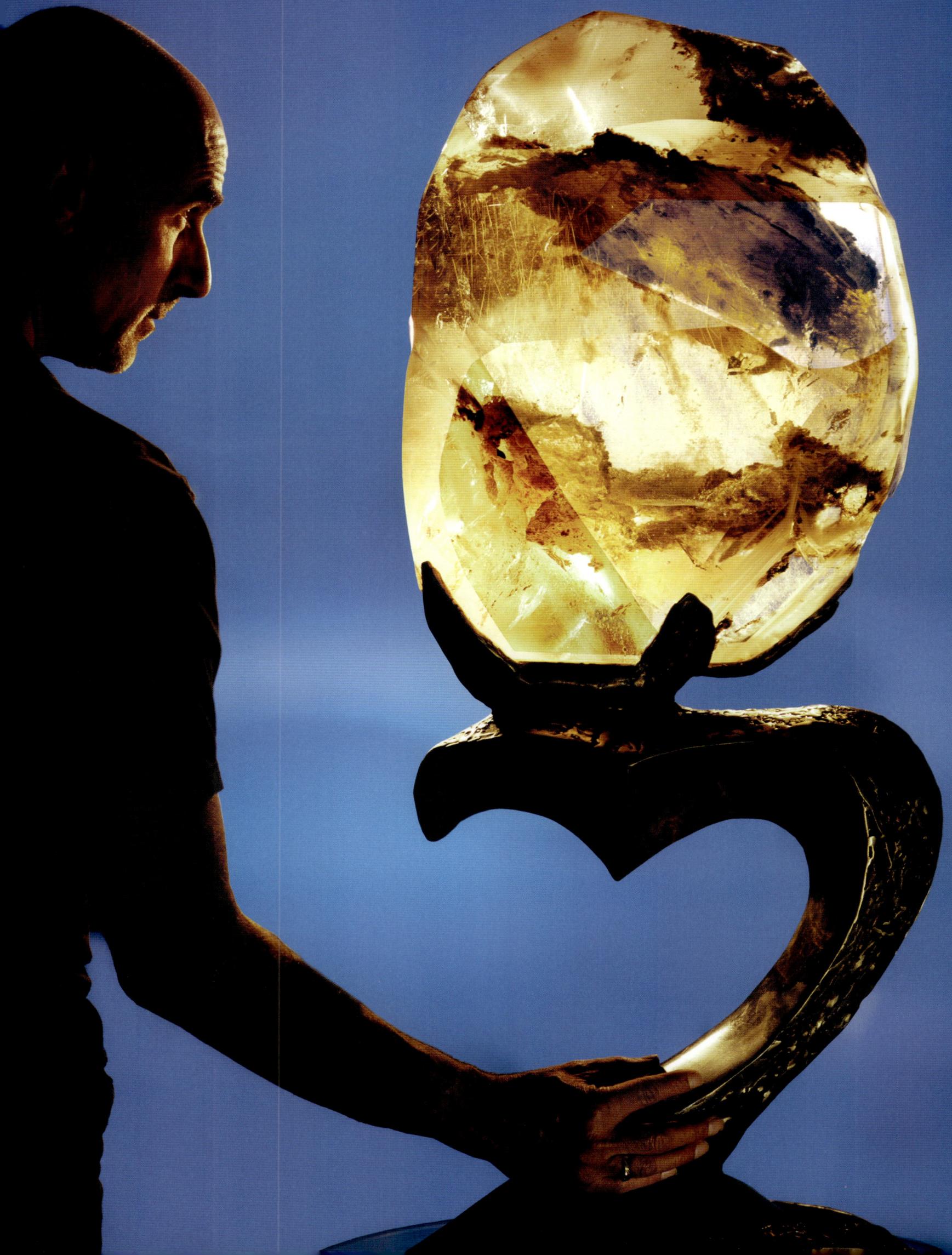

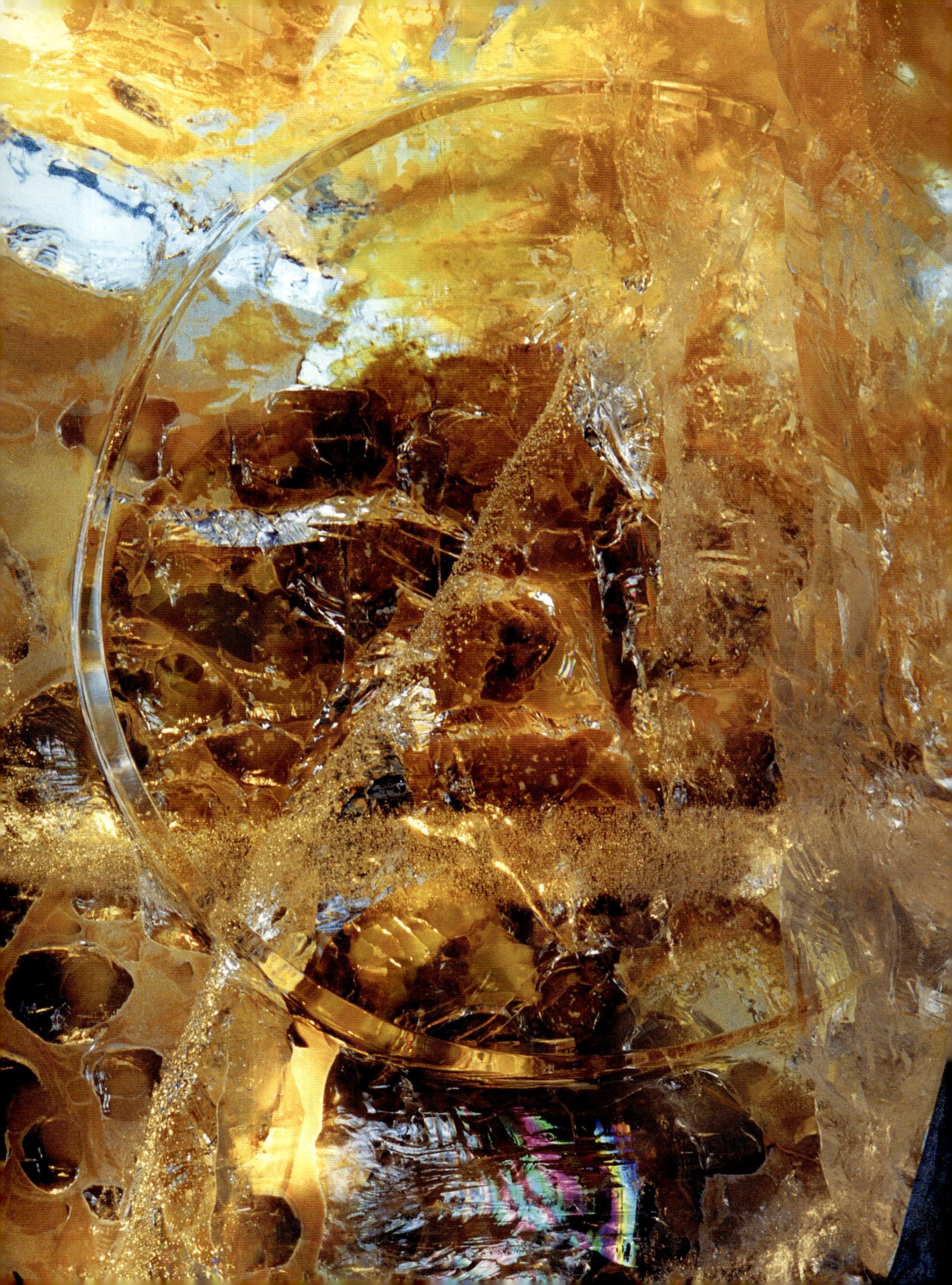

4

MINERALOGY MEETS METAPHYSICS

LEGENDS AND BELIEFS

Did the first caveperson to encounter a shiny, transparent quartz crystal use it as a tool, a hammering device to break open a shell or someone's head? Or rather was the impetus of the first encounter between human and crystal one of wonderment and fascination for the play of light? A rock having the transparency to see one's hand on the other side: how magical this must have been. So was it survival instinct or the transcendent experience of beauty and wonder that motivated our early ancestors to begin a relationship with the quartz crystal? I suspect a bit of both.

The lore of crystals predates modern scientific investigation by thousands of years. Legends abound of giant crystals being used as energy generators, and sacred monuments in Temples of Knowing in the ancient legendary civilizations of Lemuria, Atlantis, and Sirius. Stories of crystal cities, fortune tellers and crystal-ball scrying, telepathic transmitting devices, shamanistic ritual practices, and dreamers' companions, as well as the royal and precious traditions of gems, have captivated our consciousness throughout the ages. And whether they are regarded as fact or fiction, these legends and beliefs do exist as part of our collective mythology.

Growing up with these myths compelled me to want to know more about crystals, including modern science and technology, mineralogy, lore and legend, art forms, meditation, and resonance-healing modalities. Why have crystals acquired the labels of *magical* and *mystical*? When does a myth become a reality? And why are they symbols of power? By the teasing out of the essential knowledge from each of these fields of the crystal experience, a grand tableau begins to form.

Yet there are countless people who regularly produce profound results in the areas of healing, self-discovery, and enhancing the quality of life, experiences that are difficult to quantify but are nonetheless real. I have observed that many who have a metaphysical interest in crystals do not understand the scientific and mineralogical realities that are an integral part of their majesty. And while I have been immersed in crystal art for more than twenty years, I feel like I am just scratching surfaces of understanding in each field.

It seems that throughout history, battles have been waged between the physicists and the metaphysicians of a given age. Albert Einstein, for example, could be considered a metaphysicist until there was enough proof for the scientific community to agree with his theories, including Relativity. He transformed from metaphysicist to physicist when a critical mass of his peers agreed that his theories were by and large correct. Today, quantum physics is redefining what we have come to accept as the nature of reality, straddling the precipice between conventional science and metaphysics.

The crystal is a perfect metaphor for this conundrum. Crystals are the hardest substances on earth, yet light passes through them with ease. Within the crystal there is a substantial presence that is measurably hard, and at the same time hard to measure. Substance and light appear to represent the polar ends of the spectrum of physical matter, yet they are part of the same continuum. There is great symmetry in that the job of the physicist is to illuminate the true nature of substance, while metaphysicians call forth the light of soul and spirit to be grounded in the worlds of that which is matter and that which matters.

We learn from crystals to strengthen the balance of substance and light within ourselves.

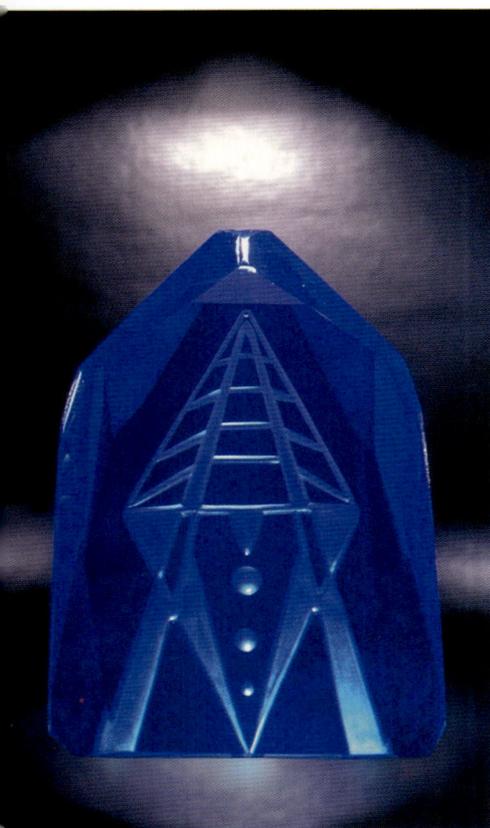

ABOVE: *LUNAR LANDING*, SYNTHETIC COBALT QUARTZ, 6", RUSSIA
OPPOSITE: *TIME MACHINE*, GOLDEN RUTILE, GOLD CHAIN, AND BRONZE, 7", BRAZIL

THE BALANCE OF SUBSTANCE AND LIGHT

Throughout my career, I have witnessed a chasm of understanding between the fields of mineralogy and metaphysics. Crystals are fundamental to the interests of each, yet they are perceived very differently. Understanding one field is challenging; understanding both fields adds a quantum level of complexity. The mineraLOGICAL mind tells me that some of the metaphysical assumptions about crystals are not scientifically verifiable.

QUARTZ IN TECHNOLOGY

Technology has harnessed quartz for its electronic capabilities. Quartz is a raw material, a commodity, processed and inserted into various electronic components. Only the purest, energetically truest, highest-quality quartz is used. After the crystals are tested (through polarizing devices) and qualified as usable, they are sliced into thin wafers and used as starters to grow larger crystals of synthetic quartz by suspending the wafer in a "batter" of supersaturated solution. Under exact heat and pressurized conditions, the bat-

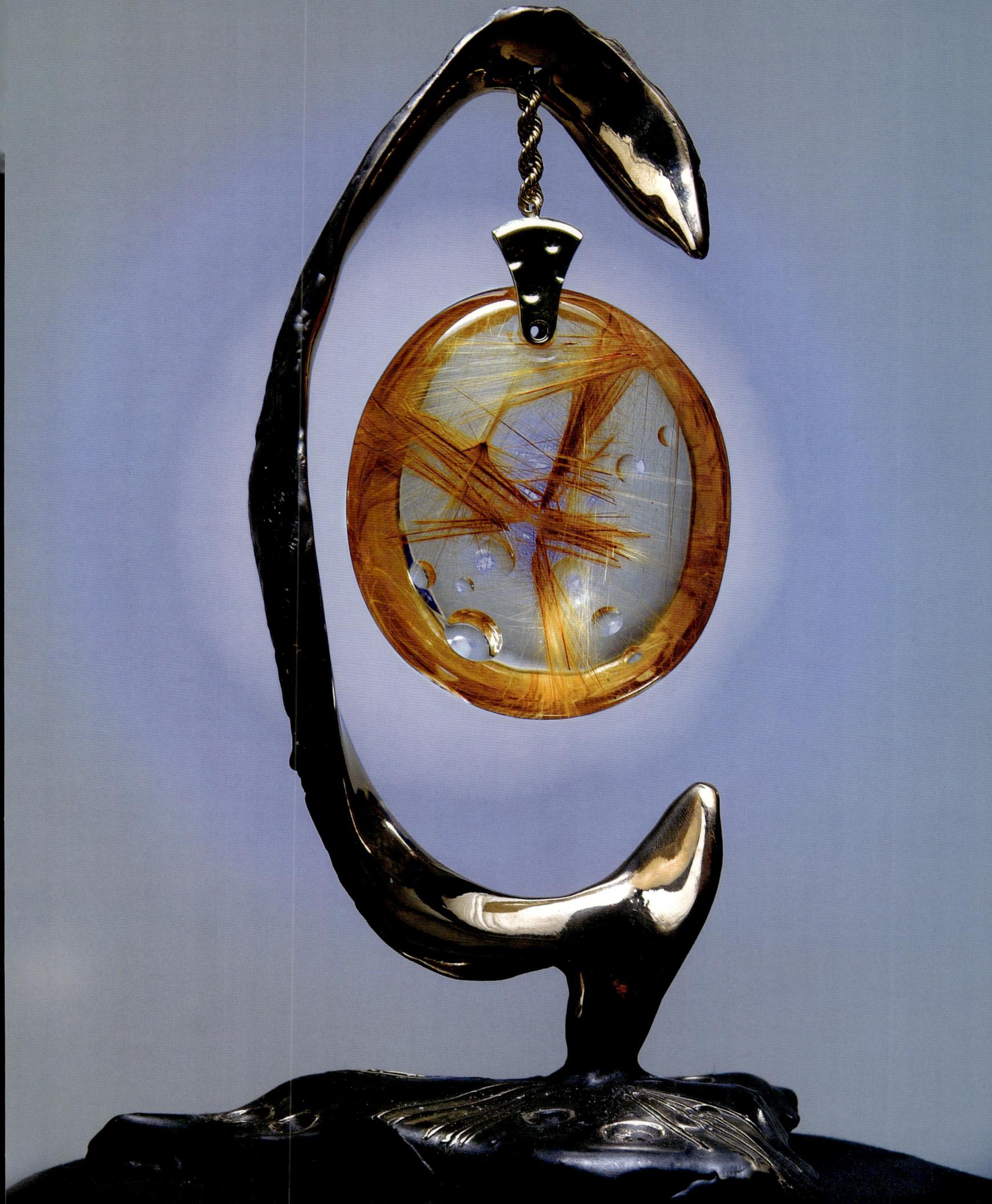

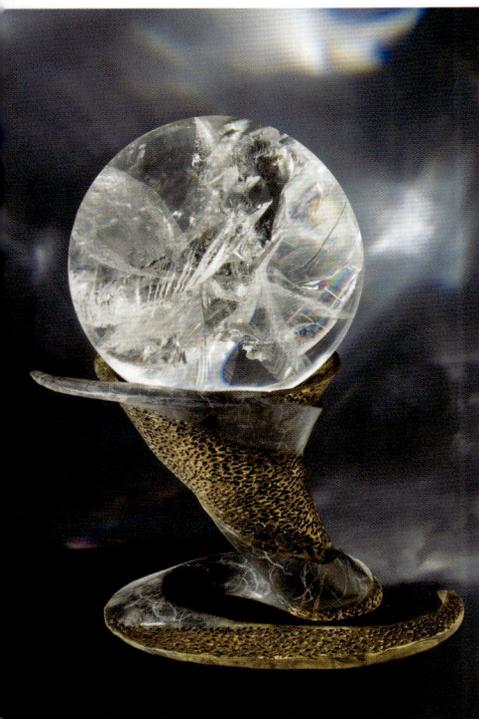

ABOVE: *Orbital globe,* 4"-DIAMETER QUARTZ SPHERE; CUT IN BRAZIL
OPPOSITE: Eight-sided double-terminated generator, 8", BRAZIL

ter allows the quartz wafer to grow, in approximately six weeks, forming into a larger crystal. Even starting with a thin rectangular wafer, the quartz tries to recreate the original hexagonal shape. A synthetic crystal can only be grown from the seed of natural quartz.

To achieve a particular electronic result, the crystal may be cut in any number of specific configurations. Very precise geometry and dimensions will produce the highly predictable and repeatable electronic result required for industrial use. As a result, quartz performs unique and vital functions in electronic componentry. For example, radio tuning was achieved when a quartz chip was designed to hold a specific frequency, focusing a radio wave to allow the receiver to stay tuned to one station. Quartz has also been cut as lenses for optics and faceted to refract light in chandeliers. In Tibet, sunglass lenses were cut out of smoky quartz.

Electronic-grade quartz from Brazil and Madagascar became an integral component in the weaponry of World War II, essential to the newly invented technologies of radar, sonar, and other electronic and optical devices. Freighters were filled and stockpiles amassed for the war effort by the United States, Germany, the USSR, Canada, and the U.K. Strategic planning included having enough quartz on hand to fight World War III, but war machinery has since progressed beyond its usefulness.

This abandoned technology has benefited me greatly in that many of the fine crystals I have cut over the years came from these governments' outmoded stockpiles of quartz. Their destiny is now to enhance the living, rather than to be used in the weaponry of death.

On several occasions, electrical engineers have asked me to create exotic forms, following exact specifications to produce specific electromagnetic results. For these projects, I go to great lengths to evaluate many crystals before selecting one whose nature is consistent with the form and function that I will ask of it. Quartz functions as an oscillator, with the capacity to regulate the flow of energy in precise ways, as well as condensing and amplifying electrical current. The crystal acts as an agent of change, conducting energy so as to alter the resonant quality of a substance.

This is typical of the letters I have received over the years. A select few I am willing and able to fulfill; others I am not in a position to do.

We are the PET [Positron Emission Tomography] Development Laboratory of the M. D. Anderson Cancer Center at The University of Texas. Created in 1993 by Wai-Hoi (Gary) Wong, Ph.D., our laboratory is recognized as one of the premier nuclear instrumentation

development laboratories in the world. We have developed and validated ultra-high-resolution camera technology that has been adopted commercially for the next generation of PET cameras. For the development of those and for our commercial projection, we currently have a variety of different crystal detector projects and we need them cut in different sizes of crystal detector materials.

We need to know if you can cut LSO, BGO, or any other detector crystal for us? We will send the specifications and the material to you. Normally, they are small blocks of few centimeters that need to be cut into smaller slices within one millimeter.

I asked my friend Bill Atkinson to briefly explain how quartz is used in technology. Bill was an integral part of the original team that designed the Macintosh computer; his photographic book *Within the Stone* has also inspired me. Here is his response:

When a quartz crystal is stressed mechanically, it generates an electric voltage, and when a voltage is applied to a quartz crystal, the crystal will change its shape slightly. This piezoelectric property of quartz has been used in many ways, including phonograph pickups, microphones, pressure gauges, beepers, and the nozzles of ink-jet printers. The most common use is to make very stable crystal oscillators, such as those used in digital watches, radio transmitters, and the primary timing circuits in computers and other electronic devices.

The piezoelectric property is also used in a quartz crystal microbalance to measure very small changes in mass. Quartz is used in optics because it is transparent to ultraviolet light whereas glass is not.

The high thermal stability of quartz allows it to be used in heat-ray lamps and quartz-halogen lamps.

Quartz can be reduced in an electric arc furnace to the element silicon, which can be used to build integrated circuits and solar cells.

I have also cut many crystals for use by healers, physicians, and metaphysicians, who are conducting energy by using the same principles as the electrical engineers. Specific configurations are used to create a desired effect for the practitioner. Some want to send energy to the crystal, some want to draw energy from it. In some cases, the crystal tool wants to move energy faster; another is designed to move energy more slowly. Precise specifications are used when cutting quartz for electronics components, and the same principles apply when

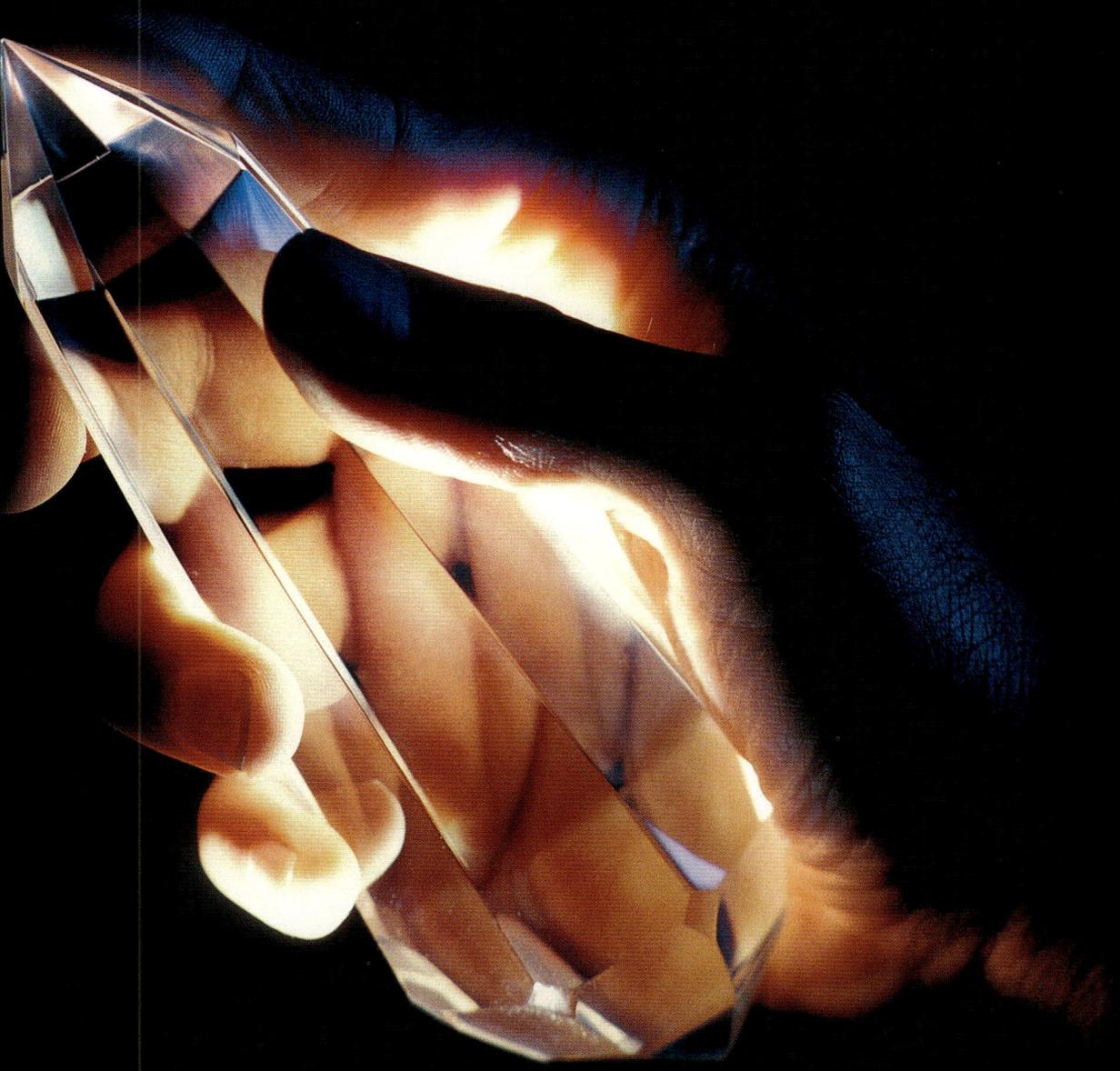

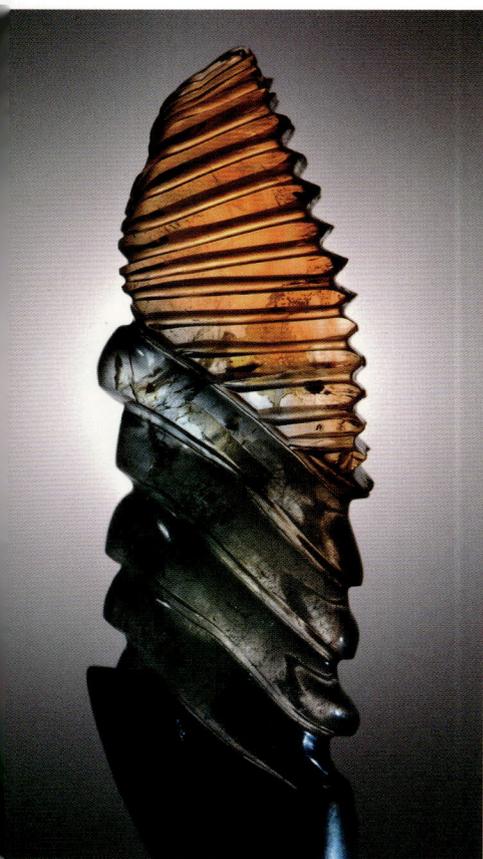

cutting crystals for use as energy medicines. The electronics industry uses quartz to move energy in electrical contraptions; the energy medicines use quartz to change resonance in the human body and mind.

DO CRYSTALS HAVE POWER?

One of three answers will satisfy each of us on the question of whether crystals have power. Yes, no, and maybe.

There are unique physical properties that exist only in quartz and a few other crystals. Quartz and tourmaline are *piezoelectric*, which refers to the phenomenon that allows a crystal to amplify, resonate, focus, condense, project, and direct electromagnetic energy. Piezoelectricity, discovered by Pierre and Jacques Curie in 1880, is a strange, important phenomenon, somewhat contradictory to common sense. Piezoelectric crystal plates or wafers cut to specific sizes and orientations will generate an electrical charge when pressure is applied in particular crystallographic directions. Conversely, the application of an electric charge can make the crystal plate expand or contract. This property can be utilized to fabricate crystal plates or wafers, carefully cut in precise orientation and to precise dimensions, that will vibrate at exact frequencies to accurately control radio broadcast or reception, and for an ever increasing number of timing devices. After its discovery, it lay fairly dormant until the 1920s, when radios became popular.

The idea of crystals emitting energy has had a fascination through the ages. Before it was scientifically proven, the belief that crystals have power was accepted by many ancient, and not so ancient, cultures around the globe. In my research on the subject of the flow of energy in quartz, I find a correlation between its uses in science and technology, and those uses by practitioners employing it for healing the body, for meditation, and for personal enjoyment. Quartz, you see, empowers both contraptions and people.

When a crystal is put under pressure, it will propel that energy along its surfaces and internally along the c-axis of the crystal. The c-axis of a crystal is the axis that runs from the base to its tip, as opposed to from side to side.

A World War II–vintage technique used to find the c-axis in a crystal whose shape has been reduced to a fragmented chunk exhibiting no natural faces was to place it in a fish tank–like container filled with an oil that has the same refractive index as quartz. The transparent quartz disappeared. But by looking through two polarizing filters, one could orient the crystal so that the pattern created by the offset filters aligns when the crystal is oriented with the c-axis, indicating the direction of energy flow. Simpler yet more refined techniques using the same basic principles exist today. Because of this fundamental property, humankind has harnessed the crystal's capacity to power and affect many electronic components.

Science has been able to demonstrate the flow of energy in quartz, but it has not explained why so many people feel the very palpable and undeniable sensations emanating from crystals. This energy can be accessed in demonstrable, repeatable, and productive ways.

To establish the fact of piezoelectricity to their colleagues in the world of physics, the Curie brothers faced a challenging task requiring long, hard, and dedicated effort, including no small measure of genius.

It is my belief that there are truths about the power of crystals that are yet to be defined. From time to time I hear the term *placebo effect* inaccurately attributed as the cause of results achieved using a crystal to effect a change in a part of the body. I have heard this answer used dismissively, insinuating that the results produced are simply fabrications of the mind. The consequence of such judgment is that it may prevent the discovery of a fascinating axis of truth. Similarly, for decades there was no agreed-upon medical explanation as to why aspirin relieves pain; but when you have a headache, it sure "works wonders," doesn't it?

It is my contention that there are several truths about the power of crystals that are not mutually exclusive, but rather must be examined with different measuring devices, be it for technological or personal use. With any new (or scientifically undocumented) discovery, there is usually a phase during which unexplained phenomena cannot be validated using then-current scientific methodology. This in no way invalidates the existence of the phenomena: it simply points to the limits of our current observing and measuring devices, which in turn demand new approaches, and new ways of looking in order to realize (make real) a new discovery.

My own observation regarding uses of crystals in healing and meditation is that they can have profound results. When a crystal is pressured—which can include by one's hand, a heat source, or electric current—the crystal propels this energy along its surfaces and internally along the c-axis, acting as a vibrational conduit. I can pick up most any

quartz crystal and feel energy streaming from it. Sometimes this energy feels faint, sometimes it is strong and distinctive. A crystal is often the tool of choice for healing professionals who are directing a higher resonance of energy to an ailing part of the body. The healer is using the properties of the crystal in an attempt to change the resonance of the part of the body that is experiencing dis-ease.

Some people believe crystals have powers, some don't. I have experimented by directing energy from crystals on the hand of "believers" and "nonbelievers." Some of the believers feel the stream of energy tingling their palm, and some don't. Some of the nonbelievers feel it, and some don't. Believing the crystal moves energy doesn't seem to be a criterion for whether one experiences it.

Inspired in the presence of a magnificent crystal, many experience a sensation of power. There is power in consciousness, and much about the relationship between humans and crystals has yet to be discovered or articulated.

So do crystals have power? Technically, no. They are oscillators. The energy appears to originate from an outside source. Are crystals powerful? Absolutely. Our world has been irrevocably altered by the power of quartz crystals. Do crystals have power? *Yes, no, and maybe.*

RESONANCE & HARMONY

If you are going to a foreign country, it is helpful to learn the language.

Why does it feel so good to be around crystals; what is the attraction that we feel? I have been asked and asked myself this question for years, and have concluded that there is not one simple answer—just some very interesting facts and assumptions that, when pieced together, create a compelling perspective.

The world we live in and on exists in the area between the surface of the earth and its ionosphere, and resonates at a relatively fixed frequency known to atmospheric science as "the Schumann Resonance," typically 8–11 hertz. Everything resides in this "natural" resonance. We evolved in and have adapted to this resonance; it is a part of us, as essential as the air we breathe. Thus, the experience of being in Nature is almost universally positive, enjoyable, and pleasant, as opposed to the hustle and bustle of a dense city, which has a distinctively different resonance, usually the 50- or 60-hertz hum of electricity.

Most of us have had the experience of coming in contact with someone and getting a strange "vibe" from him. Or conversely, we may meet someone and instantly have a good feeling about her for no apparent reason. Perhaps we are feeling the resonance of the person's electromagnetic field. Like the strings of an instrument, we feel in or out of tune.

When a sound wave of one frequency strikes a body that vibrates naturally at the same frequency, it is called sympathetic vibration. The continuance of that sound wave is called resonance. When these pulsations cause another body to vibrate at the same frequency, which is not its own, these oscillations are known as forced vibration. A metaphysical term for this phenomenon is "The Law of Resonance," suggesting that when two bodies, each vibrating at a different frequency, come into proximity with one another, either the higher frequency will down-step to the lower, or the lower will rise to the higher, or they will meet somewhere in the middle. And thus, over time, they will harmonize.

In the case of a human-crystal interaction, the electromagnetic field of a crystal is resonating at specific frequencies. These frequencies are fixed by physics as a function of the organization of the crystal lattice structure and natural pressures on that lattice. We humans generate our own electromagnetic fields, which change due to the mercurial actions of our brains' electrochemical activities. Unlike the stable presence of crystals, we change our brains' frequencies, and thus our electromagnetic fields, by generating different thoughts, or "changing our minds," suppressing or expressing emotions. As a result, I can choose to harmonize with the natural resonance of a quartz crystal. With focus and intention, training and practice, I (along with many others) have developed this ability, and ultimately, through repatterning the neural net of the brain, created avenues of rapport. I am learning the language of crystals, communicating through the vernacular of resonance and harmony. As a result, it just feels good to be around them.

But beyond all of this, those of us who have been touched by a crystal know that all logic ceases in the experience of communing with an indescribable presence.

AMAZING STATES

I watched the woman walk straight across the room to stand before the grand "Ancient One" crystal, bowing her head to peer into the brightly lit stone. Her placid face subtly began to glow, as a current of wonder charged

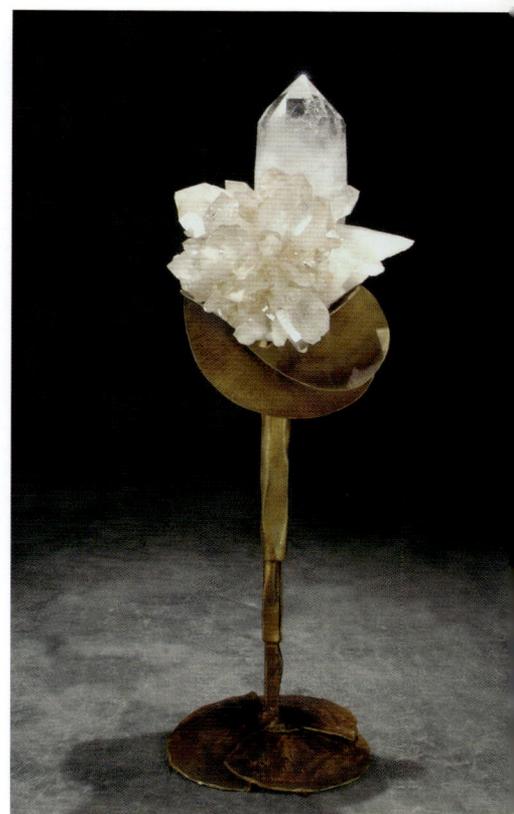

OPPOSITE: *Peaceful Warrior*, carved bi-color (natural) topaz, 11", Russia **ABOVE:** *Lotus Opus*, quartz cluster, 64", Arkansas

her from the inside out. She walked away lit up, as if she had finished work and emerged from an office building into a glorious sunny day.

Another time, a corporate gentleman who had never looked into a large crystal before—*it's only a rock, for sure*—was nonetheless eager to explore. Unsuspected, the immediate jolt from the encounter left him unprotected. Finding himself caught beneath a thundercloud, welling up with tears, not having seen the storm coming, and unable to get out of the rain, he jumped back from the crystal. He was without a clue as to why he had been suddenly overwhelmed by a shower of emotion.

Many others have experienced the knee-jerk bemusement of being in a normal state of mind, then suddenly careening off without warning into sensations of wonder induced by the enchanted moment of a close encounter. Crystals can have this captivating effect on humans.

So what *is* happening?

As my eyes explore and absorb the visual topography of a crystal, the optic nerves capture and deliver a rich palate of information to my brain, fooling me into believing that I am all eyes. But I am actually receiving a broad range of stimulation. The crystal's electromagnetic field oscillates and is amplified, emitting a vibrational spectrum that impacts many parts of my body. It happens in the same way that music is heard by the ears but is also felt. The sensations stimulated by the crystal are knock-knock-knocking at the door of other nerves and organs. I am usually blind to these doors of perception, but these impulses are getting into me through other avenues. Without warning, they flip the emotional light switch at a surprise party in my brain. Momentarily stunned, my mind grasps for reason to explain my state of surprise. But my logic has no traction, I am all feeling, ensconced in raw gems of emotions. And as these uncut feelings are faceted into a jewel of precious experience, I just stand there in a state of amazement, gazing into the crystal.

HEALING STONES & BONES

I don't spend much time in public places. But while doing a show of my work I encountered, within a matter of a few hours, two unusual people with a curious commonality. Mark, a self-proclaimed mineral lover and collector, was admiring some of my pieces. While standing still, Mark bounced around like a hobo riding a boxcar down a rickety set of tracks. His body and mind were in constant motion; his enthusiasm for the subject carried our conversation. I just wanted to grab him and hold him

still. Instead, I decided to try an experiment. I reached for a handholding crystal I had lying on a table nearby. This crystal had a big engine, a locomotive in its own right, cut 12-sided and as clear as an endless sky. I wanted to see what effect the crystal would have on Mark's equilibrium, hoping that it would calm and center him. But instead he began to "ramp up" (the words he used to describe the manic experience he was having). It took Mark about thirty seconds to go from the desert floor into outer space. I had never seen anything like it. His excitement level was through the roof, and I began to fear for those of us left in his wake. I quickly reached for a fist-sized natural schorl. I asked Mark to trade crystals with me. Instantly, as he gripped the tourmaline, his energy dropped like Newton's apple as he came back to earth. The shift in his energy was so palpable that my body felt as if I had just closed the door on a 60-mile-per-hour wind gust. Mark looked different; I could see him for the first time. He was calm, his voice had presence, and he wondered aloud at what had just happened. Dorothy was back in Kansas. I suggested that he consider carrying a small piece of black tourmaline with him in his pocket.

When a woman named Harriet, a crystal lover who has bought pendants from me over the years, arrived in my showroom a few hours later, I decided to continue experimenting. Harriet and Mark had each made the point that their attention, and consequently their conversation, was "scattered," probably to set me at ease. Being at a show in the midst of thousands of crystals can leave one feeling bounced off a wall. My exchange with Harriet reminded me of an electrical wire that was not securely attached, sparking intermittently. She was hungry to find a new crystal pendant. She asked me disjointed questions, trying to divine which pendant I thought would be best for her. I didn't know what to tell her. Most often, people choose a pendant based on the beauty of a given piece and how it looks on them. Using the criterion of beauty, the choice is subjective, based on the individual's sense of aesthetics. But I soon realized that Harriet was searching for a pendant to balance her energy and to focus her mind. So she began trying different stones on around her neck. The citrine piece looked great on her, as did the rutilated crystal. One by one, she tried on minerals of different compositions, shapes, and colors. Initially, I thought that she just had a hard time making up her mind. Then she put on a pendant carved of Bruno jasper (a form of agate in the chalcedony family). Instantly, her erratic, centerless conversation gave way to that of a woman sitting comfortably in her own living room. For the first time, she looked

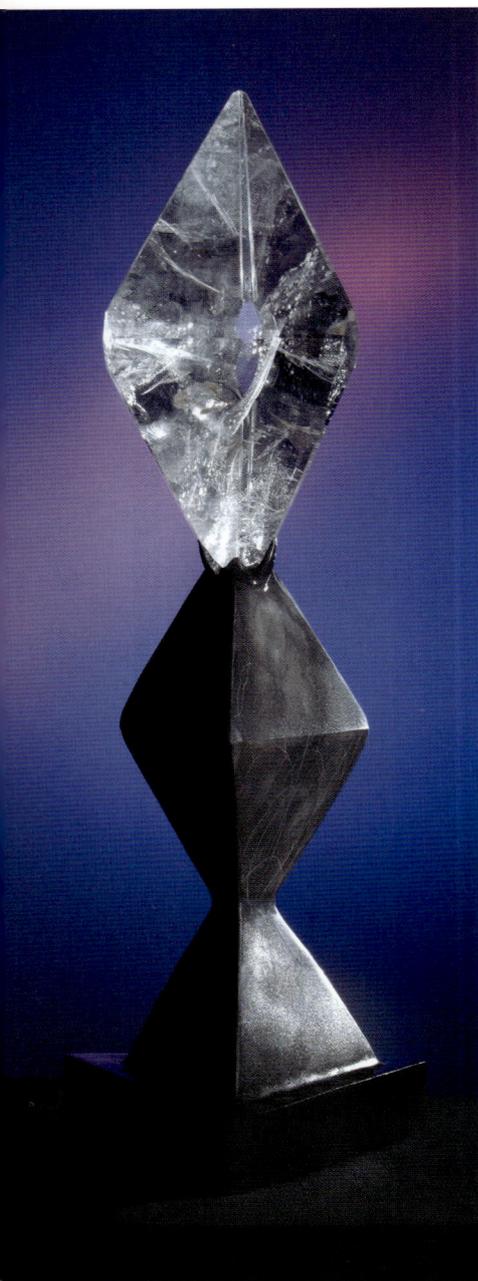

ABOVE: *Double Tetrahedron*, QUARTZ, 21″, MADAGASCAR
OPPOSITE: *Crystal Skeleton*, QUARTZ, OVERALL LENGTH 6′5″

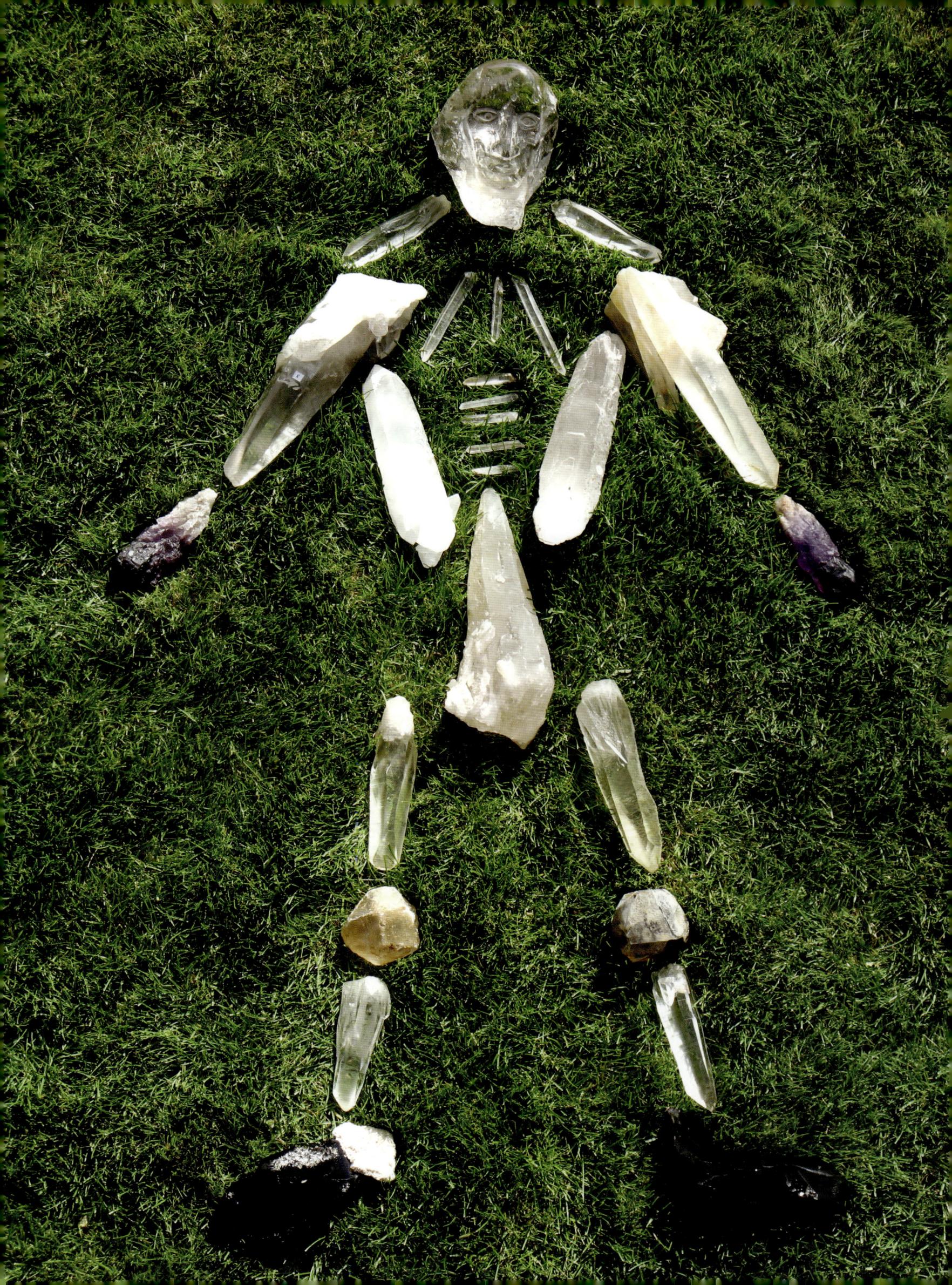

me straight in the eye, and with conviction said, "This is the one."

When I have discomfort in a specific part of my body, I don't hesitate to grab a crystal out of my medicine bag. But what I enjoy most is using a crystal to blast high-powered, supersaturated energy throughout my body.

The crystal works in subtle ways. Lying on the couch, I'm feeling tired, an uneasy, dissonant mood ricocheting like a pinball off my bones. I don't like the way I feel. I pick up a citrine crystal, an old friend, and lay its cold body on my chest. The crystal and I talk skin to skin. I ask the crystal to work with me to change this feeling. I ask my body to harmonize with the pulsing, natural, soothing resonance of the crystal. We form an alliance. Within minutes, the crystal has warmed to my body temperature and the dis-ease that pervaded my body has vanished, and I feel good again. The crystal doesn't change: I do.

One of my first experiences of crystals possessing healing properties came during a party at my home. A friend of a friend was sitting on the couch; I had never met the guy. He told me he'd had a stomach-ache for three days, hadn't eaten for two days, and that he wouldn't be joining us for dinner. I walked into my bedroom, grabbed an 8-inch-long golden citrine crystal, and told him to hold it on his stomach. Checking in ten minutes later, this gastrically stressed visitor asked me with transformed astonishment, "What did you do to me?" He had never held a crystal, but the one resting on his stomach had, within minutes, made three days of discomfort disappear. I explained, "Crystals can be used for healing." While the statement had little meaning to him, the fact that his pain had transformed into hunger meant a great deal. He handed the citrine back to me and proceeded to devour a full meal.

Since that time, I have discovered that there are many cultures throughout history that have used stones, crystals, and gems for healing. Initially my limiting judgments saw them as modalities used by primitive, superstitious peoples without modern medical knowledge. But I have come to realize that, like herbal medicines, stones are part of the wisdom and abundance provided to us by earth herself. And that with proper use, the results can be remarkable. The Jivaroan Indians living in the tropical forests of Ecuador and Peru; Sri Ganapathi Sachchidananda, a guru from India who has a following of hundreds of thousands of disciples; a successful foot surgeon in San Francisco; Native American shamans; a biopsy cancer specialist; practitioners of Ayurveda, a 6000-year-old medical tradition commonly practiced in India: they all use quartz crystals to remove dissonant energy from the body.

These individuals and the cultures they live in have virtually no contact with one another. There are no textbooks, guidelines, or associations that bind their knowledge of crystals. They live on distant quadrants of the planet and know nothing of one another. Yet these people are intrinsically connected through their intention to heal and their use of crystals as auxiliary tools in their practices.

Why is it that although these people do not have a common source of knowledge and there is no affirming clinical data compiled by the modern medical profession, many people successfully apply crystals to their work of healing? What is inherent in the crystal, and the person using it, that produces practical, effective results?

Through independent invention, the traditional and generational passing on of knowledge, and vertical knowing (i.e., spontaneous, nonlocal), the art of using crystals as tools for healing, as well as other valuable functions, continues to endure.

VESSELS OF CONSCIOUSNESS

Why do people meditate with crystals?

I am preparing for a show of my work. The usual suspects appear: chaos, frustration, fear. They spill all over my day like glue. The lobes of my brain feel compressed. A to-do list is spreading like wildfire: pieces to finish, people to call, displays to make, money to be spent. I let my tornado mind spin, the debris bouncing off my brain like hard rain hitting the windshield. I need to stop the mayhem, to slow it all down, a change of scenery. Picking up a crystal, I sit down, close my eyes, and slip into meditation, moving beyond the riffraff of disjointed thoughts and entangled emotions.

In the same way crystals are used to align radio waves, they can also focus and tune disjointed and competing thoughts and emotions. Without a tuning device, a radio will break in and out of stations. In a similar way, a crystal can work as a tuning device for the brain, facilitating clear, organized, and aligned thought— allowing you to tune in.

One can also program crystals to perform different functions, similar to the way a computer is programmed to perform a variety of

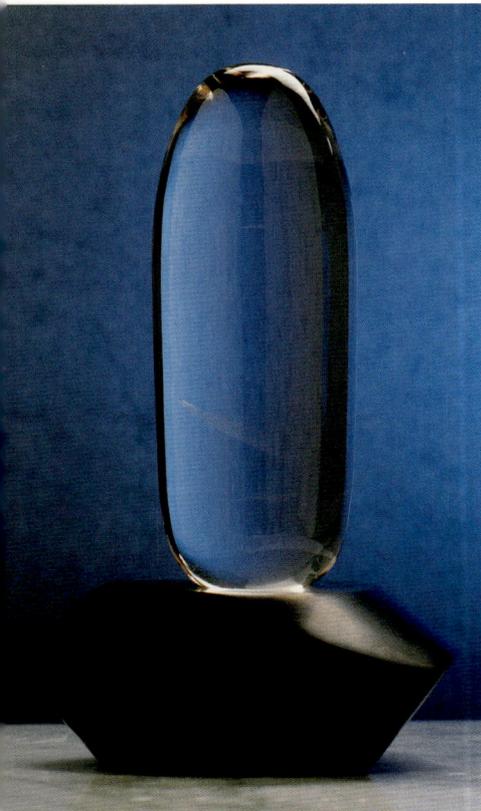

ABOVE: *Lingam*, OPTICAL QUARTZ ON CARVED BASALT, 8″, BRAZIL
OPPOSITE: *Clear Conscience*, SCULPTED QUARTZ, 20″, RUSSIA

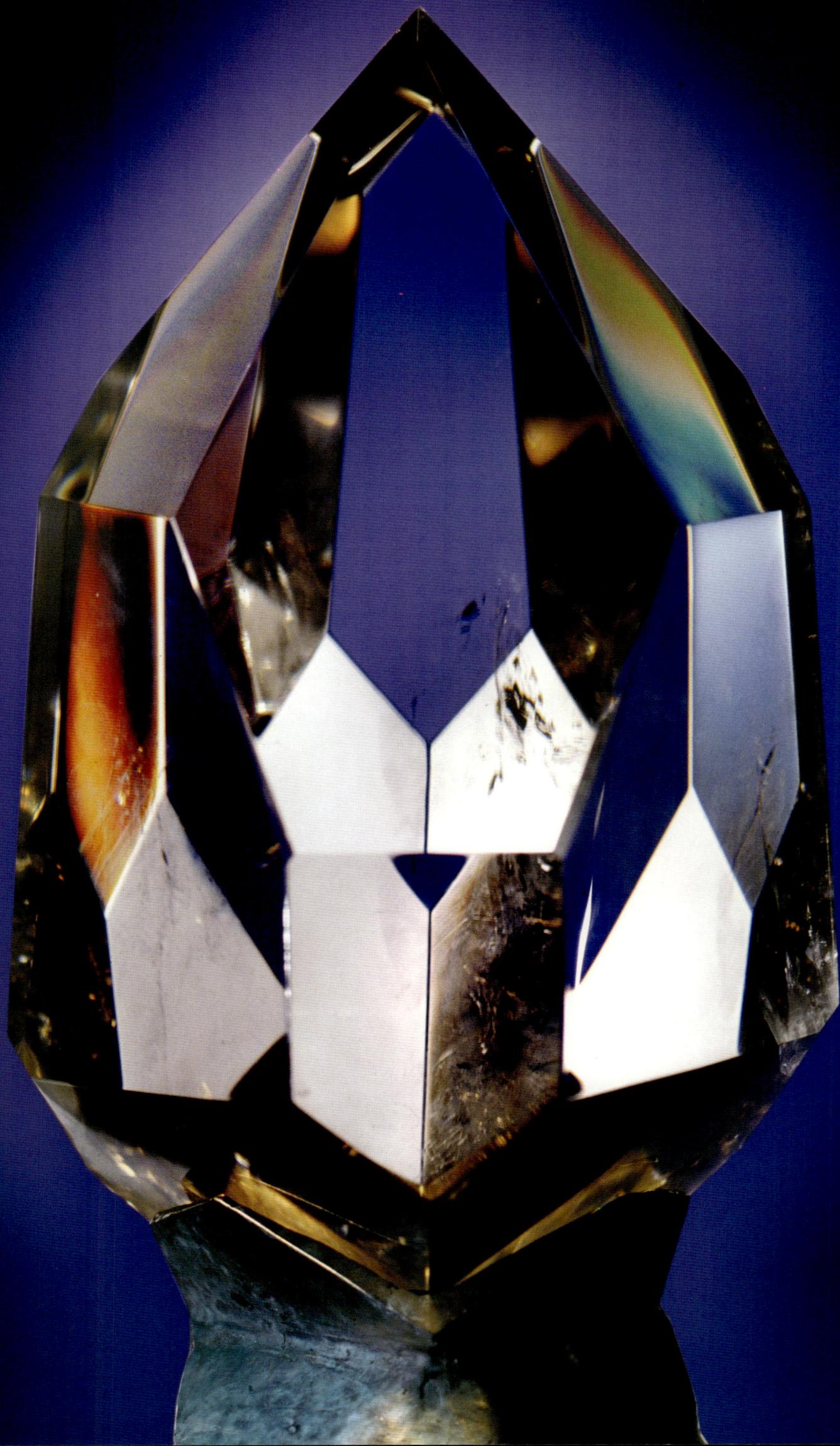

tasks. I have "programmed" a crystal for meditation. My having used this crystal many times, it is now a touchstone that stores the vibrational resonance of a deep state of meditation. When I pick it up, the Law of Resonance insures that the crystal and I synchronize. As a result, my consciousness glides easily, triggering my brain to release the chemical neuropeptides that alter my electromagnetic field. Magically, a peaceful tide washes over my body, as my mind becomes more lucid.

I plunge like a scuba diver, using the crystal as ballast to keep my consciousness alert while submerged. The crystal is my inner-dimensional traveling companion, a vessel I have cut and angled specifically to transport me. It accompanies me as both navigator and compass: a mix of copilot and technical apparatus, nestled comfortably in my hand. Like a high-tech instrument, the crystal amplifies my deep-brain theta waves, creating an enriched mental timbre. These very precise, emotional coordinates replace haphazard thoughts. My hand becomes calm and relaxed from the contact, which spreads peaceful sensations throughout my body, harmonizing with the cadence of the crystal's piezoelectric pulse.

As I finish meditating, I ascend from the depths to the surface of my awareness, delivering more of myself to the beach of my everyday life. And there I rejoin the me who has been waiting on the shore, observing the horizon of a new reality.

Why meditate with a crystal? Because it helps concentrate the mind to be focused, productive, energized, and expansive.

ROMANCING THE STONES

When I started looking for answers to the crystal mystique in the early 1980s, I was seeking knowledge beyond hard science and definitions of geology and mineralogy. I perused books on the subject of crystals and metaphysics. I had some knowledge of mineralogy and lapidary, but was looking for sources of information that would demystify the metaphysical qualities and applications of crystals that were rumored to exist. At that time, I found that the books I had read on the subject either didn't make sense to me, or that the information was misleading or inaccurate.

But still I was drawn to learning about the mystical qualities of crystals. I realized that I had to be my own scientist, to ask my own questions, to do my own experimenting, to draw my own conclusions, to challenge those conclusions, and to keep experimenting. I sought empirical data that rang true for me.

Convincing others of my findings became less and less relevant.

I did eventually find the information on crystals presented by the spiritual teacher Lazaris to be powerfully illuminating, a magical blend of the practical and that which exists beyond the five senses. In a series of audio and video tapes, Lazaris has beautifully documented the metaphysical principal of crystals. Still, much of what I have discovered is personal and thus very difficult to communicate objectively. Not only is there a problem of language, but there are significant hurdles in working with a belief structure that is outside of conventional thinking. As must be true in any discipline, through immersing myself in the ongoing practice of working with crystals, I have learned to produce repeatable, beneficial results. As relevant as these manifestations are to me, when using the measuring stick of conventional knowledge, many of them are classified as subjective. On the other hand, quantum physics may be a better tool to explain the validity of many of these results. But I am not a quantum physicist.

Some of the answers I have been seeking may live in the fact that metaphysical knowledge and meaning do not come from the crystal; instead, such knowledge and meaning come from the individual as reflected by the crystal. At the crossroad of objectivity and the physics of crystals is a narrow path that leads through the heart of the experience of the observer. And as we each venture alone into the undiscovered wilderness of our experiences, we find new worlds that stretch the boundaries of our personal universe.

When one attempts to explore the depths of a subject, one looks for its outermost edges, journeying beyond common knowledge to find its mystery. Within its mystery lies its essence, and within its essence resides a part of yourself that you never knew was there.

The crystal is light, frozen into expression in solid matter.

It is a touchstone for beauty. Beauty, while always present, waits to be discovered. When I happen upon it, it consumes me; I resonate in awe. I am in touch with its essence, which touches my essence, and connects me to the source.

Therein lies the answer.

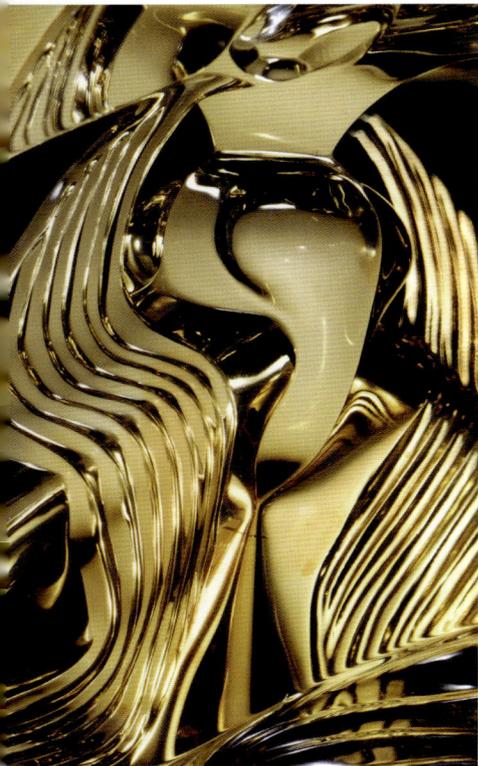

ABOVE AND OPPOSITE: *SPIRIT RISING*, CITRINE QUARTZ, 21″, CRYSTAL WEIGHT 15 LBS., BRAZIL

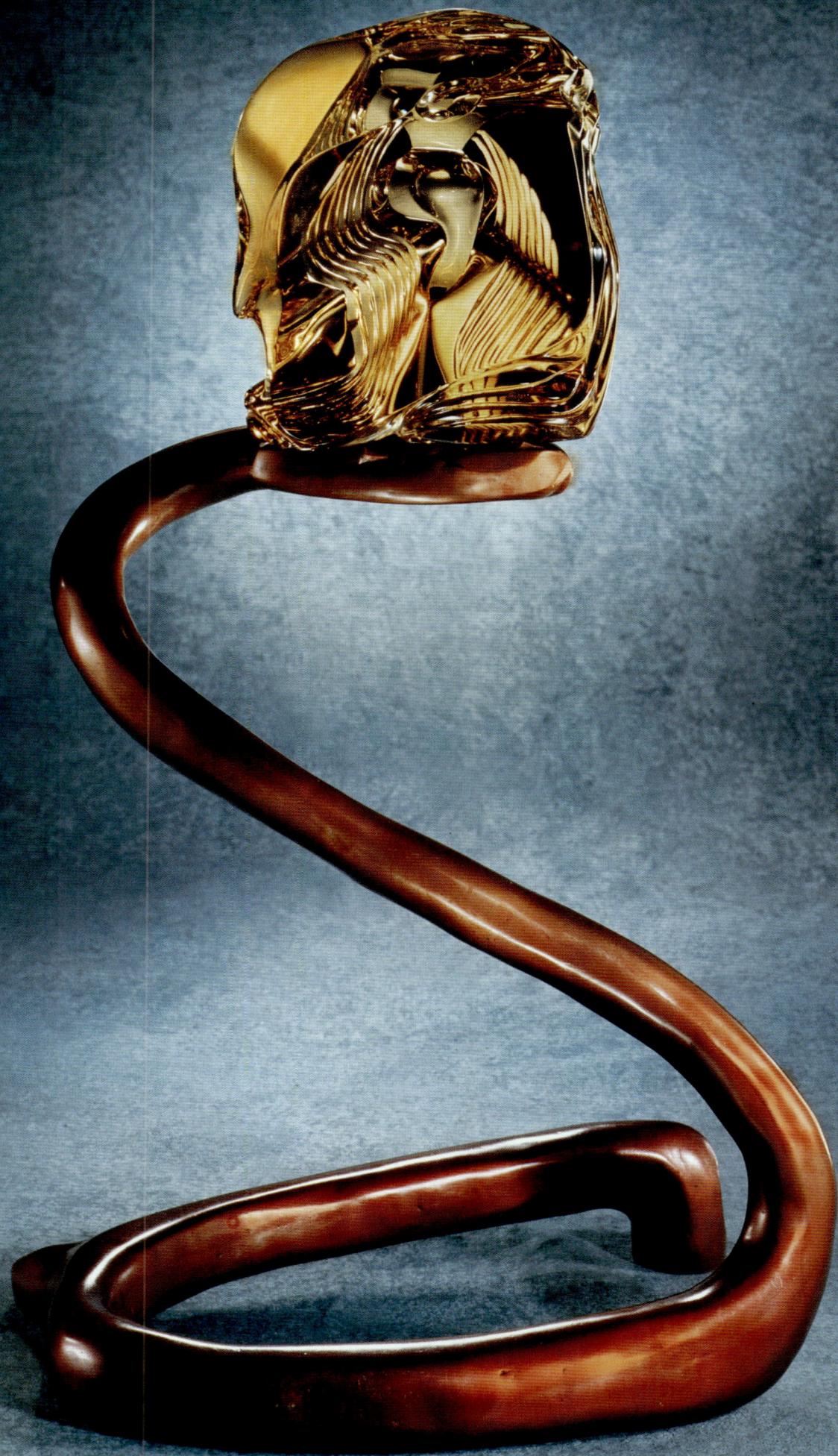

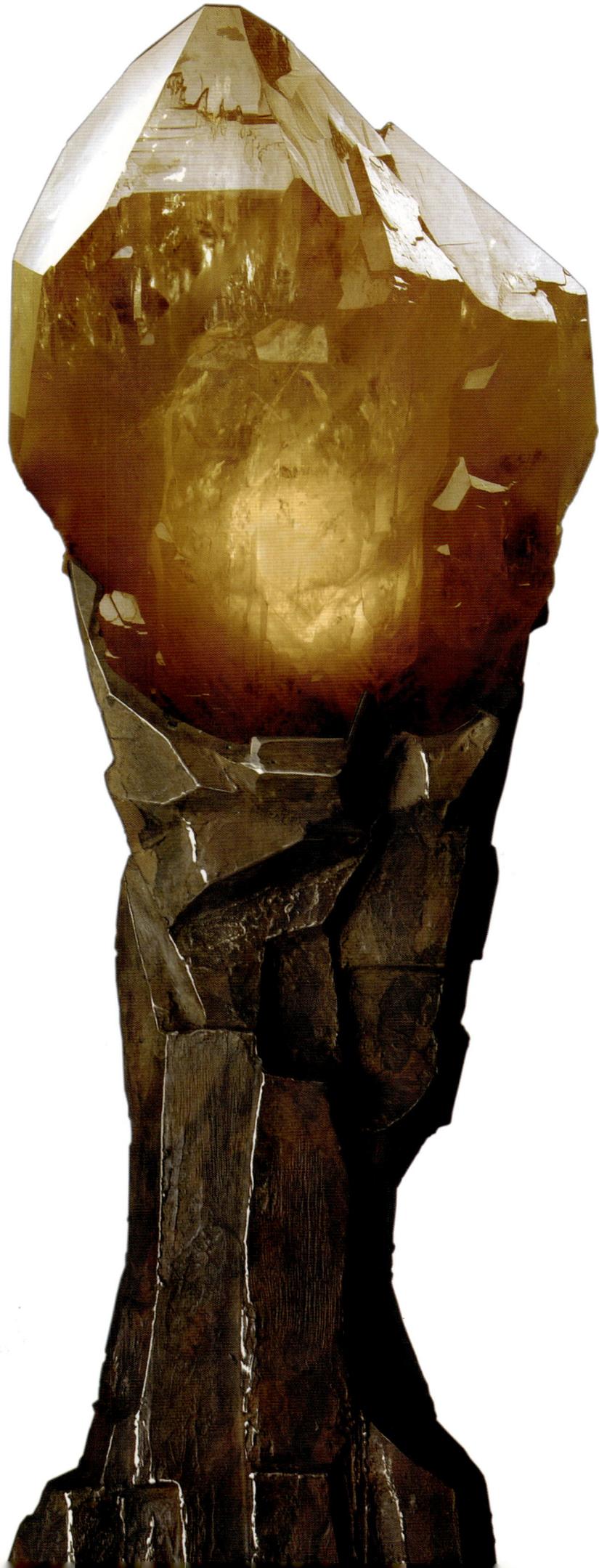

CRYSTALS CAN SERVE ME

Revealing more about myself,

A gateway to discovering who I am,

They can amplify, condense and focus, direct and project energy as force.

They can be focal points of choice,

Allies of my attention and intention,

Bringing balance and harmony to resonance,

Can gather and hold energy.

They can hold and release my intent,

Can release energy in-formation,

Co-creating alliances.

Allies in the energy medicines

Can facilitate change, healing, and protection,

Can work to calibrate and balance my brain and mind,

Can trigger my unfamiliar senses.

A gateway to the complexities of consciousness,

A conduit for the expression of other consciousness

Can help reprogram and re-pattern the subconscious and unconscious minds,

Can be a focal point in my actions in the creation of my future.

They can be a doorway to the beautiful unknown.

A crystal that has presence is a vessel for knowing,

Retaining information in the form of resonance.

They can stimulate love,

Receive that love, amplify it,

And return it to me.

They give exaltedly without expectation of receiving something in return,

And yet they are willing to receive.

And I have the choice to accept these possibilities as opportunities to grow

Or to perceive crystals as inanimate objects commonly called rocks.

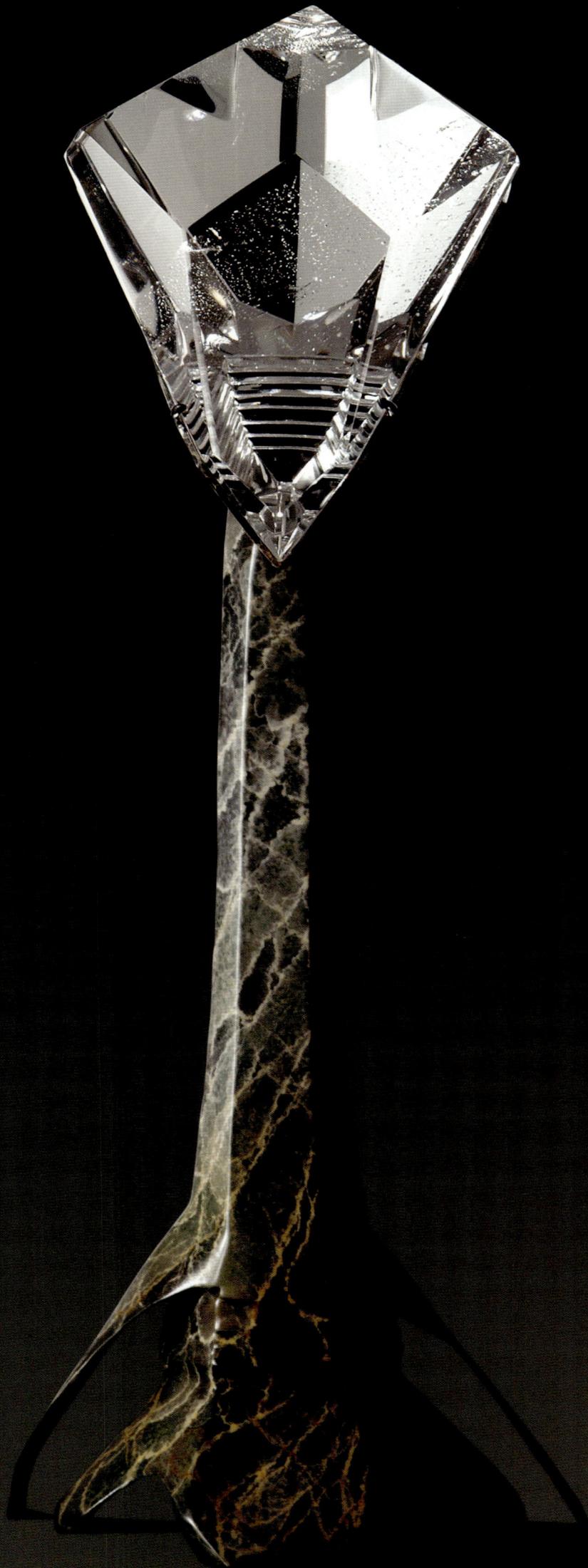

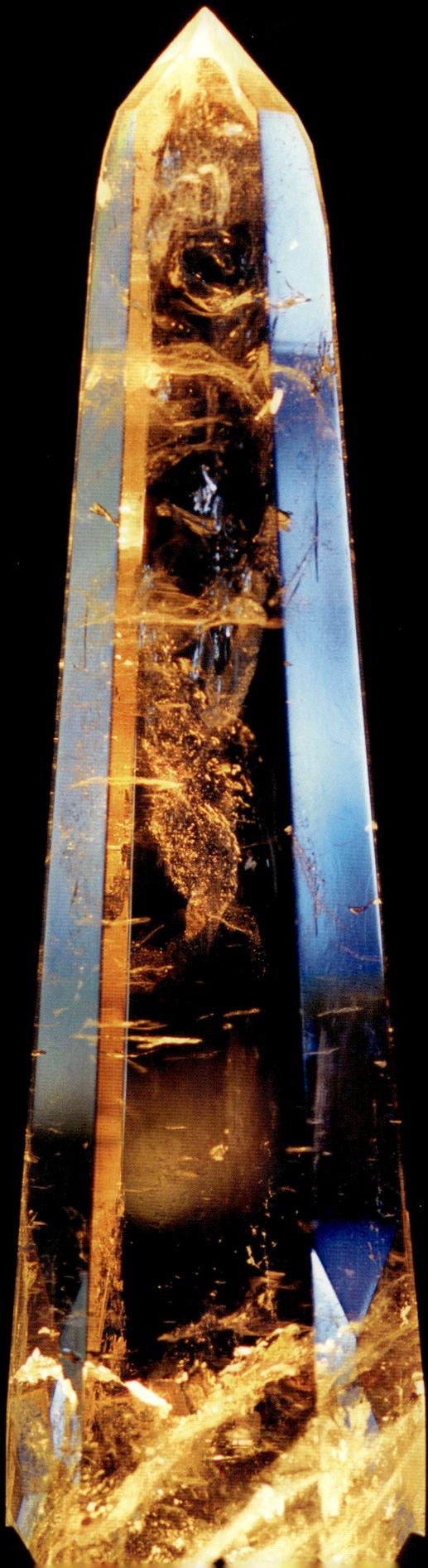

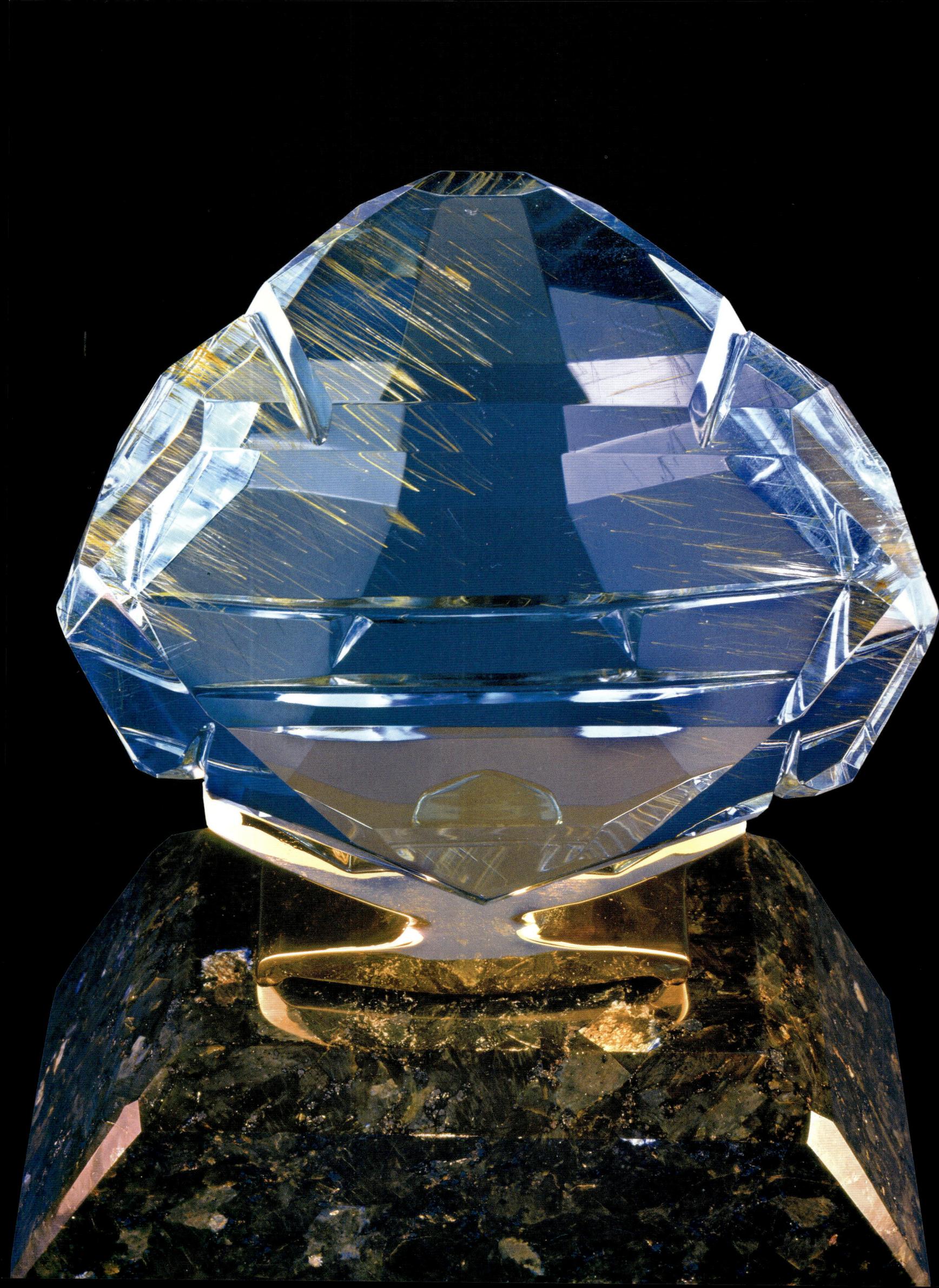

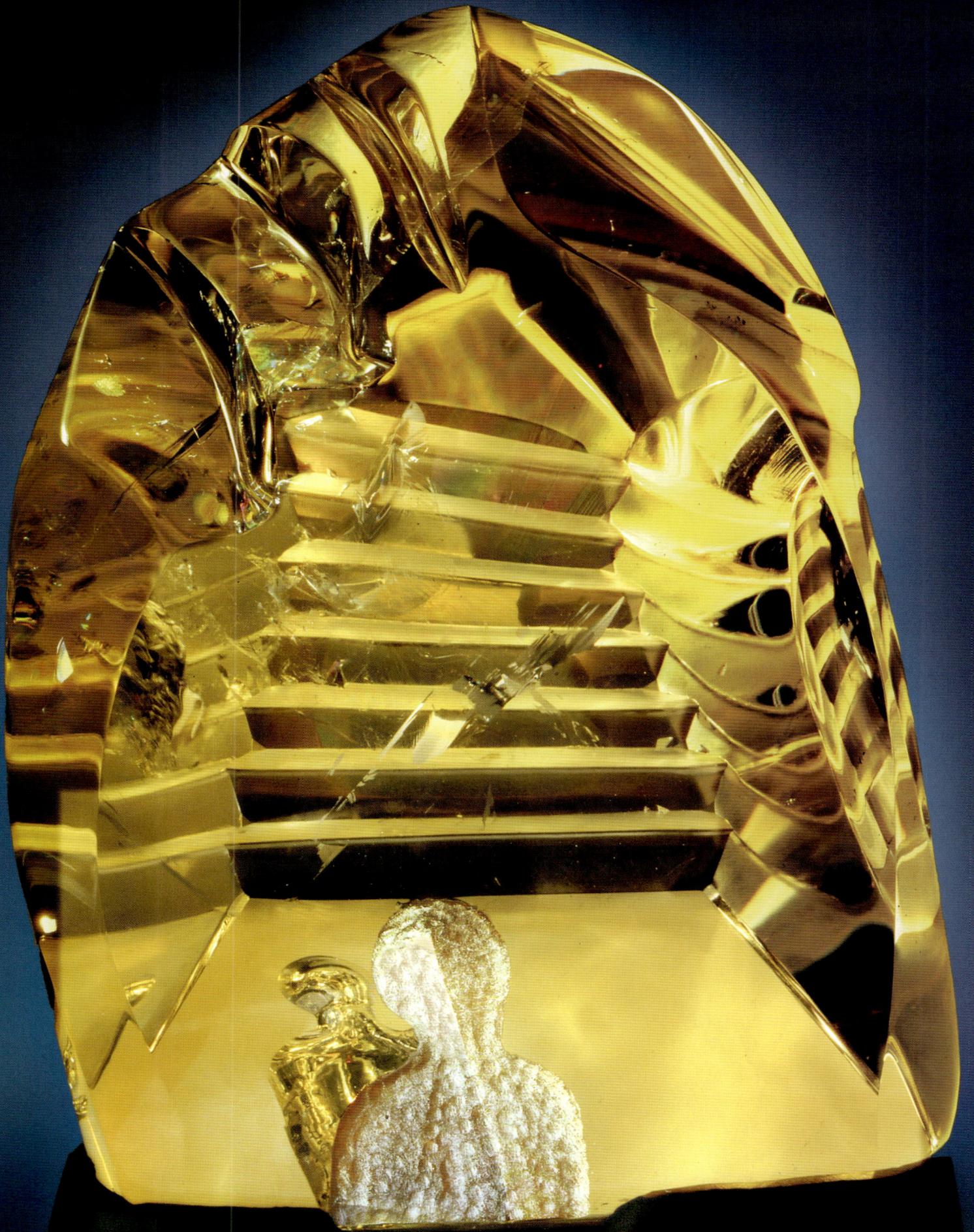

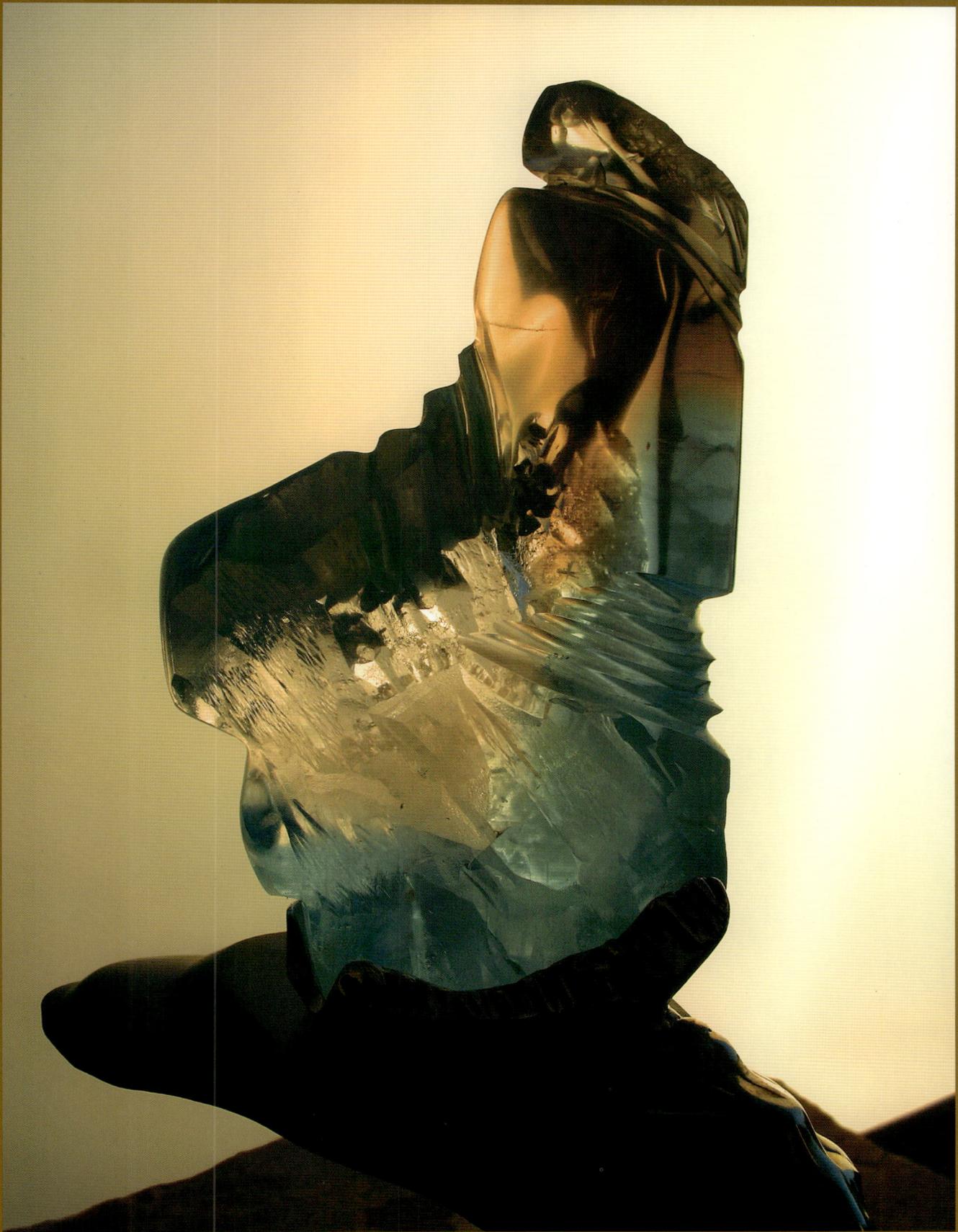

OPPOSITE AND ABOVE: *Dreaming the White Buffalo,*
carved natural bicolor topaz on silver base, 419 grams, Russia

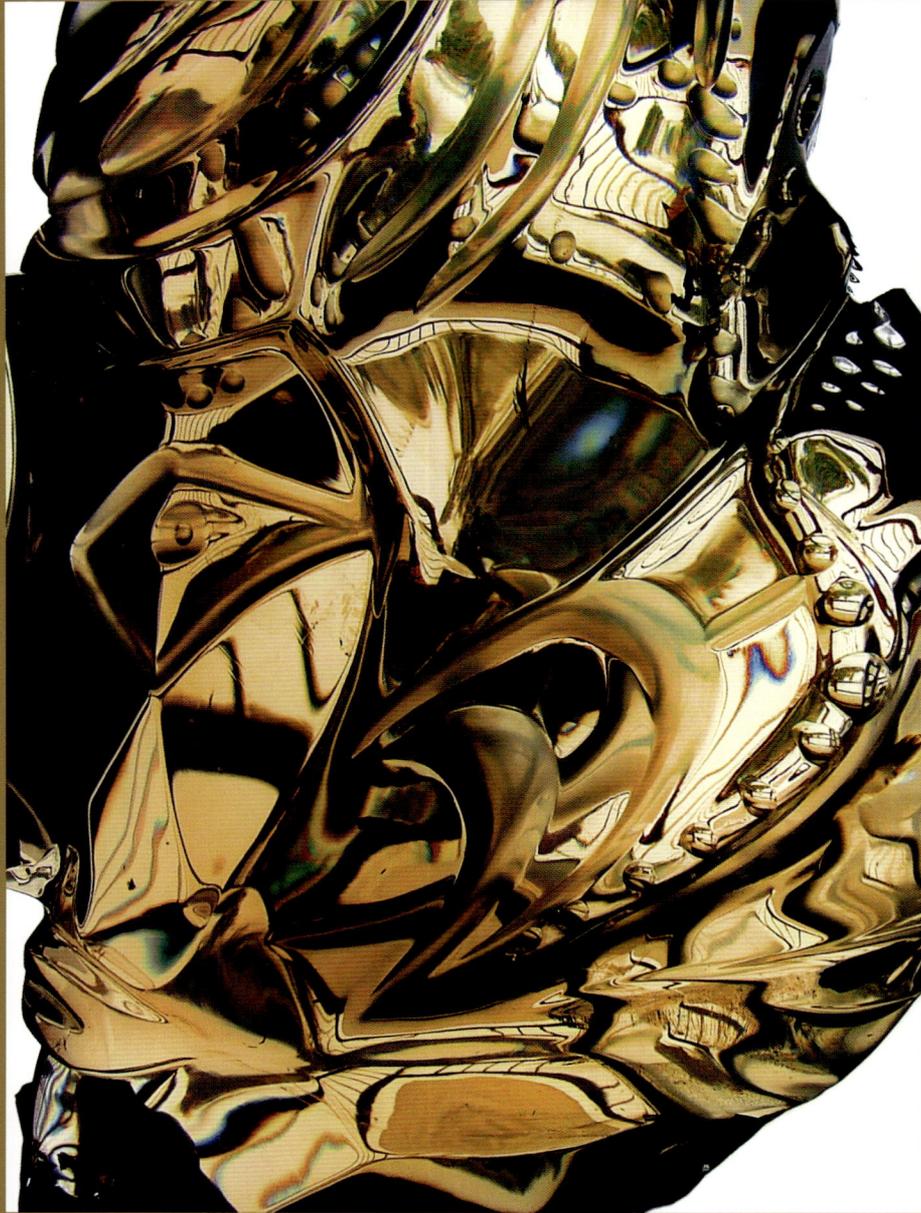

ABOVE: *DREAMER*, DETAIL **OPPOSITE:** *DREAMER*, SCULPTED CITRINE
QUARTZ HELD BY BRONZE ON BLACK GRANITE, 33", BRAZIL

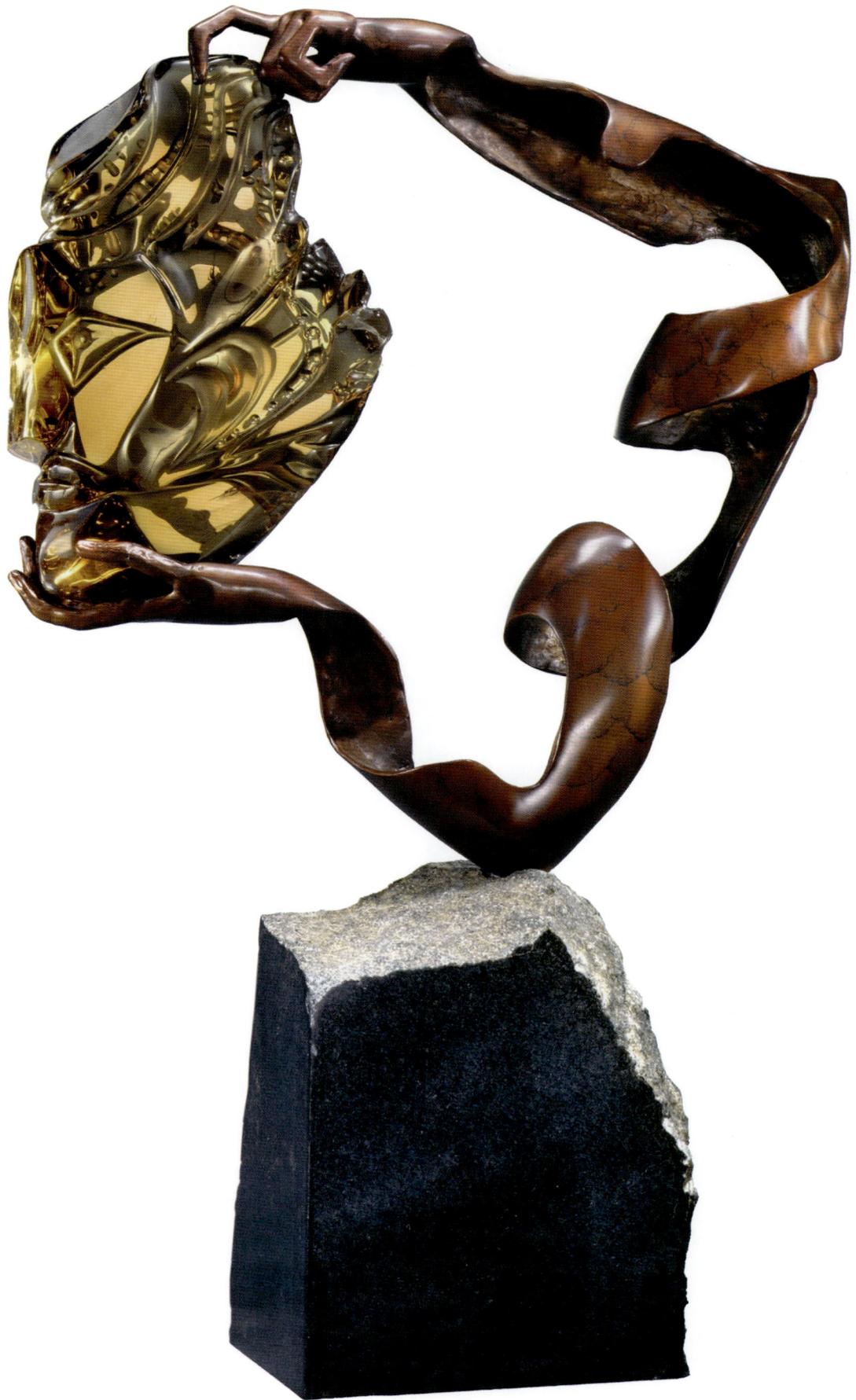

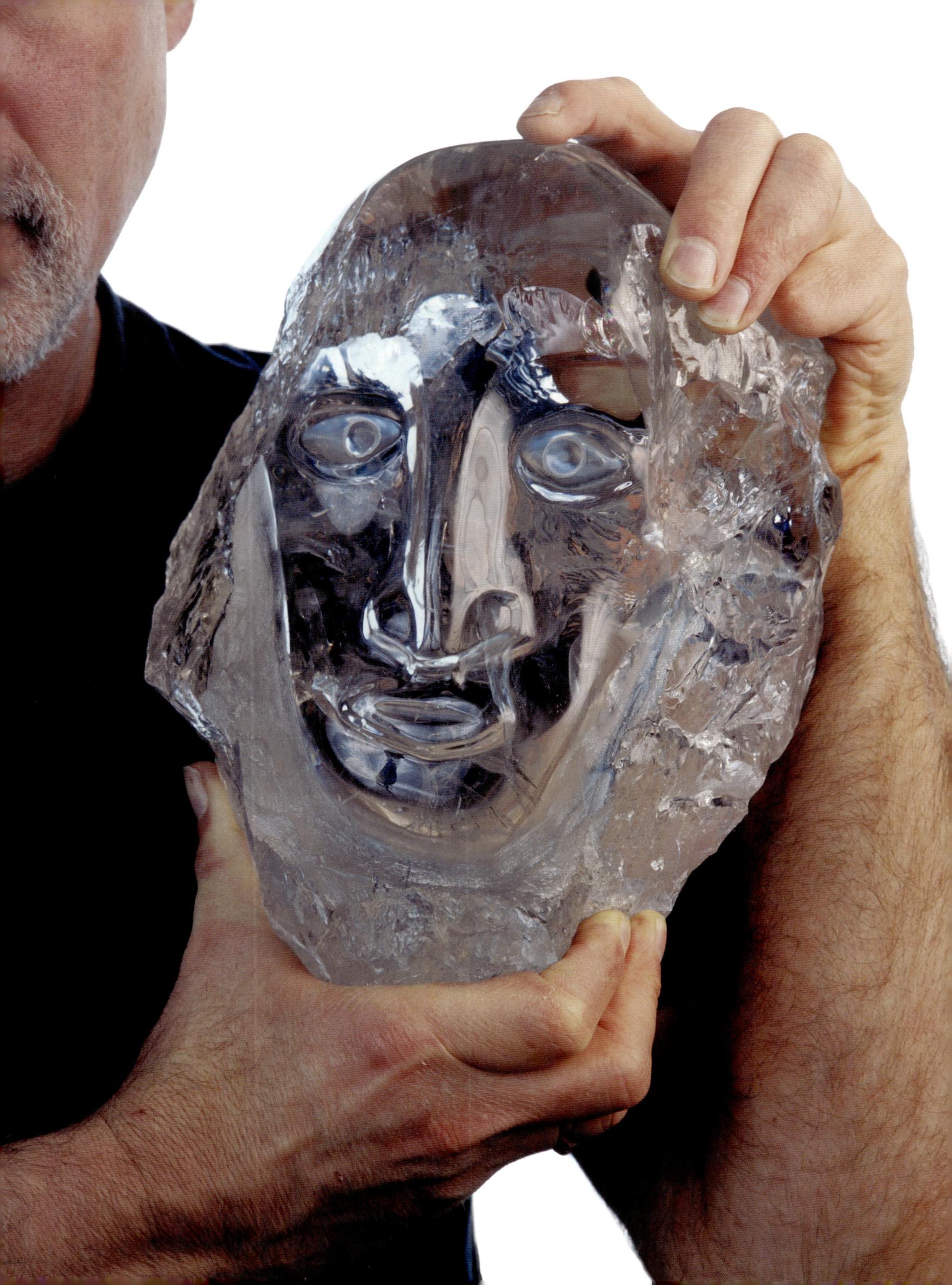

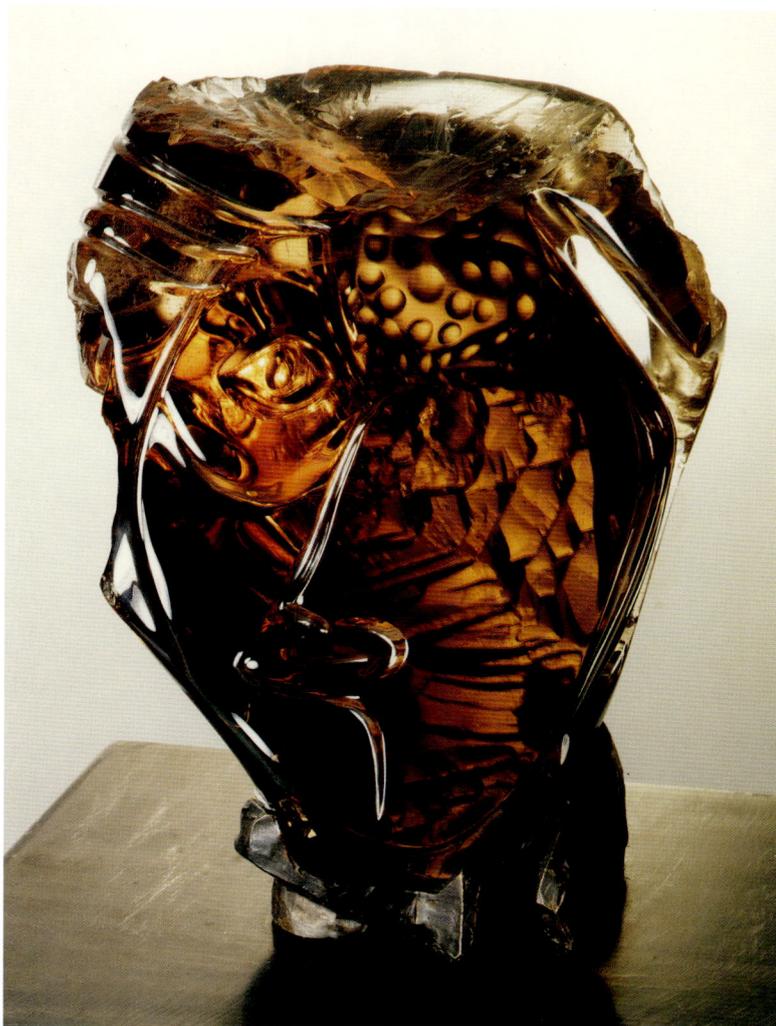

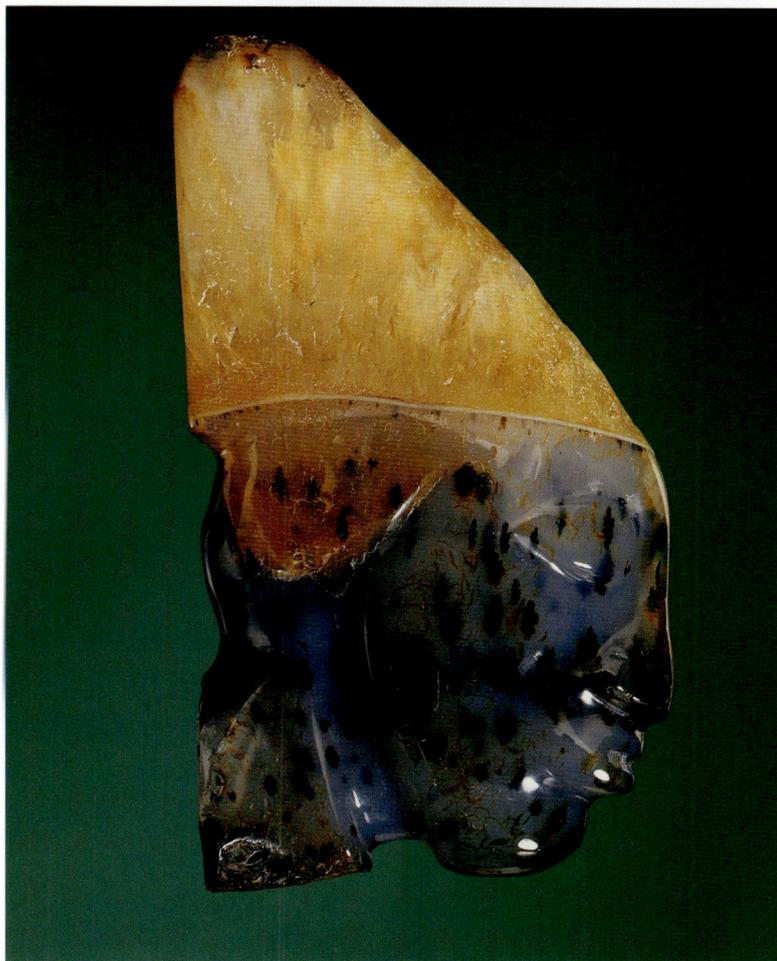

OPPOSITE: *OLD FRIENDS*, QUARTZ, 22 LBS., BRAZIL TOP: *PICASSO'S DREAM*,
CARVED SMOKY QUARTZ WITH NATURALLY ETCHED SKINS (EYE IS CARVED ON THE BACK FACE
BUT PERCEIVED THROUGH THE FRONT), 8″, BRAZIL ABOVE: *AGATE HEAD*,
CARVED DENDRITIC AGATE, 5½″, MONTANA

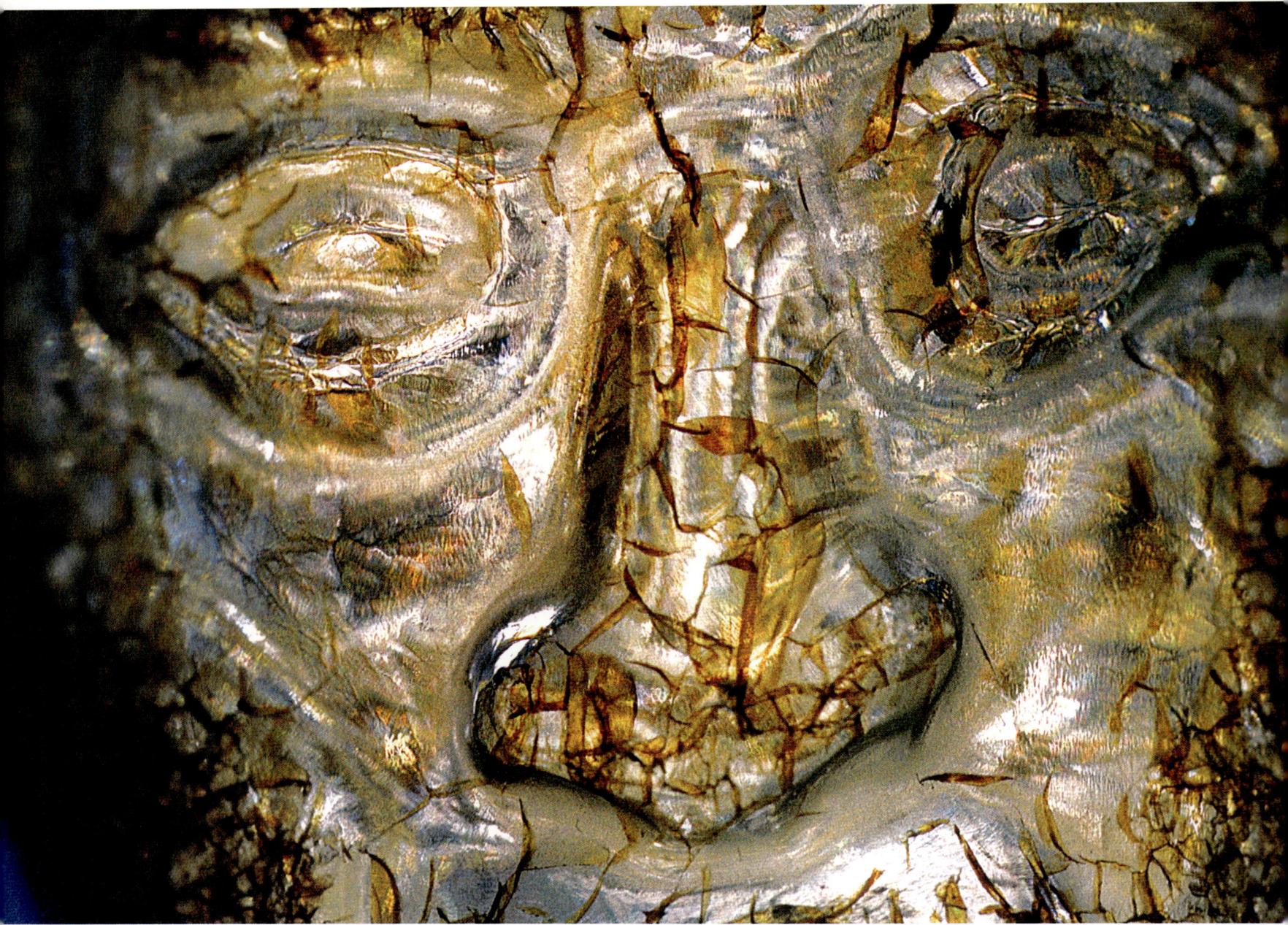

ABOVE: *Ancient Face*, river-tumbled quartz, 3″, Madagascar

OPPOSITE TOP: *Felinian*, reverse intaglio carving of black tourmaline in quartz, 4″, Madagascar

OPPOSITE: *Geronimo*, carved banded agate, 3½″, Oregon

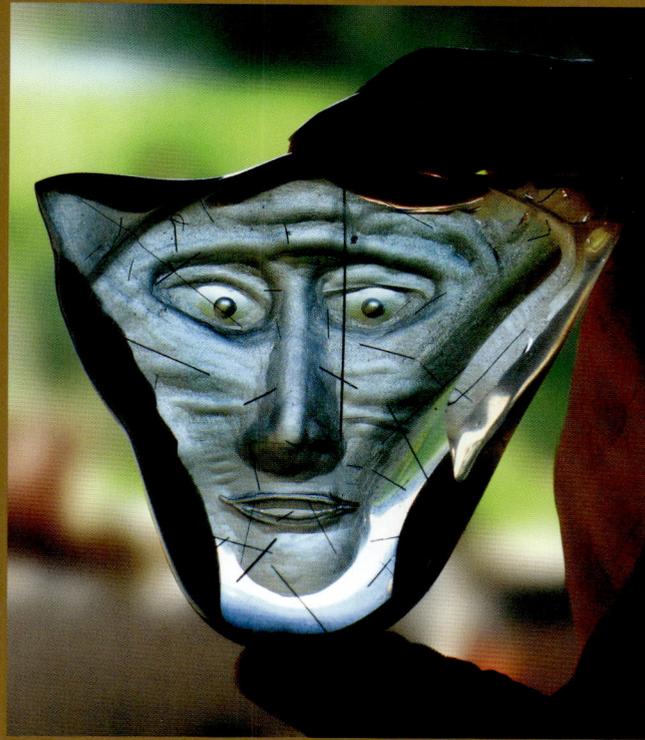
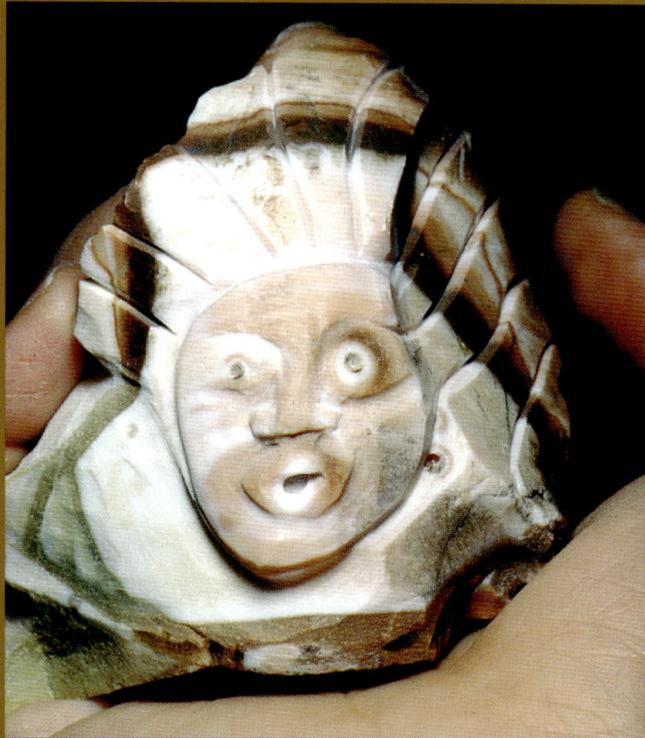

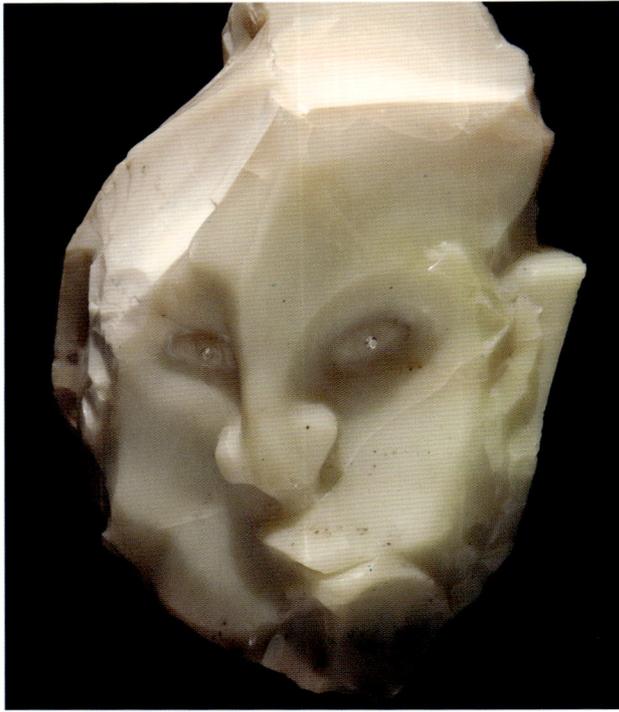

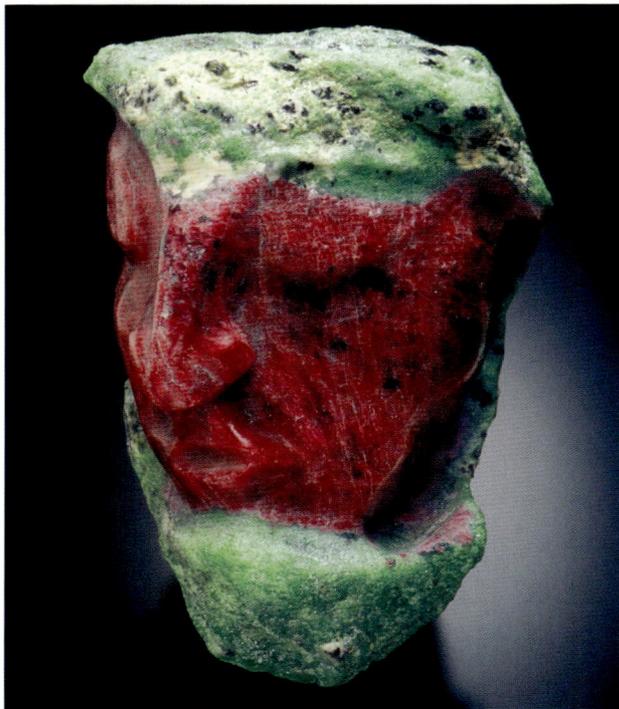

TOP: *Leprechaun*, carved opal with inset diamond eyes, 5″, Oregon
ABOVE: *Ruby Moses*, carved ruby and zoesite crystal, 254 grams, India
OPPOSITE: *Van Geode*, amethyst geode with calcite, 13″, Uruguay

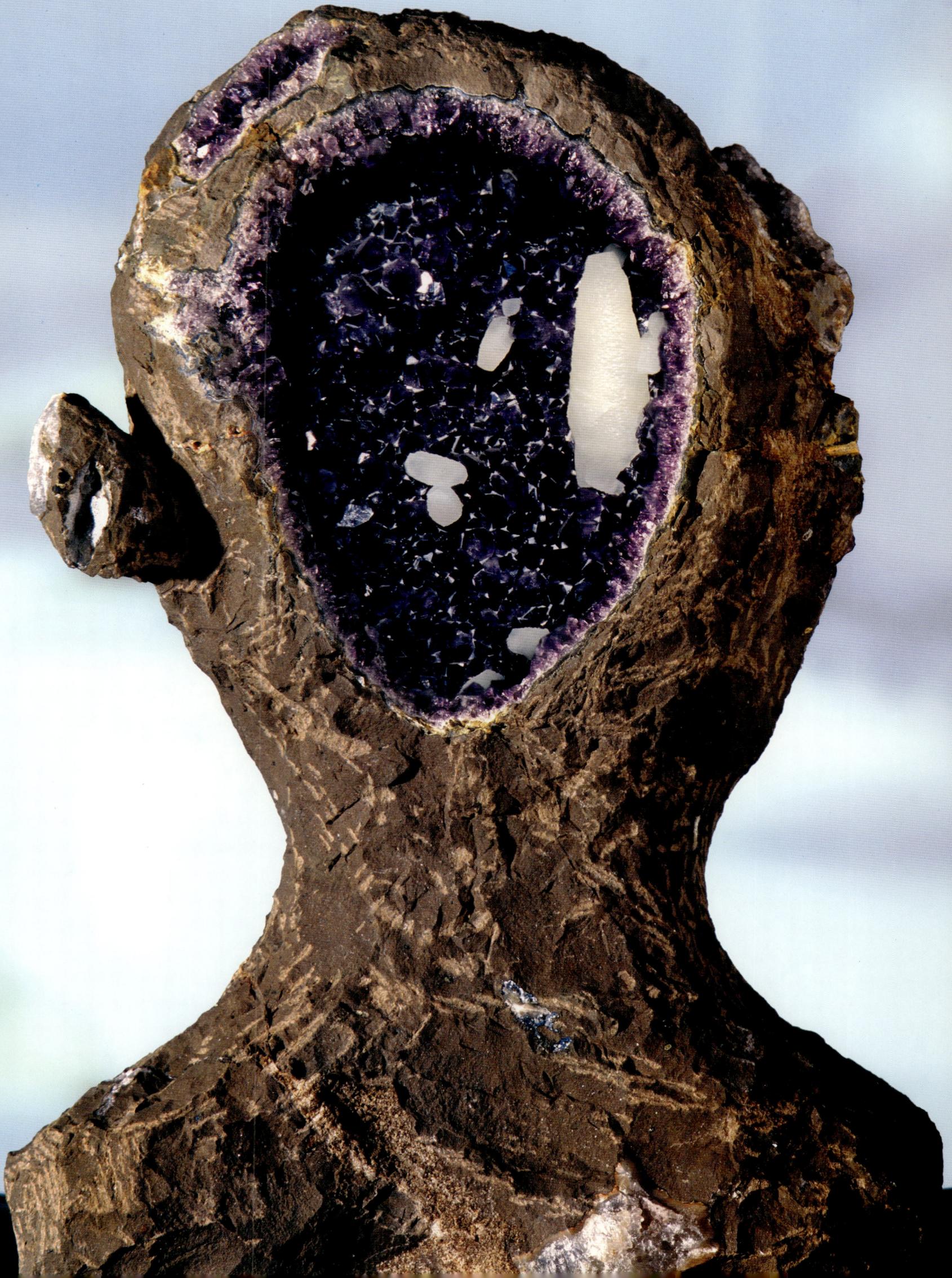

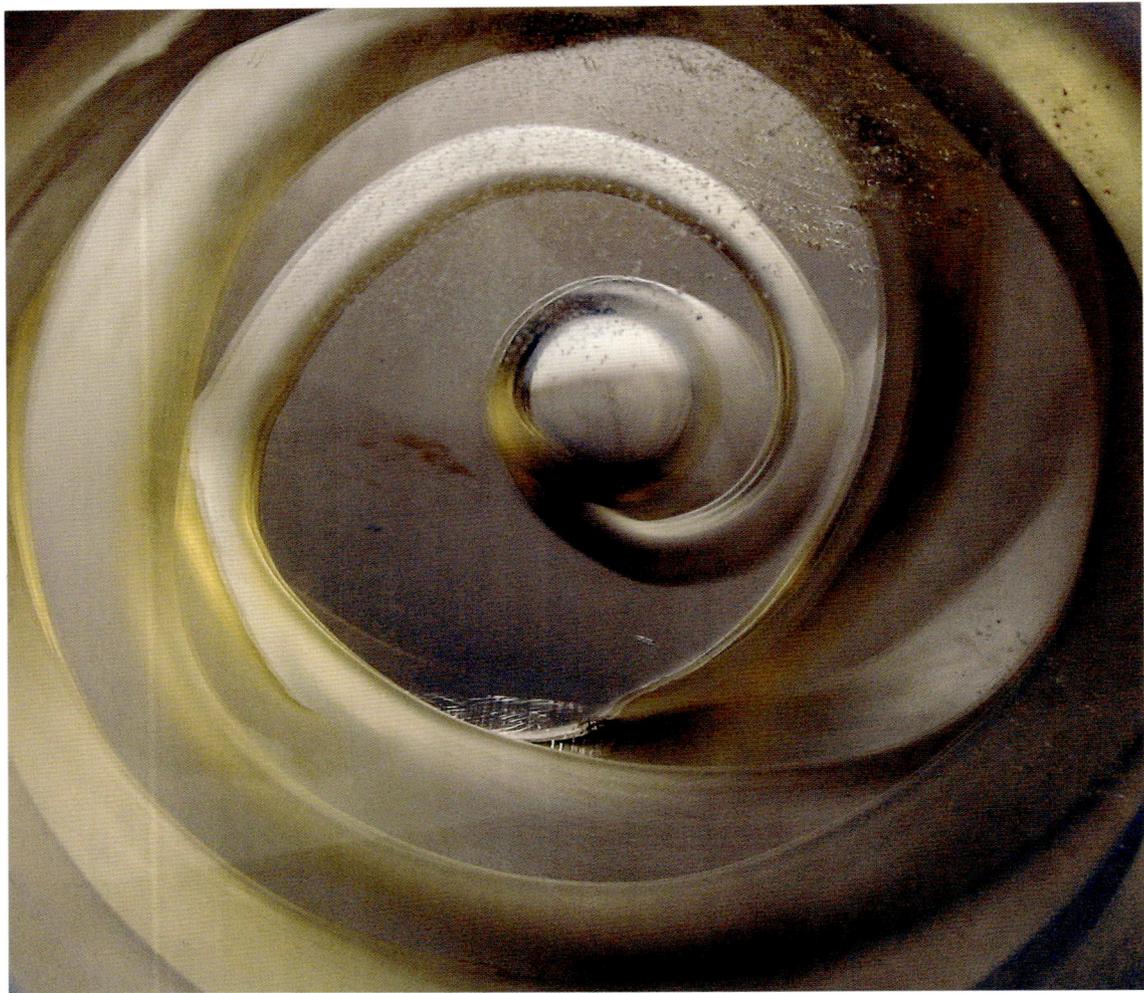

ABOVE: *Inner Vision*, carved quartz, 4″ diameter, 7″ deep, Brazil
OPPOSITE: *Chakra Wands*, clear quartz crystals combined with Zambian tourmaline,
Brazilian citrine, Brazilian yellow beryl, Russian helidor, Afghani topaz, Bolivian
amethyst, Brazilian rose d'France

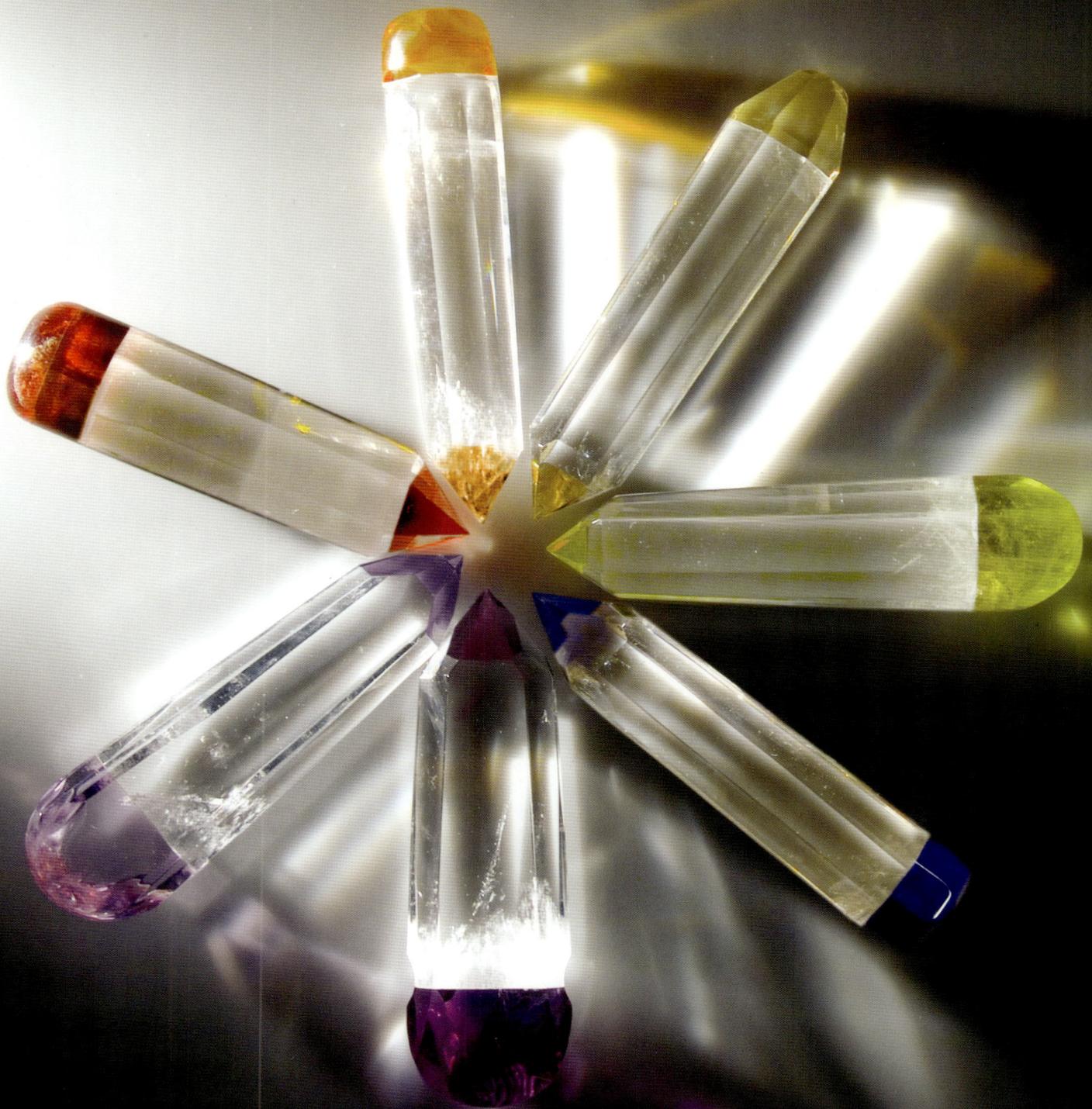

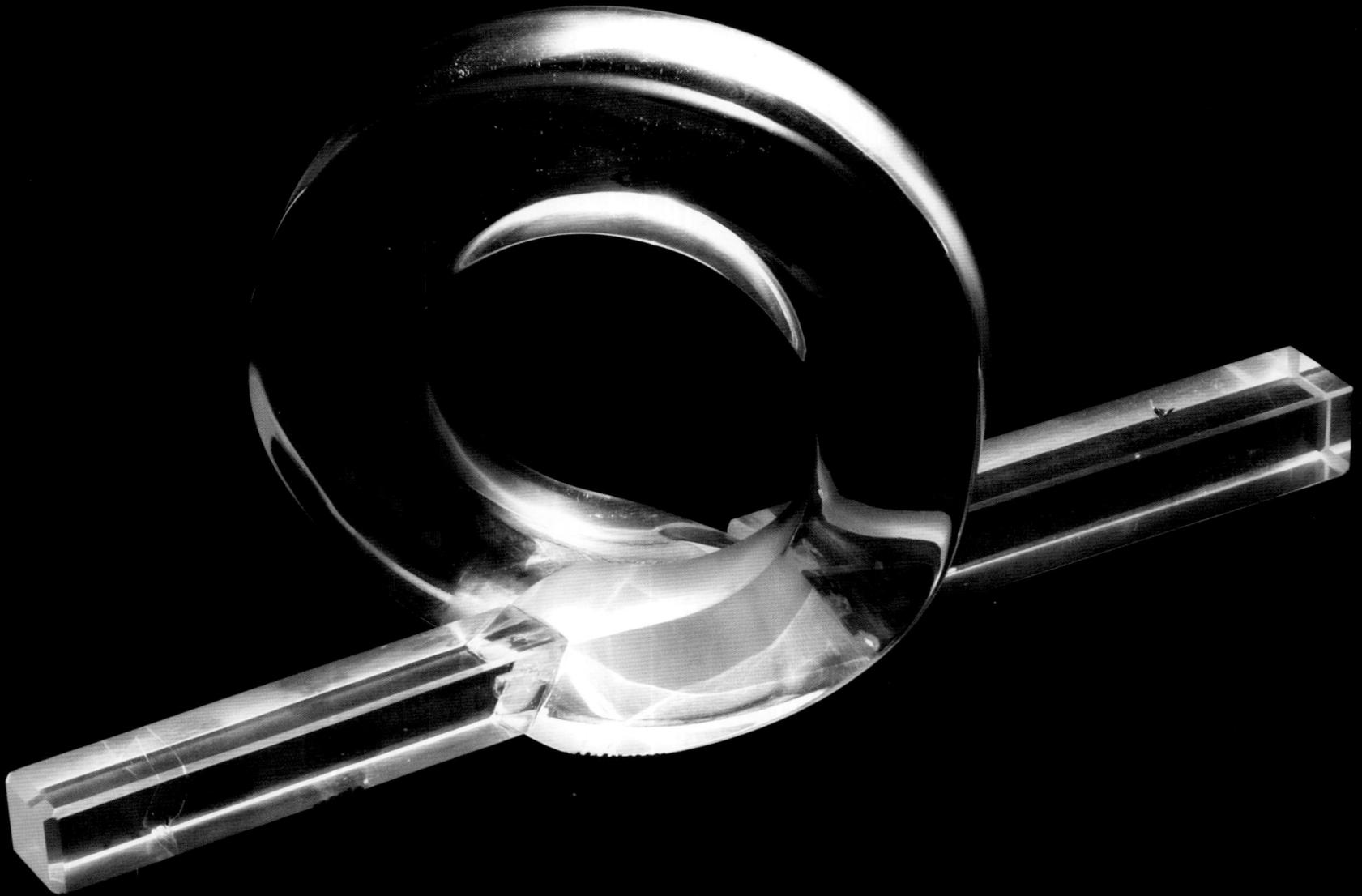

ABOVE AND OPPOSITE: *Harmonichi Loop*, carved synthetic
quartz for use as connecting component
for resonating device, 6″ high, 10″ long

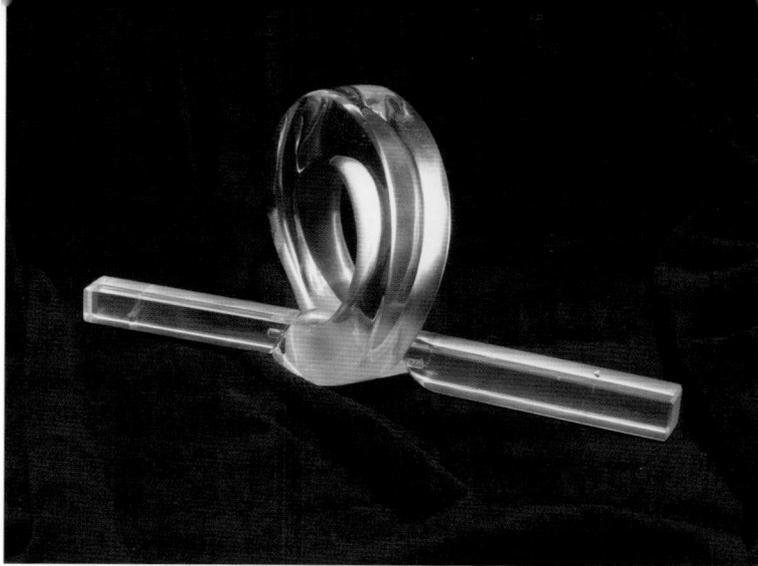

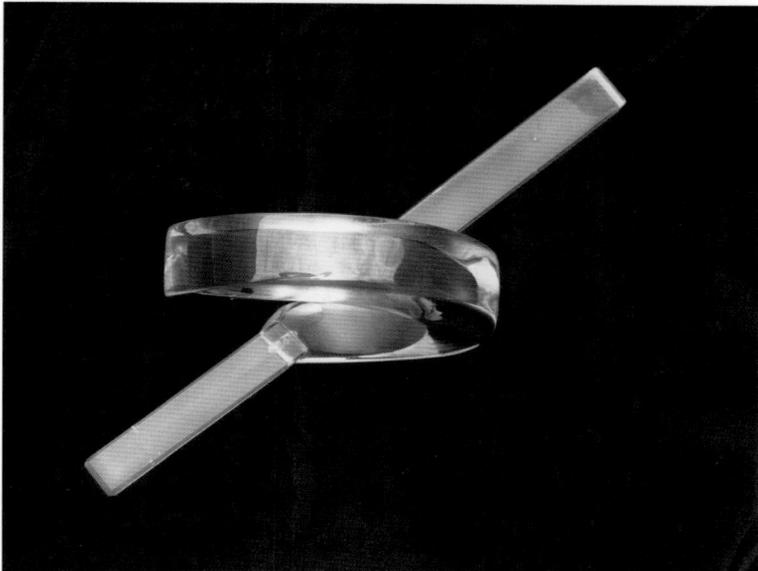

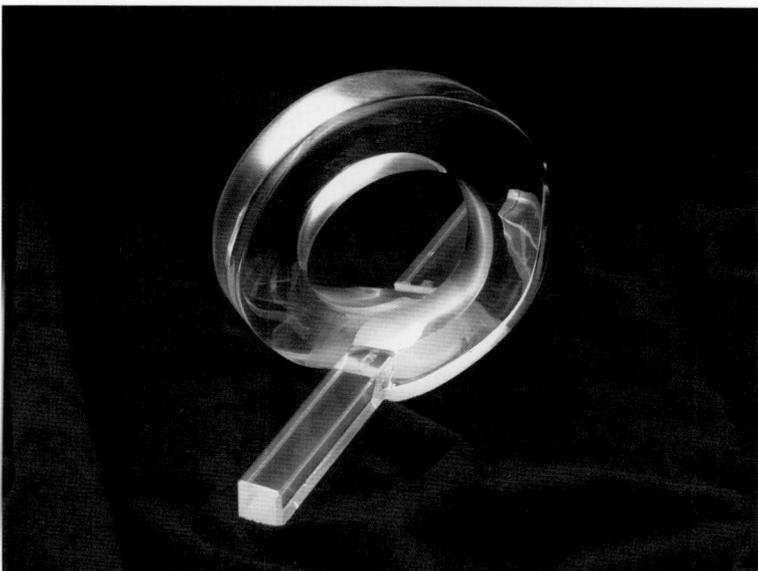

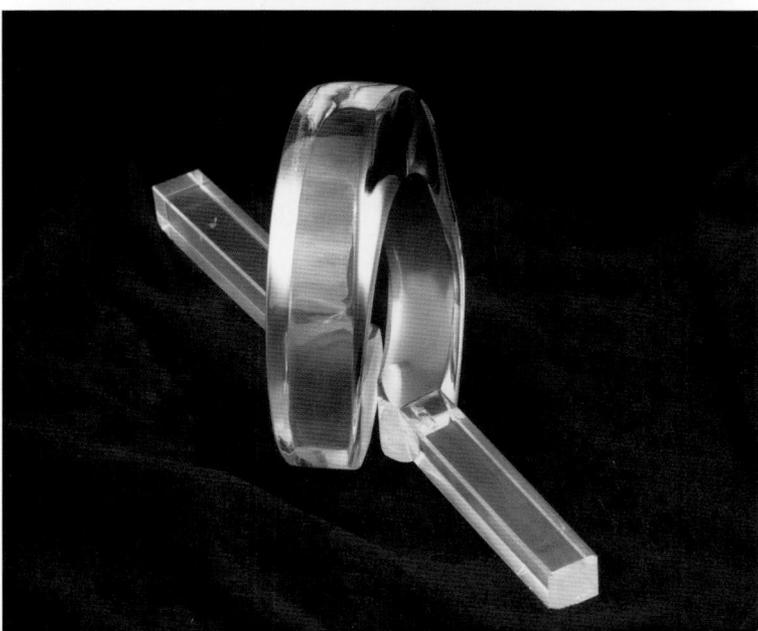

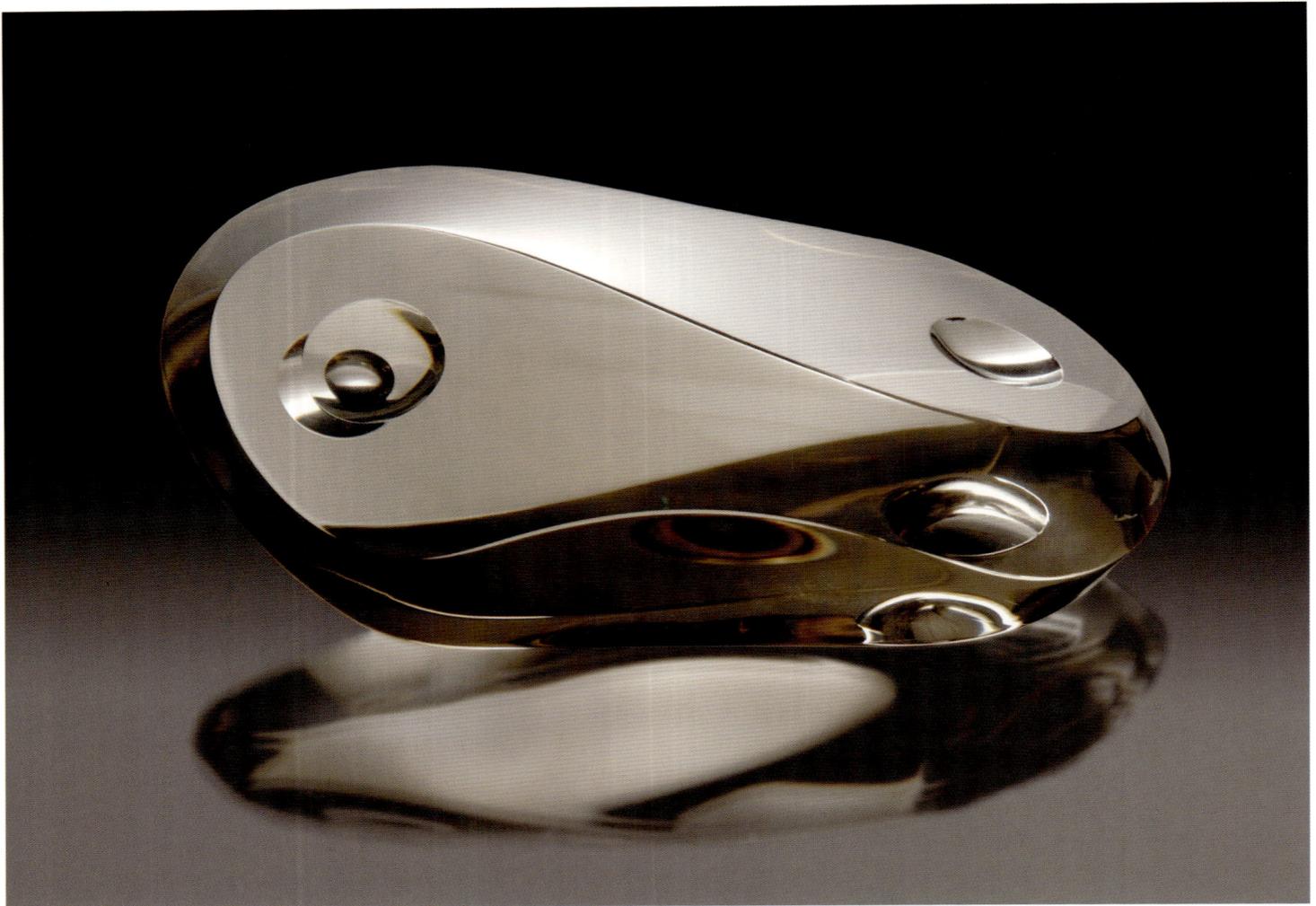

ABOVE AND OPPOSITE: *Infinity Crystal*, SMOKY QUARTZ, 5˝, BRAZIL

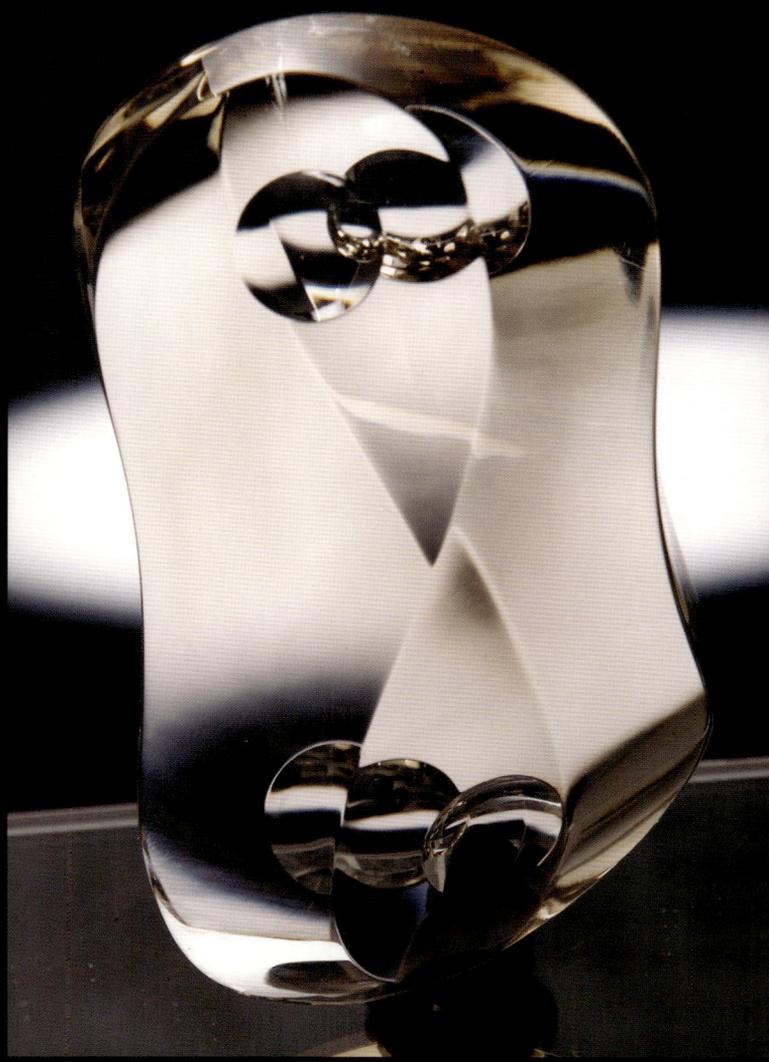

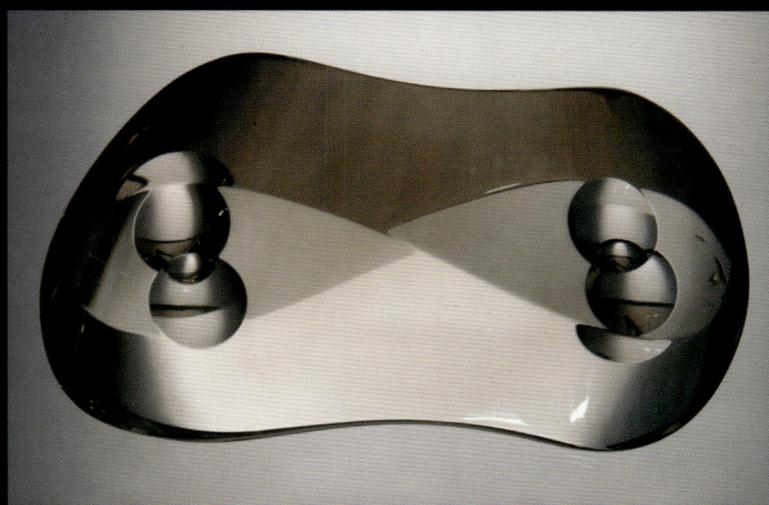

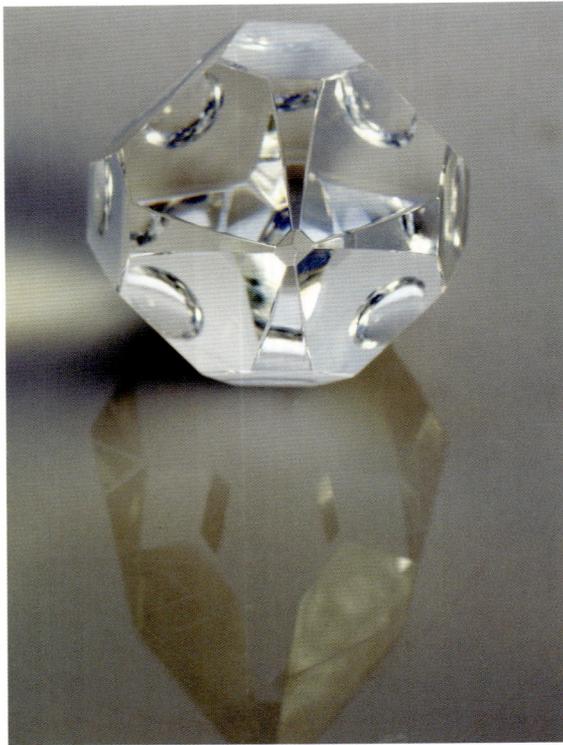

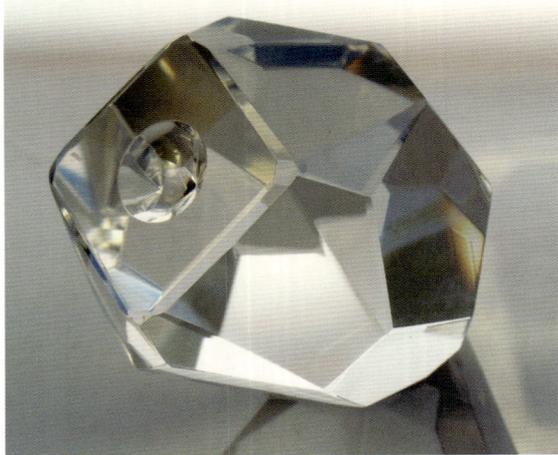

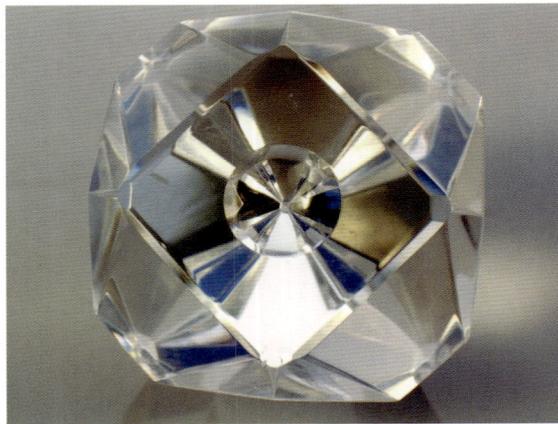

ABOVE AND OPPOSITE: *Focus Crystal*, ELECTRONIC-GRADE QUARTZ,
4½″, MADAGASCAR; FOUR VIEWS

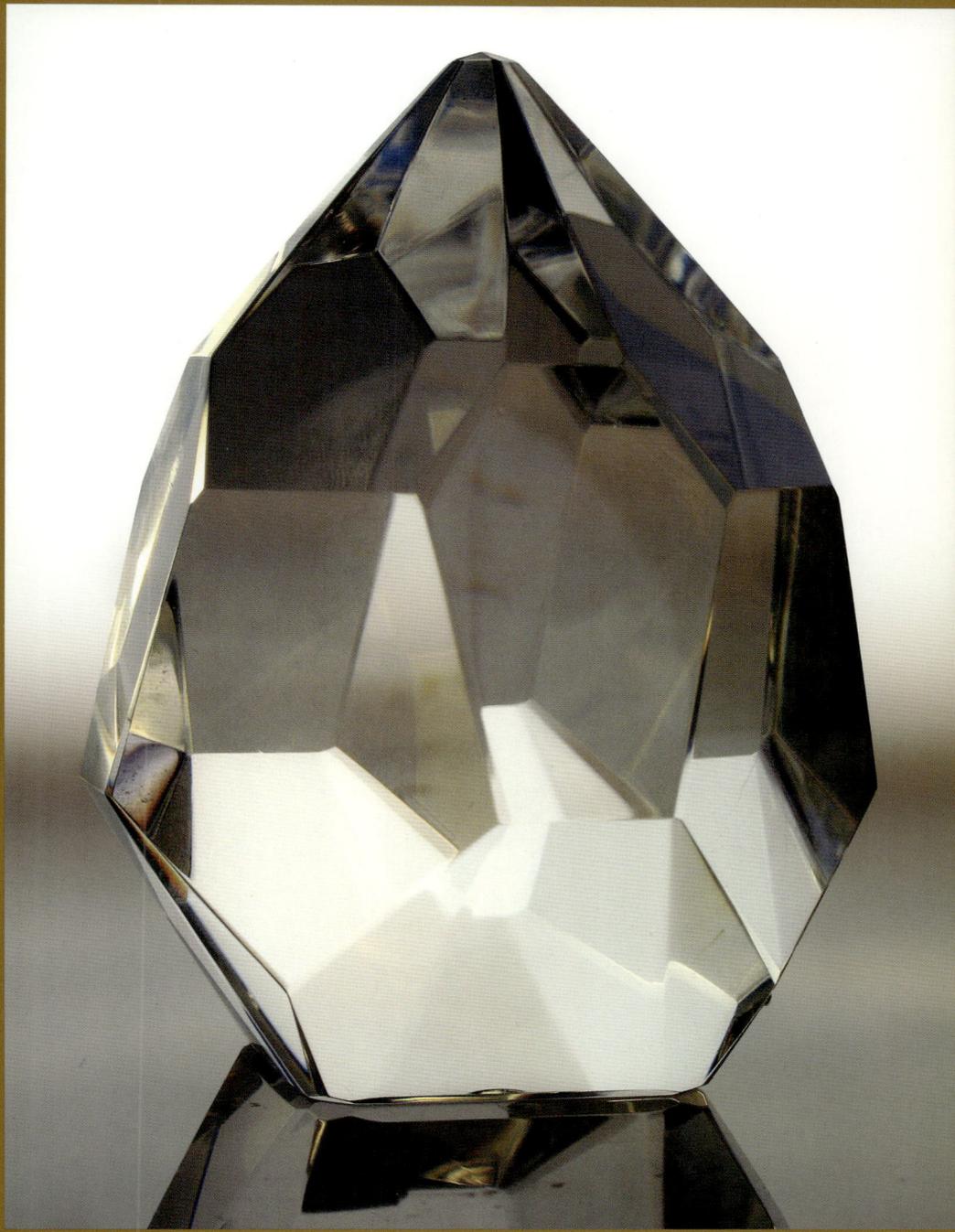

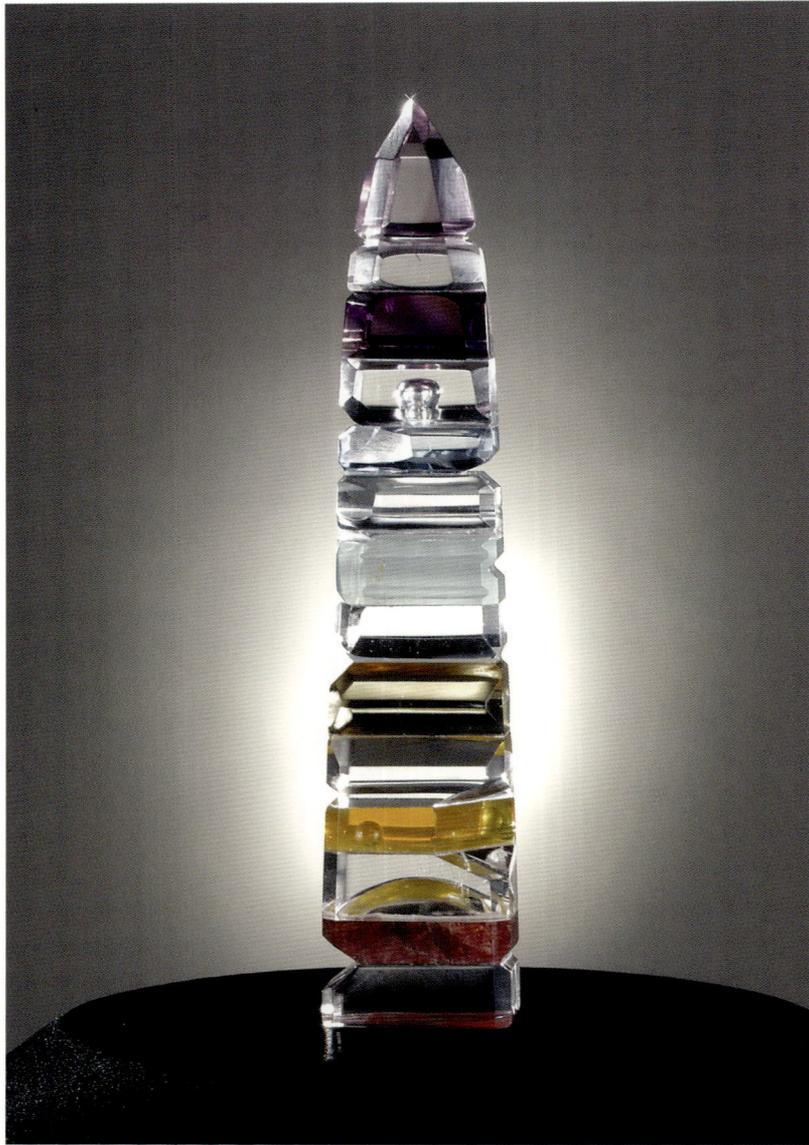

ABOVE: *Chakra Totem*, composite of Zambian tourmaline, Brazilian quartz, Brazilian opal, Madagascar citrine, Arizona chrysoprase, Brazilian topaz, Bolivian amethyst, Brazilian rose d'France, 8″ long
OPPOSITE: *Flower of Life Mandala*, quartz, 6″ diameter, Madagascar; used as conducting device for water-restructuring system

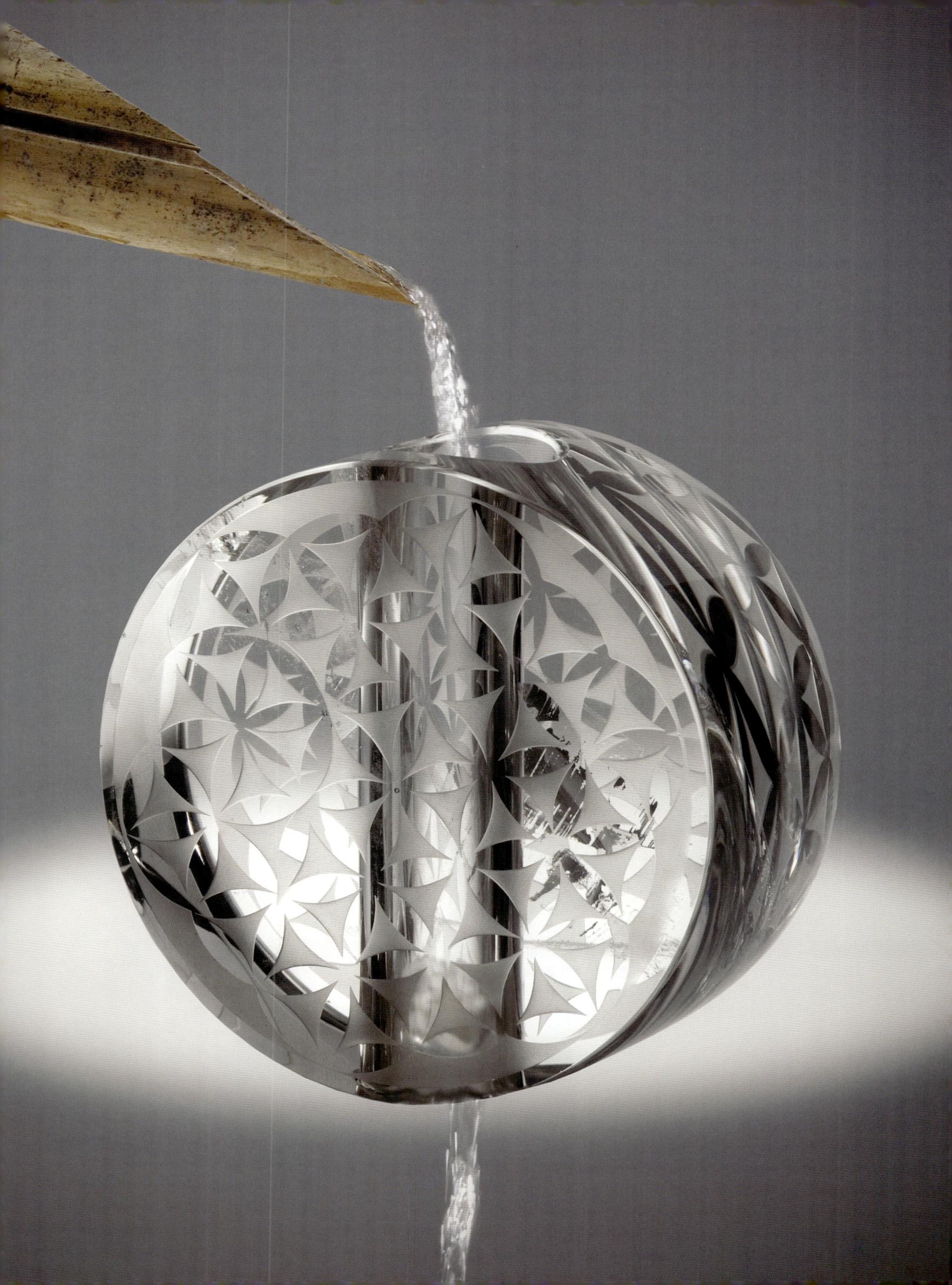

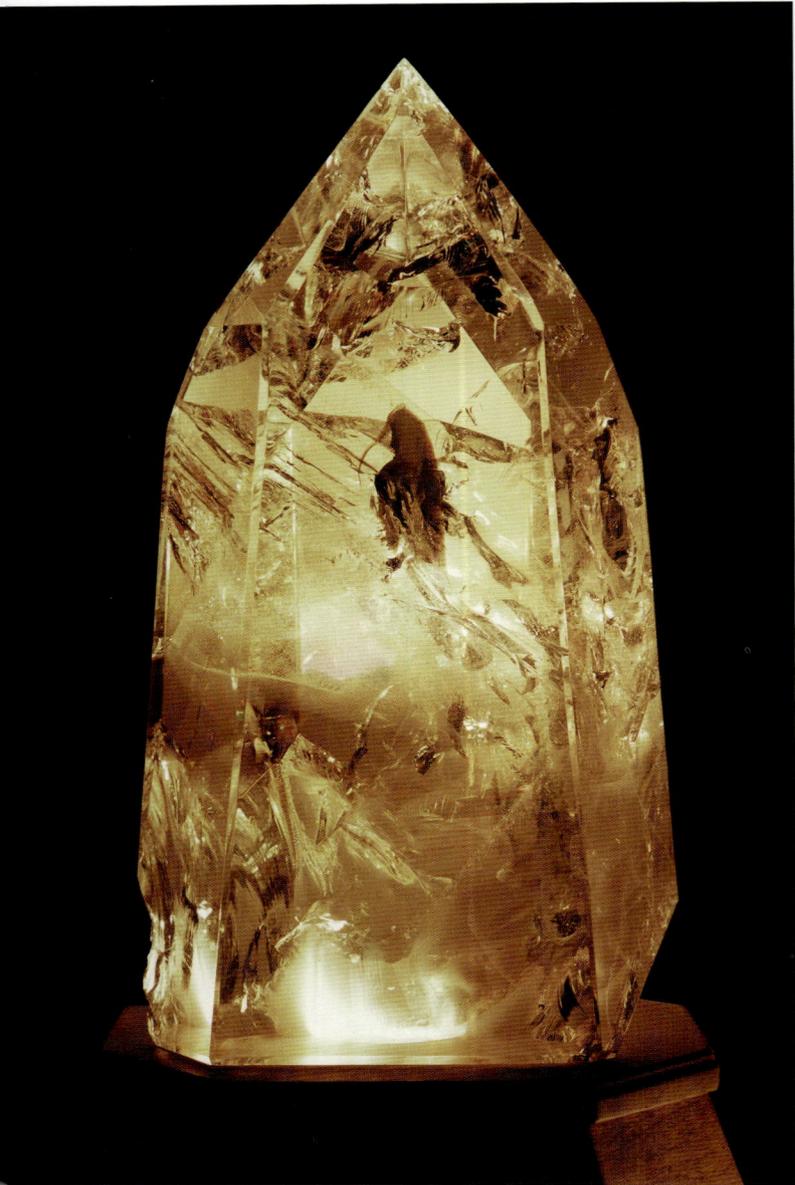

ABOVE AND OPPOSITE: *One Earth One Sky*, QUARTZ, 144 LBS., RUSSIA

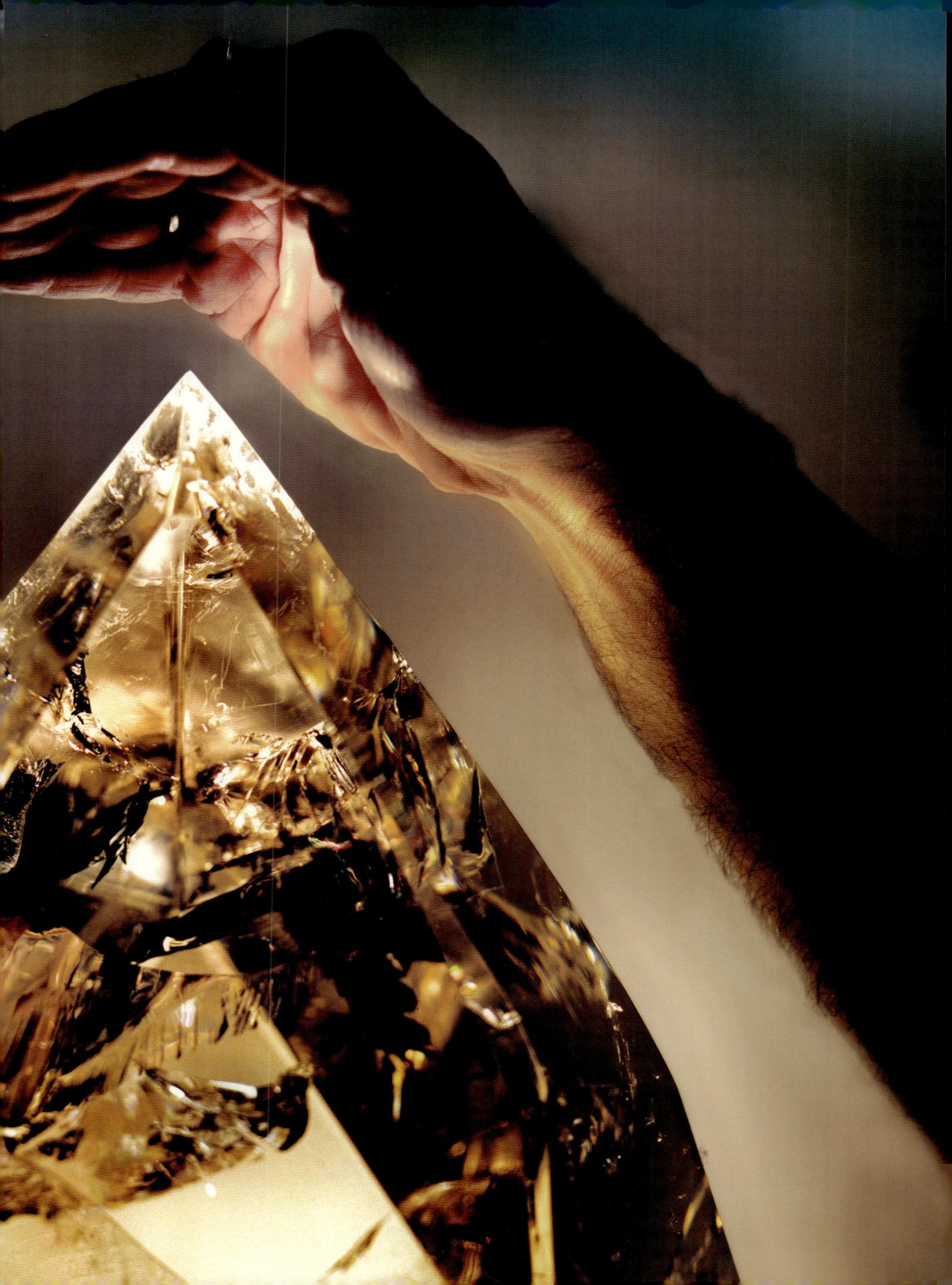

ABOVE: FINISHING WORK IN THE BRONZE FOUNDRY ON
BOUGAINVILLEA, AMETHYST CLUSTER, 512 LBS., BOLIVIA

ACKNOWLEDGEMENTS

The pages of *Frozen Light* reflect the many facets of collaboration that bind this book. It is with deep gratitude that I thank those who have been a part of this journey.

For you who have collected my work over the many years, your appreciation and patronage has been the fuel that has sustained and propelled my career.

I especially want to thank:

Nancy Burke for watering the seeds of inspiration that grew into this book.

The Palace Press/Earth Aware Editions staff for the gift that is *Frozen Light*: Raoul Goff and Michael Madden for the opportunity to bring this book to light; Mark Burstein, my editor, who has done a masterful job of framing my thoughts, clarifying my voice, and polishing my words: thank you for your commitment and friendship; Iain Morris and Scott Erwert for bringing text and images together in a design that touches the eyes and heart even after the book has been closed.

My editing and technical review team: Robert J. Stoller, Si and Ann Frazier, John S. White, Franc Sloan, Katherine Martin, Jim Anspach, Barb Williams, and Helen Avalon.

Norman Seeff for escorting me through the publishing process.

Glenn and Sharon Lehrer for your teaching, camaraderie, and friendship throughout the years.

Seth, Marla, Talia, and Mukti for continuing to be more of who you are becoming, and for sharing that with me.

Nick and Joni Prince for your ever present support and friendship throughout my career.
Warren and Lisa Kahn for your inspiration and love, and for igniting the spirit of the muse that becomes music.

Rick, Jonathan, and Roger, and all of your families, for influencing my life as only brothers and family can.

My eternal appreciation to Jach Purcel, Peny and Michael North, Barbra Brannon, and the Concept Synergy Staff. (The first part of "The Golden One" on page 113 was taken from a reading with Lazaris.)

And to the many whom I have not mentioned specifically, thank you for being part of the fabric that has become *Frozen Light*.

CREDITS

MINERS AND IMPORTERS

The rough-mineral miners and importers are on a constant lookout for raw crystals that have been unearthed in the hinterlands, caves, and distant mines of the planet. Their efforts to find these magnificent stones allow me to work with some of the world's finest. My gratitude goes to:

Ned and Bob Strickland, Star Van Scriver, Zee Haag, Edward Swobota, Marc Jobin, Tom Warton, Charles Cosac, Rui Almedia, Badin Milholo, Jurgen Bohrer, Peter Nebert, Damian Quinn, Brian Cook, Michael Siegel, Harvey Siegel, Ben Gaskill, Thomas Nagin, Danny Duke, Bill Larson, Butch Valley, Ramiro Ravera, Rock Currier, Michael Base, Carlos Vasconcelos, Ron Coleman, Jimmy Coleman, and many others.

PHOTOGRAPHERS

The art of photographing crystals is uniquely challenging. The crystal's transparent and elusive beauty reflects and refracts light that the camera compresses into a two-dimensional format. It takes special talent to recreate the magical beauty of the crystals' dynamic three-dimensionality. The photographers listed below have done a masterful job.

Gary Alvis – 2, 5, 12, 23 (top), 24, 26, 28, 29, 30, 31, 36, 37 (bottom), 39, 42, 46, 47, 49, 50, 52, 54, 55, 56, 57, 60, 61, 66, 67, 71, 73, 74, 76, 77, 79, 80, 86, 91, 94, 96, 97, 98, 99, 100, 112, 118, 119, 120, 121, 122, 123, 124, 125, 131, 132, 135, 136, 139, 142, 144, 156 (top), 159, 162, 163, 166, 167, 170, 171, 173, Back cover

Wernher Krutein – 10, 11, 14, 16, 17, 18, 19, 21. 23 (bottom), 25, 27. 32, 40, 43, 44, 45, 59, 68, 70, 72, 87 (left), 92, 93, 101, 104, 105, 106, 108 (top, middle), 109, 114, 115, 126, 127, 128, 129, 130, 133, 134, 137, 145, 148, 149, 150, 152, 154, 155, 157, 158, 164, 165, 168, 169, 174, 175, 176

Erica & Harold Van Pelt – Cover, 8, 35, 53, 63, 75, 81, 82, 83, 88, 89, 95, 102, 103, 107, 109 (top), 116, 117, 140, 141, 147, 151, 153 (top)

Jeff Scoval – 37 (top), 51, 62, 64, 84, 90, 153 (bottom), 156, (bottom),

Bill Kaunitz – 22, 146
Franc Sloan – 33
Lars Francke – 38
Azad – 48
L. Stoller – 58, 85
Indivar - 65
© 2007 **Lee-Carraher Photography** – 87 (right)
Sunni Kerwin – 108 (bottom)
Michael Justice – 110, 111
Kevin Kabota – 138
Craig Sullivan – 160, 161
Seth Silberfein – Cover flap portrait

COLLABORATION

My work is collaborative.

With great appreciation, I offer my gratitude to those who have worked with me to bring the labors of my art to life. Their help is integral and fundamental, and it is reflected in the beauty of each piece (including the many that do not appear in this book).

Timothy Turco and Ingred Mrensco have mastered the lapidary arts, and their dedication to excellence echoes throughout this book.

Somdee Chanthaphat and Fred Valenzuela assisted me through the many years of pioneering this art form. Their work hangs in a gallery that is timeless.

Peter W. Small is a giant of talent, an engineer of solutions, a purveyor of fine resolutions; with mastery of the mechanical, he fabricates metals into art.

Roy Swan casts, pounds, welds, and patinas, turning imagination into bronze.

My wife Sunni is my partner and collaborator, who has fashioned a life with me that is mirrored in the art we live.

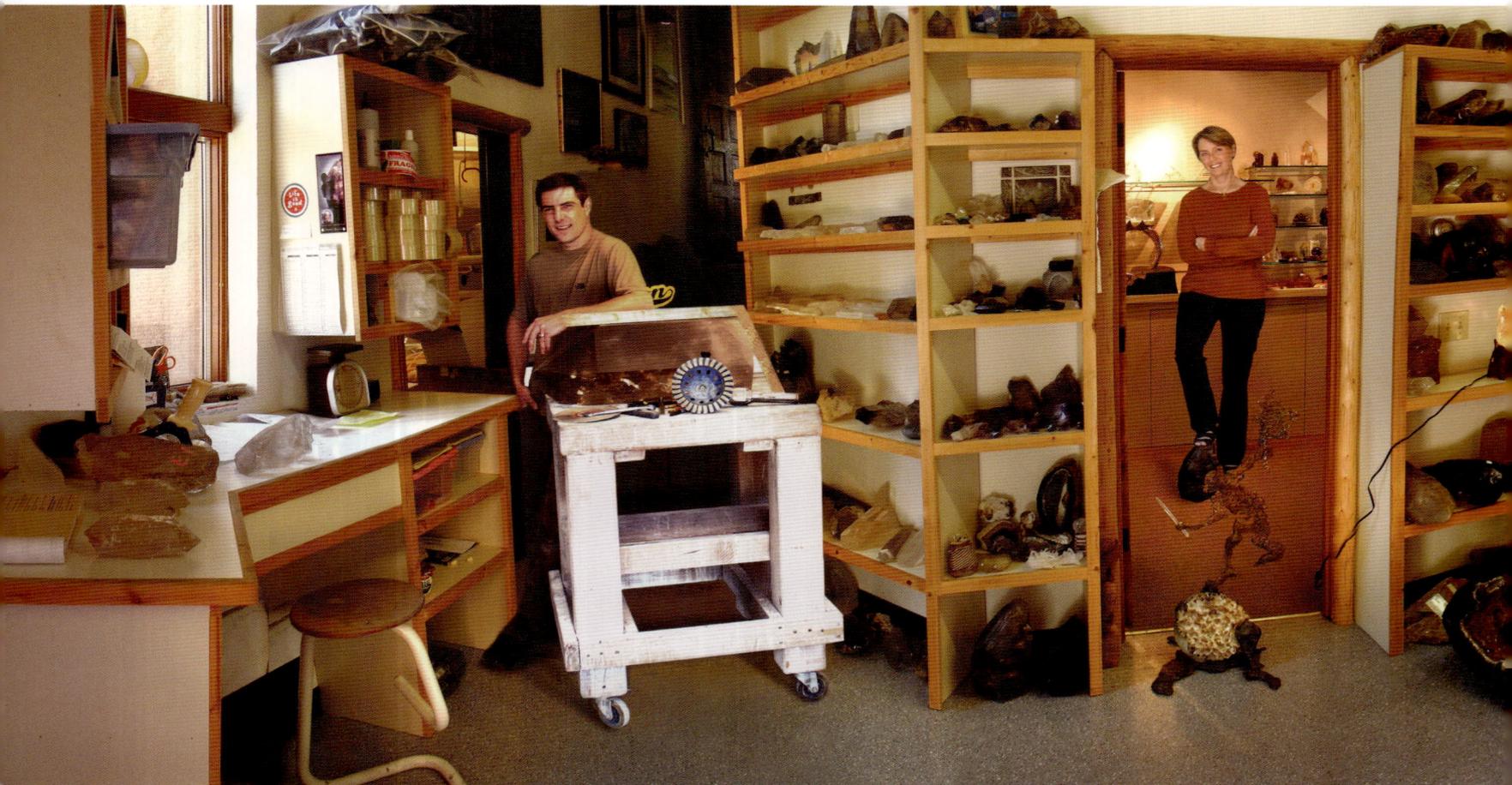

ABOVE: CRYSTALWORKS STUDIO; L TO R: TIMOTHY TURCO, SUNNI, LAWRENCE, PETER W. SMALL, ROY SWAN, INGRED MRENSCO

COLOPHON

The body and majority of display type *Frozen Light* is set in is Gill Sans, a popular typeface designed by Eric Gill for the UK Monotype Corporation between 1928 and 1930. It is based on the typeface Edward Johnston created for the London Underground. The font used for captions is KopyKat. All folios and chapter numbers are set in Thessaly, a contemporary font designed by Jim Marcus.

This book was printed in five colors with an offline dry-trapped interior spot varnish.

Publisher and Creative Director: RAOUL GOFF
Executive Directors: MICHAEL MADDEN, PETER BEREN
Acquisitions Editor: LISA FITZPATRICK
Art Director: IAIN R. MORRIS
Graphic Design: SCOTT A. ERWERT
Project Editor: MARK BURSTEIN
Production Editor: CARINA CHA
Studio Production & Press Supervision: NOAH POTKIN

LAWRENCE STOLLER
CrystalWorks Inc.
PO Box 7502, Bend, OR 97708
541 388-1721
www.crystalworks.com

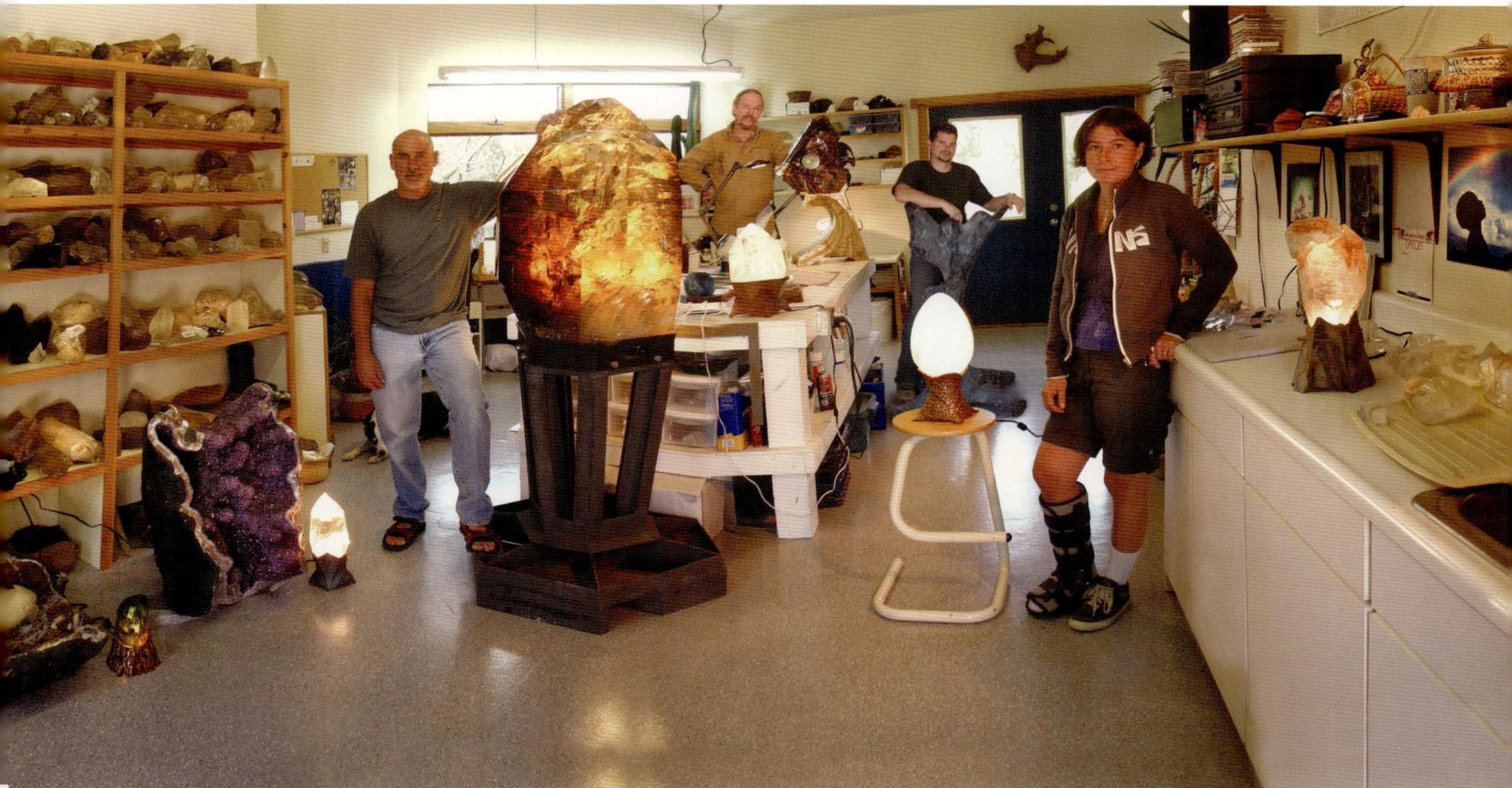